S0-AGV-934

8

FRANZ MARC

HORSES

CHRISTIAN VON HOLST

with essays by

KARIN VON MAUR · ANDREAS SCHALHORN

ANDREAS K. VETTER · KLAUS ZEEB

BUSCH-REISINGER MUSEUM, HARVARD UNIVERSITY ART MUSEUMS
HATJE CANTZ PUBLISHERS

DIRECTOR'S FOREWORD

For the opportunity to join Hatje Cantz Publishers in presenting the English-language edition of this catalog, we are grateful to our colleague, Professor Dr. Christian von Holst of the Staatsgalerie Stuttgart. He first suggested this to us, and Peter Nisbet, Daimler-Benz Curator of the Busch-Reisinger Museum, seized on the idea and conceived of an exhibition focusing on Franz Marc's *Red Horses*, which has been on long-term loan from a generous friend to the Busch-Reisinger Museum since the opening of its Werner Otto Hall in October 1991.

The importance of that painting to the Museum and to Marc's public reputation is described in Peter Nisbet's introduction, and its importance to the artist's oeuvre is dealt with in the text of the catalog. Let me just add here that we are enormously grateful that the painting's owner has entrusted us with its care these past ten years, and thus has allowed us to share it with the legions of students and visitors who have come to think of it as inseparable from the Museum, indeed as

one of its signature works. We are thankful too, to Christian von Holst and to Kathy Halbreich, director of the Walker Art Center, and Thomas Krens, director of the Solomon R. Guggenheim Museum, for supporting our exhibition with generous loans from their collections.

The exhibition as conceived by Peter Nisbet is precisely the kind of production and presentation that a teaching and research museum like the Busch-Reisinger does so well: focused on a work of art of great importance, it repays long looking and is the occasion for the publication of new scholarship. For these reasons, and for those mentioned above, we are very pleased to join Hatje Cantz Publishers in bringing this important book to an English-speaking audience.

James Cuno
Elizabeth and John Moors Cabot Director
Harvard University Art Museums

INTRODUCTION

Since October 1991, for almost ten years, Franz Marc's canonical painting *The Red Horses* of 1911 (fig. 68 and cover) has hung in the galleries of the Busch-Reisinger Museum at Harvard University. Entrusted to us by an extraordinarily generous private collector, this painting has quickly established itself as a key work, one of the essential centers of gravity in the Museum's display of modern art and design from German-speaking Europe. It is one of the few twentieth-century paintings that can almost shock on sight, regularly provoking a brief hesitation before the smile of pleased recognition: "So *this* is where the Red Horses are! There was a reproduction of this painting hanging at home, and I feel as if I've known it all my life." This widespread familiarity is not surprising, especially among our European visitors, as the painting was the subject of the first large-scale color reproduction of a work by Marc, issued at the time of the pathbreaking exhibition of Blue Rider artists in Munich in 1949 and for some ten years afterwards the best-selling of all modern fine art prints in Germany. Given the innumerable subsequent reproductions in books, postcards, posters, and other media, there is no doubt that *The Red Horses* remains one of the most beloved and recognizable of modern masterpieces.

Custodianship of such a talisman, known in reproduction but rarely seen in public, is a special honor and responsibility. We have been looking for ways in which to carry the attention of our students and public beyond affectionate esteem and toward a deeper understanding of the true achievement of a work whose very fame has tended to obscure a clear view. When our colleague Dr. Christian von Holst of the Staatsgalerie Stuttgart approached us with his ambitious idea for an exhibition devoted exclusively to Marc's treatment of his signature theme, horses, in all media, we were intrigued and enthused. Our interest turned to delight when the owner of *The Red Horses* signaled a willingness to lend to the Stuttgart exhibition and Dr. von Holst in turn offered the generous reciprocal loan

of his museum's two horse paintings by Marc, the *Small Blue Horses* (1911) and the *Small Yellow Horses* (1912) (cat. nos. 46, 47). These paintings have formed the nucleus of a small exhibition that cannot in any way match the scope of the Stuttgart undertaking, with over 150 works of art, but instead sets *The Red Horses* (cat. no. 38) into the concentrated focus of a handful of closely related works, including also the magnificent *Large Blue Horses* (1911) from the Walker Art Center in Minneapolis (cat. no. 48), and two highly significant later paintings from the Solomon R. Guggenheim Museum in New York, *Stables* and *The Poor Country of Tyrol*, both of 1913 (cat. nos. 117, 121).

With these six masterworks, our exhibition can direct attention to Marc's compressed trajectory from legibility of the motif rendered in intensely heightened colors, through a rhythmic stylization, and on to the use of the horse image as the basis for both faceted abstraction and an attempt at grand history painting of allegorical import. The ambition and experimentation of the later paintings cast a provocative light on the earlier ones in this three-year span, suggesting a level of significance beyond the decorative color patterning and pastoral subject that have surely contributed to the widespread popularity of Marc's horse pictures.

In presenting this highly selective installation of works by Marc, the Busch-Reisinger Museum is drawing on history. It was the first American museum to devote a solo exhibition to the artist, when it took over the show assembled by Curt Valentin in 1940 at the Buchholz Gallery in New York. This was accompanied by a small catalog, with an essay by Robert J. Goldwater, whose pioneering *Primitivism in Modern Painting* had appeared two years earlier. In both the catalog and the book, Goldwater emphasized *The Red Horses*, prominently illustrating it in the former as "the first picture in which [Marc] found his own style," and describing it in the latter as "famous." Indeed, the reviews of the exhibition when it was

shown from 4 February to 4 March 1941 at the Busch-Reisinger Museum (the Germanic Museum, as it was then known) confirm this painting's considerable status. In the *Christian Science Monitor* on 11 February 1941, Dorothy Ablow opened her article with the sentence, "After having admired from colored reproductions 'The Red Horses' of Franz Marc, it is a joy to see the canvas in the original." The fame of the painting was clearly much enhanced by color reproductions, even before the boom after World War II. Moreover, American audiences had the opportunity to experience "the canvas in the original" at least once before, when it was included ten years earlier in Alfred Barr's exhibition *Modern German Painting and Sculpture* at the recently founded Museum of Modern Art in New York, in March and April 1931. For Barr the painting was the "most admired picture" by "perhaps the most brilliant of 20th-century German painters," and he included it as the earliest of six major paintings by the artist in his survey (one of which he even illustrated in color on the catalog cover). Barr's opinion of the artist was shared by Katherine Dreier, the foremost collector and promoter of avant-garde art in America at the time, who wrote in a book for a 1926 exhibition that "in the death of Franz Marc, Germany lost one of her greatest artists of all times," and in 1950 called him "one of the most vital personalities in the art world of the first quarter of this century." An additional supporter in the 1920s was Wilhelm Valentiner, who trained and served with Marc in the First World War and then went on to be director of the Detroit Institute of Art, where he promoted the work of Marc and his fellow Expressionists.

In one sense, then, the presentation of *The Red Horses* at Harvard in early 1941 continued a remarkable tradition of American enthusiasm for Marc's work; in another sense, of course, it was a very different moment. The status of the picture had been radically altered in the 1930s by the National Socialists' campaign against modern art in general, and against modern art acquired by German museums in particular. *The Red Horses* was the first picture by Marc to be acquired by a museum, having been bought by the Museum Folkwang in Hagen at the end of 1911, a few months after it was completed. This long-term public accessibility no doubt contributed to its popularity, but public ownership in turn exposed the work to confiscation in 1937 and disposal at the notorious auction of masterpieces of modern art from German museums in Lucerne on 30 June 1939, along with seven other works by the artist. In fact, the inclusion of the painting in the exhibition in New York and Cambridge in 1940–41 was the first public showing of the painting after it had been bought for 15,000 Swiss Francs (about two-thirds of the estimated price) as lot 87 in that auction. The purchaser was a young collector who had graduated from Harvard only three years earlier.

Since 1941, the painting has occasionally been seen in exhibitions, for example in the United States in the Busch-Reisinger Museum's survey *Artists of the Blue Rider* in 1955 and the traveling Marc exhibition organized by Mark Rosenthal for the Berkeley Museum of Art in 1979, and in Germany at the important exhibition devoted to "degenerate art" in Munich in 1962 and subsequently in the Hamburger Kunsthalle's Marc exhibition of 1963. The infrequency of these appearances makes the inclusion of the painting in the recent Stuttgart project all the more important.

We are especially pleased that we can use this occasion to publish an English edition of the Staatsgalerie's comprehensive and lavishly illustrated catalogue, in which Dr. von Holst and his colleagues provide an extensive underpinning for the exhibition's iconographic focus on the image of the horse in Marc's oeuvre. A powerful cumulative case is made for the exemplary status of the horse motif throughout the artist's career. Although he devoted great attention to a wide range of animals (deer, monkeys, bulls, birds, cows, and many others),

Marc was strongly drawn to the horse, and a very high percentage of his key works (notably, of course *The Red Horses* itself) deals with the theme. In addition to a summary chronology of the artist's life and Dr. von Holst's meticulous and closely observed review of Marc's engagements with the image of the horse, the catalog also offers Karin von Maur's account of the Blue Rider artist's place within the struggle for modernism in Germany. Three essays consider specific aspects of Franz Marc's horse pictures. Klaus Zeeb applies his expertise in animal behavior in commenting on the extent to which Marc may have represented identifiable aspects of the horse's nature (suggesting, for example, that the title which scholarship has largely in vain attempted to propose for the *Red Horses, Grazing Horses IV,* may itself be inappropriate for the equine activity depicted!). Andreas K. Vetter examines the issue of landscape in the horse pictures, where the representation of the environment is shown to be inextricable from the depiction of its inhabitants. And Andreas Schalhorn offers provocative thoughts on the implied and occasionally actual presence of humans in these horse pictures. These extend beyond the focus on riders to cases where compositions with horses, such as Stuttgart's own *Small Yellow Horses* and a 1913 postcard (cat. no. 79) are actually built up over and subsume human figures, a practice echoed in *The Red Horses,* which, I can report, is itself painted on the verso of an unfinished and reworked composition of one and maybe two nude female figures reclining in a landscape. Together, these scholarly contributions point the way to further questions and research, and we hope that their availability in English will prompt art historians outside Germany to a deeper engagement with Marc's work.

We are happy to acknowledge our cooperation with Hatje Cantz Publishers on this volume, which has been ably translated by Elizabeth Clegg and Claudia Spinner, and edited in its English version by Elizabeth Clegg, assisted with characteristic grace and efficiency by Tawney L. Becker, curatorial assistant of the Busch-Reisinger Museum. We have decided not to erase all traces of the book's original function as a catalog for the Stuttgart exhibition, replacing only the sponsor's statement, the list of lenders, and Dr. von Holst's preface and acknowledgments (though we like to think that his warm expressions of thanks to the many who made the Stuttgart exhibition possible are incorporated here by implication!).

For the chance to show *The Red Horses* for an extended period in such good company, we thank our colleagues at the Walker Art Center (Kathy Halbreich, director, and Joan Rothfuss, associate curator), the Solomon R. Guggenheim Museum (Thomas Krens, director, and Lisa Dennison, deputy director and chief curator), and, of course, at the Staatsgalerie Stuttgart.

The exhibition and publication have been supported by the Friends of the Busch-Reisinger Museum, under the leadership of Timotheus R. Pohl, who saw immediately the importance of both parts of this project in promoting American enjoyment and understanding of the art of German-speaking Europe. Finally and most crucially, it is to the present owner of *The Red Horses,* an honorary member of the Friends of the Busch-Reisinger Museum, that we owe the profoundest thanks for confidence shown in us in placing the picture on long-term loan to Harvard. We very much hope that this exhibition and publication justify that confidence by providing a scholarly and visual forum in which the painting can flourish, attracting new attention and admiration.

Peter Nisbet
Daimler-Benz Curator of the Busch-Reisinger Museum

Franz Marc
1880 — 1916

ANDREAS K. VETTER

1880 Franz Moriz Wilhelm Marc is born on February 8th in Munich. He is the second son of a local painter, Wilhelm Marc (1839—1907), and his wife Sophie Maria Marc, née Maurice (born 1847). Both boys receive a devout and bi-lingual (Franco-German) upbringing, reflecting the fact that their mother is a Calvinist from Alsace. (Marc's surviving correspondence with her is largely in French). Marc's father had initially studied law, but by 1880 he had been appointed to a Professorship at the Munich Academy of Art. His conventional treatment of landscapes, interiors, and genre scenes appears to have had no influence on the later work of his younger son. Franz Marc has a peaceful, orderly, bourgeois childhood, a good high-school education (one of his fellow pupils at the Luitpold-Gymnasium is Albert Einstein), and every encouragement to develop his musical, literary, and sporting abilities.

1897 By the age of 17 Marc seriously begins to consider training as a Protestant minister. He now frequently explores the environs of Munich along with his small dog. He also starts making drawings in his first sketchbook.

3
Franz Marc, c. 1892/93

page 14
2
Franz Marc, c. 1913

1899 After completing his high-school education, Marc enrolls at Munich University (the Ludwig-Maximilians-Universität) with the intention of studying theology and philology; but he is first required to serve in the military for a year (1899—1900) at Lechfeld, near Munich. He com-

4
Wilhelm Marc
Franz Marc Making a
Wooden Model, c. 1894/95
Bayerische Staatsgemälde-
sammlungen, Munich

pletes this year with the rank of sergeant. It is during this time that he first comes into direct contact with horses, mastering the elements of grooming and riding. This year also gives Marc the chance to reconsider his choice of career.

1900 Marc decides on a change of direction, and in the fall he enrolls at the Munich Academy of Art, taking the drawing class taught by Gabriel von Hackl (1843—1926) and studying painting under Wilhelm von Diez (1839—1907), who had previously taught Wilhelm Trübner, Max Slevogt, and Adolf Hoelzel. Marc, with his somewhat reserved manner, establishes few contacts with his fellow students. The work that survives from Marc's student years includes portraits of members of his family and studies of landscape

motifs, most of the latter being produced during trips into the foothills of the Bavarian Alps and in the moorland around the village of Dachau, by this time extremely popular with Munich painters (fig. 185).

1901 In October, together with his elder brother, Paul (a Byzantinist currently studying in Florence), Marc visits Venice, Padua, and Verona.

1902 Marc spends the summer at the cottage in the mountain pasture above the village of Kochel am See (an area to which he will repeatedly return). He draws and paints a series of landscape views and motifs.

1903 Marc is invited by a wealthy fellow student, Friedrich Lauer, to spend two months of the summer in Paris. Here, he is chiefly interested by the work of Eugène Delacroix and Gustave Courbet, and that of the French Impressionists. Responding to the continuing Parisian vogue for Japanese art, he buys some woodblock prints. Completing this vacation with a stay in Brittany, Marc returns to Munich on September 26th. While this experience does not appear to be reflected in Marc's work of this time, it encourages in him a greater degree of self-awareness.

1904 Marc stops attending classes at the Academy of Art and moves into a studio of his own at 68 Kaulbachstrasse. Here, over the next years, he produces paintings and graphic works (etchings, lithographs, and later woodcuts, and above all drawings), often elaborating on studies made in the foothills of the Bavarian Alps. He nonetheless retains some connections with the Academy; he also establishes contact with the well-known Munich animal painter Heinrich von Zügel (1850—1941) and with the landscape

painter Adolf Hoelzel (1853—1934), a key figure in the artists' colony at Dachau.

It is probably during the summer of this year that Marc first spends a few weeks at the monastery at Indersdorf, north-west of Dachau (he is often to return here to paint during the following years).

By this time Marc is beginning to tire of his relationship with the painter and writer Annette von Eckhardt (who is older by 9 years and also married).

1905 In October Marc meets the young Swiss painter Jean Bloé Niestlé (1884—1942). They become good friends and encourage each other in their work as artists. (When Marc later leaves Munich to live in the country, Niestlé will do likewise). Significantly, Niestlé has already resolved to specialize in animal painting. Under his influence, Marc gradually loses his interest in portraits and landscapes in order to focus on animals; until 1908 he also makes a careful study of animal anatomy, producing many drawings. From this point on Marc is primarily absorbed in the animal subjects he encounters in his immediate surroundings in the Bavarian countryside. These include his own dog and deer, and the village cats, sheep, cows or horses. A small study dating from this year (fig. 25) reveals Marc's early interest in domesticated, working animals.

In the winter Marc is introduced by friends to Marie Schnür (born 1869), who teaches at the Munich Union of Women Artists (*Künstlerinnen-Verein*) and is associated with the local artists' association *Die Scholle* [Native Soil], and to one of her students, Maria Franck (1878—1955), who comes from Berlin. The decorative character of Schnür's work (very much in the manner of Munich *Jugendstil*) will temporarily have a strong influence on Marc's own style.

1906 In April Marc and his brother spend three weeks at the monasteries on Mount Athos in Greece, where Paul Marc has arranged to study illuminated manuscripts and icons in connection with his academic research.

May through October, at times in the company of Marie and Maria, Marc paints at Kochel am See and in the alpine pasture above it.

1907 In March Marc marries Marie, in large part (it would seem) as a matter of form, so that she will be able to maintain custody of the child she has had with another Munich painter. Both soon admit the marriage to be a mistake and they divorce in 1908. (Unforeseen complications relating to the divorce settlement are, however, to prevent Marc from legally remarrying until 1913).

On his wedding day Marc leaves Munich alone for Paris, where he is now fascinated by the work of Paul Gauguin and Vincent van Gogh. On his return to Germany, he spends more time at the monastery at Indersdorf. He moves to another studio, at 33 Schellingstrasse, but does not at first use it for his own work. The need, however, to earn a living leads him to start using it for teaching, above all for the classes in animal anatomy that he continues to give until 1910.

On May 27th Marc's father dies, after suffering for many years from increasing paralysis. Marc collaborates with Annette von Eckhardt on a booklet of patterns for woven textiles to be produced on a hand-loom, she providing the text and he the stylized representations of animals suitable for adaptation to a simple geometrical scheme.
In September Marc stays with Marie Schnür and her family at Swinemünde [now Świnoujśie, Poland] on the Baltic coast. A number of small oil paintings survive from this period, including *Horses by the Sea* and *Riders by the Sea*. Marc

returns to Munich via Berlin, where he visits the Zoo and makes drawings of exotic animals including elephants, bears, lions, and flamingos. Over the next few years he will become a keen collector of books about animals and an enthusiastic visitor to the Zoological Collections and the Anatomical Institute in Munich.

To augment his income during this and the next year, Marc also provides 7 images of animals for a series of postcards, and a group of lithographs for a children's book, *The Zoo* (but it seems that this does not sell especially well).

1908 Marc spends the summer in the village of Lenggries with Maria Franck (who is tentatively beginning to establish herself as a painter and textile artist). He takes to setting up his easel in the pasture. One result is the *Large Picture of Horses at Lenggries I* (fig. 34), but Marc is unsatisfied with this and later cuts up the canvas. (He will destroy several other "unsatisfactory" large paintings over the next few years; see fig. 32).

In the fall, as a form of advertisement for his classes in animal anatomy, Marc makes several large demonstration studies on brown wrapping paper (figs. 5, 27). These are displayed in various locations (including Heinrich von Zügel's private art school) but with very little success.

Marc tries his hand at sculpture, working in wax, wood, and other materials and having a number of pieces cast in bronze, among these (in late December) the group *Two Horses* (figs. 37—39).

1909 In spring Marc sees the large exhibition of work by the Idealist painter Hans von Marées and is impressed. (Marc's later work will occasionally reflect the influence of Marées; see figs. 69, 70). He succeeds in making his first sales, to the Munich art dealers Franz Joseph Brakl and

Heinrich Thannhauser, although it is probable that they only agree to buy work in a style they see as unusual at the urging of a friend of Marc, the painter Fritz Osswald (1878—1966).

In May, happy to be able to get away from Munich, Marc moves to Sindelsdorf, where he will spend the summer with Maria Franck. This village in the Loisach valley is more isolated than nearby Kochel am See, and life is less expensive there. They find lodgings in the house of the local master carpenter, Josef Niggl, which adjoins a paddock (fig. 6). They usually paint out of doors, but sometimes use the empty attic as a studio. One of the paintings produced during this first, very happy stay at Sindelsdorf is *Foals at Pasture* (fig. 41).

In December Marc repeatedly visits the first exhibition to be mounted by the *Neue Künstlervereinigung München*, hereafter *NKVM* [New Munich Artists' Union], founded by two Russian expatriates, Wassily Kandinsky (1866—1944) and Alexei Jawlensky (1864—1941) and several of their German colleagues, notably Kandinsky's companion Gabriele Münter (1877—1962). Marc is excited and inspired at finding a group of artists who appear to have so much in common with him both intellectually and esthetically.

1910 In early January the art dealer Brakl mounts an exhibition of Marc's work (this too the result of Fritz Osswald's intervention). In all probability, the first image of a horse that Marc exhibits is the *Foals at Pasture* (fig. 41). Among the prints he shows is the lithograph *Horses in the Sun* (fig. 30). The works of medium size sell for between 200 and 300 Reichsmarks. Among the few sales made, a lithograph is bought by the young Munich publisher Reinhard Piper (1879—1953). His attraction to this work and his own interest in the artistic rendering of animals prompt him to introduce himself to Marc and to ask him to collaborate on a publi-

cation then in progress: *Das Tier in der Kunst* [Animals in Art]. The volume will include a reproduction of Marc's sculpture *Two Horses* (figs. 37—39) and a short text by the artist. Piper also attends Marc's lectures and drawing classes on animal anatomy, and the two discuss Piper's (ultimately unrealized) plan to publish a book based on these.

The exhibition mounted by Brakl is also seen by the artist August Macke (1887—1914), who is based in Bonn. Macke immediately calls on Marc at his studio and a friendship is soon established, this also embracing Maria Franck, Macke's wife Elisabeth, née Gerhardt, and his brother Helmuth. Through this connection Marc will meet Elisabeth's uncle, the Berlin industrialist and art collector Bernhard Koehler (1849—1927), and his son of the same name. From the time of his first meeting with Marc, in April 1910, Bernhard Koehler, Sr. consistently buys work from him, later paying him a monthly stipend to be offset against the payment due for future purchases. (Koehler also proves a benevolent patron of August Macke and of the painters of the *NKVM*, in addition to his support of other projects in which Marc later becomes engaged).

Together with Brakl (whose eye is on emerging trends in the Munich art market), and August and Helmuth Macke, Marc draws up plans for the foundation of a new Munich-based artists' association that is to make its debut with a show opening on December 21st. This scheme is abandoned when Marc learns more of the nature and similar aims of the *NKVM*.

During the course of 1910 Marc devotes more attention than in the past to important texts on and by recent and contemporary artists (including Cézanne, Gauguin, and Maurice Denis). He also studies Signac's writings on color theory, while Macke draws his attention to the work of Matisse. In April, having quit his Munich studio, Marc moves

definitively to Sindelsdorf, where Maria Franck joins him for the summer months. Her parents, visiting in August, declare their approval of the couple's plan to marry. (Complications arising from the nature of Marc's divorce from Marie Schnür are to lead, however, to his marriage with Maria being

postponed until June 1911 and only formally recognized after a second ceremony in 1913).

In August an exhibition of the work of Paul Gauguin at Thannhauser's gallery increases Marc's fascination with this artist.

5
Franz Marc in his anatomy class, seated on the right (with cat) Maria Franck, 1908

In September Marc designs a cover for the Cézanne monograph by Julius Meier-Graefe to be published by Reinhard Piper, for which he provides a drawn adaptation of a painting of bathers (fig. 170). This challenging exercise initiates Marc into the significance of Cézanne's achievement.

In the same month the *NKVM* mounts its second exhibition at Thannhauser's gallery, on this occasion under the auspices of Hugo von Tschudi, former Director of the Nationalgalerie in Berlin (where his Modernist enthusiasms have proved too much for some) and recently appointed to an equivalent post in Munich. The *NKVM*, where the principal chairmanship has just passed from Kandinsky to Adolf Erbslöh (1881—1947), prides itself on its internationalism — its second exhibition includes over 115 works by 29 artists, among them Picasso, Rouault, and De Vlaminck — but is in fact dominated by its Russian members.

Incensed at the negative public and critical reaction to this show, Marc publishes an article defending and praising it. This leads to his first meeting with the principal members of the *NKVM* (except for Kandinsky), which takes place in October.

In November Reinhard Piper publishes a small book on Van Gogh by Julius Meier-Graefe. Marc, now based in Sindelsdorf, studies this avidly, his interest in Van Gogh having been extended the previous year thanks to the exhibition presented at Brakl's gallery. In works such as the vigorously pointillist *Leaping Horses* (fig. 54), painted in the fall, Marc's style clearly reflects his attention to Van Gogh's work. While the pointillism is to prove a passing phase, the much bolder use of color is to endure in his next works, the series of *Grazing Horses* (figs. 57—59).

At this time Marc also turns his hand to the applied arts, making vases and objects in metal. At Christmas he gives Elisabeth Macke a bronze

plaque of a *Panther attacking a Horse*, largely in *Jugendstil* mode.

1911 Marc is invited to a New Year's party at the apartment of Alexei Jawlensky and his companion Marianne von Werefkin (1860—1938) in the bohemian Schwabing district of Munich. Here he meets Kandinsky for the first time. Immediately drawn to each other, they soon establish an intense relationship, both as friends and as fellow artists. The next evening the group reassembles to attend a concert given by the Austrian composer Arnold Schönberg (1974—1951). Marc recognizes that he has found a circle that meets his needs in every respect.

In late January Marc takes the collector Bernhard Koehler, Sr. around the Munich galleries and the studios of his artist friends, where Koehler purchases a great many works. He also visits Marc at Sindelsdorf and is delighted at the "enormous progress" in his recent paintings. It is at around this time that Marc begins work on the large picture *The Red Horses* (fig. 68), and in the following months he paints two versions of the *Blue Horse* (figs. 72, 74), *The Small Blue Horses* (fig. 77) and *The Large Blue Horses* (fig. 78). A related picture, *The Small Yellow Horses* (fig. 79), follows in 1912.

On February 4th a "delegation" from the *NKVM* (comprising Erbslöh, Jawlensky, and Werefkin) visits Marc at Sindelsdorf. All three are very impressed by his work. Marc is invited to become a member of the association and is promptly elected to its board.

Independently of the *NKVM*, Marc and Kandinsky mount a joint exhibition at the Goldschmidt Salon in Frankfurt am Main in April; and in May Thannhauser presents Marc's work in Munich alongside that of the French artist Pierre Girieud (1874—1940), this show later traveling to Mann-

heim. Marc's contribution is dominated by pictures with horses, including *Leaping Horses* (fig. 54), *Fighting Horses* (fig. 65), *Grazing Horses III* (fig. 59), *Three Red Horses* (fig. 68), *Blue Horse I* (fig. 72), and *Blue Horse II* (fig. 74).

In June Marc acquires copies of the manifestos issued by the Italian Futurists the previous year — the Manifesto of Futurist Painters, and The Technical Manifesto of Futurist Painting — and reads these with interest. The writings of the principal aritsts associated with the Futurist poet F. T. Marinetti (Balla, Carrà, and Boccioni) are not published in German until 1912—13.

At this time Marc also becomes acquainted with the work of the young German painter Heinrich Campendonk (1889—1987), and he urges that he be admitted to membership of the *NKVM*. Four months later Campendonk moves from Krefeld to Bavaria and settles, like Marc, at Sindelsdorf.

On June 4th an exhibition of Marc's work opens at the *Kunstverein* [Art Association] in Barmen, near Wuppertal. At around this time a painting titled *Grazing Horses* is given to the factory owner and art collector Holzrichter in exchange for *Blue Horse II*, which he had acquired at Marc's exhibition at Thannhauser's gallery. In September the Barmen *Kunstverein* is able to sell *Blue Horse II* to the Wallraf-Richartz-Museum in Cologne.

Also in June, Franz and Maria travel to London in the belief that marrying there will enable them to circumvent the legal difficulties still preventing the possibility of doing so in Germany. A ceremony takes place but the arrangement is not recognized under German law (necessitating a second ceremony, which will take place in Munich, in May 1913). On their return journey they stop off in Bonn to see August and Elisabeth Macke. During the summer Marc travels extensively in Germany, seeking to raise moral and financial support for the *NKVM*, meeting gallery owners

and museum directors (including those of the Städel Kunstinstitut in Frankfurt and the Wallraf-Richartz-Museum in Cologne).

6
Maria Franck and Franz Marc with his dog Russi in front of their house at Sindelsdorf, 1911

A letter of June 19th to Marc from Kandinsky appears to contain the first reference to the idea of publishing an annual almanac. The name for this publication, *Der Blaue Reiter* [The Blue Rider], emerges in September in the course of a long series of meetings in which plans are discussed. Marc writes three articles for the first edition: "Geistige Güter" [Spiritual Goods], "Die Wilden Deutschlands" [Germany's *Fauves*], and "Zwei Bilder" [Two Pictures].

In October, August and Elisabeth Macke, Helmuth Macke, and Heinrich Campendonk stay with Marc and Maria at Sindelsdorf, deeply enjoying this experience of shared life and work, which (according to Marc's comments in a letter) includes the enthusiastic production of many paintings on glass; among them *Landscape with Animals and a Rainbow* (fig. 83). Reinhard Piper, who has already agreed to act as publisher for the projected almanac, advises the artists to study the history of glass painting as an aspect of folk art in the library of the *Bayerisches Nationalmuseum*.

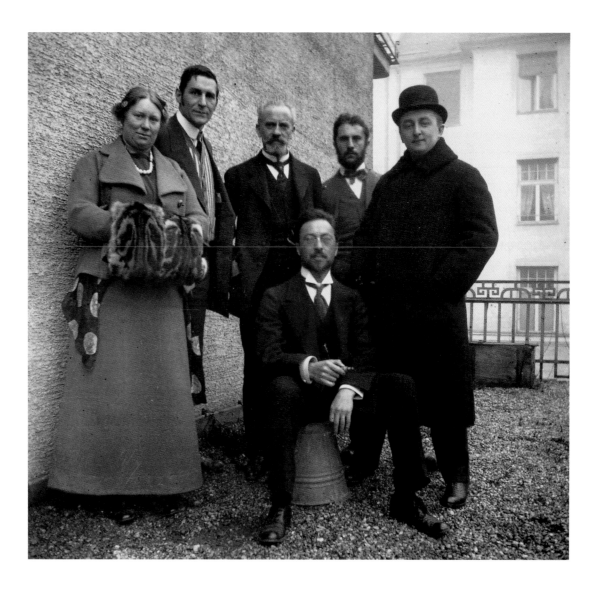

7

Maria Franck, Franz Marc, the Berlin collector Bern- hard Koehler, Sr., Wassily Kandinsky, Heinrich Cam- pendonk, and the composer Thomas von Hartmann, 1911

In October the first full editorial meeting for the almanac takes place at the small house in the village of Murnau where Kandinsky lives with Gabriele Münter. Kandinsky, Marc, and Macke debate their various ideas and resolve the basic layout of the publication. But it is Marc who assumes most of the responsibility for organizing the exhibitions that are to take place in association with the almanac. Piper, who has come to feel that Kandinsky exerts too much influence on the group, seeks to give Marc a larger part in the almanac too, in December asking him (rather than Kandinsky) to design its cover.

Meanwhile, the differences of opinion long sim- mering within the *NKVM* come to a head, and on December 2nd Marc, Kandinsky, Gabriele Münter, and the Austrian artist Alfred Kubin (1877— 1959) leave the association. The "First Exhibition organzied by the Editorial Board of *Der Blaue Reiter*" opens on December 18th, continuing until January 1st 1912, on one floor of Thannhauser's gallery, while the third exhibition of the *NKVM* is installed on another. Marc, in the former display, shows four paintings, among them *The Large Blue Horses* (fig. 78). Other artists represented include the recently deceased Henri (Le Douanier) Rousseau, Arnold Schönberg (whose talents as a

painter have been encouraged by Kandinsky), Marc's old friend Jean Bloé Niestlé, and the Parisian artist Robert Delaunay (1885—1941), whom Marc has only just discovered. Bernhard Koehler, Sr. yet again lends his support, and many of the works are in fact drawn from his collection. Subsequently, a selection of the exhibited items tours to Cologne, Bremen, Hagen, and Frankfurt am Main.

In December Karl Ernst Osthaus, Director of the Museum Folkwang, in Hagen, acquires *The Red Horses* (fig. 68) for 750 Reichsmarks, and is already planning to mount an exhibition devoted to Marc's work.

1912 Franz and Maria spend the New Year in Berlin with her parents, and on January 2nd Marc meets with some of the Expressionist artists of the *Brücke* [Bridge] group: Ernst Ludwig Kirchner (1880—1938), Otto Mueller (1874—1930), and Erich Heckel (1883—1970), whom Marc comes to admire greatly. Marc also meets again with the composer Arnold Schönberg, and further pursues his interest in the Italian Futurists (a selection of whose work is about to embark on a long pan-European exhibition tour).

Through his contact with Kandinsky, Marc is able to show a picture at the second exhibition of the progressivist artists' group *Bubnovy Valet* [Jack of Diamonds], in Moscow.

February through April the second exhibition associated with the almanac *Der Blaue Reiter* — devoted to prints and drawings — is held at the Munich bookshop of Hans Goltz. Among the 315 exhibited items are works by the Swiss-German artist Paul Klee (1879—1940), whom Marc now meets for the first time. (A firm friendship soon develops, and in June Klee and his wife, Lily, visit Franz and Maria in Sindelsdorf). In this exhibition Marc shows four drawings and his color

woodcut *Resting Horses* (fig. 89), another impression being included in the fifth exhibition of the *Neue Sezession* in Berlin.

Marc's contact with members of *Die Brücke* (whose inclusion in the second exhibition of *Der Blaue Reiter* he has upheld against Kandinsky's objections) encourages his long-established interest in the woodcut. Between 1912 and 1914 he engages eagerly with this medium, achieving some striking and very original results: *Horse and Hedgehog* (fig. 150), *Lion Hunt, after Delacroix* (fig. 151). Marc's work in 1912 is also distinguished by the brief appearance of human figures, as in *The Dream* (fig. 103), or *The Shepherds* (fig. 104). In March he completes the *Large Landscape with Horses and a Donkey* (fig. 81), later acquired by Koehler.

The poet, composer, and critic Herwarth Walden (1878—1941), since 1910 editor of the progressivist Berlin literary and art magazine *Der Sturm* [The Storm], opens a gallery of the same name on March 12th with an exhibition of the work of artists associated with the almanac *Der Blaue Reiter*. Exhibited items by Marc include *The Large Blue Horses* (fig. 79) and one of the paintings on glass that survives to this day, *Landscape with Animals and a Rainbow* (fig. 83). As the powerful Berlin art dealer Paul Cassirer (1871—1926) tends to balance his own commitment to progressive trends with support for the Berlin Secession and other elements of the art establishment, Walden's gallery swiftly emerges as the focus of avant-garde art life in Berlin.

Marc is nonetheless invited by Cassirer to contribute to the magazine *Pan*: the March issue carries his article "Die neue Malerei" [The New Painting], in which he outlines his fundamental artistic principles, and these are further elaborated in "Die konstruktiven Ideen der neuen Malerei" [The Notion of Construction in the New Painting] in the same publication. When the painter Max

Beckmann (1884—1950) responds angrily to Marc's arguments, Marc is able to reply with a third text in *Pan*, "Anti-Beckmann".

In April—May Walden presents at his Berlin gallery the exhibition of work by the four main Italian Futurists — Boccioni, Carra, Russolo, and Severini — that has recently been shown in Paris and London. German public reaction to this show is mainly negative.

In May the almanac *Der Blaue Reiter* appears, published by Reinhard Piper and with a cover design by Kandinsky.
Shortly after this a large international exhibition opens in Cologne organized by a Rhineland-based association of patrons and artists and running May 25th through September 30th. While largely devoted to a survey of progressivist trends in contemporary art across Europe, it includes important "historical" sections devoted to the work of Gauguin, Van Gogh, and Cézanne. Marc exhibits

The Small Yellow Horses (fig. 79), loaned by Bernard Koehler, Sr.

Those pictures by artists associated with *Der Blaue Reiter* that are "withheld" from the Cologne display by its selectors are provocatively presented, as such, at Walden's Berlin gallery in June—July. Among pictures by Marc included in this category is the *Large Landscape with Horses and a Donkey* (fig. 81), which Marc regards as a particularly important work. Marc comments on the Cologne show and the disputes arising from its selection in two articles published in Walden's journal *Der Sturm*.

In June the Folkwang Museum in Hagen includes Marc's *Leaping Horse* (fig. 99) and two prints each called simply *Horses* in an exhibition entitled "Modern Art".

In September the Frankfurt gallery of Ludwig Schames opens an exhibition devoted to Marc's work. This too includes *The Small Yellow Horses* (fig. 79), but also *Horses and an Eagle* (fig. 106), *The Dream* (fig. 103), and *The Shepherds* (fig. 104).

In late September Franz and Maria accompany August Macke to Paris, where they remain through early October. In addition to seeing many galleries and exhibitions, they visit the painter Henri Le Fauconnier (1881—1946), the poet and commentator on art Guillaume Apollinaire (1880—1918), the art dealer Daniel-Henry Kahnweiler, and they finally meet with Robert Delaunay on October 2nd. Delaunay is already making plans to publish a French edition of the almanac. The three Germans return to Bonn, where Marc and Macke decorate the latter's house with a mural depicting *Paradise*, then go to Cologne to assist Herwarth Walden hang an exhibition of Italian Futurist pictures (a smaller version of that presented earlier in Berlin) at the Gereonsclub. Marc is deeply impressed by this show and, as public reaction is again negative, he

8
Franz Marc, c. 1912/13

publishes an enthusiastic article, "Die Futuristen" [The Futurists], in *Der Sturm*. (In November the Futurist exhibition is shown at Thannhauser's gallery in Munich).

In mid-October Marc comes to know the work of Emil Nolde (1867—1956) when he sees a large selection included in an exhibition held at the Munich gallery of Paul Ferdinand Schmidt. Meanwhile Goltz, who has by now opened his own gallery, includes 19 works by Marc in his first exhibition of "New Art". Among this group are the lithograph *Horses in the Sun* (fig. 30), the woodcut *Blue Horses*, a drawing of foals, and a watercolor exhibited as *Schimmel* [The White Horse].

In December Marc and Delaunay embark on a lively correspondence on the theoretical aspects of art; this reveals some fundamental differences between them, but Marc retains his interest in Delaunay's work as a painter.

As usual, Franz and Maria spend Christmas and New Year with her parents in Berlin. While there, they meet the Expressionist poet Else Lasker-Schüler (1869—1945), the former wife of Herwarth Walden. The intimate friendship established between them and the long distance from Berlin to Sindelsdorf result in the dazzling series of painted postcards sent by Marc (figs. 110, 114, 115, 116, 117).

By the end of 1912 it is clear that the almanac *Der Blaue Reiter* has not proved a commercial success, but Bernhard Koehler, Sr. pays Piper the 3000 Reichsmarks he has lost on the unsold copies.

1913 In January Thannhauser exhibits works by Marc alongside animal sculptures by Fritz Behn. Marc's contribution, largely consisting of recent, markedly expressive images, is later shown in Jena, where it is provocatively presented alongside works by Rudolf Schramm-Zit-

tau and Alfons Purtscher, both of whom had trained under the Munich animal painter Heinrich von Zügel and who work in a naturalistic manner. The pictures by Marc then move on to Berlin (where they are shown at Walden's gallery), and lastly Hamburg (for exhibition at the gallery of Bock & Sohn).

In the spring Franz and Maria travel to Austria to visit her father, who is staying at a sanatorium in Meran in the South Tyrol [now Merano, Italy]. This trip provides Marc with fresh impressions of a bleak mountainous region. After returning to

9
The Blue Rider presents his Blue Horse to Your Highness, 1912
Bayerische Staatsgemälde-sammlungen, Munich

Bavaria Marc paints a series of pictures directly or indirectly inspired by this experience: these include *The Poor Country of Tyrol* (fig. 157), *Animal Destinies* (fig. 177), and *Stables* (fig. 161). In July the first of these is sold to a Dutchman for the remarkably high sum of 2600 Reichsmarks.

In Munich a plan for an illustrated Bible is agreed by Marc, Kandinsky, Klee, Heckel, Kubin, and the Austrian artist Oskar Kokoschka (1886—1980). While the advent of war will put an end to this project, Marc makes a number of woodcuts in connection with his planned illustrations for Genesis, among them *Birth of the Horse* (fig. 153). Marc also embarks on the search for a publisher who might replace the now disenchanted Reinhard Piper.

Also in March, Marc organizes an auction of donated works at the Munich gallery of Paul Ferdinand Schmidt, the proceeds of which are to benefit Else Lasker-Schüler, who is both impoverished and in ill-health.

In May Marc completes the works that soon come to be recognized as his masterpieces, *The Tower of Blue Horses* (fig. 111) and *The First Animals* (fig. 155), the former untraced since 1945, the latter destroyed in a fire.

In August, during a three-week visit to the East Prussian estate of Maria's brother, Marc and Maria are presented with a doe, which they have sent to Sindelsdorf. On their way back to Bavaria they stop in Berlin in order, with August Macke, to help Herwarth Walden organize the "Erster Deutscher Herbstsalon" [First German Fall Salon], which is to be presented, under the auspices of Walden's gallery, in a factory rented for the purpose. The show will include a total of 366 works of a progressivist character by 75 artists from 12 countries. Marc's striking contribution to the show includes *Three Horses II* (fig. 159), and the large canvases *The Tower of Blue Horses* (fig. 111),

The First Animals (fig. 155), and *Animal Destinies* (fig. 177). While of great significance culturally, this show proves to be a financial disaster; and, as on so many other occasions, Bernhard Koehler, Sr. steps in to make up the deficit.

Inspired and encouraged by the works exhibited in Berlin by Futurist artists and by what Apollinaire has recently termed the "Orphism" of Delaunay, Marc begins to adopt a more abstract style. He draws further strength for this move through his meeting with the German-American artist Lyonel Feininger (1871—1956). Nonetheless, throughout 1913 and the earlier part of 1914 Marc continues to produce small works, such as his painted postcards, that combine exquisitely intense coloring with deft and delicate collage.

In the fall Franz and Maria acquire two deer and enlarge their Sindelsdorf enclosure to accommodate them. After a long period of harmonious coexistence in this village, disagreements with their neighbors begin to undermine their happiness.

In November Marc publishes a tribute to Kandinsky in Walden's journal, prompted to do so by the increasingly negative reaction to Kandinsky's work since his Hamburg exhibition of the previous spring.

1914 In January *The Large Blue Horses* (fig. 78) and the recent semi-abstract composition *Stables* (fig. 161) are included in an exhibition of "The New Painting" at the Galerie Arnold in Dresden.

Between February and July an exhibition of artists associated with *Der Blaue Reiter* tours to three cities in Scandinavia: Helsinki in the still Russian-ruled Grand Duchy of Finland, and Trondheim and Göteborg in Sweden. Among pictures by Marc to be presented in this show are

Mare with Foal (fig. 107). Meanwhile, an exhibition of woodcuts sent by Walden's gallery to Tokyo includes works titled *Untamed Horse* and *Drinking Horse.*

At the end of April Marc is able to acquire his own house in the country in exchange for his inherited share of his parents' former home in Pasing, and he moves to Ried near Benediktbeuern, which is not far from Sindelsdorf. (In addition to the increasingly less friendly situation at the latter, the house there has become too small for Franz and Maria, and it could be dangerously cold in winter). The location of the new house — at the edge of a wood and near to a meadow — is perfect for Marc. One of the small upper rooms becomes his temporary studio, though he also sometimes works downstairs or on the veranda. (In the letters he is to send home from the Western Front Marc will repeatedly ask after the much loved animals with which he and Maria share their home: his old dog Russi, and four deer called Hanni, Schlick, Trimm and Peterchen).

Marc continues resolutely in his progress toward abstraction, producing works such as *Playing Forms* (fig. 162) and *Battling Forms* (fig. 181). He is, however, frustrated in his attempts to move in another new direction: his plans to mount an innovative production of Shakespeare's *The Tempest* at the Munich *Künstlertheater* (with music perhaps by Schönberg, Berg, or Webern) come to nothing.

In June the *Neue Kunstsalon* in Stuttgart, founded only a year earlier, shows a small Marc retrospective. This includes *Animal Destinies* (fig. 177) but, on account of the large size of this painting, it has to be kept in its crate in the yard and is only shown to those who request to see it.

A second printing of the almanac *Der Blaue Reiter* contains a new preface, written by Marc; but his plan to bring out a second edition of the publica-tion remains unrealized because of the advent of war.

Like many of his artist friends, Marc immediately enlists in the army. On August 6th he joins the First Royal Bavarian Field Artillery Regiment "Prince Luitpold" as a reserve officer. At first put in charge of training new recruits, within a month he has been posted, as a mounted messenger, to serve on the Western Front in Upper Alsace. Physically exhausted during the fierce

fighting that takes place in the Vosges in September, he contracts a severe case of dysentery.

Franz and Maria write to each other regularly, he usually once a week, she often every other day and at much greater length. The close pre-war community of artist friends rapidly disintegrates: Kandinsky returns to Russia via Sweden and the Balkans, Jawlensky, Werefkin, and Münter move to Switzerland, somewhat later Klee is himself called up to fight.

On September 26th Marc's closest friend, August Macke, is killed in action. Almost in a state of shock, Marc writes an obituary (not published

10
Franz and Maria Marc during his first home leave, July 1915

until 1920). Marc nonetheless continues to believe
in the war as a positive development and one that
will issue in cultural and social renewal: "It will
not set humanity back; it will bring about the nec-
essary purgation of Europe."

In October Marc produces a text on the "mystical"
character of the battles in which his regiment is
engaged; this is published, as "Im Fegefeuer des
Krieges" [In the Purgatory of War], on December
15th in the Berlin newspaper *Vossische Zeitung*.

1915 Around February 20th Marc completes
his *100 Aphorisms*, which he has been writing for
two month in a *gendarmerie* report book. At about
the same time he completes work on two essays,
one of which — "Das geheime Europa" [The Secret
Europe] — is published in the March—April issue
of the soldiers' journal *Das Forum*. Between March
and June he makes pencil drawings in his so-called
Sketchbook from the Front (figs. 163—166), bring-
ing this with him to Reid when he is granted his
first period of home leave in July (fig. 10). These
drawings are virtually his only work as an artist
after the outbreak of war.

After returning to his regiment, Marc is decorated
with the Iron Cross on August 10th. On October
13th he is promoted to the rank of lieutenant.
From August to October a Marc retrospective
organized by Walden is shown in Sweden (one of
the states remaining neutral in the war).
Marc is granted a second period of home leave in
November. It is to be his last.

1916 In early February the authorities in
Berlin plan to ease the situation of artists and
other especially talented individuals currently
serving in the German army through granting
them certain privileges and liberties or by with-
drawing them from the Front. Maria Marc
receives official notification of this plan with
regard to Franz Marc. But, before it can take
effect, he is killed in action, receiving a fatal head-
wound from a shell fragment on March 4th while
on reconnaissance near Braquis during the Ger-
man assault on the French fortress of Verdun.
Marc is initially buried at Gussainville near Etain,
but about a year later Maria Marc has his remains
transferred to the graveyard at Kochel am See.

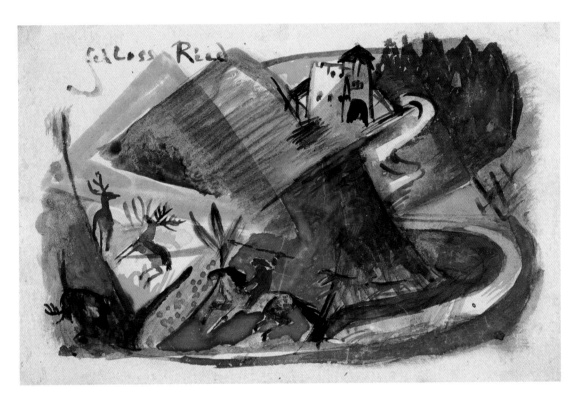

11
Schloss Ried, 1914
Staatliche Museen zu Berlin, Kupferstichkabinett

12

Franz Marc, 1912

Wassily Kandinsky:
Our Friendship, 1935

This painter, Franz Marc, was a "true Bavarian". In those days he used to live in a farmhouse at Sindelsdorf (in Upper Bavaria, between Murnau and Kochel). We soon became friends, and it was clear that his outer aspect was fully in accord with his personality: a tall man with broad shoulders, a purposeful stride, a face of great character with quite curious features indicating a rare combination of strength, acuity, and benevolence. When we were together in Munich he seemed too large, his stride too broad. He gave the impression of being cramped by the city, of feeling "uncomfortable" there. It was in the countryside that he could be himself, and it always really delighted me to see him striding across the meadows and fields and through the woods with an alpenstock in his hand and a rucksack on his back. His own naturalness was such that he felt perfectly at home in the landscape, and it seemed that the landscape took pleasure in his presence. This symbiosis was echoed in his relationship with Russi, a large white sheepdog, whose entire nature — similarly alert and mild — was a four-legged equivalent of that of his master.

13
August Macke
Franz Marc with his dog Russi, 1911
Westfälisches Landesmuseum, Münster

The relationship between Marc and Russi is only one example of Marc's organic and deep-felt relationship with the entire animal kingdom [...]

Marc often came to Munich to see "what was going on" there, and I would go to Sindelsdorf, where I would always be sure to find his latest pictures and the music played by his wife, Maria — those were wonderful hours. Even in winter Marc worked up in the attic of his farmhouse. Outside, everything was white — the fields, the hills, the woods, everything was covered in snow — frost would bite at one's nose and the stillness made one's ears sing. Up in the low-roofed attic (one was constantly banging one's head on the rafters) "The Tower of Blue Horses" sat on the easel, and Franz Marc stood there in his big fur hat and his home-made straw shoes. "Now, tell me honestly, how do you like the picture?" I always had the impression that it wasn't only from the fur that Marc drew his warmth; it was as if some inner flame were steadily burning in his soul. This flame made itself felt in his work as an artist, it could be seen in his painting and heard in his words. But his deep voice was never too loud, his movements were never over-hasty, and he never lost his calm and his inner balance, even in the most difficult circumstances. I'm certain that he stayed that way until his very last hour at the Front.

CITED IN LANKHEIT 1960, PP. 46 ff., 50

Albert Bloch:
Draft of a letter to Maria Marc, 1935

What, then, are Franz Marc's pictures? And what was the man himself? Tall, slim, but with broad shoulders, large bones and large muscles; it was only at first glance that he looked somewhat awkward, because he used to stoop a little when talking with someone; yet he moved swiftly and noiselessly, like the cats he so loved; and, when walking, he would sometimes seem to tramp along, like his dog Russi, and sometimes appear as full of grace and quiet self-confidence as only one of his tame deer could be; he had very distinct facial features, a prominent nose and chin, the hint of a smile on his lips, eyes that were dark and soft, and that could be dreamy one moment, then suddenly gaze at you so intently. That's his portrait in words; but each of his paintings is in its own way an image of his appearance.

CITED IN EXH. CAT. MUNICH 1997, P. 179

Paul Klee:
from his diary, July/August 1916

On one of the many occasions when I was on guard duty at the ammunition depot at Fröttmannig, I was thinking a bit about Marc and his art. All that circling around a few ammunition stores offered optimum conditions for becoming quite absorbed in one's thoughts. It was the height of summer: the days were full of the fabulous colors of plants and flowers, and at night and just before dawn, the sky spread out above me and before me drew my soul into its immensity.

When I say who Franz Marc was, I have at the same time to confess who I am, for a great deal of what has made me what I am is also a part of him.

He was more humane than I am, more openly affectionate, more explicit about everything. He treated animals as if they were human, imaginatively raising them to his own level. He did not begin by assuming himself to be separate from the rest of Creation; as a result, he was able to see himself as located on the same level as plants and stones. For Marc, the idea of the earth seemed more important than the idea of the world (I'm not saying that he wouldn't have changed — but then, why did he die?).

There was a Faustian aspect to him, a sense of the need to strive for redemption. He was always asking questions. Always asking if something were really true; invoking the notion of heresy. But he had none of the calm certainty that comes with faith. In the end I often used to feel afraid that he would one day change out of all recognition.

He felt dejected at the sense of living in an age of transition; he wanted people to agree with his ideas and convictions. Because he was himself still a man, an air of struggle still hung about him. He envied the ease of humanity in its most recent stage of development: the Empire of the bourgeoisie, where a moral and intellectual consensus still prevailed:

"I seek merely a place for myself in the Kingdom of Heaven, and if I enjoy a connection with God I don't delude myself that my brothers are not also related to me; yet that is their concern".

He had a curious, almost femimine, urge to tell everyone about what he saw as his own good fortune; but when he failed to convince others to see his point of view he was filled with doubts about his own direction. Often I became anxious that, after this ferment of creation and activity, he would return to earthly simplicity. Not as a more complete way of embracing the entire world, but in order to return to it more fully out of a love for humanity.

My own ardor is more that of the dead or the as yet unborn. It's not surprising that people loved him so much more, responding to the warmth of a noble sensuality. Marc retained all the potential of the species; somehow, he did not suffer from the limitations of the individual creature.

CITED IN LANKHEIT 1960, PP. 59ff.

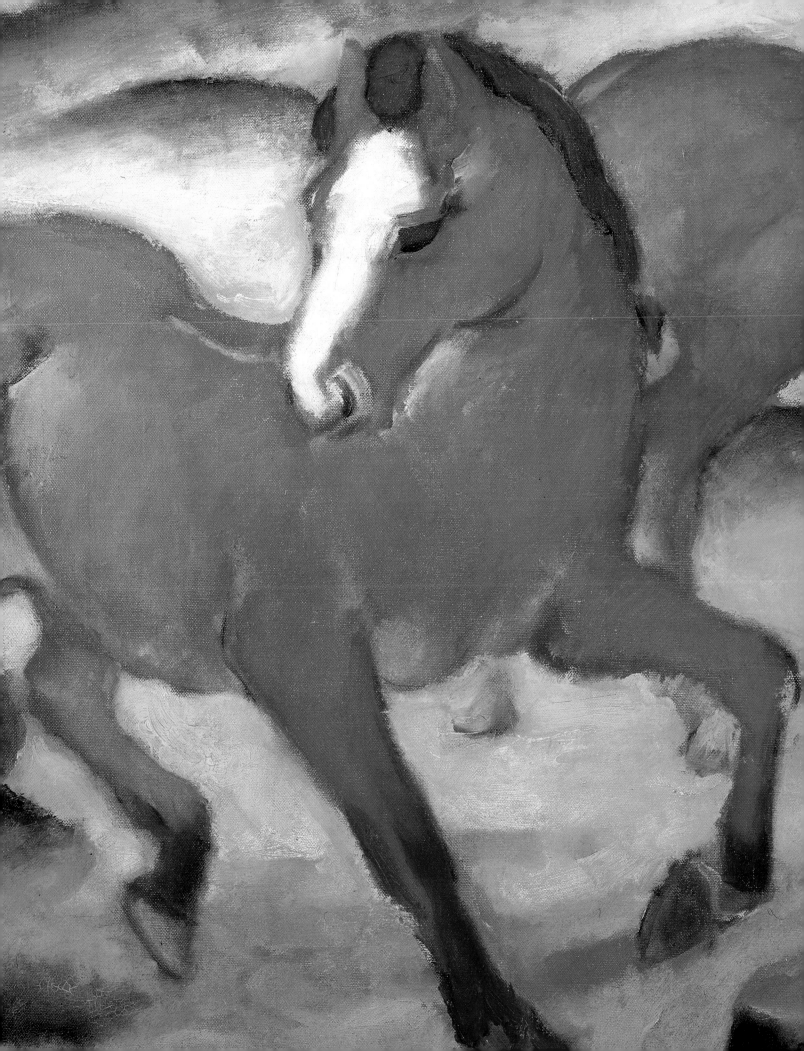

»…*the hoofbeat of* my *horses*«

CHRISTIAN VON HOLST

INTRODUCTION: A FAUSTIAN SEARCHING — "THE LONGING FOR A RELIGION"

"[...] When I've done with this really exhausting work for the exhibition [in the Galerie Thannhauser, Munich]," wrote Franz Marc on March 20th 1911, "I'll start over with painting; my head is full of ideas that aren't at all far from what Kandinsky and Burlyuk are doing, and yet they'll be *mine*, the hoofbeat of *my* horses. I can envisage the wildest and yet most obvious possibilities, things that no German artist at work today has yet thought of [...]."[1]

In these lines, written by Franz Marc at the age of 31 to Maria Franck, his companion and future wife, we find the articulation of a stance very typical of the artist: a combination of critical distance toward his own work, determination to embrace change and embark on new beginnings, and a need to demarcate his own position even within his fellow feeling for others struggling for the same goal: a new art.

Marc's awareness at this time of his own capacities may have been due to the fact that he was then at work on a picture later recognized as a masterpiece: *The Red Horses* (figs. 14, 68). He also

owed a great deal to the inspiration he derived from conversations and correspondence with Vasily Kandinsky, whom he had met at the beginning of the year. His sense of intellectual sympathy with this cosmopolitan Russian, based in Germany since 1896, strengthened him in his own convictions, but it also opened up new horizons.

Another, even closer friend was August Macke, with whom Marc had been in contact and animated correspondence since early 1910. Writing to Macke on February 14th 1911, Marc claimed: "My paintings now look very different to those of last summer; but it's not easy to describe exactly how. I'm gradually learning how to 'organize' color, to make it fully a tool of artistic expression, without any reference to chromatic 'verisimilitude'. It's evident, of course, that one can't paint in an 'arbitrary' fashion, because then one would lose precisely what one was striving for. One aims, on the contrary, at *regularity* of every sort, in terms of form as well as color."[2]

These comments introduce us to further constants in Marc's work: his unremitting efforts to achieve the right colors and forms to communicate his will to expression; his notion of regularity and

page 34
14
The Red Horses, 1911
Detail from fig. 68

the arbitrary as opposed categories; and his view of the process of creation as perpetual metamorphosis. This readiness for transformation was rooted in Marc's nature, and also in his continuous exchange of ideas with those close to him. He was always committed to an existential approach to understanding the world, to finding ways of getting closer to the meaning of life, to grasping the connections that lay behind appearances. The new art for which Marc strove constituted his means to this end.

This determined commitment to innovation, which Marc shared with other artists of his generation, may be seen as one aspect of a reaction against the materialism and positivism of the second German Empire (1871—1918), particularly as it had developed after 1890. To these characteristics Marc opposed a romantically-tinged idealism, an emphatically spiritual striving, and an enthusiasm for intellectual exploration. Along with Kandinsky and several other comrades-in-arms, Marc saw himself as a messenger on the threshold of a new era, as one who would prepare a path for the new art.

On September 8th 1911 Marc wrote to Macke from "Symbolsdingen" (his nickname for the Bavarian village of Sindelsdorf) of the plans for an almanac to be called *Der Blaue Reiter* [The Blue Rider]. He continued: "I'm striving with all my might to become more spiritual [in my art], to give every color and every form that appears in my pictures an inner necessity, albeit not one that can be *demonstrated*. The impact of true art can never be demonstrated or explained."[3] Yet again, we can detect Marc's unanimity with Kandinsky, with the "principle of inner necessity" that pervades the argument of Kandinsky's path-breaking volume of 1911, *Über das Geistige in der Kunst* [On the Spiritual in Art].

Marc was also at one with Kandinsky with regard to the notion of a religious dimension in art. On July 31st 1912 Marc wrote to his Russian friend: "In mid-August I'll send about ten new things to [Ludwig] Schames [an art dealer in Frankfurt am Main] for my one-man show in September. It would

be a pity if you weren't able to see them any longer; each of them (they're all very different) is an attempt at something or other; I'm pretty sure that most of them aren't bad; though God knows what people will think of me when they see them! It bothers me that none of them is really clear enough to achieve an unambiguous expression of my longing, the longing for a religion that doesn't yet exist; but then one can't hide one's work away simply because one has appeared on this planet 50 or 100 years to soon."[4]

In his contribution to the almanac *Der Blaue Reiter* (published in May 1912) Marc had already devised a celebrated and frequently cited formula to describe his own aims and those of his artist friends: they wished, he wrote, "through their work, to create *symbols* for their age that will in future take their place on the altars of a new spiritual religion, [symbols] in which there will remain no trace of the artist as maker."[5]

Marc's deep capacity for belief, the mystical character of his response to all living creatures, and his earnest commitment to the responsibility of being an artist combined to issue in a concept of the new art that saw in it the capacity to bring enlightenment and a form of salvation. In this respect Marc could be said to link the ideas of early German Romanticism (with which he himself felt a deep connection) and the achievement of a later 20th-century artist such as Joseph Beuys.

* * *

In Spring 1913 August Macke visited his wife's uncle, the art collector Bernhard Koehler, Sr., in Berlin. Looking at Koehler's collection, he noted there several of the most recent works by Marc. On May 22nd Marc responded to Macke's comments on these: "I'm really pleased that some of my things at Koehler's made a good impression on you; when I think now about the picture of the cow I'm not too sure about it; it's a bit too willfull, *trop voulu* [...]." And as if to illustrate the fact that his struggle for the right answer admitted no homogeneity,

Marc continued: "I've been painting pictures of all sorts. As for their titles, they won't tell you anything but they'll perhaps make you smile: The Tower of Blue Horses [fig. 111]; The First Animals [fig. 155]; The Poor Country of Tyrol [fig. 157]; The Trees Showed their Rings, the Beasts their Veins [now known as *Animal Destinies*, fig. 177]"[6]

Nothing, however, that Marc states here nor in his later comments suggests that he had perceived that, with some of these paintings, he had already created the "altarpieces" to which he had referred in his text in the almanac *Der Blaue Reiter*, images that we would now classify among the icons of early Modernism.

A year later Europe was about to be engulfed by the First World War. Macke was to have only a few months to live, Marc less than two years. Both had been Francophiles; both were to die in action in France. Marc's understanding of himself as a German is conveyed in comments he made to his friend Paul Klee (who felt much the same) on June 12th 1914, only weeks before the outbreak of war: "I'm a German and I cannot but plow my own furrow; why should the painting of the Orphists concern me? We can try to paint like the French do, to produce real novels of color and form, but we can't really do it. We Germans are and will remain natural graphic artists, illustrators — even in our work as painters [...] You know how I love the French — but that doesn't mean I can turn myself into a Frenchman. In my work I investigate myself, always only myself, and I try to convey what it is that lives in me, the rhythm of the blood pulsing in my veins." And there follows a statement that cannot but astonish us with regard to Marc's oeuvre: "I'm still convinced that I won't paint my best pictures until I'm 40 or 50; I'm not yet ready in myself for this."[7]

On August 6th 1915 Marc, then only 35, wrote from the French Front to his wife Maria: "The self-tormenting process of creation allowed me to make so many detours that were perhaps not necessary and that in fact presented more obstacles for my work than they provided support and clarification.

Now I have to change the direction of my learning, i.e. to switch from pure learning to pure *feeling*, and to trust more and more in pure feeling."[8]

Repeatedly we encounter Marc in the guise of the seeker, a "Faustian" figure (Klee's term, see p. 33), as someone who is not entirely satisfied with himself, someone so uncompromising in questions of art that he may on occasion be found cutting up his own work (figs. 32, 34, 36, 58). Bearing in mind this aspect of Marc's character allows us to adopt a new approach both to the variety and the richness of his tragically short career and to the coexistence of different sorts of work. It is on this account that, even with a particular focus on Marc's treatment of horses, the comments that follow are both chronologically and thematically wide-ranging and embrace diverse categories of work.

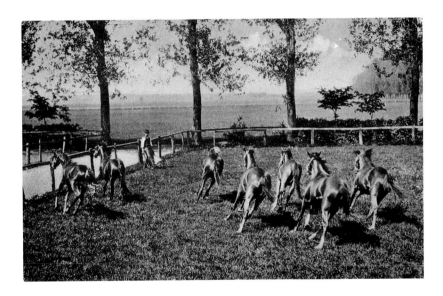

MARC'S CLOSENESS TO ANIMALS

15
Horses in a paddock
Postcard sent by Marc to Kandinsky on August 16th 1912

Already as a child Marc felt a particular closeness to animals. In adult life his white dog Russi was his permanent companion, almost a sort of spiritual partner (see Kandinsky's comments, p. 31), and later he treated his deer almost as if they were his own offspring. Without doubt, however, horses were the animals to which he always felt closest. It was during his year of military service in 1899—1900, when he learnt to ride, that he first really

came to know horses well. Later, working at the villages of Kochel, Lenggries, or Sindelsdorf, he observed horses in the paddock and would sometimes set up his easel on their pasture. For Marc horses were part of everyday life in the country.

From 1910/11 animals became the principal focus of Marc's interest as an artist; and it was above all in relation to the motif of the horse that he evolved his notion of a new art. Why is it that Marc was so drawn to horses? Could he not just as easily have devoted most of his attention to other animals that deeply appealed to him? He did indeed produce superb images of deer, dogs, cats, or cows, as also of exotic animals such as tigers, apes, elephants, and so on. So, why this particular feeling for horses?

This remains a mystery, and Marc himself never commented on the matter. Was it essentially the esthetic appeal of the horse: the calm nobility of its movements, its beauty and strength? Or its combination of power and timidity, its curiosity, the alertness of its gaze, its deep, large eyes? Was it the relationship between its varieties of pose and movement: from the placidity of reclining, grazing and walking to the springy rhythm of the trot, or the thrill of the gallop? While we cannot provide a direct answer to this question on Marc's behalf, Marc's own observation of horses itself provides a

form of response; and this response is most clearly and eloquently preserved in his images.

Marc sought with such determination to achieve a genuine empathy with animals, and above all with horses, that one of his paintings of a horse (fig. 72) has even been interpreted as a self-portrait.[9] And in 1913 the poet Else Lasker-Schüler, who was particularly close to Marc, wrote to him: "Just think, you are yourself a horse, a noble brown horse with long nostrils, nodding your head proudly and imperturbably."[10]

The closeness to animals and to nature recalled in Kandinsky's eloquent reminiscence of his friend (see p. 31) is even more clearly articulated in Klee's words (see p. 33): "He [treated] animals as if they were human, imaginatively raising them to his own level." On this account we cannot conceive of Marc as an "animal painter" in the conventional sense of this term. This becomes especially evident in Marc's celebrated statement of 1911/12: "For artists, is there a more mysterious notion than that of how the landscape appears through the eyes of an animal? How does a horse, or an eagle, or a deer, or a dog see the world? How miserably soulless is our convention of placing animals in the landscape as we perceive it, rather than seeking to penetrate the soul of the animal so as to glean something of its own world of images."[11]

While we are in fact able to provide a scientific answer to the question as to how a horse sees (cf. pp. 259 ff.), we have no means of comprehending the psychology of its visual perception. Marc's attempts to establish some notion of the horse's "world of images" have hardly resulted in scientific insights, but they have led to an enriching of art, to the creation of images that have been recognized as milestones on the path of Modernism, to a significant alteration of our, human image of the world.

Marc's new approach finds a reflection in the humorous lines written by Kandinsky in August 1911. In Sindelsdorf he had taken some photographs of Marc and he then, as a joke, proposed to

16
Horses at pasture
Postcard sent by Marc to Kandinsky on November 10th 1912

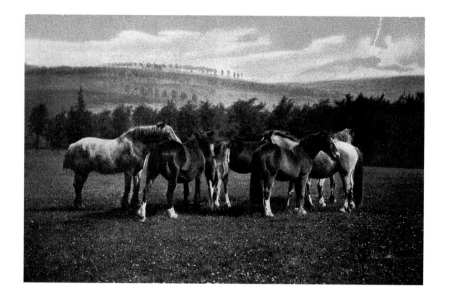

publish these accompanied by the following text: "With the Bavarian and Munich painter Franz Marc we enter a new era in animal painting. The still relatively young artist does not in general see animals as such; rather, he places his cows in the landscape, and merges his deer with the forest to produce a new view of the world that is entirely his own [...]."[12]

In Kandinsky's words there is in fact a kernel of truth. Marc's new "view of the world" is expressed even more clearly in a line in a letter from the Front written to Maria Marc on April 8th 1915: "I never have the desire e.g. to paint animals 'as *I* see them'; I paint them, rather, as they themselves *are* (as they themselves see the world and are aware of their own being)."[13]

Marc's first name was Franz [Francis] and, already as a child, he had sometimes teasingly been called Francis of Assisi on account of his earnest character. If one bears his work in mind, one finds that this analogy is by no means far-fetched. For there is indeed a Franciscan dimension and a related sense of humility to be detected in Marc's tendency toward religious feeling; in his spiritual relation to nature, to fellow creatures, and to the cosmos; in his urge to see deep connections and to discern "in an image of the world the *mystical and spiritual structure* that is the great theme of today's generation [of artists]."[14] It was as if Marc, too, spoke to the animals.

ART AS MISSION, ART AS RIDDLE

Marc's elevated notion of art evolved out of fundamental convictions that were idealistic and indebted to Romanticism, but that often also had an aspect that was monkish and ascetic. He saw the impact of art on the human spirit as equal in status and significance to that of the world's great religions. On June 21st 1915 he wrote to Maria Marc from the Front: "The most serene peace was always only a latent state of war; but the individual can

free himself and then help others to do so — that is the meaning, at the personal level, of Christianity and Buddhism and of all art."[15] Already eight years earlier, at a time of deep personal crisis, he had written to her of his sense of leading an "oppressively idiotic life", adding: "only pure and painterly beauty can save me, a beautiful face, a beautiful animal, a spirited line, a particular juxtaposition of colors."[16]

In 1907, when Marc had little more than a vague notion of his future goals as an artist, art appeared to him to be a sort of spiritual remedy. Later, however, it assumed the character of something mysterious. On February 22nd 1916, only two weeks before his death, he wrote to Maria: "The thing that earlier always used to deter me from surrounding myself with my own works was a deeply felt sense of shame at what I had produced; it's difficult for me to explain this feeling — it goes back to the very moment of creation, when the mysterious compulsion of inspiration takes the place of individual will. In the case of so much of my work, and in particular my best things, I no longer know anything at all about *how* I managed to create them; it astonishes me that I made them and they rather disturb me. Even when looking through my sketchbooks, it sometimes really gives me the creeps."[17]

In Kandinsky's *Über das Geistige in der Kunst* there is an even clearer and more confessional acknowledgement of this element of the alien, of the not entirely explicable in the origin and the effect of a work of art. "The true work of art arises 'out of the artist' in a mysterious and mystical manner. Set free from him, it takes on a life of its own, becomes a personality, an autonomous, spiritually breathing subject, which also leads a life in material reality, and which is also a *living creature*. It is not an entity that originates indifferently and arbitrarily, and that then equally indifferently lingers in the life of the mind; rather, like every living creature, it is active and capable of stimulating further creation. It lives, and exerts an influence [...]."[18]

* * *

Having touched, by way of setting the scene, on these essential aspects of the work and thought of Franz Marc, let us turn to his central theme, the hoofbeat of *his* horses.

MUNICH AND THE "BLUE COUNTRY"

Franz Marc belonged just as much to Munich as he did to the beautiful Bavarian Alpine foothills around

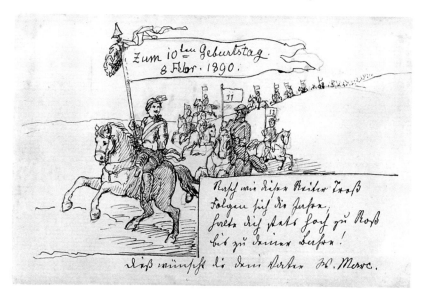

17
Wilhelm Marc
Drawing for Franz Marc's
10th birthday
Germanisches National-
museum, Nuremberg

Kochel am See, the region he sometimes imaginatively transformed into the "Blue Country".[19] Born in Munich, he grew up there in a cultivated, bilingual household: his father was a painter, his mother came from Alsace. But from visits made to Kochel am See during his childhood he also felt at home there (fig. 17).[20] Marc did extremely well at high school and, it is clear, was also imbued with the deep religious feeling of both of his parents (his mother was a Calvinist). At first he wanted to be a priest, then (following the example of his elder brother, Paul), a philologist. After military service, however, he opted to train as an artist. At the Academy of Art in Munich he absorbed a fundamental knowledge of anatomy in the drawing class taught by Gabriel Hackl. This was later to serve him well

when he, too, gave drawing lessons (figs. 5, 27). He also trained under Wilhelm von Diez, himself an outstanding draftsman whose repertoire included the study of animals.

During his years at the Academy, from 1900 to 1903, as indeed also later in his life, Marc gained a reputation as a rather self-contained personality, something of a loner, who seemed always to be pondering his own thoughts on great subjects. Yet the tall, dark-haired young man was by no means unworldly; he was, moreover, a keen sportsman, frequently playing tennis or ice-skating and riding; and he had made his first long hiking and climbing expedition in the Tyrolean Alps at the age of 15. In the summer months he was often to be found for weeks at a time on the slopes of the mountain pasture above the village of Kochel.

In this small bathing and health resort on the shore of Lake Kochel, and even more so in its inviting environs, Marc was to find the place that suited him best. The moorland bordering the lake offered an uninterrupted view of imposing mountain ranges. Regularly flooded by the River Loisach, the moor guaranteed an atmospheric setting in every season. On its northern edge was the village of Sindelsdorf, where Marc first came to live in 1909, and where he definitively settled in 1910. A few kilometers away was Ried, where he owned a house from 1914. Also nearby was Murnau, where from the summer of 1909 Kandinsky lived with his companion, the painter Gabriele Münter, in their "Russian House". And half way between Sindelsdorf and Murnau was the provincial and regional stud-farm of Schwaiganger, associated for centuries with thoroughbred horses. Over the years all this made these beautiful Alpine foothills into a sort of Bavarian Pont-Aven for Marc and his friends. But Munich was near enough (around 50 kilometers to the north of Kochel) to allow the artists to keep up with the latest developments in its art life and, when they so wished, to participate in these.

While Marc was at the Munich Academy he made small landscape sketches in and around Kochel, but there appear at first to have been no

studies of horses. This period was important, however, for Marc's growing familiarity with the countryside and the animals to be found there.

* * *

A few years later Marc encapsulated his feelings for nature and the cosmos, and in a manner still marked by the stylization of Munich *Jugendstil*, in an illustration intended to accompany Gustav Renner's poem on a shooting star, "Dort fiel ein Stern" (Lankheit 1970: 319; fig. 18). While this image is the achievement of an immature artist who is still feeling his way, the relationship to the world that Marc later articulated is here already present in embryo, as is often the case with the early work of extremely gifted individuals. Man and animal occupy a single threshold, united in their rapt response to a cosmic event. In compositional terms, they are both "enclosed" within the rounded top of a mountain, a decorative device often to be found in Marc's later work, for example in the case of *The Small Yellow Horses* (fig. 79). Man, as the "crown of Creation", does not appear here as a dominant individual. He lowers his gaze before the heavenly phenomenon and pays homage to it as a revelation of a higher order of things. The "king of the animals", mean-

while, inclines its head as if in silent prayer. The lion, too, is thus shown to be a creature capable of understanding and possessed of a soul, part of a Creation in which, for Marc, there is no difference in rank between man and beast. Here, then, Marc has already raised an animal to the status of a human being (the characteristic of his work that Klee was later to observe). This is not the attitude that would be adopted by a conventional animal painter. Here, the animal appears fully incorporated within the artist's religiously determined relation to the world: it is capable both of belief and of humility.

THE FIRST STUDIES OF HORSES

In 1904 Marc broke off his studies at the Munich Academy. He had embarked on a passionate affair with a fellow artist, Annette von Eckhardt, who was not only rather older, but was also married. (In 1917, a year after Marc's death, she was to publish the volume *Stella Peregrina*, reproducing his drawing of 1906, fig. 18). This relationship soon turned sour and, at the same time, Marc was feeling oppressed both by the strain of worrying about his now partially paralyzed, and rapidly weakening, father and by his sense of uncertainty regarding his own goals. For a while he was plunged into melancholy.

It is at this period that animal studies first appear among Marc's drawings and sketches. This development was no doubt encouraged in 1905 through meeting and befriending a kindred spirit, the young animal painter Jean Bloé Niestlé, who came from French-speaking Switzerland and who was later to move to Sindelsdorf.

In the winter of 1905—06 Marc met two women artists from northern Germany: Marie Schnür and Maria Franck (respectively, nine and two years older than Marc). The trio soon became great friends and in 1906 they went together to Kochel. Here, Marc painted the other two as *Women on a Mountain* (Lankheit 1970: 46), but he

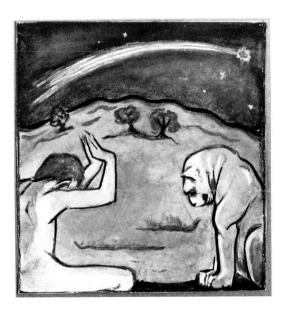

18
Illustration to the poem
"Dort fiel ein Stern", 1906
Pen and ink (colored by
Annette von Eckhardt),
published in the volume
Stella Peregrina, 1917
Germanisches National-
museum, Nuremberg

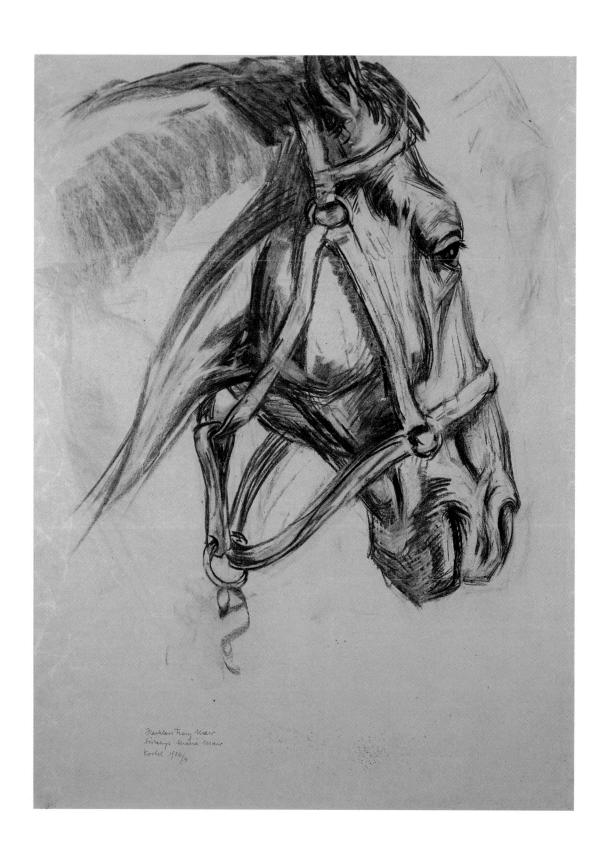

Stablen Franz Marc
bisdyso Maria Marc
Krötel 1906/11

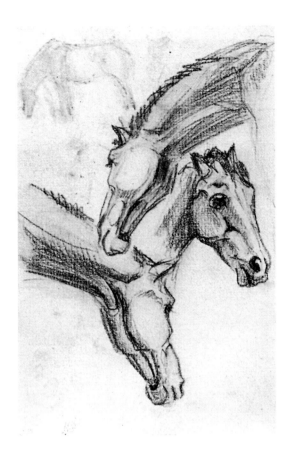

also found himself in an emotional tangle that prompted him, even years later, to speak of his memory of this situation as a sort of "hill of tears". Marc's emotional state was to be reflected in the fate of this painting. Marc was to cut it up, letting Marie Schnür have "her" half, but keeping the other (showing Maria Franck) for himself.

In all probability it was so that Marie Schnür would be able to retain custody of the child she had had with another Munich painter (something the law at that time forbade to single mothers) that Marc married her in March 1907. He left Munich on the day of their wedding and fled, alone, to Paris, in order to draw strength from the work of Van Gogh and Gauguin. But he also found sustenance in his correspondence with Maria Franck. She became his constant companion and later his wife. It would be difficult to overestimate the role of this wise, selfless, and many-sided partner in discussion as a support in Marc's human and artistic development. Above all, she helped Marc, at first so irresolute in his nature, to attain both stability and a sense of certitude.

It was around 1905/06 that Marc began to engage more intensively with the horse as his subject. We shall first consider a number of studies of horses' heads. The life-size head of a tired workhorse (fig. 19) is rendered in energetic charcoal strokes partially

19
Horse's Head, 1906
Franz Marc Museum, Kochel am See
CAT. 1

20
Three Studies of a Horse's Head, 1906
Estate of Franz Marc, on loan to Franz Marc Museum, Kochel am See
CAT. 2

21
Head of a Dead Horse, 1907/08
Private collection, on loan to Franz Marc Museum, Kochel am See
CAT. 3

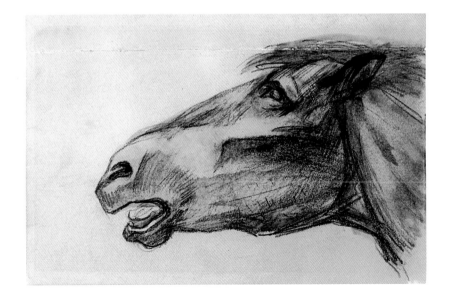

erased, corrected, and rubbed: it is in every respect an "inventorizing" study from nature and not a particularly inspired one. The earnest approach to every detail of this "portrait" is a testament to Marc's intense engagement with the individual creature, and to his capacity for calm observation. In three studies of a young horse we encounter for the first time Marc's use of his sketchbooks (fig. 20). There were once over 30 of these, many of them now split up, an enormous store of detail studies to which

claimed that Marc attempted to learn nature "by heart". At the blacksmith's in Kochel, for example, or while walking in the enclosed pasture, he would repeatedly fix his gaze on the individual body parts of the animals, such as their hooves or their joints, and then attempt to draw these from memory when he got home.[21] Such a process is, indeed, suggested by this sheet. The various individual horses, drawn in pencil, are shown calmly grazing, sluggishly standing, or pulling a load, or (in the case of the

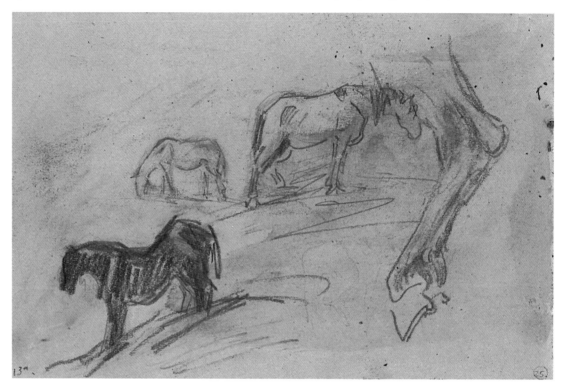

22
Horses, c. 1905
Stangl Collection, on loan to Franz Marc Museum, Kochel am See
CAT. 4

Marc was to refer in devising his later compositions with horses. While Marc was evidently interested in the various sorts of exploratory curiosity expressed by horses, he invested the *Head of a Dead Horse* (fig. 21) with almost the same sort of dignity as he was a little later to bestow on the record of his *Father on his Deathbed*.

A sheet of studies probably somewhat earlier in date (fig. 22) is quite different in character. In the Marc monograph published by Alois Schardt in 1936 (a time when Marc's widow was still able to provide scholars with very precise information) it is

darker figure) posed as if breaking the momentum of descent; in addition there is a bent back leg with a very assured rendering of the section from heel to hoof. In spite of its economy of means, this sheet of drawings evinces both clarity in observation and confidence in recording the observed.

After a study trip to Mount Athos in Greece in April 1906, undertaken with his brother Paul, Marc threw himself into work at Kochel in order — as he wrote to Paul on June 17th — "to stifle all my passionate instincts for life."[22] An example of the work of this phase is the fine drawing in red chalk, *Horses on a Hilltop* (fig. 23). At the Schwaiganger stud-farm

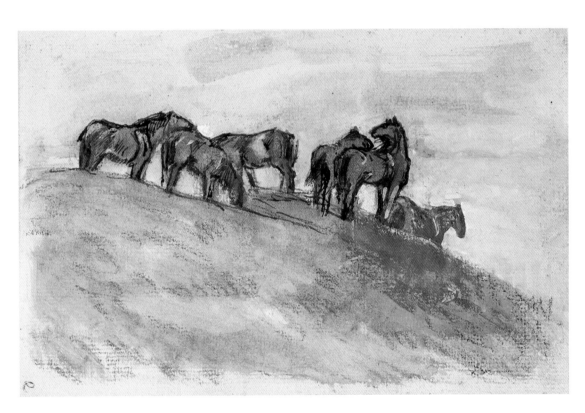

23
Horses on a Hilltop, 1906
Private collection, on loan to Franz Marc Museum, Kochel am See
CAT. 5

it is still possible to observe horses that love to stand in the fresh air on the tops of hills. In Marc's drawing they appear to fall into two groups. And while this study from life reveals no deliberate compositional compression of the animal bodies, it is already evident that it was from such beginnings that the compositional concepts found in Marc's later pictures were to evolve. To the left we find horses engaged in calm gazing and grazing; to the right examples of standing, the exploratory backward turn of the head, and the focusing of attention on descent. Though distinguished in this way, these animals nonetheless merge, as a group, to form a crown on the grassy peak of the hill.

Also on June 17th 1906 Marc reported to Marie Schnür: "The pasture is really wonderful, there are dark horses against the glow of the evening sky facing into the breeze;" but he continued in another tone: "I often feel so alienated and disturbed, so far away, so far from everything in the present time, that I hardly even notice the passions that resound among the friends at my side. I'd really love to escape, to get right away from this present time."

During this turbulent phase of his early career, full of a sort of apocalyptic melancholy and much confusion concerning his future, Marc speaks of the small instances of progress that he makes each day; but he also says: "I often feel desperate, it goes without saying, just as one would if a longing for love were never fulfilled; or, in painting, if one were not oneself painting [...] Nowadays I can't even bear to live as a painter without myself being engaged in this activity, sooner or later! It has to liberate me — and if you ask, astonished, from what it is that I want to be freed, then I'll tell you: from my *sense of dread*; so often I feel a dizzying dread at being in this world; it seems to be a sort of panic terror that suddenly comes over one, the sense that one has to create gods to which one can pray."[23]

Dating from around the same time as *Horses on a Hilltop*, itself a pure study from life, is an idea for a composition found in a sketchbook of 1906 (fig. 24). This small, unpublished drawing treats a theme from classical mythology.[24] So enchanting are the song and music performed by Orpheus with his lyre that even the animals, both tame and wild, flock to him in harmony (see also fig. 191). In this mystic parallel to the story of Saint Francis of Assisi's preaching to the animals, three viewed from behind horses assume a prominent position. Marc was frequently to resort to this presentation in later work.

Alongside works on paper, Marc also produced individual studies in oil, which were similarly sketchy in character and small in scale. The *Small Study of a Horse I* (fig. 25) dates from 1905. While here we find the brown workhorse shown in bright daylight against the wall of a farm building, in the *Sketch of Horses II* from 1906 (fig. 26) the bodies of

24
Orpheus with the Animals, 1906
Germanisches Nationalmuseum, Nuremberg

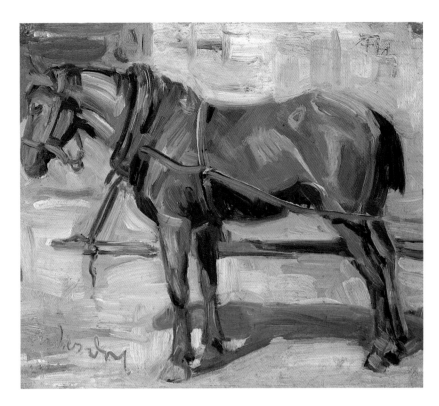

25
Small Study of a Horse I, 1905
Franz Marc Museum, Kochel am See
CAT. 6

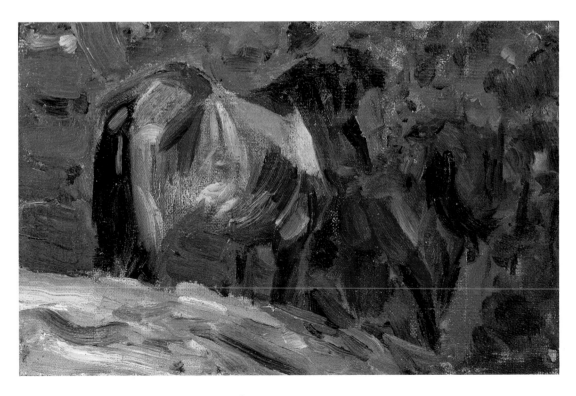

26
Sketch of Horses II, 1906
Franz Marc Museum, Kochel am See
CAT. 7

the animals are almost absorbed into the green of the foliage of the forest trees. As in the *Sketch of Horses III* (Lankheit 1970: 43), now in the collection of the Solomon R. Guggenheim Museum, New York, the beasts and their setting constitute a true unity. The animals are not isolated and monumental figures under an open sky, as was to be the case in later images; rather, posed at the edge of a shady forest, they are almost difficult to identify as horses. Marc was clearly interested at this time in movement and light effects, and in sketchily capturing the image of animals seen from a distance, whose calm being he was already able to render with sensitivity in this summary style.

"[...] THE INNER TRUTH OF THINGS" — STUDIES OF ANATOMY

Increasingly, Marc was concerned to get to the heart of things, and in philosophical as well as psychic terms. His second trip to Paris, in the spring of 1907, proved enlightening in many respects. Marc's earlier enthusiasm for the work of the Impressionists faded as he recognized in himself the need to dig deeper. On May 10th he wrote to Maria Franck: "Life is a parody, a diabolical paraphrase, behind which there stands the truth, our dream. I'm quite convinced that this is how things are. Art, you see,

27
Anatomical Studies of Horses, 1907/08
Destroyed

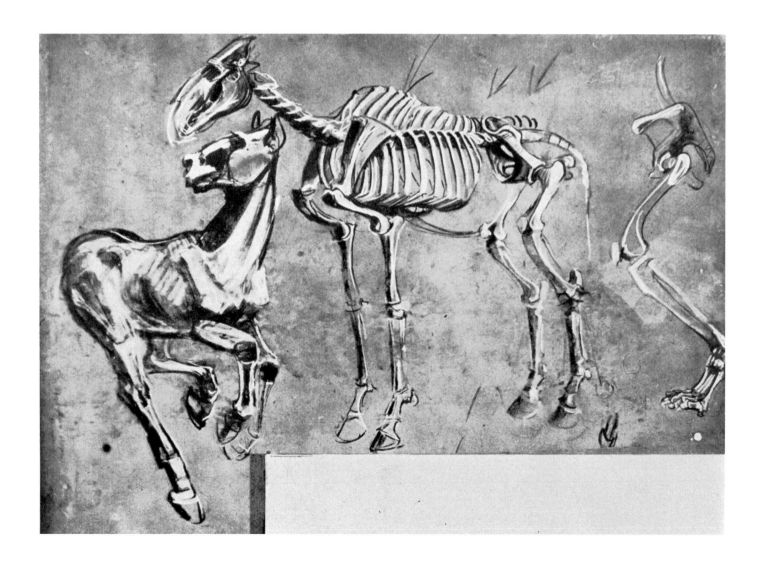

is nothing but the expression of our dream. And the more we give ourselves over to it, the nearer we get to the inner truth of things and to our dream-life, the true life [...]."[25]

Marc now recognized both the life and the art of Paul Gauguin and above all of Vincent van Gogh as exemplary. On July 27th 1907 Marc wrote to Maria that he saw in Van Gogh, the "truest, most touching painter that I know. Choosing the simplest possible elements in nature to paint and imbuing them, as he painted, with all his faith and all his desires, this is the most worthy thing one can imagine [...]". And on August 6th he reports: "[...] What I'm painting now is already the simplest I can manage; in fact I don't look at anything else in nature. Nowadays, I hear a voice within me that perpetually says: back to nature, to the simplest things, for it is only there that one can find the symbols, the deep feeling, and the mystery that are in nature."[26] The 27-year-old Marc was here unknowingly listing the characteristics of his own future work.

To begin with, however, Marc observed nature in the variety of exotic forms to be found at the Berlin Zoo, so laying up a store of motifs to which he would later refer. At the same time he was concerned with a precise knowledge of skeletal structure, musculature, and the entire system of animal bodies, not least in connection with the anatomy lessons that, for financial reasons, he was forced to give from 1907.

Schardt, in his Marc monograph of 1936, wrote of the artist's high regard for the study of anatomy, presumably basing his comments on information provided by Marc's widow or his pupils. "Anyone who had grasped the interrelationship between bones, tendons, and ligaments and how this functioned, was in a position, as he [Marc] said, to invent what were, in effect, new creatures that would nonetheless seem to be natural because they were based on the general principles of nature. In his classes he drew various demonstration studies on

large sheets of brown wrapping paper, later tearing these up."[27]

A few photographs of these almost life-size anatomical drawings have survived. In one, almost baroque in character, a dramatic study of a bull attacked by a panther, Marc is seen seated between an unknown female student and Maria Franck (fig.

5). The *Anatomical Studies of Horses* illustrated here (fig. 27) shows a standing skeleton with three inverted arrows pointing toward it and a line indicating the belly, features presumably relating to the explanation and commentary that Marc would

28
Horse Rolling on the Ground, 1907/08
Germanisches National-museum, Nuremberg

have provided. The horse shown galloping demonstrates above all the importance of the back legs for forward movement. The sharp sideways turn of its head and the corresponding position of the pricked ears — both in contradiction of the implied direction of movement — achieve a curious merging of active and static.

The young Munich publisher Reinhard Piper, who was a close friend of Marc from 1910, was so taken with Marc's studies of anatomy that he wanted to make a book of them.[28] This project was, however, forced to give way to others of more importance. Meanwhile, Marc's ability to capture extremely complex movement in his studies of horses, is evident not only in the afore-mentioned galloping horse of the sheet of anatomical studies (fig. 27), but also in the *Horse Rolling on the Ground* (fig. 28). In this small, unpublished sketch he captures the furious to and fro of the limbs in a flurry of thick and nervous lines. One can truly sense the animal's pleasure as it sticks its head into the air.[29]

29
Three Horses, 1908
Staatliche Graphische
Sammlung, Munich
CAT. 8

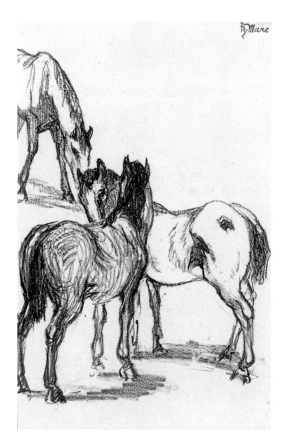

page 51
30
Horses in the Sun, 1908
Staatliche Graphische
Sammlung, Munich
CAT. 9

1908—1909: HORSES IN PAIRS AND IN GROUPS, THE FIRST LARGE PAINTINGS

In considering the work of 1908—09 we shall begin with two prints that Marc produced as a means of earning money. The artist's proof for a postcard shows the trusting way in which two horses turn toward each other while a third animal grazes in the background (fig. 29) — an unpretentious but well-observed scene. *Horses in the Sun* (fig. 30), a color lithograph, a larger work and a more elaborate composition, is also known as *Horses in the Forest* and, erroneously, as *Horses at a Watering-place*. Here Marc shows us two contrasting types of animal behaviour. In the foreground an animal licking its coat in a sturdy but ungainly pose with straddled legs: the circling form of the rump and the hindquarters is taken up in the vigorous swooping movement of the neck, mane, and tail. As an antithesis to this dynamism and self-absorption, Marc shows the calm and alert standing and gazing of the second horse. The animal's attention is directed into the forest. The suggested density of the trees is interrupted in the area around the horse's head in a manner suggestive less of a forest clearing than of a halo. There is something solemn and majestic about this scene. Through an air of earnestness and the relative simplicity of technique and style, the image of an animal is here elevated into a generally valid statement about nature and creature. Moreover, in the standing horse seen from the back Marc had in fact found a formula to which he would frequently return.

This first truly significant rendering of horses was to have important consequences. Exhibited in 1910 by the Munich art dealer Brakl, it led not only to Marc's first meeting with Reinhard Piper, but also to the beginning of his friendship with August Macke.

Marc spent the summer of 1908 in Lenggries, living there with Maria Franck at the Pacher house on Gebhartgasse on the southern side of the village.

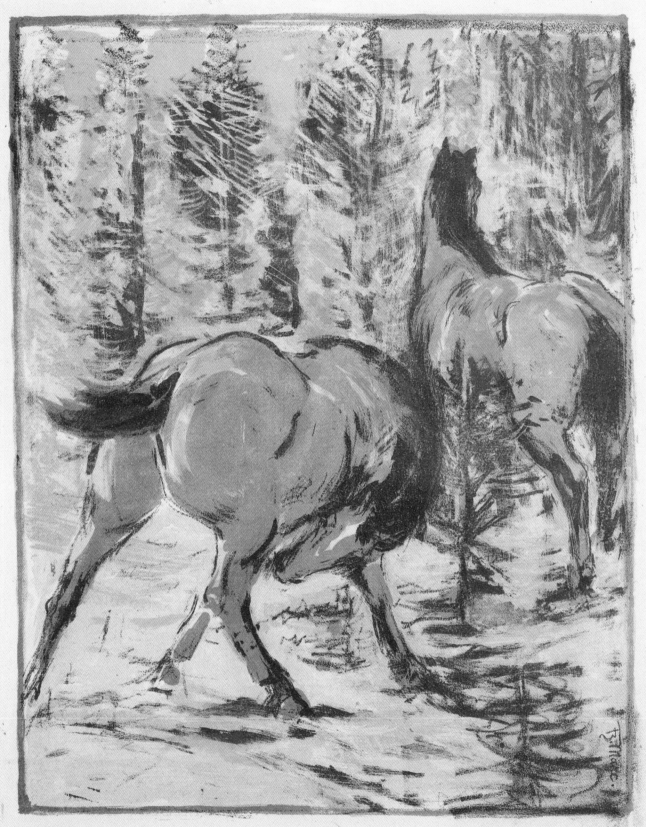

fz Marc.

31
Two Standing Horses with a Bush, 1908
**Germanisches Nationalmuseum,
Nuremberg**

32
Horse in Front of a Large Bush, 1908
Staatsgalerie, Stuttgart
CAT. 10

From here a short path led up to the Eham farm, which lay in the midst of large meadows extending as far as the wooded ridge of hills. It was here that Marc painted his first pictures with almost life-size horses. But Marc was eventually not pleased with these and he cut up the canvases.

In sketchbook IX we find a drawing with two horses in front of a bush (fig. 31). The somewhat arbitrary arrangement is not altogether successful. Yet Marc has indicated the intended extent of the composition through adding two vertical lines. According to these, the horse on the right, turning its head, was to be included in its entirety, while only half of that on the left was intended to appear.[30] The large fragment of canvas in the Stuttgart collection, reconstructed out of two smaller pieces and never publically displayed until now on account of its passages of flaking paint (fig. 32), offers a naturalistic representation of a horse, the glossiness of its brown coat evident in the pink highlights. A great deal of white is worked into the rendering of the meadow and the foliage, and even into the treatment of the shadow cast by the horse's body. Directly above the animal's back there is a flame-like green bush.

While it is true that the appearance of the horse has largely been captured here, it would nonetheless be fair to say that its essence has escaped Marc. It was no doubt for this reason that he destroyed this picture; and only posthumous piety has ensured the preservation of what survived. We should, of course, bear in mind the artist's own decision when we consider and interpret such a fragment; but, from the point of view of iconography, it may nonetheless be understood as an interesting measure of Marc's artistic progress.

In a *Group of Horses* in sketchbook X (fig. 33), we find Marc already working with the compositional formula that he was to employ not only in his painting *Large Picture of Horses at Lenggries I* (fig. 34), but also in all the later, related rectangular compositions with blue and yellow horses (figs. 77—79), including that reworked in 1913/14 (fig. 80).

In the frieze-like study of four closely packed standing horses (fig. 33) Marc has established the picture outline with powerful pencil strokes and, in doing so (as was often the case), has partially but insistently cropped the bodies. As a result, the animals are brought nearer to the viewer while the distance between them is reduced. Our sense of them as a group is thus strengthened. With convincing realism and yet with unambiguous compositional intent, Marc ensures that a triangular group emerges in the foreground: one horse seen from the rear, one from the front and positioned at a sharp angle to the first, and the upper outline of a third animal to the rear, standing parallel to the picture plane. To the right of this principal grouping, we find a fourth horse that effectively extends into the background the line of the diagonally positioned body of the second horse. The head of this fourth animal, viewed in profile and stretched up above the assembled bodies, enlivens the group. While the later related compositions with only three horses show this last animal to have been an addition better omitted, Marc had not yet reached the stage where he could recognize this.

The large picture (fig. 34) gradually came to occupy Marc throughout the summer of 1908. He set up his canvas in the pasture around the Eham farm, where he was constantly in the presence of animals, in order to draw inspiration directly from the motif. But he remained unsatisfied with the result of his persistent working and reworking. The next year he took the still unfinished picture with him to Sindelsdorf, cut it up and used the parts to strengthen the roof of his studio. Discovered and reassembled in around 1960, illustrated in color in Mark Rosenthal's monograph of 1989/92, and last heard of in the collection of J. Aberbach in New York, this picture is now untraced.[31] The formal strength and grandeur of this image is rather contradicted by the pale, naturalistic coloring. The potential symbolic power of the composition, which we may presume Marc to have perceived, is lost in this dichotomy.

33
Group of Horses, 1908
Private collection
CAT. 11

34
Large Picture of Horses at Lenggries I, 1908
Untraced

35
Landscape with Horses, 1909
Destroyed; formerly in the Koehler Collection, Berlin

36
Large Landscape I, 1909
Private collection
CAT. 17

In 1909 Marc returned to this compositional idea, initially in a picture in tempera that was destroyed in a fire in 1945 along with other works in the Koehler Collection (fig. 35), and then in the *Large Landscape I* (fig. 36). To assist Marc with his work on the second of these two paintings, the Sindelsdorf master carpenter Josef Niggl, who owned the village house that Marc rented, built a simple shack in the pasture so that the large canvas did not have to be carried back and forth. But Marc was also evidently unsatisfied by this composition; I would interpret the large "salvaged" fragment of this picture as a revealing testament to the artist's struggle.

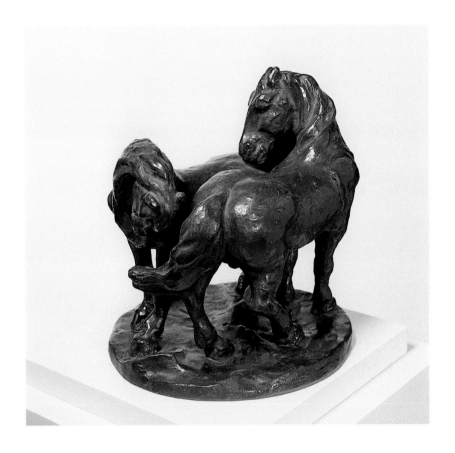

In the picture once owned by Koehler (fig. 35) the horses at Lenggries are shown as if at some distance from the viewer; they are standing to one side of the composition, in a dip in the ground.[32] In the background, half buried in the depth of the landscape and running along the edge of the meadow, there is a row of bushes and, beyond them, the occasional tree. At a greater distance and on higher ground to both left and right, there are forests of fir trees, with the mountains rising up behind them. In this sort of landscape, which unites the motifs found in Lenggries in a naturalistic manner, the undulating rhythm of the horses' bodies is taken up in that of the setting; but this effect is weakened on account of the sheer variety of landscape motifs.

The large, privately owned picture (fig. 36) effectively offers only a detail of the composition found in the painting in tempera from the Koehler Collection (fig. 35). A strip of 60 centimeters has been cropped from the upper half of the canvas. The group of horses appears more cohesive and also more visually significant within the scene as a whole, occupying around a sixth, rather than approximately an eighth, of the composition. As far as form is concerned, there is a more powerful dialog with the rhythm of the bushes; and, in comparison with *Lenggries I* (fig. 34), color is now clearly beginning to depart from the naturalistic and to attain greater autonomy. In the painting of 1909 the bodies of the horses are already red in tone, although there

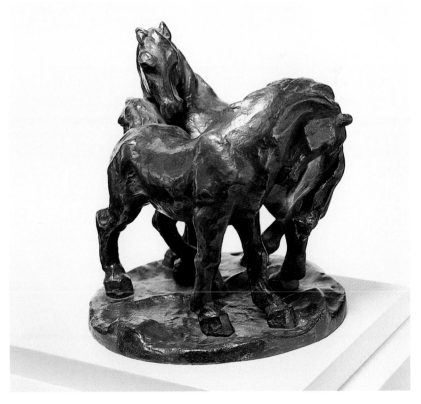

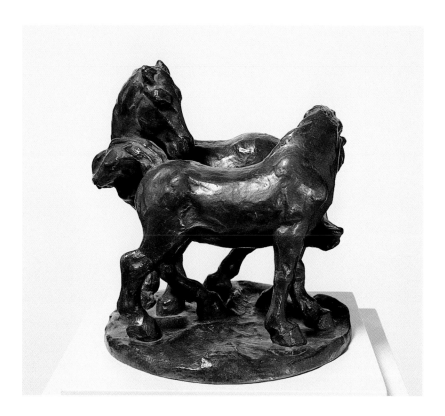

37—39
Two Horses, 1908/09
Staatliche Kunsthalle,
Karlsruhe
CAT. 12

remains a sense of uncertainty about their chromatic harmony with the setting. In any case, Marc can here be seen taking a further step in the direction of the bolder solutions he was to essay in the future.

In the winter of 1908—09 Marc made a small sculptural group of *Two Horses* (figs. 37—39). Through the use of a pair of animals facing in opposite directions, and through initiating a rhythm of movement and countermovement, Marc establishes the impression of a compelling symbiosis. He was to achieve this again, a little later, in the case of his *Cats on a Red Cloth* (Lankheit 1970: 106) and above all in *Two Cats* (Lankheit 1970: 824), which was used as the motif for the poster advertising the exhibition at Brakl, the paired animals conveying closeness and communication but also a sense of confrontation. As in that case, the sculpted horses also perhaps point to a difference in rank between the two animals, in spite of their physical similarity: one with head raised and tensely pricked ears, the other with the inclined head and inward turning gaze that are so characteristic of the horses in Marc's work.

This sculpture was in fact to become the first item in Marc's oeuvres to be published. Reinhard Piper used it to conclude his book of 1910 on *Das Tier in der Kunst* [Animals in Art] (see pp. 239 ff.). Piper also gave Marc the chance to add to the text. In retrospect Marc described his *Two Horses* as a "tentative endeavor" to approach an "animalization of art". According to Marc, it was a question of "[...] the circulation of blood in the bodies of the two horses, expressed through the variety of parallelisms and oscillations in the lines of their bodies. The viewer should not be prompted to ask what 'type' of horses are shown here; rather, he should be able to sense the life quivering within these beasts. I have expressly endeavored to remove from these horses any specific mark of type. Hence, e.g., the forceful quality of the limbs, which is more or less unlike that of a horse."[33] Already in the case of *Lenggries I* (fig. 34), as also later in his pictures with blue and yellow horses (figs. 77—79), Marc eschewed this element of the "forceful" in his treatment of the limbs; in every case the result was an increase in the symbolic resonance of the image.

In a *Study of a Horse* painted in around 1908/09 (fig. 40), as in his sculpted horses, Marc is concerned, as he renders a spontaneous observation, to convey a sense of vitality, of the "life quivering within", of the power and beauty of unconstrained bodily movements. His use of color in a manner increasingly independent of its appearance in nature underscores the impact of such works.

It was in the summer of 1909 that Marc and Maria lived for the first time at Sindelsdorf. In the seclusion of this tiny village on the edge of the moor, they found a place that truly suited them. It is also possible that the happiness of this life lived in harmony with each other and with nature, which was also soon to be reflected in Marc's letters and in his pictures, found symbolic expression in a work such as *Foals at Pasture* (fig. 41). Pale in its coloring, light in its sense of movement, the picture gains in planarity as the absence of a horizon detracts from a sense of depth. A trotting move-

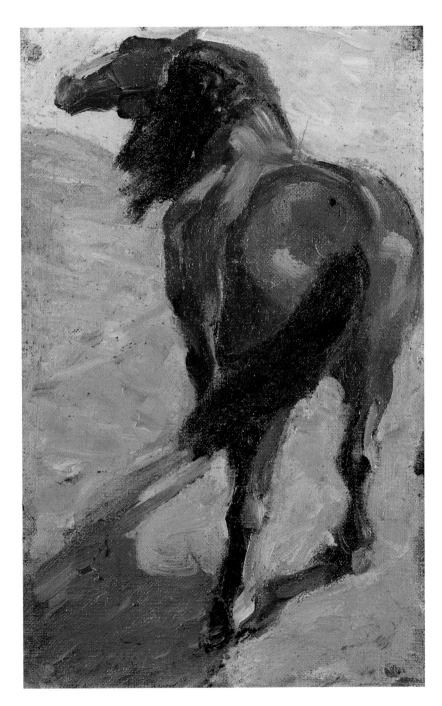

40
Study of a Horse, 1908/09
Private collection
CAT. 13

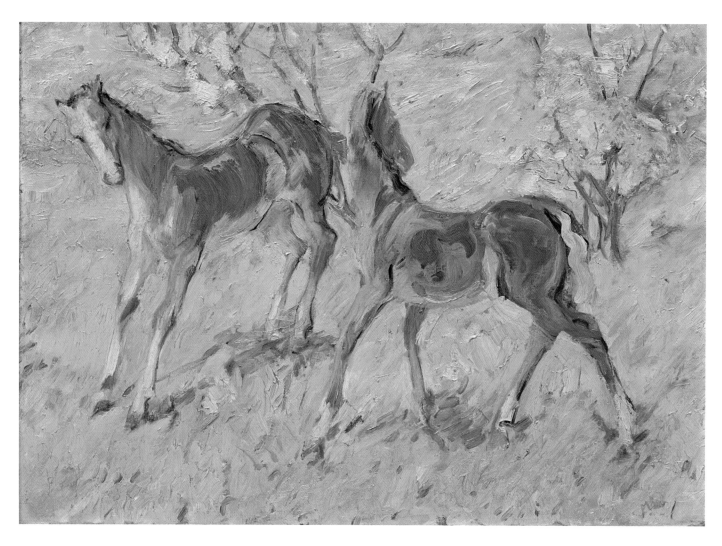

41
Foals at Pasture, 1909
Private collection
CAT. 14

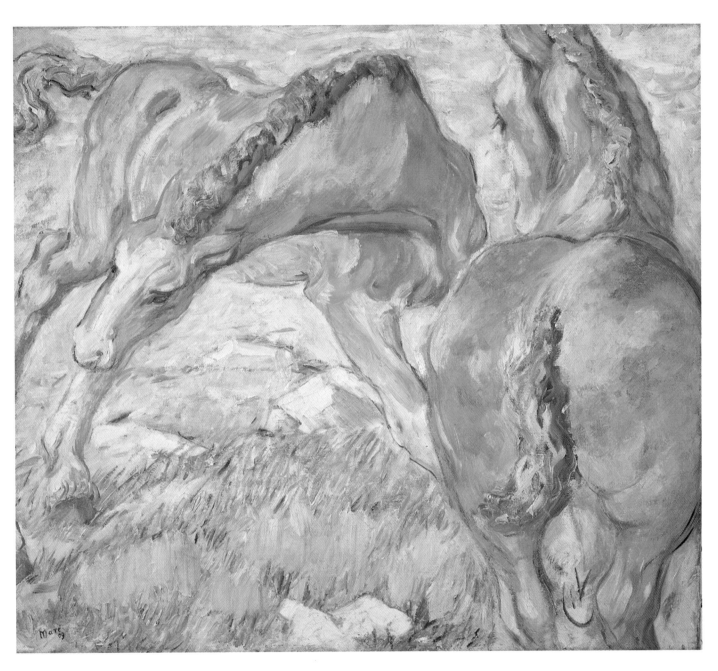

42
Mare with a Foal, 1909
Private collection
CAT. 15

43
Small Picture of Horses, 1909
Stangl Collection, on loan to
Franz Marc Museum, Kochel
am See
CAT. 16

ment, an erratic pausing, a rapid shifting of glances, a sense of suppleness and the as yet still slightly awkward quality in the rhythm of the bodies of the young animals, executed in a sketchy painting style with vigorous brushstrokes: all this

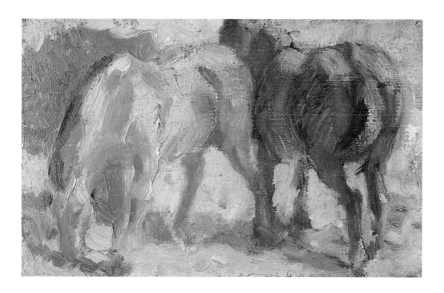

blends into a sunny image that seems to exemplify youth, as fresh as spring.

The *Mare with a Foal* (fig. 42), painted at approximately the same time, is more dramatic, and in compositional terms very idiosyncratic. The bold rear-view that draws us almost oppressively close to the animals, and the expansive pose of the already powerful foal, find their equivalent in the freer use of color, in which there are clear reminiscences of the paintings of Van Gogh.

Related to this mood evoked through color is the sketchy *Small Picture of Horses* from the collection of Otto and Etta Stangl, now on loan to the Franz Marc Museum at Kochel (fig. 43). In his still cautious use of complementary contrasts, Marc achieves an effect of depth, by means of which he is able to grasp more of the essence of the horse than before. This was yet another step toward the emanicipation of color. Yet an echo of Impressionism is still to be detected in this work.

1910: MARC'S SEARCH FOR "A STYLE THAT'S GOOD, PURE, AND LIGHT"—"THE ANIMALIZATION OF ART"

For Marc, 1910 was a year with far-reaching consequences. In February he turned 30, in April he definitively left Munich for Sindelsdorf. In January he had had his first exhibition, mounted by the art dealer Brakl in Munich. As already mentioned, this led to his meeting with the publisher Reinhard Piper; he also became friendly with August Macke. Above all, through his enthusiasm and sympathy for the artists of the *Neue Künstlervereinigung München*, hereafter *NKVM* [New Munich Artists' Union], he first came into contact with Wassily Kandinsky, Alexei Jawlensky, Gabriele Münter and their circle.

On April 20th Piper received a text from Marc in Sindelsdorf intended for his volume *Das Tier in der Kunst*. He published this more or less unaltered because, in his view (as in ours), it made very clear the artist's intentions: "My aims lie beyond those of animal painting. I'm searching for a style that's good, pure, and light, in which at least a part of that which we modern painters will want to express can be fully conveyed. I'm attempting to heighten my feeling for the organic *rhythm* that is to be sensed in everything; I'm endeavoring to empathize, in a pantheistic fashion, with the quiver and flow of the blood in all of nature, in the trees, in the animals, in the air: I'm trying to make a picture out of that, using new types of movement and with the sort of colors that are despised by our old easel painting." In France artists had been following such principles for more than half a century. But none of the artists whom Marc singles out for praise — from Delacroix and Millet, by way of Degas and Cézanne, to Van Gogh and the Pointillists — had concentrated their attention on painting animals. "I see no more appropriate means to the *animalization* of art, as I'd like to call it, than the image of the animal. That's why this is what I'm aiming at."[34]

In speaking of *animalization,* Marc chose a somewhat unusual term and one that he employed in a very personal way. It is clear that he wished his use of this term to be understood in two senses. It has in fact most readily been seen as referring to animals as Marc's subject matter; but this meaning clearly cannot apply when Marc writes of "finding everything animalistic" in a picture by Van Gogh or Signac, "the air, even the boat [...] and above all the painting itself." For Marc, it would appear, the notion of *animalization* embraced the notion of *animation* (from the Latin term *anima,* meaning a breath), the idea of life being breathed into a creature. And, accordingly, in his sculpted horses (figs. 37—39), Marc was concerned that the viewer should be able to "sense the life quivering within these beasts." The "*animalization* of art" means that the artist should not take as his subject the perception and rendering of surfaces or optical phenomena (and hence Marc's rejection of Impressionism). The purpose of art was to penetrate to the core of life and bring out the essence of things. It was a matter of getting close to the mystery of being that lay beyond outer appearances.

As it was through his images of animals that Marc sought to accomplish this ambitious task, it was not among the conventional animal painters that he found like-minded artists but, rather, in the circle of the *NKVM.* And it is for this reason that the spiritual and intellectual affinity between Marc and Kandinsky was effectively established even before the two met.

The "*animalization* of art" was also central to Marc's contribution to Modernism. In essence, this consisted in a striving for the visualization of a paradisaical world of animals — paradisaical because it was as yet unspoiled by human error. Just as in the art of the Renaissance and the Baroque it was the convention that rulers appear in the guise of the heroes or gods of antiquity, thus allying themselves with a higher sphere, in Marc's work we find a path that leads from the human to the animal realm,

where the animal is ennobled, even sometimes presented as sacrosanct. As Langner has demonstrated,[35] conventional compositional schemes for the romantic contemplation of landscape, or for representations of the Holy Family or other such groups, were not without an impact on Marc's images. But in these it is no longer exalted individuals or events drawn from mythology or history that serve as exemplars; this role is now assumed by animals in all their existential simplicity.

* * *

At the beginning of January 1910 the 23-year-old August Macke, along with his younger brother Helmuth, and Bernhard Koehler, Jr., visited Marc's exhibition at Brakl's and thereafter — delighted above all by *Horses in the Sun* (fig. 30) — immediately went to call on Marc himself. For the meditative Marc, this meeting with August Macke and the extremely close friendship that swiftly developed between the two (soon also embracing their respective wives) brought a new stimulus and a sense of liberation. This was the case not only because of Macke's own work as an artist (in which respect his particular significance lay in his already further developed use of color emancipated from objective description), but also on account of the transformation of Marc's everyday life through the boisterously cheerful character of his new friend.[36] Yet Marc, in his correspondence with Macke, though seven years his senior and far richer in well-digested experience, never assumed a position of superiority (even though he has sometimes appeared to be doing so to those who have focused on his later statements).

On the whole, and particularly after he had overcome the personal crisis provoked by his involvements with Annette von Eckhardt and Marie Schnür, and had firmly established his relationship with Maria Franck and settled calmly into life with her at Sindelsdorf, Marc comes across as an energetic, upright, urbane man who comments on events with a laconic humor that is very Bavar-

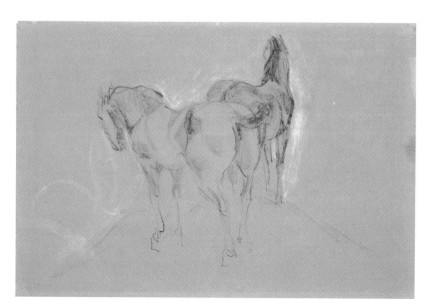

ian. Yet he retained all his earnestness, and it was this that found expression in his tireless artistic struggle. Increasingly, this also embraced public advocacy for a new art in the eloquent texts that he was able to produce with speed and ease. Marc's commitment to agitating for this goal is also evident in his other activities: his efforts on behalf of artists' associations, his crucial contribution to the planning of exhibitions, his eagerness to establish contacts, and his invariable openness to fellow artists. While Sindelsdorf was indeed a refuge in the style of Pont-Aven, it also became a sort of organizational hub (especially after contact was established with Kandinsky in nearby Murnau), from which the cause of Modernism was both intelligently and deftly championed in many different directions.

In considering Marc's work of 1910 we will begin with several pencil drawings. A *Study of a Horse* (fig. 44) shows an animal standing on three legs and calmly cleaning itself. Marc first recorded this motif in a manner suggestive of particular interest in firm external outlines (fig. 224); he then used the other side of the sheet for a second version. This example demonstrates the speed and success of his grasp of an extreme, and momentary, pose. Already in 1908 he had treated a zebra in much the same manner in a design for a children's book (Lankheit 1970: 889).

In the larger drawing *Two Horses* (fig. 45) we find one animal turning round in curiosity, or perhaps in sudden irritation, in addition to Marc's favored back view of a horse with its gaze focused on the distance. The isolation and monumentalization of these animals on a stretch of raised ground is achieved simply through the presence of two diagonal lines. It is uncertain as to whether this composition was intended as a study for a painting. The gouache *Horses at Pasture* (fig. 46) presents an idyllic scene attesting to the harmonious coexistence of creatures and their natural environment. Rendered in pale, predominantly blue and green tones, the animals are fully self-absorbed, both in activity and in repose, and appear against a background of large bushes as if occupying a sort of *hortus conclusus*. Beyond, forming a broad arch that spans the entire picture, we see a gently sloping hill with coniform haystacks. This truly Arcadian composition recalls Marc's enthusiasm for Gauguin.

Marc was often moved to record horses in or near water, on account of their evident pleasure and their interaction in such a setting, and also because

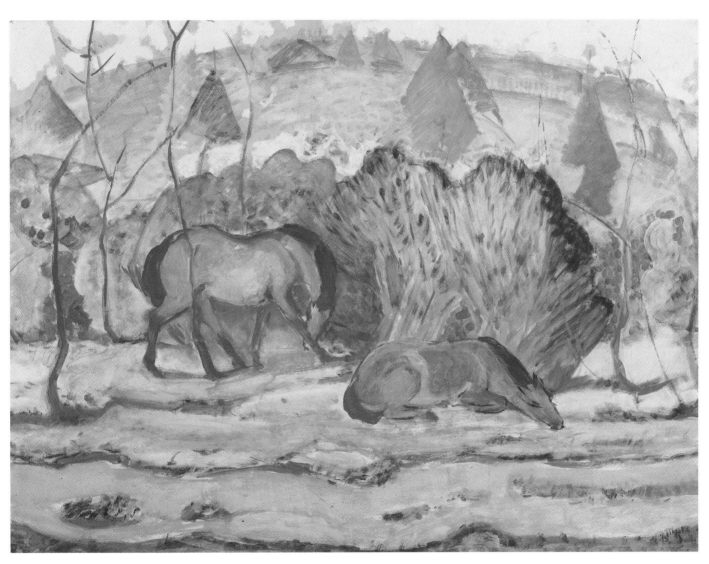

46

Horses at Pasture, 1910

Musée d'Art moderne et d'Art contemporain de la Ville de Liège

CAT. 20

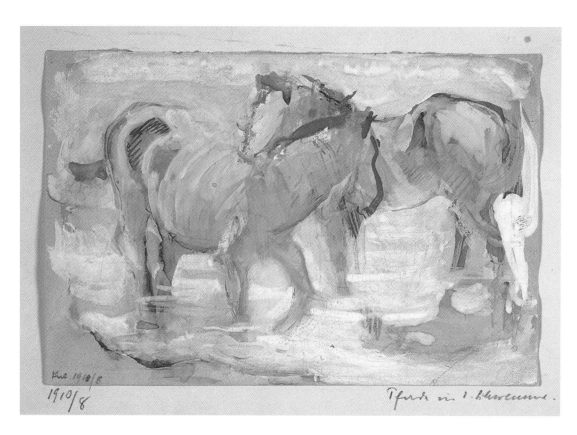

47
Horses at a Watering-place, 1910
Private collection, Switzerland
CAT. 21

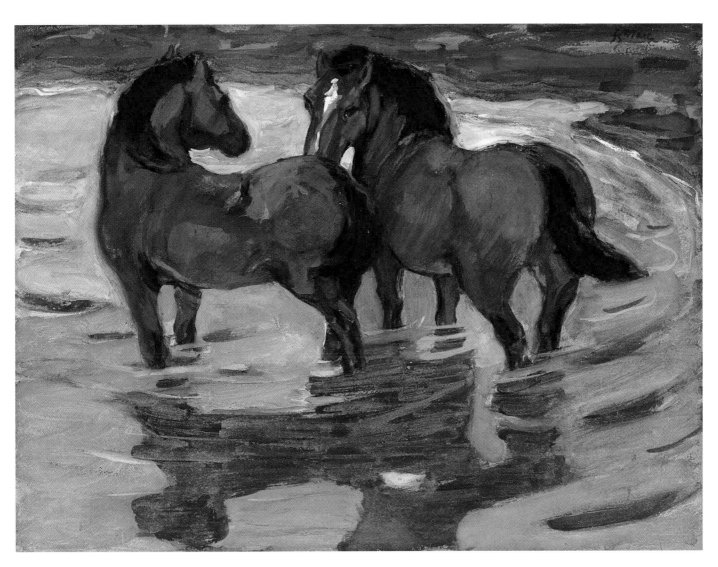

48
Two Horses at a Watering-place, 1910
Private collection
CAT. 22

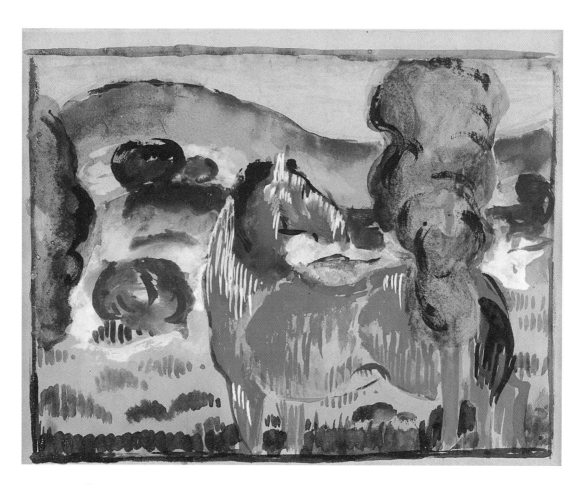

49
Red Horse in a Colored Landscape, 1910
Private collection
CAT. 23

50
Three Foals at Pasture, 1909
Germanisches Nationalmuseum, Nuremberg

51
Four Foals at Pasture, 1910
Germanisches Nationalmuseum, Nuremberg
CAT. 24

52
Studies of Foals, 1910
Germanisches Nationalmuseum, Nuremberg
CAT. 25

the presence of striking reflections could serve to unify the image of a pair or a group. In the sketch in watercolor and gouache, *Horses at a Watering-place* (fig. 47), probably originating in a sketchbook, the animals are engaged in cleaning each others' coats; in the larger gouache heightended with gold that treats the same subject (fig. 48), the horses stand next to each other in the evening light as if engaged in conversation. The scene conveys a sense of calm such as is barely attainable in human society.

Comparable in its pose and its air of contemplation with the horse closer to the viewer in this gouache is the animal seen in *Red Horse in a Colored Landscape* (fig. 49). The simplicity of the composition in fact led to its being used as the model for a tapestry (Lankheit 19170: 885). In the present context, however, the interest of this image is the *red* coloring of the horse. In the text of Kandinsky's *Über das Geistige in der Kunst*, completed by the end of 1910 and published (thanks to Marc's intervention) by Piper in December 1911, one finds passages that might also record Marc's thought and feeling at this time. "Observed in isolation, the invariably stirring tone of warm red will substantially alter in its value if it is no longer isolated and therefore abstract, but serves to record aspects of a living being and is thus connected with a natural form."[37] Depending on whether red were used in rendering the sky, a flower, a dress, a face, a horse or a tree, a variety of different effects would arise. "[...] finally a red horse. The very sound of these words transports us into another realm. The impossibility of the existence of a red horse in nature absolutely demands an unnatural setting in which such a horse might be placed."[38] This is something of which Franz Marc was aware, and it was surely also a subject of the discussions that he had with Kandinsky from January 1911. In Marc's work, too, it is notable that the "atmosphere", in Kandinsky's sense, may be found to alter along with the colors of the horses, be it red, blue, or yellow (and in a number of important works Marc was to limit himself to these three). 1910 was also the last year of Marc's particular pre-

occupation with drawing and painting foals, these being a subject that he recognized as suited to a more naturalistic approach. While Marc liked to group adult animals closely together, and to show them standing or engaged in relatively calm movement, in taking young horses as his subject he was clearly captivated by their verve and their eagerness to explore their own physical strength. Following his work on the painting of 1909 *Foals at Pasture*

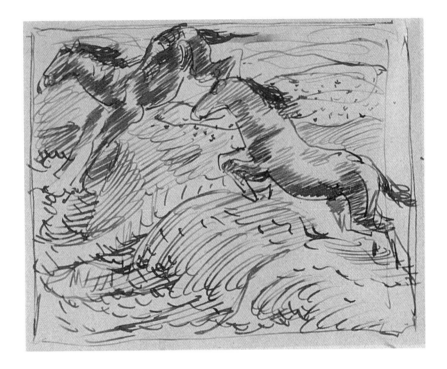

(fig. 41), Marc made many drawings of young animals in the sketchbooks now in Nuremberg; none of these studies has been published. One drawing of 1909, in soft pencil, shows three foals beside a bush (fig. 50): rather than being a premeditated study for a painting, it is an instance of the unpretentious but enchanting notation of spontaneous perception made in the presence of the subject.[39]

A relatively more dynamic image is the watercolor framed in drawn lines found in sketchbook XVIII (fig. 51). Young horses — yearlings, no longer foals — form a group extending, in an ornamental fashion, across the sheet. The rising diagonal movement is underlined by the expansive backward kicking motion of the principal figure. Its

53
Leaping Horses, 1910
Private collection
CAT. 26

54
Leaping Horses, 1910
Untraced

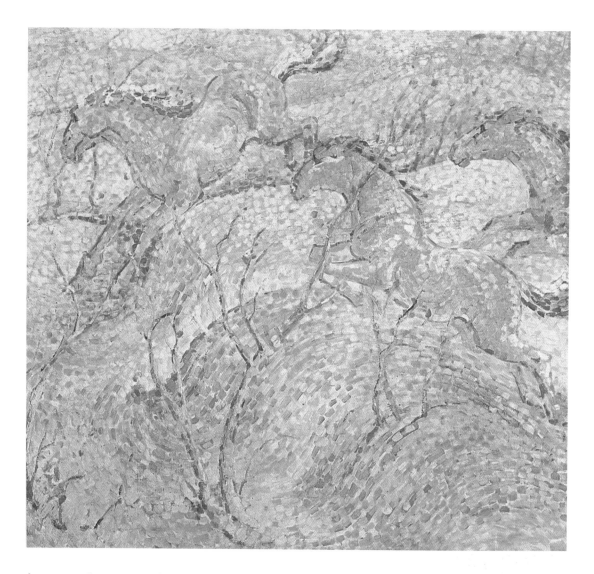

three agitated companions keep a respectful distance as they dance around it.

The same sketchbook has an image extending across two sheets that is of even greater charm (fig. 52). In the two versions of a standing animal to the left, Marc sensitively records the combination of caution and curiosity in both pose and facial expression. On the facing page he offers three masterful images demonstrating the sheer vigor exuded by a young horse leaping. The assurance of the drawing here reveals Marc as a true master of his chosen subject.

A drawing now in a private collection, but originating in the same sketchbook, also shows leaping horses (fig. 53). Here, with the exception of the drawn frame, there are no verticals or horizontals. In this spirited pen-and-ink sketch the resilient leaping action with bent front legs recorded in the foreground is countered by the motion of the second horse, which is about to land on its own outstretched forelimbs. This up-and-down rhythm is echoed in the flowing movement of the landscape, its undulating rhythms reminiscent of churning waves. Longer and shorter curves, plains rendered in a pointillist manner and, above these, looping ribbons of line are features that anticipate the large and important painting made shortly afterwards (fig. 54), which is now, sadly, untraced.[40] Here, for the first time, Marc is found working with pure color dabbed freely onto the canvas so as to pro-

55
Horses Running on Pasture, 1910
Germanisches Nationalmuseum, Nuremberg
CAT. 27

56
Two Horses, 1910
Stangl Collection, on loan to the Franz Marc Museum, Kochel am See
CAT. 28

duce a pointillist structure with all the bright, buoy-ant atmosphere of spring. In its overall effect this picture is a symbol of the power and energy of youth. The lessons of the work of Van Gogh and of the Neo-Impressionists are clearly reflected in both the drawn and the painted versions of this theme. In the period 1910—11 Marc repeatedly produced images of "horses at pasture", although this brief and traditional picture title does not always corre-spond precisely to the action shown (on this point, see the observations of Klaus Zeeb, pp. 262 ff.).

The drawing *Horses Running on Pasture* (fig. 55) also derives from sketchbook XVIII. According to Maria Marc, this vigorous composition was made as part of the preparatory work for a painting with life-size horses that Marc in fact never finished. The sharply cropped rear view of the paired ani-mals found here suggests that Marc may have observed and sketched them while seated on the box of a carriage.

Another drawing of 1910, *Two Horses* (fig. 56), now in the Stangl Collection, achieves an especially

promising pictorial arrangement, Marc himself tes-tifying to the value he placed on this sheet through inscribing its place and date of composition and through the addition of white heightening. The ani-mals seen here are aligned at right angles to each other and stand with their heads turned to one side in the manner favored by Marc, one seen in full profile, the other almost entirely from the rear. The vigorous rhythm of the animal bodies is taken up in the outlines of the hills in the background, the overall composition thus conveying a sense of for-mal consonance. The compact form of the horse in the foreground offers an early instance of a figural and compositional device to which Marc was fre-quently to return, to begin with in reverse, in the background of all three versions of *Grazing Horses* (figs. 57—59) and in the painting now in Essen (fig. 60), then in the following year as an uncropped figure in *The Red Horses* (fig. 68).

The three scenes with *Grazing Horses* (fig. 57—59), almost exactly equal in breadth (and ini-tially also in height) must have originated in a sin-

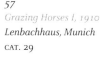

57
Grazing Horses I, 1910
Lenbachhaus, Munich
CAT. 29

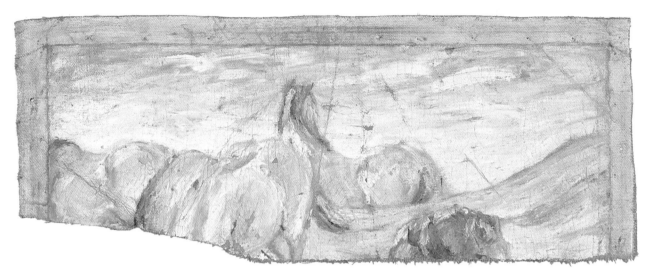

58
Grazing Horses II, 1910
Staatsgalerie, Stuttgart
CAT. 30

59
Grazing Horses III, 1910
Private collection
CAT. 31

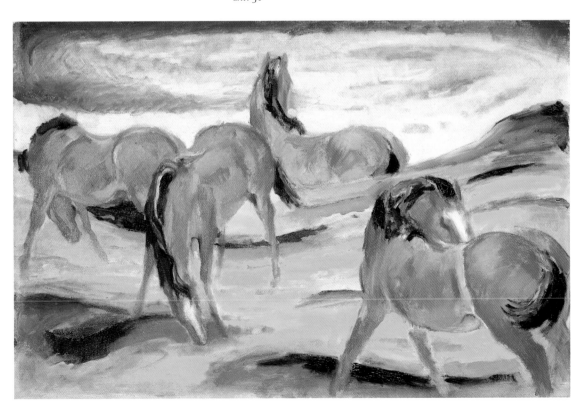

gle preparatory drawing, for both of what seem on stylistic grounds, to be the earlier pictures (figs. 57, 58) contain the horizontally cropped figure of a horse on the left, which then re-appears, in uncropped form, in the presumably later third composition (fig. 59). This would suggest that Marc initially wanted to achieve a concentration of the group through cropping the figures of the horses to both left and right, but was not happy with the result.

In the first image of the three (fig. 57) the alignment of the horses forms a loose pattern of crossed diagonals, but there is relatively little emphasis on the relation between the animals. In accordance with the habit of "reading" compositions from right to left, the viewer's starting point is likely to be the horse shown with its head turned back, engaged in cleaning itself. Skipping the intervening space, the eye comes to two grazing horses and, beyond these, it encounters the fourth horse, partially hidden by the sloping pasture and with its attention directed into the distance. While the forms and colors found in this scene are relatively naturalistic, the version of the composition now in Stuttgart (fig. 58) is paler, and in part more chalky, in its tones. It may have been the resulting lack of "weight", or indeed of substance, in this version that prompted Marc to abandon work on it and subsequently to cut up the canvas.

With regard to both composition and coloring there is quite a distance between the Stuttgart picture and the third version of this subject (fig. 59). Here, the poses and the outlines of the animals are somewhat more emphatic; and the colors used are no longer so "arbitrary". The horses are rendered in a powerful reddish brown, the landscape setting in tones that are almost complementary contrasts. The sky is dominated by what appears to be a single cloud caught in a vast sweeping movement. The overall effect is of pure animal existence and restrained drama.

There is an enormous difference between these compositions and the ambitious *Horse in the Landscape* in the collection of the Museum Folkwang, Essen (fig. 60), the latter representing signifi-

cant progress above all in the direction of the autonomy of color and form at which Marc had been aiming. By means of the isolation and "cornering" of the body of the animal and the unprecedentedly emphatic manner in which it is cropped, the horse's head occupies the center of the composition, and the sense of distance between animal and viewer is reduced. Observer and observed effectively, and involuntarily, merge, and the former is more than likely to identify with the horse. As in the case of our experience of looking at Caspar David Friedrich's *Wanderer above the Sea of Mist* (painted in around 1818), there is a tendency to share imaginatively in the horse's perception of the expanse of land it surveys. While Friedrich's protagonist stands at the top of the highest of a range of hills, Marc leads our gaze across a gently rising expanse of grassland with no visible horizon. The large passages of saturated color (yellow and red) are articulated by the green of the clustered bushes. Through the horse and with the horse, the viewer encounters a landscape that is already in many respects "abstracted" (particularly in terms of chromatic exaggeration); but at the same time he encounters a work of art distinguished by pictorial language of astonishing transcendental power.

A statement from Kandinsky is appropriate here: "A very simple movement, the purpose of which we have no idea, may be very effective, in its own right, as something significant, mysterious, and solemn. And it remains thus as long as one does not know its ostensible, practical purpose. In formal terms it can function as pure tone."[41]

A number of individual studies allowed Marc to enlarge his treatment of the theme of horses at pasture: *Three Drinking Horses*, now in the Solomon R. Guggenheim Museum, New York (fig. 61), a double sheet originally forming part of sketchbook XXIII, shows an animal idyll evoked in a sketchy fashion. In the shade of a group of trees that arch over them in the manner of a pergola, three brown horses are seen drinking from a pool that holds a silvery blue reflection of the sky. The grace and beauty of this trio was again to attract Marc's inter-

60
Horse in the Landscape,
1910
Museum Folkwang, Essen
CAT. 32

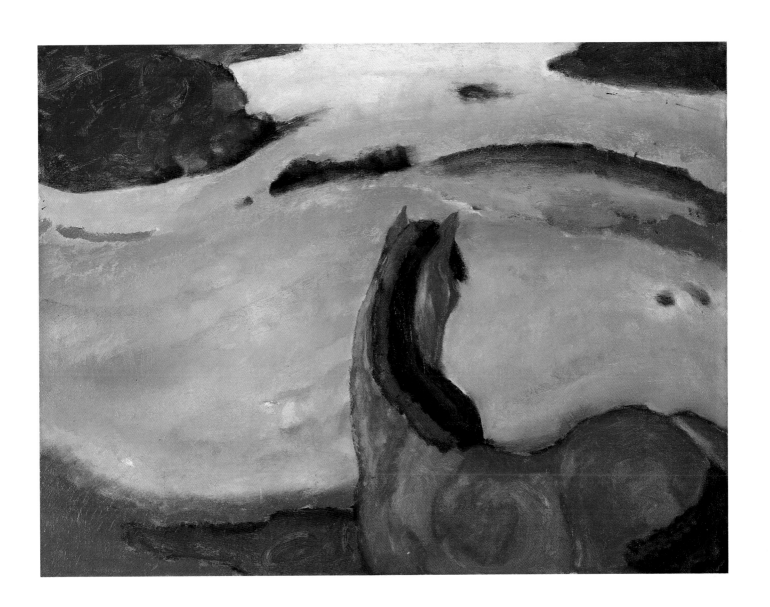

61
Three Drinking Horses, 1910
Solomon R. Guggenhein Museum, New York
CAT. 33

62
Horses at Pasture, 1910/11
Private collection
CAT. 34

63
Two Horses in a Mountain Landscape, 1910/11
Staatliche Graphische Sammlung, Munich
CAT. 35

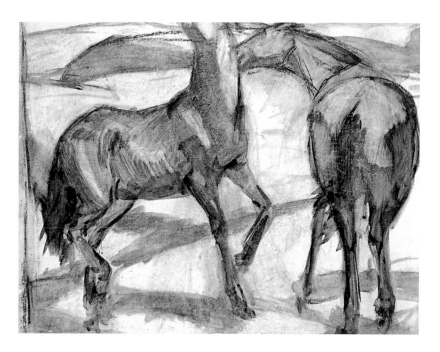

64
Two Horses Fighting, 1910
Private collection
CAT. 36

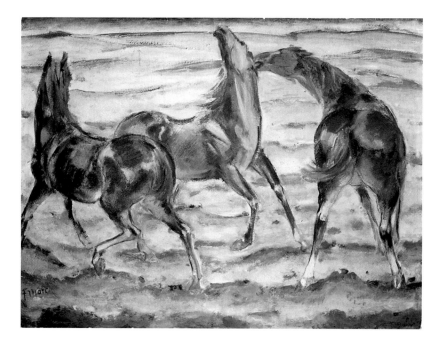

65
Fighting Horses, 1910
*Destroyed; formerly in the Heise Collection,
Hamburg*

est the following year (fig. 188). By contrast, a pen-and-ink drawing from the same sketchbook (fig. 62) appears little more than a spontaneous finger exercise in response to a group of animals encountered by chance. In comparison with the realistic rendering of the horses seen here, who appear to be plagued by a swarm of flies, the graphic stylization and idealization of the animals found in *Two Horses in a Mountain Landscape* (fig. 63) "elevates" these both physically and metaphorically. For Marc it was only a short step from this approach to the production of images such as *Blue Horse I* (fig. 72) or the later *Tower of Blue Horses* (fig. 111).

In *Two Horses Fighting* (fig. 64), however, a large, preparatory charcoal and wash drawing for a destroyed painting with three animals (fig. 65), Marc gave yet another proof of his gift for the precise observation of nature (see p. 263). The animal evidently higher in rank is shown biting the other, whose body language clearly conveys discomfort. In the larger, painted version it is clear that the action would have been more dramatic as a result of the greater vigor of pose and movement and above all through the presence of the third horse, who trots past in an animated fashion.[42] In this figure Marc has for once associated his favored rear-view presentation with a mood other than the contemplative. In contrast to what we find in the drawing, the pasture extends almost to the upper picture edge, featureless except for its undulations. The destroyed picture may well have resembled that in Essen (fig. 60) in terms of its "tone", except that the minor key would here have been replaced by a powerful major.

THE STRUGGLE FOR A NEW INTENSITY OF COLOR

Toward the end of 1910 and at the start of the next year Marc was particularly preoccupied with color. On December 6th he wrote to Maria Franck: "[...] I'm constantly pondering my system of comple-

mentary colors, it's the only way of getting out of and away from what I see as the 'arbitrary'". Much of his work of the fall and winter of 1910 now seemed to him a little too decorative in its effect, and he felt that he had to "know much more about color" and that he should "not fiddle with 'illumination' in such an unsystematic way."[43] Two days later Marc told Maria of an observation made by the Russian artist Marianne von Werefkin. German artists, she said, often mistook light for color, "while color is in fact something quite different and has nothing at all to do with light, i.e. illumination."[44]

At around the same time Marc received a long letter from August Macke with detailed reflections on the color wheel and its parallels with musical structures. In his reply, of December 12th, Marc presented his own ideas on this matter, and in great detail. In spite of a great many idiosyncratic comments on the notion of "woman" and the fact that Marc later saw and employed the symbolic value of colors differently (with the exception of blue),[45] the text nonetheless serves as a highly informative introduction to how best to approach the paintings made in 1910—11:

"Now I'll explain to you my own theory about blue, yellow and red, and it will probably seem to you to be just as 'Spanish' as my face.

Blue is the *male* principle, austere, and spiritual.

Yellow is the *female* principle, gentle, serene, and sensual.

Red is *matter*, brutal and heavy, and always the color that has to be fought and overcome by the other two!

If, for example, you mix the earnest, spiritual blue with red, then you intensify the blue to an unbearable degree of sadness, so that it becomes essential to add the reconciling yellow, the color complementary to violet. (Woman as consoler, not as lover!).

If you mix red and yellow to obtain orange, you imbue the passive and female yellow with a 'shrew-like', sensual power, so that now it is essential to add the cool, intellectual blue, the man, and in fact blue takes its place immediately and automatically along-side orange, these colors having a natural affinity. Blue and orange: an altogether festive tone.

But if you mix blue and yellow to obtain green, you arouse red, matter, the 'earth', into life; and here, as a painter, I always sense a difference: with green you can never fully offset the forever material and brutal red, in the manner of the previously cited tonal combinations.

(Simply imagine, e.g., objects of applied art in green and red!). Green always has to depend on the assistance of blue (the sky) and yellow (the sun), in order *to silence the voice of matter.*

And then there's another thing (it will sound rather laughably literary, but I don't know how to express it any better than this): yet again, blue and yellow do not stand at an equal distance from red. In spite of all the evidence of spectral analysis, I can't rid myself of the painter's conviction that yellow (woman!) stands closer to the red of the earth than does blue (the male principle). This concurrence with the age-old physiological theory about 'woman' sounds somewhat odd here, but it supports the way I myself imagine and characterize the colors. The fact that I don't, as you can see, attach equal value to the individual colors from the point of view of the theory of painting, is explained by my most recent experiences (in fact all of them are recent): that the problem of color masses is just as important and much more difficult to solve than the simple problem of complementary colors. The fact that blue goes well next to orange is not difficult to grasp, but as for what *amount* of blue may stand in each individual case alongside orange — that's a much harder nut to crack. This is something that the theories damn well leave out, unless all one wants to do is to paint cigar boxes."[46]

These considerations were followed on January 14th 1911, when Marc was at work on *The Red Horses* (fig. 68), by a further letter to Macke: "There's an idea that persistently preoccupied me today while I was painting and that I think I'll use in my work: It is by no means essential that one allow the complementary colors to appear directly

alongside each other as they do in a prism; rather, one can place them as far apart as one wishes. The partial dissonances that will arise as a result will be absorbed within the composition as a whole, where they will achieve an effect of consonance (harmony) in as far as they are complementary in their extension and their relative strength."[47]

Here we may note the evidence of a new influence on Marc's thinking. At the start of 1911 Marc had his first meeting with Kandinsky, an occasion on

moment I felt the great joy of his strong, pure, fiery colors."[48] One is tempted to see the reflection of this feeling in Marc's work of 1911. Marc had in fact already written to Maria of his enthusiastic response to the second exhibition of the *NKVM*, and in particular to the work that Kandinsky had shown there: "What artistic insight this singular painter harbors within himself! The great consistency of his colors is balanced by his freedom as a draftsman: is this not in itself a definition of painting?"[49]

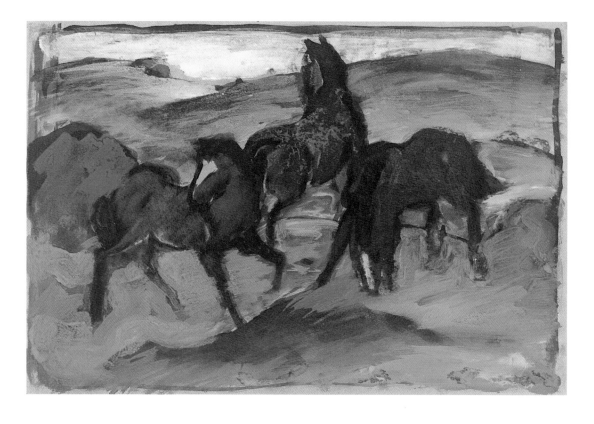

66
Horses at Pasture II, 1910
Private collection
CAT. 37

which, it seems, each artist immediately recognized both the capacities and the congeniality of the other. Kandinsky responded to the practicality, the openness, the feeling for quality, and above all the sincerity of the handsome Marc with his sometimes almost "Mediterranean" air. A friendship between the two soon developed, and Marc conveyed his own sense of excitement to Maria Franck. On February 10th 1911 he wrote to her about visiting Kandinsky: "[...] in the very first

It is in this context that we should also seek to understand a number of confessional statements made by Marc and the insights he appears to have attained within only a few weeks. On January 31st 1911 he wrote to Maria: "Every color must clearly state 'who and what it is' and, to this end, it must possess a clear form".[50] And on February 10th: "I will *never* paint a bush blue merely for decorative purposes, but only in order to intensify in its entire being the horse that stands in front of it."[51]

1911: STRONG FORMS FOR POWERFUL COLORS

The large painting *The Red Horses* (also known as *Grazing Horses IV*, fig. 68) in the collection of the Busch-Reisinger Museum in Cambridge, Massachusetts, is a major work of the year 1911 and, indeed,

gether traditional and naturalistic form of coloring. By the early months of 1911, however, Marc was determined to break with this conventional approach. On February 2nd, writing to Maria, he added a small sketch (fig. 67). The picture, he writes, will be "full of color from one corner to the other [...] For the ground, pure cinnabar alongside

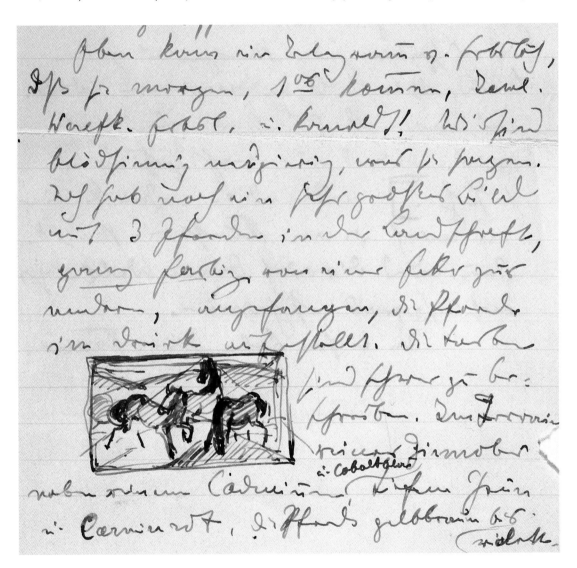

67
Sketch relating to The Red Horses (cat. 38), detail of original size from a letter of February 2nd 1911 from Franz Marc to Maria Franck
Private collection

of considerable importance within Marc's entire oeuvre. The studies made in preparation for this picture include a splendidly spontaneous gouache painted in 1910 (fig. 66); however, with the exception of a blue bush and a little blue in the rendering of the grass of the meadow, this employs an alto-

pure cadmium and cobalt blue, deep green and carmine, the horses ranging from yellowish brown to violet. A very imposing, emphatically modeled setting; whole stretches of it (e.g. a bush) in the purest blue! Can you even imagine that? All the shapes astonishingly strong and clear so that they'll

pages 84—85
68
The Red Horses, 1911
Private collection, anonymous loan to the Busch-Reisinger Museum, Cambridge, Mass., 21.1991
CAT. 38

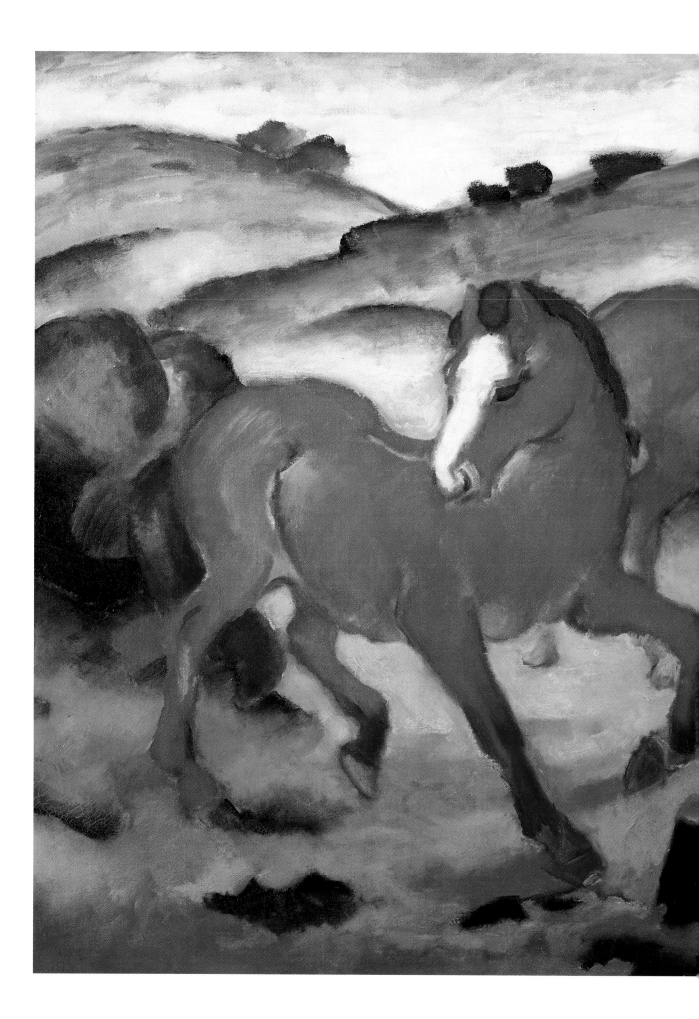

be able to support the colors [...]".[52] At this point Marc had not yet arrived at the notion of using red for the bodies of the horses. His letter describes a stage in the evolution of this work that lies somewhere between the gouache (fig. 66) and the definitive version of the painting (fig. 68).

Marc painted only a few compositions with groups of horses shown in full, without any cropping. The picture in the Busch-Reisinger Museum is the largest of these and, with its joyous, fanfare-like coloring, also the most striking. It has an almost dazzling glow like that of Gothic stained-glass windows seen against the light. A bright, warm red for the two horses in the foreground, with violet manes and tails, and in the case of the third horse the red itself tending to violet. The ground in powerful greens, shading into lemon yellow, and in the left foreground through orange to a glowing red. The corresponding blue tones are to be found to the right; and, to the left, we see the blue bush mentioned in the letter to Maria. The green dominating in the ridges of the hills is occasionally broken by yellow, orange, and pink in addition to a red-violet tone on the left in "dialog" with the horse at the center. The gleaming whitish-yellow of the sky has passages of orange and blue that pick up the brightness of the unreal colors of the earth. This chromatic interaction intensifies the coloristic unity and the sheer luminosity of the image.

Strong forms and colors effectively become Marc's theme here. Starting with the three versions of the *Grazing Horses* of the previous year (figs. 57—59), in each of which a rear-view figure is also to be found, he reduced the number of animals and, as he wrote to Maria on February 2nd, arranged then in a triangular configuration. The central and right-hand horses form a pair in a counterpositional relation to each other: the raised head of one complements the inclined head of the other, their diagonally positioned torsos face in opposite directions, and they are both linked by their shared reddish coloring and yet distinct because of its varying nuances. The aroused vitality of the horse on the left establishes a decisive counterweight

to this pair. Its dance-like deportment enlivens the group as whole and ensures the open arrangement that Marc was soon to abandon in favor of more compact groupings of blue and yellow horses (figs. 77—80).

The picture in the Busch-Reisinger Museum presents three distinct modes of equine behaviour: the charm and self-awareness of physical power in the trotting movement; the calm state of grazing (in both cases with the same bold coloring intensified through the white of the blazes); and thirdly the almost melancholy state of visually exploring the world. Despite his tendency to use ever stronger forms, so that these (as he said) will be able to support the strong colors, Marc still treats both landscape setting and anatomy in a way that is in essence naturalistic. In this respect the composition might be said to be tentative; and there is further evidence of this in the *pentimenti* on the belly and hind quarters of the horse on the right.

Marc has here effectively produced an image of nature, an image of the world, in which the red horses with their bluish-violet eyes, almost seem not so much to stand as to hover. Their hooves appear to exert no pressure on the luminous terrain, and it is not an earthly air that their nostrils breathe. Here, creatures consisting entirely of color occupy a shining world that is imbued with the rhythm of their bodies and its equally melodious echo in the swooping rhythms of the hills. The chromatic intensity of Kandinsky's "spiritual" world has here been introduced into a still concrete image of landscape. But the aim of both artists was very much the same: through the power of "essential color" (Lankheit's apposite concept) to devise magnificent forms to embody a poetic vision of both nature and creature. It is perhaps in this picture that the sunny feeling for life that Marc knew in Sindelsdorf attained its finest symbolic expression.

According to the statement by Marc quoted earlier, red was for him the color of matter, a color that had to be "overcome" by the others. In the picture from the Busch-Reisinger Museum one might see the three red horses as bearers of an almost

69
Boys with Horses and a Dog, 1911
Private collection, Zollikon
CAT. 39

70
Boys with Horses and a Dog, 1911
Private collection
CAT. 40

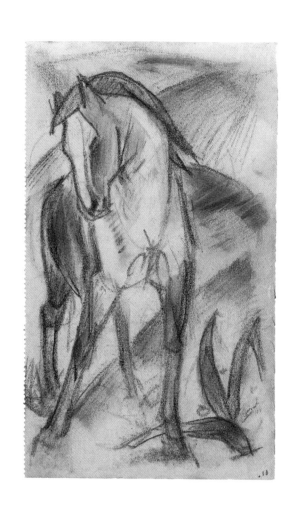

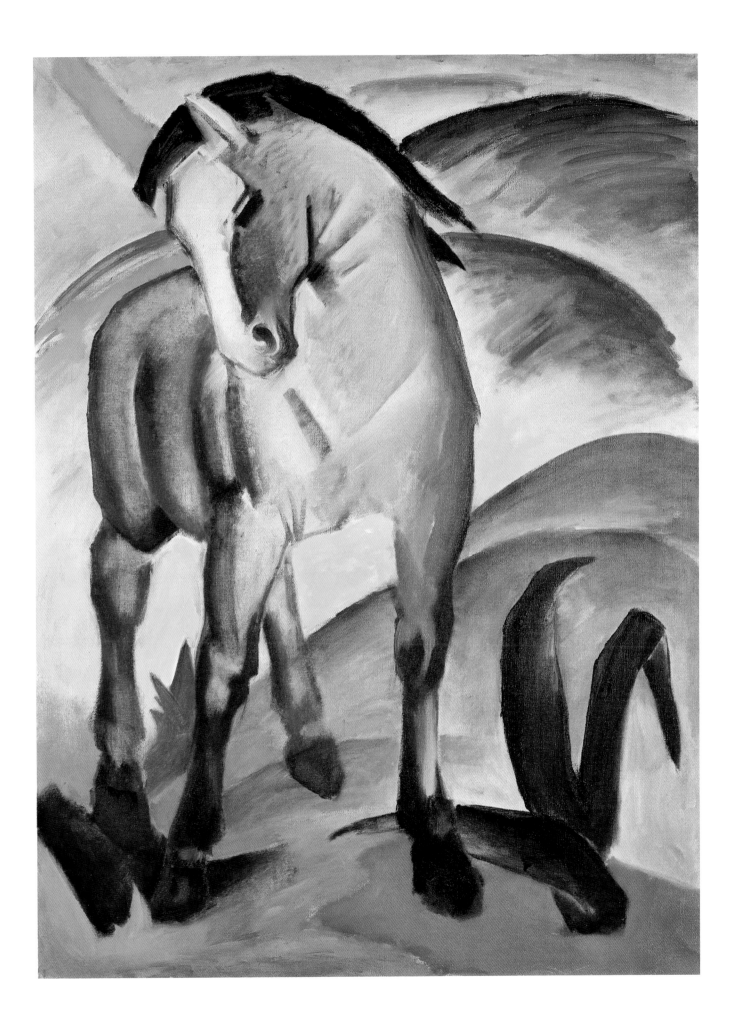

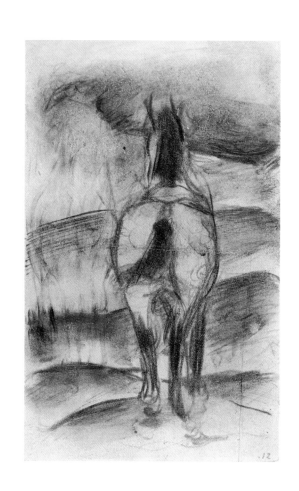

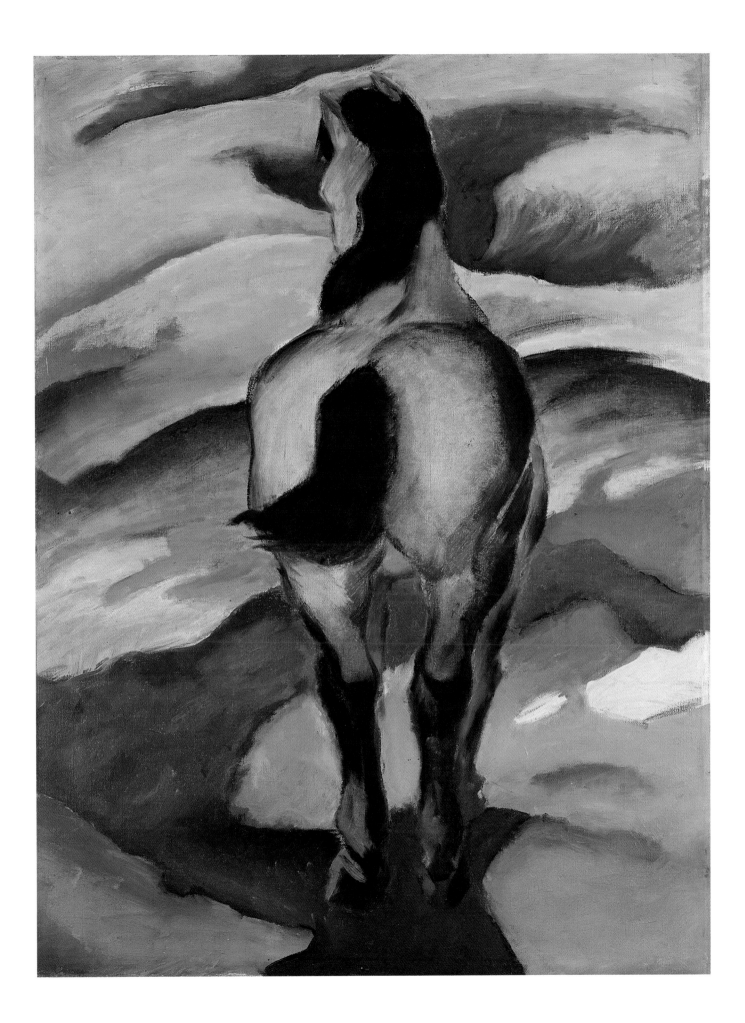

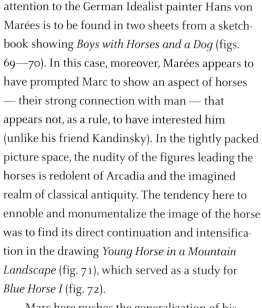

incandescent terrestrial power. The blue coloring in the earth, the bushes, and the hills and also every other forceful tone in the color palette, serves both to increase and to tame this glowing vision of the world in terms of light and heat. The immediate and lasting impact of the picture is such that one cannot be surprised at its popularity. In spite of an almost paradisaical sense of removal from reality, the horses still appear to be an earth-bound trio and, in this respect, a counterpart to the more spiritual world of the *Tower of Blue Horses* (fig. 111) produced two years later, in 1913.

During 1911 one important work by Marc followed another. A picture revealing his momentary

attention to the German Idealist painter Hans von Marées is to be found in two sheets from a sketchbook showing *Boys with Horses and a Dog* (figs. 69—70). In this case, moreover, Marées appears to have prompted Marc to show an aspect of horses — their strong connection with man — that appears not, as a rule, to have interested him (unlike his friend Kandinsky). In the tightly packed picture space, the nudity of the figures leading the horses is redolent of Arcadia and the imagined realm of classical antiquity. The tendency here to ennoble and monumentalize the image of the horse was to find its direct continuation and intensification in the drawing *Young Horse in a Mountain Landscape* (fig. 71), which served as a study for *Blue Horse I* (fig. 72).

Marc here pushes the generalization of his motif to the point where it assumes a certain stiffness, but thereby bestows on the young horse a statuesque simplicity. In relation to the slightly oblique character of the pose in the sketch, the painted animal conveys a more emphatic sense of "sculpted" mass. Despite its slenderness, it has a subtly asserted monumentality. In terms of its coloring, this impressive image is composed according to the principle of distributed complementary contrasts expounded by Marc in the letter quoted earlier. This is also the first time in Marc's work that we encounter a horse rendered entirely in blue, for him the color that was male, austere, and spiritual. It may have been this that promprted Fredrick S. Levine to interpret this painting as a "self-portrait" of the artist.[53]

Closely related to *Blue Horse I* in terms of both conception and construction, and in a certain sense its mirror image, are *Blue Horse II* from the Kunstmuseum, Berne and the drawn study made for it (figs. 73—74). Using the same vertical format as the painting from the Lenbachhaus (fig. 72), it shows the rear view of a somewhat stiffly posed horse in front of a vigorously rendered landscape. It is a key work as regards possible answers to Marc's question: "How does a horse [...] see the world?" The simplified form of the animal here, with only its tail

and its undulating mane in movement, conveys an impression of absolute calm. This is also exuded by the horse's head, of which we see no details, no eyes, but nonetheless feel the sense of attention directed entirely toward the surrounding landscape. Here in particular one is reminded of Anselm Feuerbach's *Iphigenia* of 1871, now in Stuttgart, an image of this heroine of Greek mythology pining for her homeland. Johannes Langner, writing in 1980 of "Iphigenia as a Dog" might equally well have titled his essay "Iphigenia as a Horse".[54]

The landscape background in the picture in Berne (fig. 74) appears as an almost entirely abstract sequence of color planes, alternating in a range of complementary contrasts extending to the upper picture edge. Marc's use of color here introduces us to the spiritual totality of a landscape that subsumes its individual features. Of particular significance is the absence of any indication of sky; the "atmosphere" established here by the vigorous interplay of color and form is entirely terrestrial.

A NEW START: "IN THE LAND-SCAPE WITH THREE COLORS AND A FEW LINES"

It was while Marc was dealing with preparations for his exhibition at the Galerie Thannhauser in Munich, due to open in May 1911, that he wrote to Maria Franck (on March 20th) of making a new start in painting, of his new ideas, of "the hoofbeat of *my* horses", of the "wildest and yet most obvious possibilities, things that no German artist at work today has yet thought of [...]".[55] On April 12th, writing to August Macke, he expressed himself even more precisely: "As soon as my mental store of images has spat out all it contains, I'll start over with my painting. What I now have to achieve in my work is in fact the reverse of the process that has occurred so far, where in the case of every picture I've started with quite complex concepts of form and color and, each time, only slowly and

with unutterable effort, purified, simplified, and arranged these. Now I want to start as a child would, in the landscape with three colors and a few lines, rendering my impression of it using only these and then adding forms and colors where their emphasis

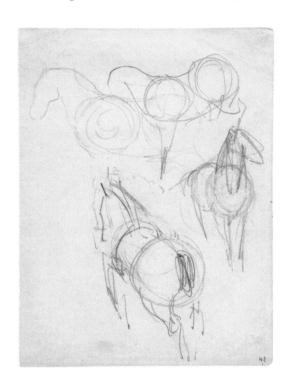

76
Studies of Horses with Circular Forms, 1911
Private collection
CAT. 45

is required, so that the working process consists of adding rather than subtracting. It's only us painters that know how terribly difficult that is."[56]

On February 5th Marc had in fact already written much the same thing to Maria: "One mustn't derive one's compositions from 'objects', but rather from spots and passages of color, from fixed forms and lines, developing what is truly objective out of these, that's the trick of it."[57]

It was Marc's determination to make a new start that led him to paint his celebrated horizontal compositions with blue and yellow horses. And he did indeed start with only a few colors and lines. To begin with, he returned to the arrangement employed in the Lenggries compositions (figs. 34–36) in two images found on an extremely revealing sheet from a sketchbook, now sadly untraced, which shows *Two Groups of Four Horses* (fig. 75).[58]

pages 94—95
77
The Small Blue Horses, 1911
Staatsgalerie, Stuttgart
CAT. 46

78
The Large Blue Horses, 1911
Walker Art Center, Minneapolis, Minn.
CAT. 47

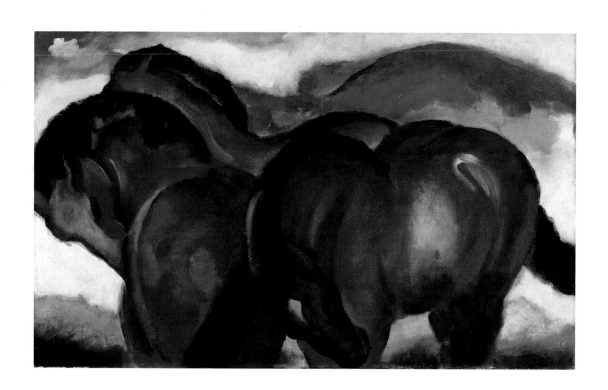

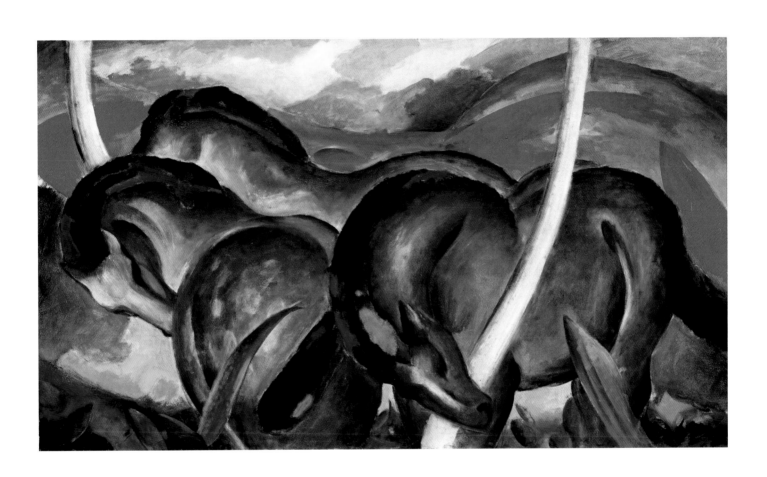

In the upper drawing he emphasizes the structure of the bodies of the animals while more or less reducing the landscape setting to it original form (fig. 34), with the result that the horses now fill out the entire picture.

The composition derives its framework from basic geometrical forms: at its exact center we find an almost complete circle, which embraces the head, neck, and chest of the horse in the foreground. The other compositional elements are almost all evolved through the process of adding larger and smaller segments of circles: the circular form around the rump of the horse on the left, and beyond this the circling movement of its neck, mane, and head; to the right of the central circle, the forms of the belly and croup of the horse in the foreground; also the rotational element in the movement of the two horses in the background. This movement is also taken up in the undulating lines of the landscape and in the hollow below the disk of the sun that radiates as if it were the source of this accumulation of circular motifs and movement.

Apparently unsatisfied with what was, in compositional terms, a somewhat half-hearted new beginning, Marc embarked, in the lower part of the sketchbook sheet, on a variation on his subject. And this time he really did start with only "a few lines". Using the purest of geometrical forms, the circle, he constructed the composition much more clearly and he simplified his treatment of the horses. He in fact adopted the same approach in a small sketch of approximately the same date (fig. 76), where the greater clarity of his procedure suggests that the image may have been intended as a form of demonstration. In both cases Marc almost appears to be exploring possibilities, in order to find where circles would be most appropriate and what might be embraced by them. It is clear that they were more effective when used for the rump and the hindquarters, and less so in the case of the chest and neck areas. An important innovation in the two sketchbook images is to be found in the treatment of the foreground horse: here, in place of the

former forward-stretching of the head we find the face turned down and back; this achieves the placid circling movement that is so characteristic of Marc's work. In both drawings this primary circle is emphasized through being taken up in the cluster of lines around the chest. While extremely clear in the drawings and fundamental to the construction of the figures found there, this incisive inner contour effectively disappears in the related paintings now in Stuttgart and Minneapolis (figs. 77—79). While there are indications that the horse seen in the right background in the first sketch was briefly incorporated within the painted composition, it is clear that Marc must have realized that a triangular grouping made possible a greater concentration and generated more of the "inner necessity" of which Kandinsky, too, was to write.

In the first painting of the related series, *The Small Blue Horses*, now in the Staatsgalerie, Stuttgart (fig. 77), Marc achieved a group that was truly monumental in character in comparison with the Lenggries composition and its descendants, above all on account of the closely packed mass of the powerful bodies and their coloring. In the painting, the vigorous curves of the body forms are taken up by that found in the landscape, or *vice versa*; this is also the case in the more fully worked of the two composition sketches. The animals are surrounded by a sequence of indeterminate colored spaces that only here and there coalesce into a more specific feature, as in the case of the red hilltop. The horses no longer appear to stand in the meadow at Lenggries (as in fig. 35); indeed, any clues as to location are here effaced. We are confronted with the horse as a species, and it is for this that Marc here finds a symbolic image. With masterful simplicity and concentration, this composition encapsulates the sociability of horses, their tendency to gather in pairs and groups, their attention to grooming, their constant readiness to graze, and the exploratory impulse signalled in the head raised and turned.

The blue of the animal bodies, altering with light and shade purely in terms of tone, gives this

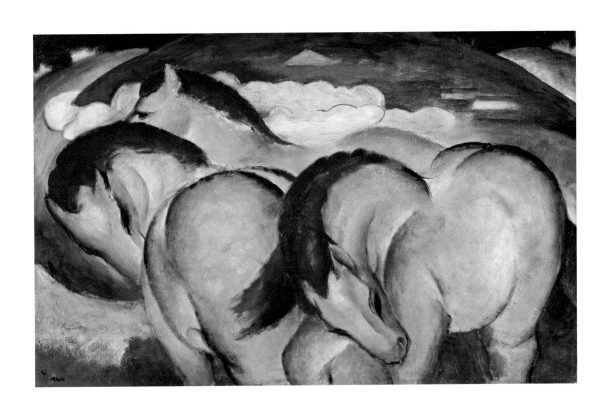

group a solemn, celebratory character and one that (according to Marc's color symbolism) was also to be identified with the male principle and with the spiritual. And it is relevant here to consider one of Kandinsky's observations. It was not difficult, he said, to see "that many colors were intensified in their effect by the forms they assumed [...] Those tending toward consolidation are encouraged in this effect through rounded shapes (e.g. the blue of circular forms)."[59] In Marc's picture the blue dominating the center of the composition is surrounded by complementary contrasts. The result is a visionary view of the horse as a creature; and Marc here found a pictorial form that has assured his enduring association with the horse as a subject for artists.

While in *The Large Blue Horses*, in the collection of the Walker Art Center, Minneapolis (fig. 78), Marc adopts the composition of the smaller and immediately preceding version virtually unaltered, the mood achieved in this picture is rather different. This is not only on account of the size of the later picture — which is over twice that of the one in Stuttgart — or the more emphatically elongated format. It is above all the result of the bolder, less

lyrical execution of this painting, the even more intense, and less modulated, blue of the bodies of the horses, and the more assertive colors found in the setting. The two blade-like tree trunks and the larger leaves appear to be almost alien elements. Taking up the movement of the horses in terms of both form and rhythm, they have a decorative effect that recalls the work of Henri (Le Douanier) Rousseau, much admired by Marc and his friends.[60]

The incorporation of the animals within the landscape is achieved here through a process of chromatic compression: in place of the white passages found in the picture in Stuttgart, the blues used for the bodies of the horses recur in both left and right backgrounds, while the vivid green of the plants is found again in the highlighted passages of the horse's manes and tails. In resorting to such devices, Marc was probably seeking to achieve an even more emphatic evocation of the male principle and the sense of melancholy. In this respect the picture in Minneapolis also offers a powerful chromatic contrast to the group of horses in the Busch-Reisinger Museum (fig. 68), with its dominant red, for Marc symbolizing matter, and

80

The Large Yellow Horses,
1913/14
Destroyed; formerly in the
Koehler Collection, Berlin

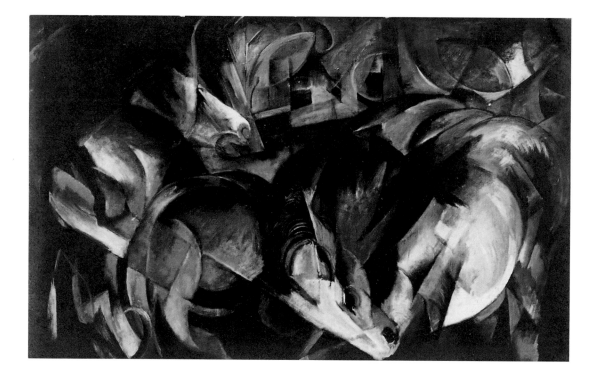

its compelling evocation of a cheerful and glowing vitality. This is countered in the composition in Minneapolis (fig. 78) with a sense of dread that might be associated, in seasonal terms, with the fall. The blue-black eyes of the horses themselves play a role here, adding to the solemnity of the faces rather than enlivening them.

through the expansive arc enclosing a mountain peak, its border of clouds, and several cursorily rendered houses. The viewer is prompted to interpret this blue arc not so much as a hilltop but as a segment of the globe. Similarly, the blue passages in the lower part of the ostensible landscape setting are no longer suggestive of a meadow. While

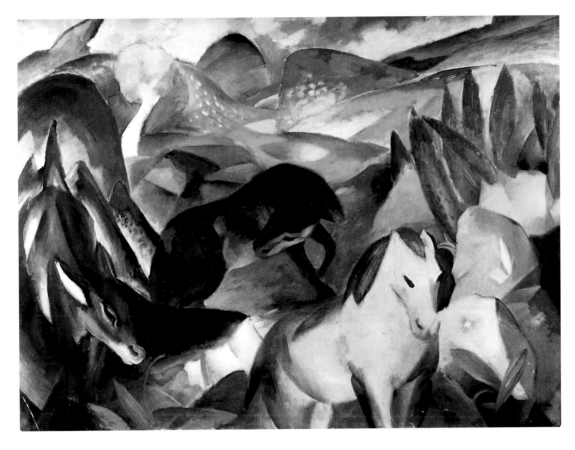

81
Large Landscape with
Horses and a Donkey,
1911/12
Destroyed; formerly in the
Koehler Collection, Berlin

In *The Small Yellow Horses*, painted in 1912 (fig. 79), also in the Staatsgalerie, Stuttgart, Marc again returned to the compositional arrangement found in *The Small Blue Horses* in the same collection (fig. 77). As a result of the decision to employ yellow for the bodies of the horses, Marc (in accordance with his ideas on color theory) largely eschewed the use of red and green in the landscape. In their place we find blue, while red only occurs toward the edges of the composition, with green and a blackish green used as a contrast to the yellow of the bodies, accenting the vigorous movement of manes and tails. The viewer also assumes a cosmic dimension

achieving here the most beautiful color harmonies, Marc also largely succeeds in significantly extending the mythical dimension of his theme.

As Claus Pese has appositely observed, Marc's *Blue Horses* are more painterly in their treatment, while in the *Yellow Horses* there is greater emphasis on line. "Combined with the implications of color [as used by Marc], this difference in treatment allows for further gender differentiation: the 'female' yellow horses are far more likely than the 'male' blue ones to awaken associations with the female nude. This is especially evident in the case of the yellow horse on the right [of fig. 79]."[61]

82
*Black Horse and White
Horse in a Mountain Land-
scape with a Rainbow, 1911*
*Graphische Sammlung
Albertina, Vienna*
CAT. 49

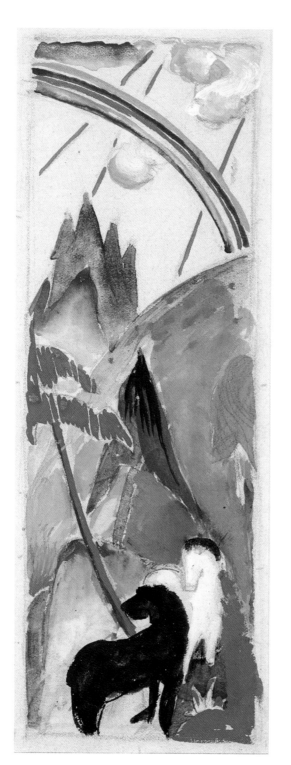

For Marc, however, *The Small Yellow Horses*, with its "cosmic" landscape, was by no means the conclusion to this series of compositions. He next started work on the painting *The Large Yellow Horses* (fig. 80), equal in size to *The Large Blue Horses* in Minneapolis. Sadly, the new picture (acquired, like the *The Small Yellow Horses*, by the Berlin collector Bernhard Koehler, Sr.), was destroyed during the Second World War. Started in 1912, it was frequently reworked (see p. 214). The pose of the horses in the foreground remained essentially the same, in spite of the segmenting of the animal bodies in the spirit of a Futurist dynamism or the adoption of an Orphist language of planar faceting; but the horse standing in the background, distinguished by the abrupt movement of its head, is utterly different in character, imbuing the scene with drama of the sort found in *Animal Destinies* (fig. 177).

A further composition acquired by Bernhard Koehler, Sr. was the *Large Landscape with Horses and a Donkey* (fig. 81); this, too, was destroyed during the war, but it nonetheless merits a brief mention in our survey. At two meters in breadth, one of Marc's largest paintings, this work derives from earlier compositional ideas, and it attained its definitive form during the especially fruitful period of 1911—12. In the animated mountain landscape further enlivened with large agave plants, a horse seen in the foreground appears as if about to step out of the picture. It is observed by a donkey, located at the extreme left; and, between the two, and also serving to link them, we see a horse mounting a slope with its head turned back in the manner that especially appealed to Marc. The description of this picture provided by Schardt in the 1930s helps us to envisage its powerful rendering of the animals in whitish blue, blue, and red. In Schardt's view, the composition as a whole evoked "a primeval world

83
Landscape with Animals and a Rainbow, 1911
Private collection
CAT. 50

84
Leaping Horse, 1911
Private collection
CAT. 51

Blaue Reiter). The vertically staggered landscape of the sketch lacks a spatial dimension in the painting on glass, where it appears as an arrangment of contiguous planes, for the techniques employed did not favor the representation of depth. Marc, however, compensated for this limitation through his joy in narrative detail, adding further animals and the new rhythms set in motion by a scatter of abstract lines. Marc in fact was so fond of this especially large glass painting that he was to include it in the show organized with Kandinsky as the first exhibition to be mounted in association with the almanac.

The brush and ink drawing of a *Leaping Horse* (fig. 84), which comes from the same sketchbook as the watercolor now in Vienna (fig. 82), relates to Marc's earlier series of pictures with foals (figs. 52, 53). In the drawing of 1911, however, Marc is clearly much readier to employ stylization and contrast, to the extent that it is easy to see a large painted composition already implicit in the small sheet, even if the painting as executed was in fact to exhibit quite different compositional structures (fig. 99).

that was still entirely untouched by, and thus still free of, the layers of the deadening future centuries."[62] From this point of view, the picture could be seen as an anticipation of subjects addressed by Marc in 1913, such as *The First Animals* (fig. 155) and *The Creation of the Horses* (fig. 145).

Among Marc's secondary activities in the busy year 1911 was his much enjoyed involvement in painting on glass. Here he was in fact following Kandinsky's example, and it is possible that he was also joined in this elevated Sindelsdorf pastime by Macke, Heinrich Campendonk, and others. Sadly, most of the works produced by Marc in this medium are now untraced.

The vertical format of a sketchbook composition now in the Albertina, Vienna, showing a *Black Horse and White Horse in a Mountain Landscape* (fig. 82) points to its function as a preparatory sketch for a paintig on glass (fig. 83). The techniques involved permitted little in the way of nuances; this accounts for the two-dimensional black/white contrast of the bodies of the two principal animals (a feature that was soon to be found in the color contrasts of the illustrations made for the almanac *Der*

DER BLAUE REITER AND THE YEAR 1912

The idea, the name, and the realization of the almanac *Der Blaue Reiter*, the two exhibitions organized in connection with it, and Marc's crucial role in all of these are discussed in the essay by Karin von Maur (pp. 195 ff.), so that these events need only briefly detain us here.

In addition to his three key, compelling texts for the almanac, Marc also produced one of the two original woodcut illustrations in the volume. For the deluxe version of the first edition he prepared a sketch of extraordinary spontaneity (fig. 85). The second version of this composition, inscribed on the back "richtige Vorlage" [correct model] (fig. 86), is distinct in its more homogenous color planes and calmly fluent outlines, which

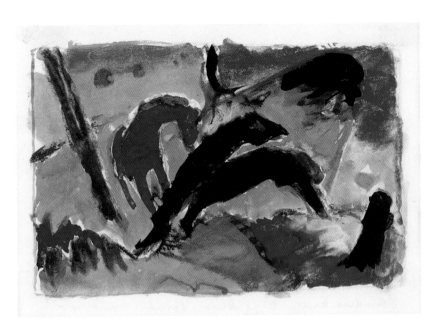

85
Two Horses, 1911/12
Private collection
CAT. 52

86
Two Horses, 1911/12
Franz Marc Museum, Kochel am See
CAT. 53

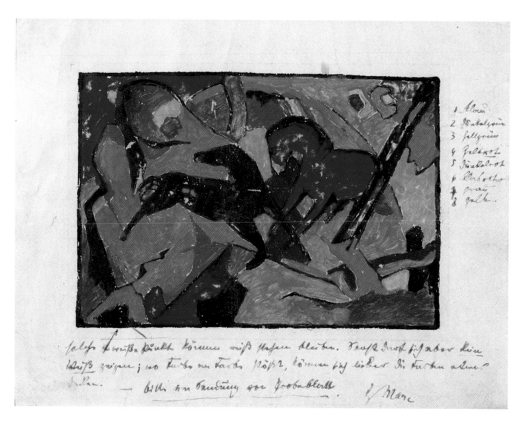

87
Two Horses, 1911/12
Private collection
CAT. 54

88
Two Horses, 1911/12
Kunsthalle, Hamburg
CAT. 55

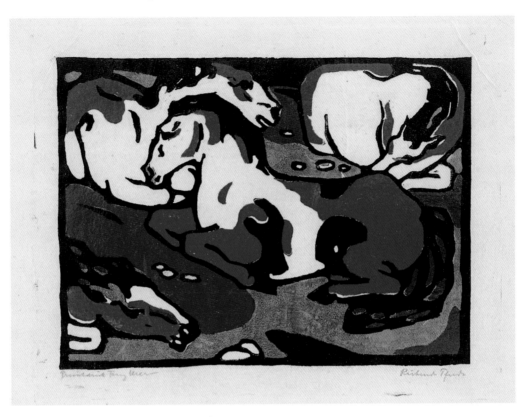

89
Resting Horses, 1911/12
Staatliche Graphische Sammlung, Munich
CAT. 56

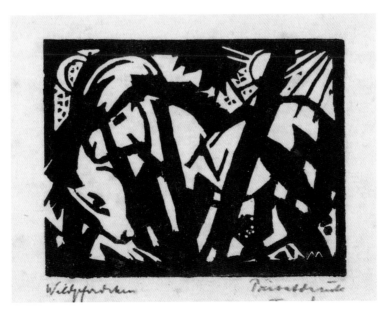

90
Small Wild Horses, 1912
Staatliche Graphische Sammlung, Munich
CAT. 57

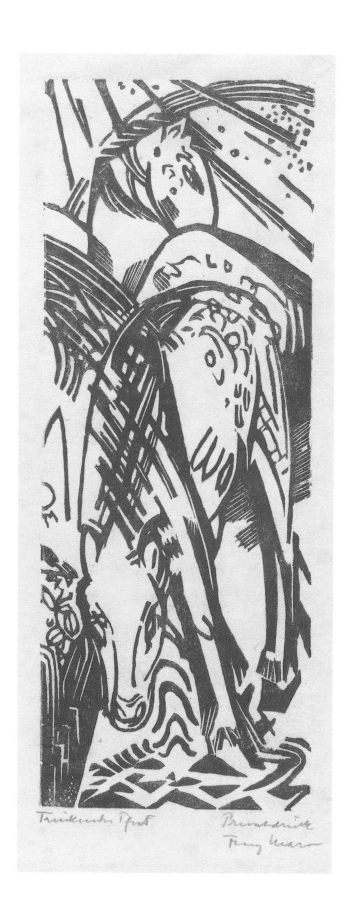

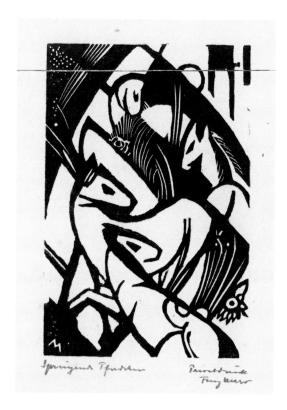

92
Small Leaping Horses, 1912
Staatliche Graphische Sammlung, Munich
CAT. 59

91
Drinking Horse, 1912
Staatliche Graphische Sammlung, Munich
CAT. 58

already resemble the hand-colored woodcut of the standard version.

For the second edition of the almanac Marc decided to adopt a slightly modified pictorial arrangement. Once again, two impressive sheets in watercolor and gouache have survived. The version incorporating Marc's comments (fig. 87) reveals that he had come to desire a much greater range of colors, but would, if necessary, tolerate white patches within the image. A sheet now in the Kunsthalle in Hamburg (fig. 88) conveys the exact appearance of the print as he envisaged it.

In both versions of this composition, Marc shows how two horses galloping toward each other are able to stop in their tracks at the last moment: the more vigorously approaching figure through the sudden backward turn of its head, the horse in the background by means of breaking its own momentum with its rigid front legs. The resulting image is a dazzlingly succinct formula for the enormous range of movements available to the horse and for its inherent dynamism, qualities that may also have assumed a symbolic value in this highly unconventional "book for riders".

A few words, too, on four prints. The woodcut *Resting Horses* (fig. 89) shows four animals comfortably reclining or sleeping. With its naturalistic forms and its ornamental, segmented planes, this sheet has a decorative charm that is akin to that of Munich *Jugendstil*. In his subsequent woodcuts Marc was to eschew the use of three colors, employing only one.

The magical *Small Wild Horses* appearing behind tree trunks by the simultaneous light of sun and moon (fig. 90) seem barely containable within the confines of the small image. For the slender standing figure seen in *Drinking Horse* (fig. 91) Marc selects a correspondingly proportioned woodblock. A rainbow merges with the mane of the horse in the background.

The *Small Leaping Horses* (fig. 92) do not in fact entirely merit their title, with the possible exception of the animal at the base of the composition. Even this horse seems, rather, to be climbing,

and its movement is taken up by the other three animals so that there arises a zig-zag rhythm that anticipates the *Tower of Blue Horses* (fig. 111).

Returning to Marc's work in color, and once again to his paintings on glass. As a highly valued form of folk art, above all in its Bavarian manifestations, glass painting was extremely well represented in the almanac *Der Blaue Reiter*, and at the wish of both its editors, Marc and Kandinsky. We have already mentioned Marc's experiments with

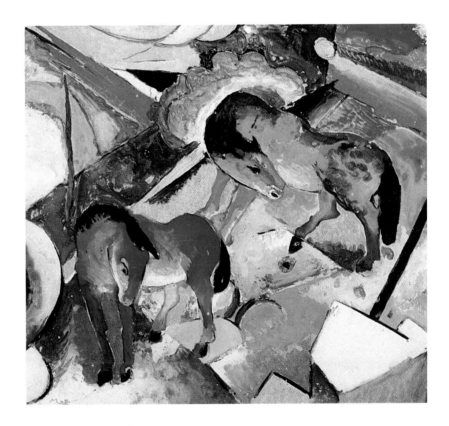

this medium, and we may here consider another, particularly fine example of his work.

Two Horses in a Landscape (fig. 93) is a paraphrase of the gouache *Red Horse and Blue Horse* now in the Lenbachhaus, Munich (fig. 94). The composition painted on glass appears in reverse because the work is executed on the back of the support. The stiffness of the latter demands a modification of painting technique (in particular the use of shorter brushstrokes to dab paint on to one small area at a time), while its transparency

93
Two Horses in a Landscape,
1912
Private collection
CAT. 60

page 109
95
Horse and Donkey, 1912
Private collection
CAT. 62

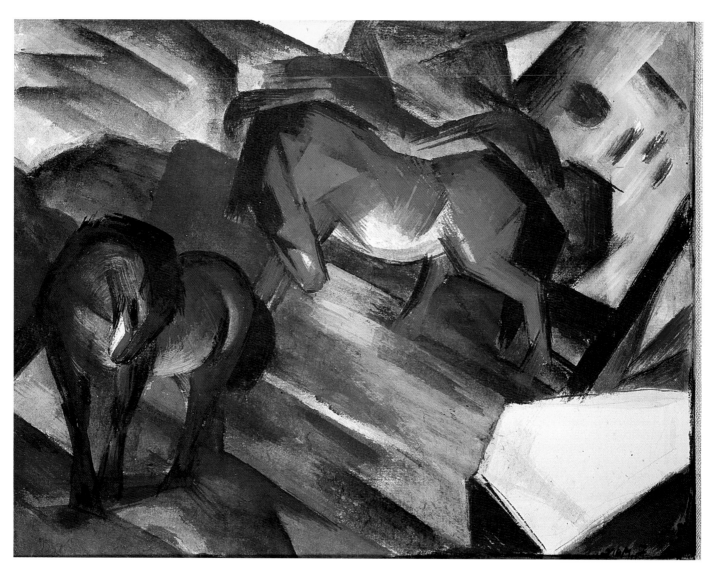

94
Red Horse and Blue Horse, 1912
Lenbachhaus, Munich
CAT. 61

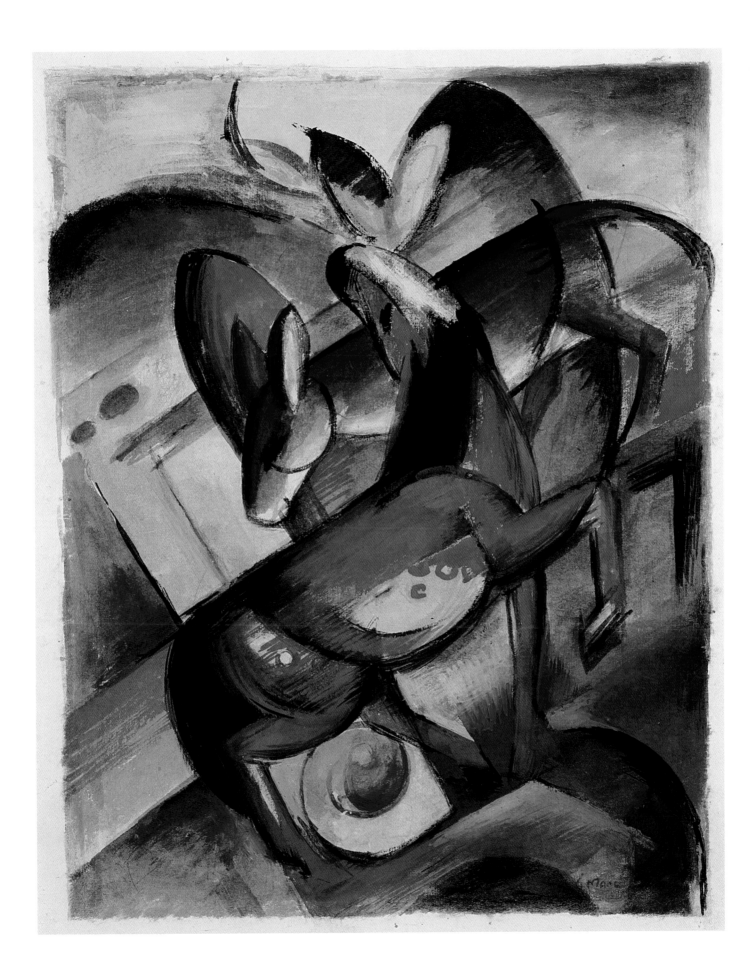

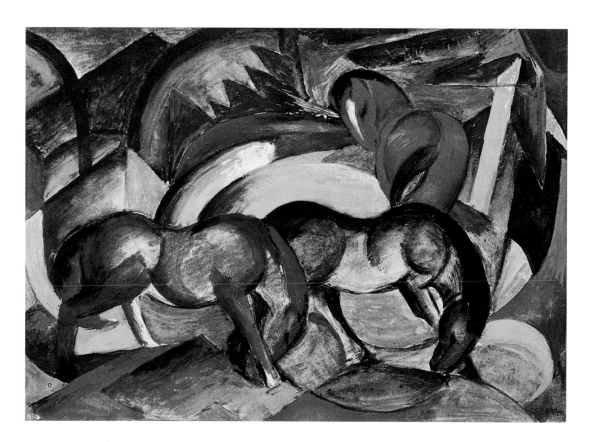

96
Three Horses, 1912
Untraced

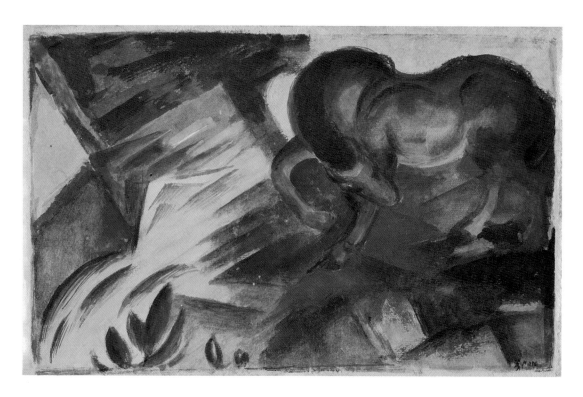

97
Green Horse, 1912
Private collection
CAT. 63

ensures that colors retain all their brightness. The blue horse is of the type found in the sculpted group of 1908/09 (figs. 37—39), testifying to Marc's preference for a relatively limited figural repertoire. The second horse, an especially lively animal, is shown turning its head to clean its right flank.

In the gouache (fig. 94) there is a strong, rising diagonal movement in the treatment of the landscape that is underscored by the positioning of the red horse but is offset to some degree by the calm fixity of the blue foreground figure. There is less of this somewhat Futuristic dynamism in the glass painting, for there diagonal and circling elements are more fully balanced.

In comparison with the gouache now in Munich (fig. 94), we find a greater tendency to abstract forms in the tempera composition *Horse and Donkey* (fig. 95), where there is even greater emphasis on the diagonal both in the setting and in the anti-naturalistic straight lines forming the backs of the two animals. As a result, the viewer is alerted to the presence of basic geometrical forms, but also has a sense of the interaction of creature and nature. Here, indeed, Marc appears to deny his animals an existence outside their landscape setting: like the observing human individual, they perceive their environment from a point within it, as a constituent part of the world understood as a unity. Hence the plethora of indeterminate transitional passages that serve to weave the animal bodies and the space surrounding them into a continuous fabric. The leftward movement of the neck and head of the red horse is taken up in the slope of a blue hill; and the outline of the hindquarters of the donkey finds a continuation in the green-gray forms both above and below its body; the legs of the red horse seem to grow out of the ground on which it stands. Through simplifying the formal elements of this composition, Marc greatly intensifies their expressive value.

The *Three Horses* (fig. 96), a now untraced composition almost twice the size of *Horse and Donkey*, shows a similarly segmented landscape with two animals in its lower portion placed parallel to the picture plane and moving forward calmly in balletic unison. Beyond them, a third horse, seen from the rear, adopts an almost coquettish sideways turn. Here, too, a rhythm established and carried by emphatic color contrasts pervades the composition, uniting the setting and its inhabitants.

Works of this sort, of small or medium scale, executed in gouache, tempera, or watercolor, and sometimes in a combination of media, increasingly offered Marc a chance to implement and explore new ideas in a less expensive or time-consuming form than represented by painting in oils. These works, most of them on paper, are not to be understood as forms of preparation for related oil paintings; they are, autonomous creations. This is also true of the numerous postcards that Marc painted (most of them produced during the course of 1913).

Although these were necessarily even smaller in scale, sometimes mere sketches, and variously poetic, dream-like, playful, and intimate in character, they nonetheless very often achieved enormous monumentality in terms of pictorial conception.

In the landscape with the *Green Horse* (fig. 97) we again encounter the self-referential circling movement of the head turned down and back. Here

98
Leaping Horse with Plant Forms, 1912
Private collection
CAT. 64

the landscape retains only a few specifiable features and these are little more than hints. The color of the animal is itself notable, for green horses appear very rarely in Marc's work. Did he perhaps share Kandinsky's astonishing views on this color? "Passivity is the essential characteristic of absolute green, for this quality is imbued with a sort of obesity and self-satisfaction. Absolute green is to the realm of color, accordingly, what the so-called bourgeoisie is in the human realm: it is an immobile element, satisfied with itself and limited from every point of view. Green resembles a fat and very healthy cow, reclining in absolute immobility."[63]

Marc made a preparatory drawing of his *Green Horse* in a sketchbook, and this is now in the Solomon R. Guggenheim Museum, New York (Lankheit 1970: 598). It is possible that a sheet of the same dimensions, showing a *Leaping Horse with Plant Forms* (fig. 98), comes from the same

sketchbook, although it differs greatly in terms of form. Here the vegetation is not concentrated in one or two areas of the composition (Marc's usual procedure), but distributed, in the form of virtually abstract simplifications, across the entire sheet against a pale, neutral background. The horse appears to be fighting its way through an almost tropical density of plant growth. A stylistic proximity to Kandinsky is evident here, but this was to represent only a passing phase in Marc's development.

Closely related to the celebrated *Tiger* in the Lenbachhaus in Munich, Marc's *Leaping Horse* in the Stangl Collection (fig. 99) adapts a sketch made in 1911 (fig. 84) and reveals both his engagement with, and his reservations toward, the stimulus of Cubism. While the image of the *Leaping Horse* is dissected in a cubistic manner, and to that extent merged with its setting, the animal nonetheless

99
Leaping Horse, 1912
Stangl Collection, on loan to Franz Marc Museum, Kochel am See
CAT. 65

page 113
100
Little Blue Horse, Picture for a Child, 1912
Saarland Museum, Saarbrücken
CAT. 66

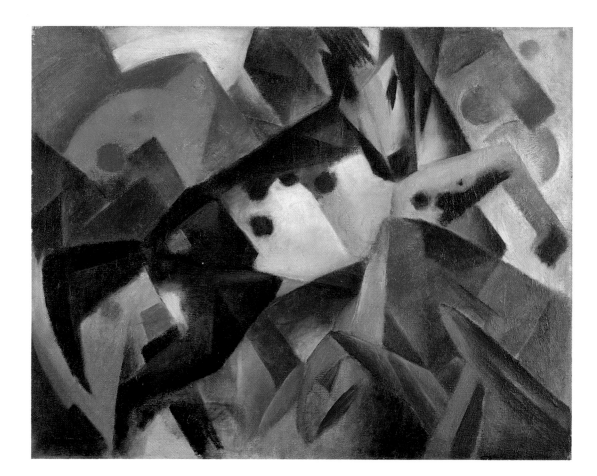

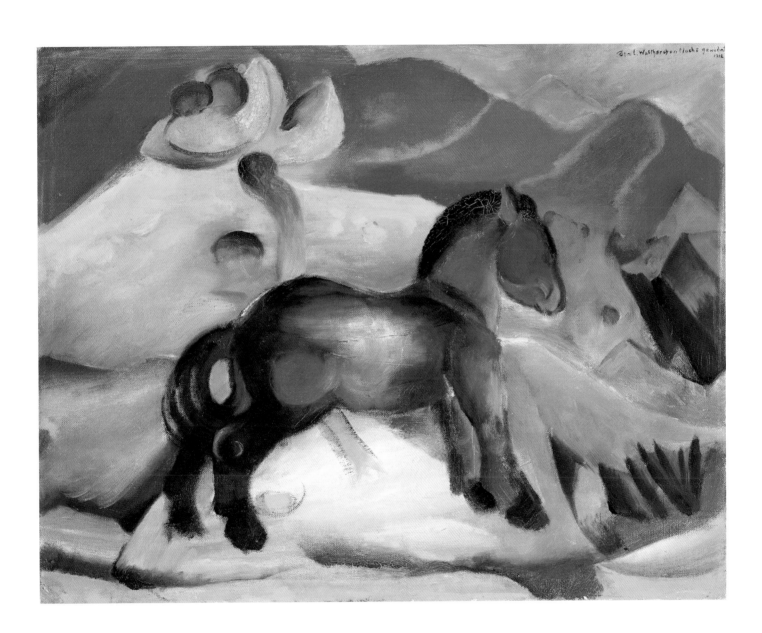

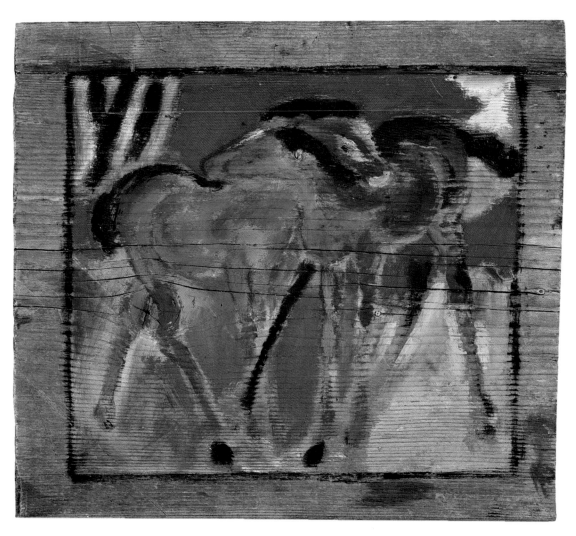

101
Blue Foals, 1912
Stedelijk Museum, Amsterdam
CAT. 67

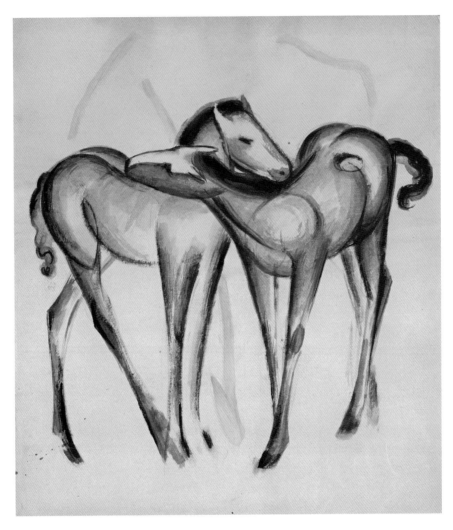

102
Two Blue Foals, 1911
Private collection, Switzerland
CAT. 68

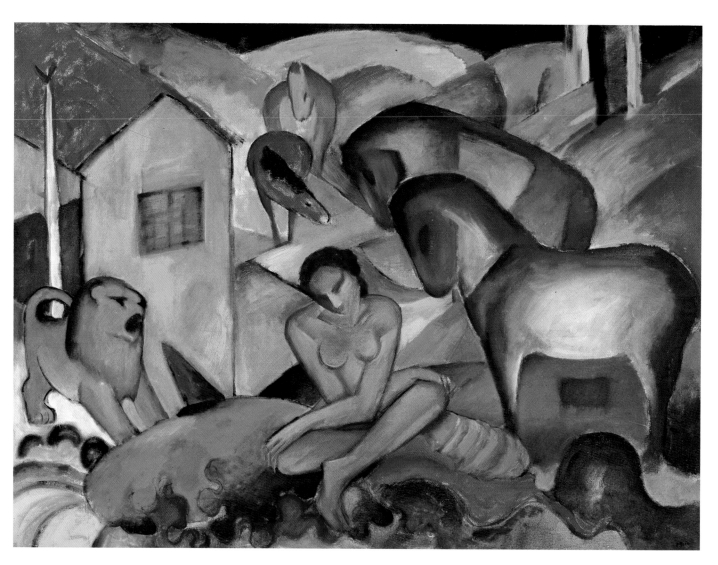

103
The Dream, 1912
Museo Thyssen-Bornemisza, Madrid
CAT. 69

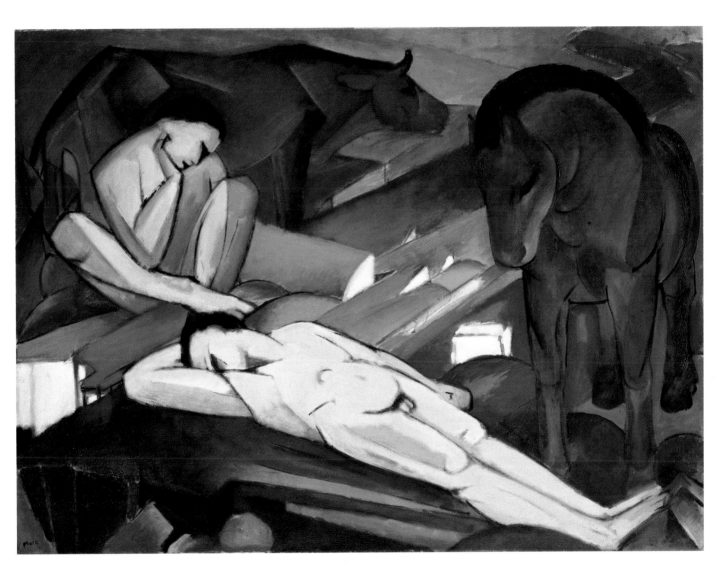

104
The Shepherds, 1912
Private collection, on loan to Franz Marc Museum,
Kochel am See
CAT. 70

clearly remains an entity distinct from the landscape. The recurrence of star-like points and disks throughout the composition introduces a further form of abstraction but also appears to signal a cosmic dimension. The horse seems to be on the point of leaping out of its earthly environment, on which only a few large agave leaves insist. The image of a horse here emerges as something approaching an archetype.

In the spring of 1912, in his essay "The New Painting", Marc formulated a series of maxims that offer a key to our understanding of his work of this period and also that of the following years. "Today we seek to look beneath the veil of appearances, at

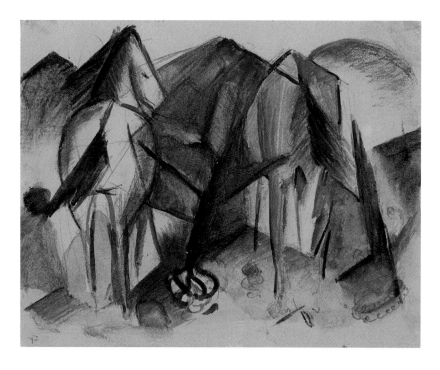

105
Two Horses, 1912/13
Private collection
CAT. 71

106
Horses and an Eagle, 1912
Sprengel Museum, Hanover
CAT. 72

those things in nature which are hidden, and which seem to us to be more important than the discoveries of the Impressionists and easily to surpass these. And it is not out of caprice or the mere desire for novelty that we seek out this inner, spiritual side of nature, and endeavour to paint it; we do this because we *see* this side, just as people suddenly once 'saw' violet shadows and the ether that enclosed and pervaded everything. We'd find it as hard to explain why they did this as we do to

explain ourselves. In both cases it's a matter of the time being right."[64]

In April 1912, not long after painting his *Leaping Horse*, Marc produced the *Little Blue Horse*, now in the Saarland Museum (fig. 100), as a birthday present for the two-year-old first son of August and Elisabeth Macke, Walter. Yet this picture is more than an avuncular gesture of friendship toward the child and his parents. In its marvellous colorfulness and the simplicity and beauty that make it so appropriate for a child, it is also a symbol of the purity, clarity, and joy associated with childhood. In its intensity, moreover, it may well signal something of the restrained sorrow felt by Franz and Maria at their own childlessness, a sorrow that sought an outlet not only in their ceaseless expression of interest in Macke's children, their concern for their progress, and their requests for photographs. It was also expressed in the care they showed for their own animals, initially a dog and a cat, and later the deer that they lovingly cared for in their own garden.

Similarly characterized by intensity of emotion, albeit not so affectionately awkward as the stiff little horse painted for Walter Macke, are two pictures with blue foals: one painted on a board that served as a table on the balcony at Sindelsdorf (fig. 101), the other a somewhat larger composition in watercolor (fig. 102). The cautiously, almost tenderly executed rite of mutual grooming produces a delicate intertwining of young animal bodies that in the watercolor assumes an almost floral character.

The splendidly poetic composition entitled *The Dream*, now in the Thyssen-Bornemisza Collection in Madrid (fig. 103), which Marc presented to Kandinsky in exchange for the latter's picture of a horse and rider, now in Munich, presents an easily comprehensible landscape setting of simple forms and clear colors. Everything seems to be mysteriously interrelated. A naked female figure with a meditative air sits cross-legged on the ground alongside a very simply rendered house with a maypole and the figure of a small roaring, yet apparently retreating, lion. Especially prominent in the composition are the two blue horses

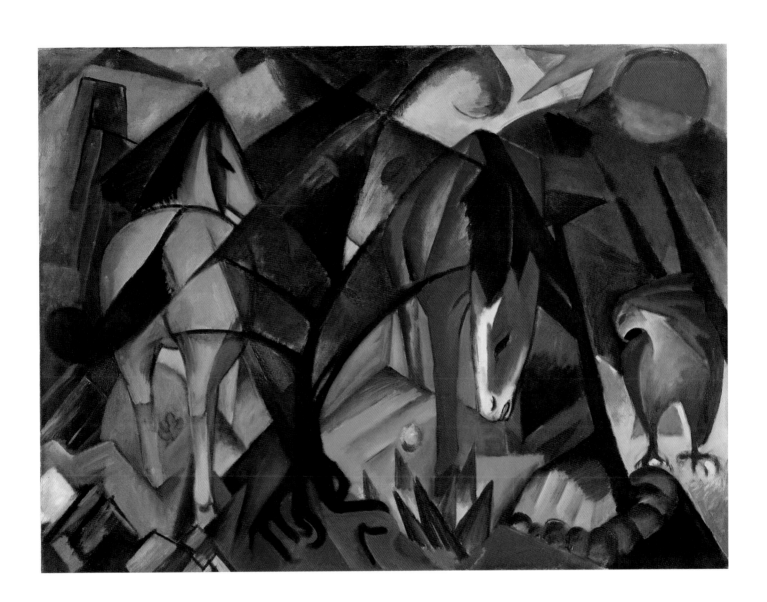

shown in profile that seem especially attentive to the seated figure. Beyond, we find two further, reddish colored horses. As a group, the four horses function here almost as patron saints, emphasizing the diminutive stature of the lion and keeping it at bay; and they begin to constitute, through their positioning, a tower-like form of the sort that Marc was soon to adopt as his principal motif (figs. 109, 110, 111).

Animals again appear to assume a protective role in a picture of equal size, *The Shepherds*, now on loan to the Franz Marc Museum at Kochel am See (fig. 194), a further example of the only sporadic occurence of human figures in Marc's pictorial universe. Once again we find a naked figure seated cross-legged on the ground, in this case at the head of another nude, who is reclining and appears to be asleep. A cow placed behind the first figure corresponds to the horse standing to the right of the second. As in the case of the picture in Madrid (fig. 103), we encounter a puzzling dream episode, in which the human figures, either self-absorbed or asleep, appear to be protected in their vulnerability by animals of a "holy" character. In formal terms, *The Shepherds* constitutes an exception in Marc's work of this period, be it on account of the stiffness of its figures, its cubistic generalization of forms, or the "sculptural" construction of the composition.

Horses and an Eagle painted in the late summer of 1912, and now in the Sprengel Museum, Hanover (fig. 106), for which a preparatory drawing from a sketchbook, *Two Horses*, also survives (fig. 105), is among the most important works to be produced by Marc during this very fruitful year. Here one can detect the evidence of his intensive engagement with Cubism, Orphism, and Futurism. Three-quarters of the picture plane is occupied by the two horses, who stand to either side of a tree, and only a quarter by the eagle. The composition is rhythmically articulated by the principal tree and the stalk found between the red horse and the eagle, these features dividing the composition into unequally broad segments, to each of which there is assigned

a creature. The broadest is the central section with the red horse, which inclines its head toward a red flower. This is flanked to either side by figures rendered in the other primary colors: the yellow horse (viewed from the rear) and the blue eagle. The narrower area occupied by this last and its own much smaller size are compensated through the intensity of its coloring and through the presence of the orange-red disk of the sun. Equally contributing to the compositional balance to be found within this picture are the violet tones present in the setting to both left and right and the countering of the inward-pointing crystalline forms on the left by the black arrow-like forms on the right.

Each of these aspects of the picture combine to create an overall lattice of forms and color planes, in which animals and plants partially merge with the setting. This is even more evident in the preparatory drawing (fig. 105): here, for example, the mane of the animal to the left appears to continue as part of the mountains in the background. In the painting there are also many striking visual echoes to be found: the black tail on the left is balanced by the large curling leaf toward the upper right; the eagle's claws and the roots of the tree curve to grip the earth in a similar fashion. While the animals and the plants nonetheless remain clearly recognizable, other elements in the composition are rendered as largely abstract, crystalline forms.

In the late fall of 1912 Marc painted *Mare with Foals*, now in a private collection in Switzerland (fig. 107), a work employing more subdued colors and evoking a prismatic world even more strongly segmented. The animals fill most of the compact horizontal canvas, the mother aligned parallel to the picture plane, spanning its entire width, with the two foals, already stocky in build, in front of her. The composition is very tightly controlled in terms of both color and form. The red and the blue of the young animals may be seen as the source of the violet tone of the mare. Or, *vice versa*: the violet may be understood as dividing into its basic components to provide the coloring of the foals. The red foal in the foreground, seen entirely from the

107
Mare with Foals, 1912
Private collection,
Switzerland
CAT. 73

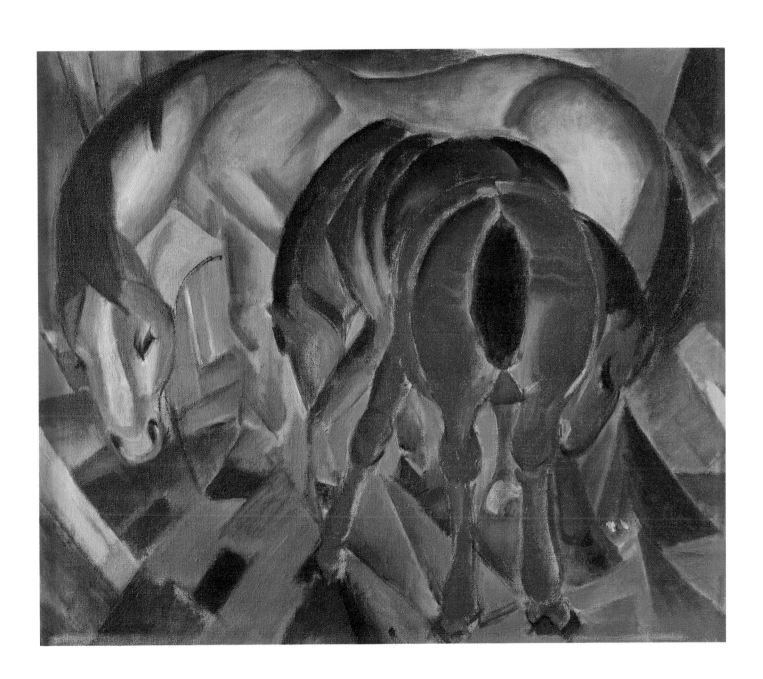

rear, is positioned at a right angle to its mother; the blue foal, which is somewhat larger, and is perhaps already a yearling, turns toward her, and our attention is drawn to this gesture by the corresponding head movement on the part of the red foal. An inner dialog, moreover, links the three animals, in as far as Marc has arranged their heads and eyes at

108
Resting Animals, 1912
Destroyed; formerly in the Koehler Collection, Berlin

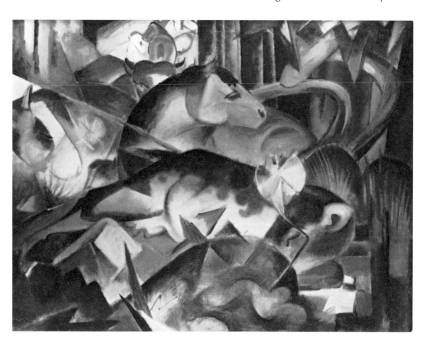

the same height. The pictorial principle of *isokephalia* — the arrangement of faces in a row, regardless of the relative proximity or distance of those shown — was a well-proven compositional device, used above all during the early Renaissance and particularly in the representation of saints. By this means, Marc succeeds in bestowing a noble and even sacred character on his animal protagonists; and here it also serves to establish a greater degree of harmony within the trio. It is telling that the alignment of inclined heads occurs at the vertical mid-point of the composition, as also at the approximate visual mid-point of the body of each horse: these animals are not in fact shown grazing but appear, rather, to be caught in a transitional movement. Its reiteration in the curved internal and external outlines of the animal bodies bestows a greater cohesion on the group. This is further

strengthened by their ambiguous relation to their predominantly green landscape setting. In spite of their emphatic solidity, they appear not so much to stand in this as to hover in front of it. The realm around them appears simultaneously two- and three-dimensional; and, within it, their own existential rhythm oscillates like a series of echoes.

Among the other significant works from this period is *Resting Animals*, painted in the late fall of 1912, a picture acquired by Bernhard Koehler, Sr. but destroyed, along with most of his collection, during the Second World War (fig. 108).[65] In as far as we may assess this painting from the evidence of an old photograph, the horse turning its head abruptly occupies a dominant position among resting cattle. In the background we can see the small rear-view figure of a second horse. The subject treated here (one that was to be further developed in the Genesis-related works of 1913/14), the dynamic quality of the composition, and the Orphist faceting, prompt us to conclude that the picture must have been very powerful in its impact, thus making its loss all the sadder.

1913: THE TOWER OF BLUE HORSES: "NEIGHING ARCHANGELS"

1913 was the most fruitful year of Marc's artistic career; and this is above all true with regard to his images of horses. As the chronological sequence of the works produced at this time is not always clear, we shall consider these, rather, in thematic groups, each embracing large painted compositions, pictures in tempera and works on paper executed in a combination of media, small studies and postcards, and finally prints.

We shall begin with the *Tower of Blue Horses,* the celebrated large painting that has been untraced since 1945, but of which old color photographs still convey a relatively good impression (fig. 111).[66] The pencil preparatory sketch of 1912

(fig. 109) and the wonderful postcard in watercolor, which Marc sent to the poet Else Lasker-Schüler at the start of 1913 (fig. 110),[67] are remarkable for their esthetic quality but, on account of their small scale, cannot really serve as a substitute for the painting, which was two meters in height.

Even if not especially familiar with Marc's ideas concerning transcendence, the sensitive observer will immediately note that in the painting the artist bestows a majestic, spiritual, indeed religious dimension on his horses through his treatment of both color and form. The compositional rhythm is established by the powerful animal in the foreground, which combines with the three further horses behind and above it, to create a tower-like structure. Each individual animal is made up of circular outlines deriving from curving, prismatic, rhomboidal, and triangular forms. In stacking his four protagonists one above another, Marc achieves not only an emphatic concentration of the sense of their animality, but also an extremely forceful intensification and elevation of our concept of "the horse". The steeds here appear almost like Old Testament patriarchs. Their calm sideways glance is no longer an expression of exploratory curiosity; almost hieratic in its repetition, it becomes a symbol of the capacity for knowledge and a more profound form of contemplation. For centuries the companion, friend, and helpmate of man, the horse is here raised to the level of humanity and perhaps even above it, a status signaled through its generalized and ennobled form, and above all through its coloring. For Marc, blue was associated with the spiritual; and since the "blue flower" of German Romanticism, this color has been seen as symbolic of the quest for what is pure and of a dreamlike innocence. In its combination here with the crystalline structure of the bodies of the horses, which appear simultaneously solid and diaphanous, there are associations with the architecture of Gothic cathedrals. The intensity of the coloring resembles that of a Gothic stained-glass window in that it exudes its own luminosity. These blue horses are

not illuminated by a particular source of light; rather, they themselves glow, they are bearers of light, if not indeed bringers of light. This accounts for their aura, and seems to demand an attitude of reverence.[68]

We are also reminded that the saints were often presented in such a manner in Medieval altarpieces. The figure in the immediate foreground would be shown in full; but the others would appear only as heads and haloes. The resulting choir-like groups exhort the congregation to a shared recognition of the presence of the divine and the imperative of devotion.

The religious, pictorial and ecclesiatical associations of the *Tower of Blue Horses* are further strengthend through the motif of the rainbow, which arches over the animals almost like a halo that they share. While rainbows are a trick of the light that are easily explained in terms of physics,

110
The Tower of Blue Horses, 1912/13
Bayerische Staatsgemäldesammlungen, Munich

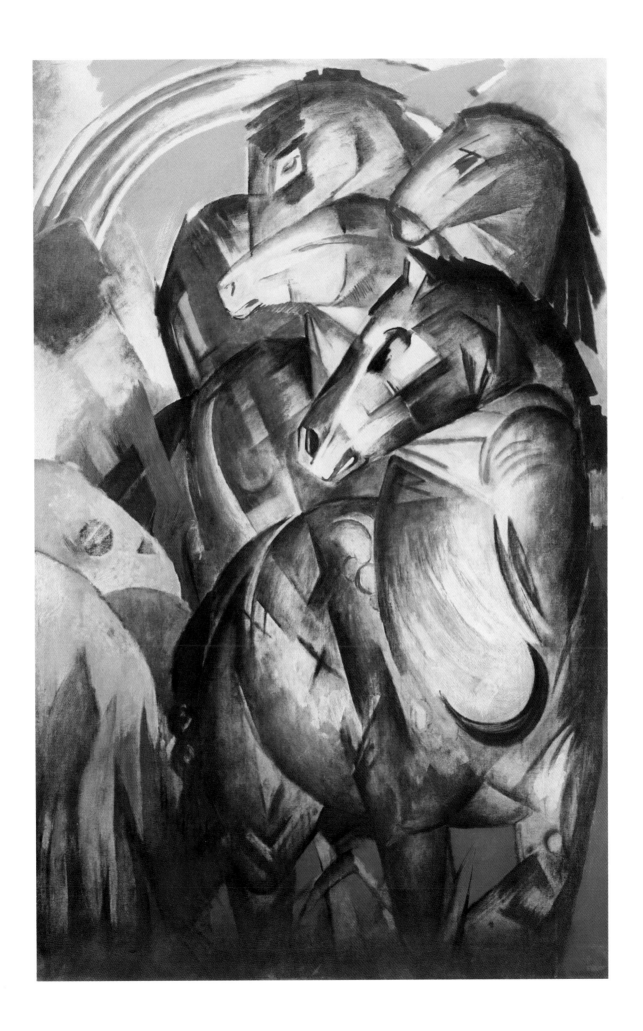

they have, since time immemorial, had a symbolic meaning thanks to their visionary, almost halluci-natory character. In the Christian context they have been seen as a sign of peace, marking God's Covenant with man after the Flood. As in the work of the artists of early Romanticism, for example Caspar David Friedrich, whom Marc valued as one of the forefathers of his own pantheistic striving, we find in the rainbow here a merging of the terrestrial and the cosmic, of nature and religion. The rainbow becomes one of Marc's key motifs, a symbolic ele-ment in his struggle to convey in his work a purified and spiritualized form of being. Often to be found alongside the rainbow are stars — as in this case the star-like crosses on the bodies of the horses — and the crescent moon: as anti-naturalistic sym-bols, these underscore the preoccupation with transcendence. Else Lasker-Schüler, in her wonder-fully idiosyncratic manner, captured the essence of

Marc's *Tower of Blue Horses* when, in response to the small watercolor version, she spoke, in simul-taneous awe and affectionate mockery, of "neighing archangels".[69]

Marc has here elevated the horse, perhaps the noblest of the animals, into a sacred being, but he has also made it into an image representing the better world that he believed the future would bring. In the almanac *Der Blaue Reiter*, Marc wrote of how he and his fellow combatants were fighting for a new art, struggling "through their work, to create *symbols* for their age that will in future take their place on the altars of a new spiritual religion [...]." It would not perhaps be wrong to see the *Tower of Blue Horses* as emblematic of this utopian ambition. Be that as it may, with this picture Marc undoubtedly succeeded in producing a masterpiece both of German art and of Modernism.

112
Horse with Female Nude,
1912/13
Germanisches National-
museum, Nuremberg
CAT. 75

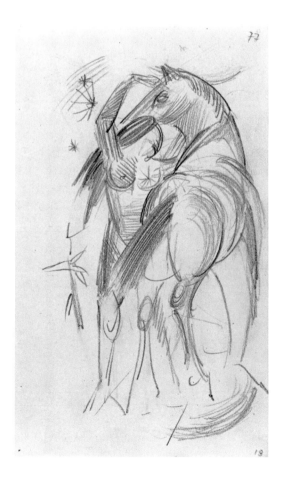

In the same sketchbook as the first, cursory design for the *Tower of Blue Horses* there is also a drawing of 1912/13 for a *Horse with Female Nude* (fig. 112). This provides another link with Else Lasker-Schüler. The poet had embraced Franz Marc, his Blue Rider, and his horses with an almost spiritual fervor. Lov-ingly, almost protectively, the woman in the sketch places her arms around the head and neck of the horse, which turns toward her in such a way that the slant of its forehead is effectively continued in the fall of her long hair. This is itself echoed in the dense hatching strokes used for the tail. The paradi-saical associations of these statuesque figures in all their purity are extended through the presence of cursorily rendered plants, stars, and a rainbow, which thus incorporate the notion of both near and distant space. We do not know if Marc pursued the possibilities suggested in this image.

"THE MOST SPLENDID POST-CARDS" TO ELSE LASKER-SCHÜLER AND TO OTHER FRIENDS

During the visit to Berlin made by Franz and Maria at Christmas 1912 there was a momentous meeting between the eloquent painter and the leading Expressionist poet, Else Lasker-Schüler. She was 13 years Marc's senior and had just obtained a divorce from Herwarth Walden, the progressivist editor, gallery owner, and promoter of the international avant-garde. There had, however, already been some indirect contact between the two. For the September 1912 issue of Walden's magazine *Der Sturm* [The Storm] Marc had a made a woodcut to accompany Lasker-Schüler's poem "Versöhnung" [Reconciliation], a work as revealing as a testament to his sensitivity to her words as it is of his rendering of the interrelation of man, beast and cosmos (fig. 113).[70] Returning to the fundamental idea informing his earlier illustration to a poem by Gustav Renner (fig. 18), Marc again takes his starting point in the humility of all living beings before manifestations of the power of the cosmos. At the center of the composition is a half-kneeling female figure expressing repentance (see also the deer in *Animal Destinies*, fig. 177), who appears to emit a sunburst. A male figure stands within its radiance and a dog (effectively replacing the lion of fig. 18) serves to reiterate the pose of the protagonist. A broad rainbow encloses this core area of the composition as if to cancel any remaining element of the egoistic. To the right there is a view into the night sky with numerous moons and stars.

The cosmic dimension and the preoccupation with the image and the concept of the stars in the work of Else Lasker-Schüler — be it in her statements, in her writings, in her extraordinary personal appearance (especially when assuming the role of Yussuf, Prince of Thebes), or in her drawn self-portraits (in which she usually has a crescent moon and a star on her face as a personal mark) — immediately established a strong inner connection between the imaginative worlds of the painter and

the poet, who in other respects could hardly have been more distinct in character. Lasker-Schüler's immediate reaction to Marc's announcement of his proposed visit, on December 9th 1912 — "The Blue Rider presents his Blue Horse to Your Highness" (fig. 9) — already testifies to this. Lasker-Schüler's reply begins as follows: "The Blue Rider is here — a wonderful statement, five words — nothing but

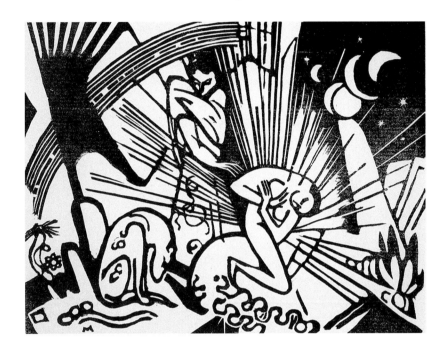

stars. I now think as if I were the moon. I live in the clouds, that's to say, in the evening when there's no longer anyone out and about. I think now as if I were the crescent moon [...]."[71]

This first, "role-playing" contact proved to be the start of a very productive phase for both artist and poet, prompting Marc to send Lasker-Schüler a long series of painted postcards. Alongside those made for his other friends, this sequence has been seen as "one of the most outstanding examples of pure creativity in the art of the [20th] century."[72] A total of over 50 of these small but highly poetic masterpieces was produced between the end of 1912 and the spring of 1914; and those sent to Lasker-Schüler are particularly striking. Most of these are in the collection of a Munich museum and cannot be loaned on

113
Reconciliation, 1912
Sprengel Museum, Hanover

account of the terms on which they were presented to this institution. A number of important examples will, however, be illustrated and discussed here, and supplemented with postcards from other collections so as to provide a representative cross-section of an aspect of Marc's work that brought him particular joy.

To return to Else Lasker-Schüler: Franz and Maria were immediately very taken with the graceful but utterly unconventional woman who often went about in cheap jewelry as the Prince of Thebes. In contrast to many of her contemporaries (even Kafka, for example), Marc, with his immense reserves of calm and spirituality and his deep sense of a connection with the natural world, was not alarmed or alienated by Lasker-Schüler's instability and extravagance or her sometimes hysterical manner, recognizing that poverty and ill health had forced her to live "on the edge". Motivated by sympathy for her situation, Franz and Maria took her back with them to Sindelsdorf at the start of January 1913; but the restless urbanite found that she could not stand the roar of silence in the "Blue Country" and felt she had to get back to the city, initially going to Munich. A letter sent by Marc to Elisabeth Macke on January 21st betrays a certain sense of good-humored relief at this turn of events: "[...] if August should get fat or excessively placid again, I prescribe for him 14 days of Mrs. Lasker-Schüler — that'll do the trick! But she's really splendid, in spite of all the idiotic pranks!"[73]

Lasker-Schüler's influence on Marc's production of postcards would be hard to over-estimate. To some extent, the painter immersed himself playfully in her imaginary realm, but he also offered her his horses, his kingdom of animals, as an alternative and consolatory world, sometimes even as a means to a form of salvation. In this spirited art game, transcending the banality of everyday existence, the extravagant poet, by turns effusive, dreamy, and melancholic, had an altogether inspiring impact on Marc. As fellow creative personalities, they made a contrasting and yet surprisingly congenial pair.

Marc's second postcard to Else Lasker-Schüler, The Tower of Blue Horses (fig. 110), has already been mentioned. Here Marc gave his horses the poet's personal insignia: stars and a crescent moon; blue was also her favorite color. By this point, Lasker-Schüler already saw Marc as "the Blue Rider" and was to do so until the end of his life (on this point, see p. 193). In the second of Lasker-Schüler's letters to Marc (which she intended for publication), she wrote: "Dear Blue Rider [...] I really feel like frolicking about, Blue Franz, because we address each other as 'Du' [the more intimate form of 'you'] and I can't think what I'll want to do if your wonderful postcards arrive tomorrow!! The great cats are very superior beasts. The panther is a wild gentian, the lion a dangerous larkspur, the female tiger a raging and shimmering yellow maple. But your blissful blue horses are like a mass of neighing archangels, all of them galloping into paradise [...] And you, so venerable, blue, and great-spirited!"[74]

Another of the "most splendid postcards" was the Mother of the Blue Horses, sent on March 20th 1913,[75] which we know from a variant not mailed by Marc and now in the collection of the Sprengel Museum, Hanover (fig. 114). Marc himself must have especially valued the composition if he kept a version of it as a record. While Lankheit regards the Hanover postcard as the second version, in the catalog of the Hanover exhibition of 1989 devoted to the almanac Der Blaue Reiter good arguments were put forward to support the suggestion that the relationship between the two images was in fact the reverse, that is to say that the postcard now in Munich (the one sent to Lasker-Schüler) evolved as a variation on the one now in Hanover. While in the postcard we illustrate here the animals are shown in a rather sparse wood with a few brushstrokes indicating trees, the other image exhibits a clearer structure in terms of both form and color, with its trees arranged in distinct planar segments. In both cases, however, the principal subject is essentially the same: the large, calm figure of the mare is seen standing in the foreground while the foals "from the stud-farm of the Prince of

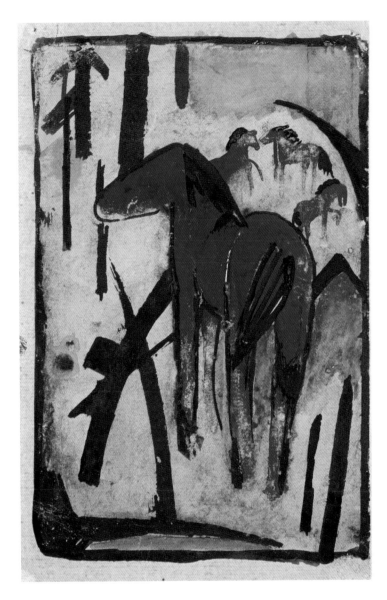

114
The Mother of the Blue Horses II, 1913
Sprengel Museum, Hanover
CAT. 76

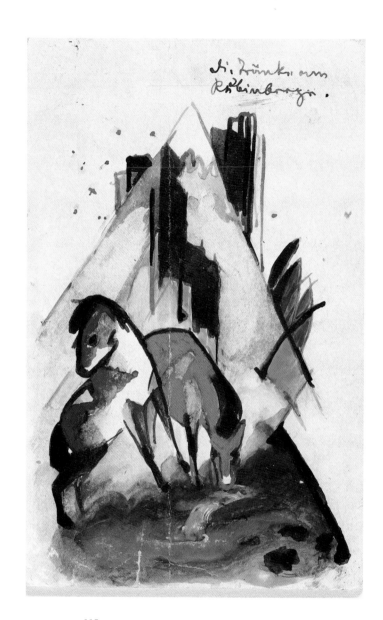

115
The Watering-place on the Rubinberg, 1913
Bayerische Staatsgemäldesammlungen, Munich

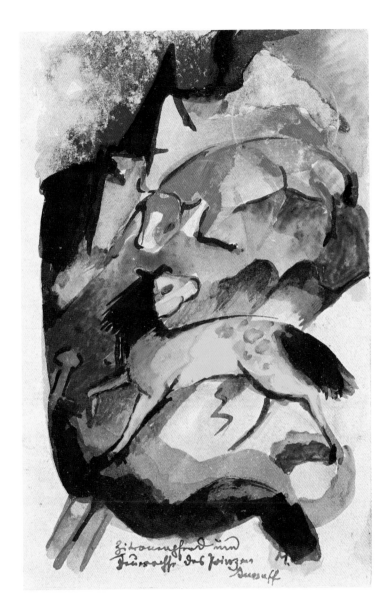

116
The Lemon-colored Horse and Fire Ox of
Prince Yussuf, 1913
Bayerische Staatsgemäldesammlungen,
Munich

117
Small Black Horse, 1913
Staatliche Museen zu Berlin, Kupferstichkabinett
CAT. 77

CHRISTIAN VON HOLST · THE HOOFBEAT OF MY HORSES

Thebes" gambol beyond, all the animals having a splendid blue color. This, the first of many postcards with foals, is the image that we place at the start of the series to be considered here.

The Watering-place on the Rubinberg (fig. 115), sent on February 15th 1913, shows small horses in blue and red at the base of a pale rose-colored peak.[76] The subject clearly alludes in both word and image to Marc's Arcadian world in the foothills of the Bavarian Alps. In her "letters", written as Yussuf, Prince of Thebes, Lasker-Schüler claimed to feel great affection for her Blue Rider as her half-brother Ruben, Great Prince of Cana, while Maria is promoted, as Mareia or even Goldmareia, to the rank of patron saint of the second city in the kingdom of Thebes. The Rubinberg is, of course, that of Ruben, an allusion to the Alpine foothills in which Marc had found his idyll. On May 21st 1913, for example, he reported: "Here in Sindelsdorf the animals bleat, or low, or neigh out of sheer peace."[77] Sindelsdorf thus transmuted into the Biblical Cana must have seemed to Lasker-Schüler a world away from hectic Berlin and a refuge in time of need.

It is naturally also in this sense that the postcard with *The Lemon-colored Horse and Fire Ox of Prince Yussuf*, sent on March 9th 1913 (fig. 116), is to be understood.[78] Common designators for a butterfly or a salamander, they evoke in the case of horse and ox an exotic fairy-tale world, from which Franz and Maria greet their prince as his "blue children".

The *Small Black Horse* (fig. 117), an image empowered through being viewed to some degree from below, was sent to Lasker-Schüler by Marc (in the role of Ruben) with the following words: "Dear Sister, if your surroundings bring you too much vexation, get on this dark steed and hasten here." Despite this offer, Lasker-Schüler did not make a second visit to Sindelsdorf. She would, however, have understood the blue mountain, toward which the "magnificent horse" turns invitingly, as a symbol for the "Blue Country", and a place of peace for her too.[79] The remaining postcard correspondence between Lasker-Schüler and Marc need not be dis-

cussed here in as far as it has been published in an exemplary fashion by Peter-Klaus Schuster.[80] A word, however, on Marc's last card to Lasker-Schüler, sent in spring 1914, and intended for her son, Paul. It shows Marc's house in the village of Ried (fig. 11), with the Blue Rider as hunter and contented home-owner. Five years later, when Marc was dead, Lasker-Schüler used this postcard as a frontispiece for the novel she developed out of her "letters", *Der Malik. Eine Kaisergeschichte* [The Malik. An Emperor's Tale], which bore the dedication: "For my unforgettable Franz Marc / THE BLUE RIDER / till the end of time."[81]

We are able to include in our exhibition three postcards that Marc sent to the Mackes in Bonn. The first, dated February 6th 1913, *Red Horse with Black Figures* (fig. 118), is visually so simple with its elongated, star-studded little horse and a figure riding on a blue donkey, that even the Mackes' son Walter must have responded to it joyfully. It is possible that the other figures were intended as August and Elisabeth, who appear (although this is a purely intuitive assumption) to be imploring the stars for assistance and benevolence at the imminent birth of their second child.

On the back of the postcard *Small Horse in Cool Pink* (fig. 119), Marc requested a photograph of Macke's second son, Wolfgang, who had by this time been born (he was later to edit the letters of both couples). This somewhat curious composition, which does not show the animal in its entirety, can be turned by 90 degrees in a counterclockwise direction to reveal that the little horse is painted on top of the pen-and-ink drawing of a woman in lace-up boots who is shown pulling on a glove. A green stole — in the context of the horse a horizontal stripe below its belly — is so chromatically strengthened in the area of the woman's head that we may assume this passage to have been misdrawn. As a whole, then, the image is a sort of pictorial palimpsest of considerable, almost Dadaist charm. It remains to be established whether Marc was in fact also responsible for the image of the

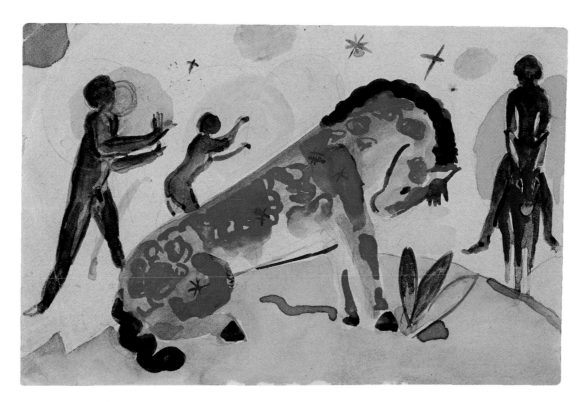

118
Red Horse with Black Figures, 1913
Private collection
CAT. 78

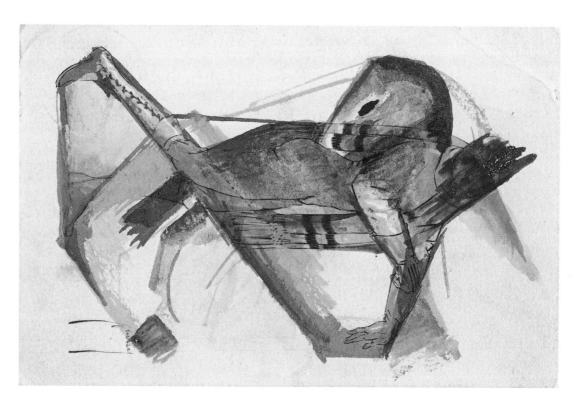

119
Small Horse in Cool Pink, 1913
Private collection
CAT. 79

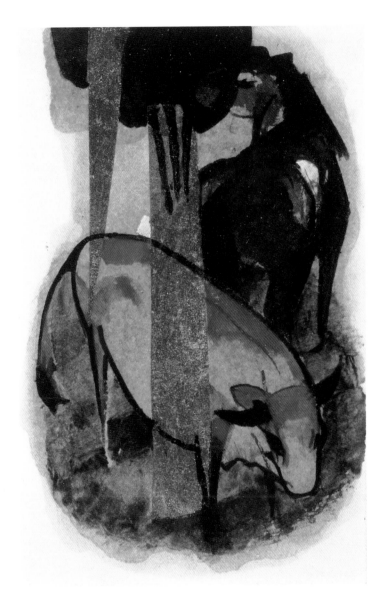

120
Blackish Brown Horse and Yellow Ox, 1913
Lenbachhaus, Munich
CAT. 80

121
Red Horse and Blue Horse,
1913
Lenbachhaus, Munich

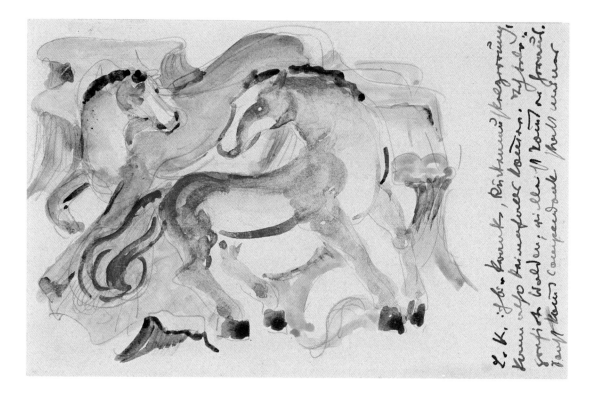

woman, for such delicate and precise use of pen and ink is not to be found elsewhere in his work.

The postcard *Blackish Brown Horse and Yellow Ox* (fig. 120), until now erroneously called "Red Horse and Yellow Ox", sent on March 24th 1913 to the artist Alfred Kubin with news of the latest developments in the plans for an illustrated Bible (see p. 161), shows a combination not unlike that of *The Lemon-colored Horse and Fire Ox* (fig. 115). Here, however, the animals are larger and thus stand closer to each other and to the viewer. The use of gilt paper bestows the simultaneous richness and emphatic artifice of a collage on this scene with its two powerful and masterfully character-ized protagonists.

Marc sent the postcard *Red Horse and Blue Horse* (fig. 121) to Kandinsky on April 5th 1913. The two decoratively juxtaposed animals are derived from a wall painting of around 1400 in the church of Saint Georg ob Schenna in the South Tyrol, which Marc had recently seen while making a trip with Maria to visit her father, who was staying at a sanatorium nearby.[82] It appears that he used the

pale colors found here to convey something of the appearance of the fresco. The scene with Saint George, painted by an unknown artist, may well also have appealed to Marc on account of its plain yet powerful use of forms, as he recognized and appreciated the enduring effect of the image (in the almanac *Der Blaue Reiter* he had written that in the art of the future there would be no trace of "the artifice of the maker").

In the postcard that Maria Marc sent on April 19th 1913 to Paul Klee's wife, Lily (fig. 122), asking about the possibility of her coming to play the piano (music was a strong link between the two women), a pictorial framework of geometrical clar-ity emerges from the combination of broad curves and color planes. As a whole, the image recalls the luminosity of stained-glass windows, and indeed Marc's earlier experiments with painting on glass. A month later, on May 21st, Maria in fact wrote to Elisabeth Macke about Marc and his postcards: "He produces as many of them as he used to make glass paintings."[83] In the postcard sent to Lily Klee, Marc once again uses the simplest poetic means

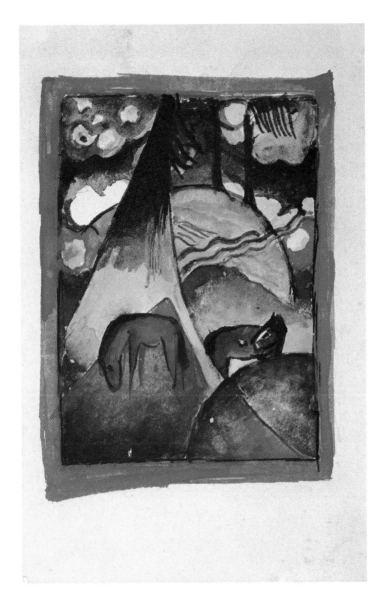

122
Red Horse and Blue Horse, 1913
Private collection, Switzerland
CAT. 82

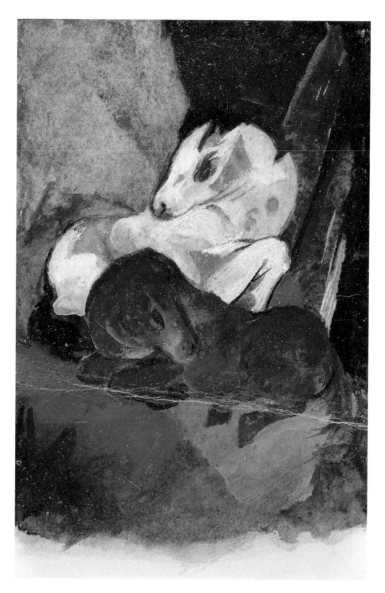

123
Green Horse and White Horse, 1913
Private collection
CAT. 83

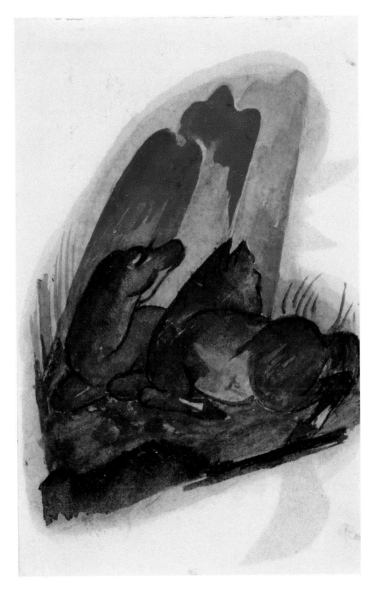

124
Two Blue Horses in Front of a Red Rock, 1913
Lenbachhaus, Munich
CAT. 84

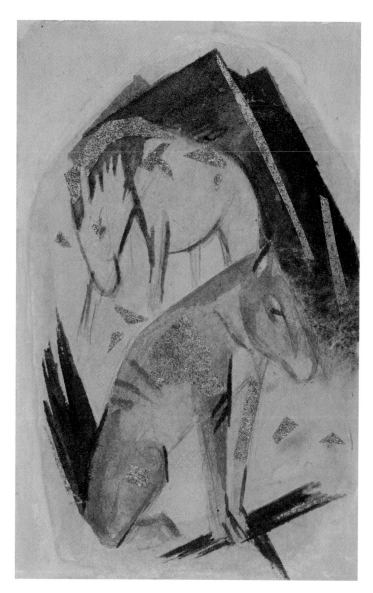

125
Two Horses against a Blue Mountain, 1913
Private collection, Switzerland
CAT. 85

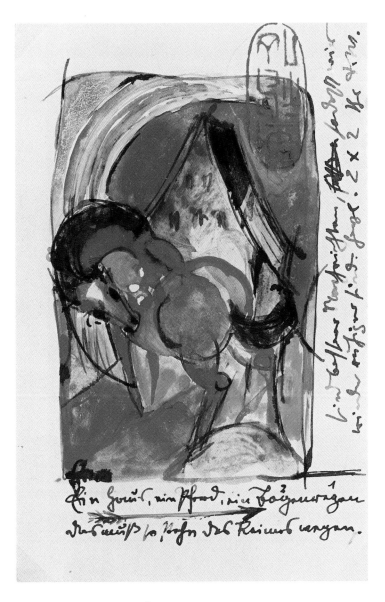

126
Blue Horse, Red Horse, and a Rainbow, 1913
Ahlers Collection
CAT. 86

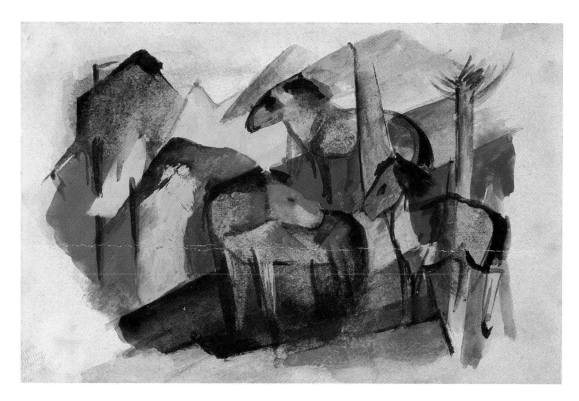

127
Three Horses in a Landscape with Houses, 1913
Private collection, Switzerland
CAT. 87

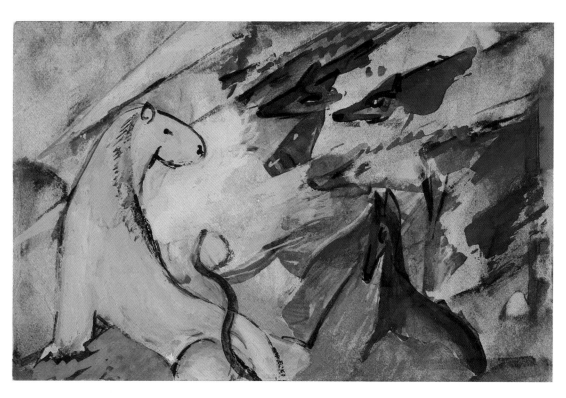

128
Yellow Lion, Blue Foxes, and Blue Horse, 1914
Private collection, Switzerland
CAT. 88

to achieve the impression that the two horses are moving through a dream or fairy-tale world reserved for them alone.

The fact that Marc did not send the postcard *Green Horse and White Horse* (fig. 123) in 1913 when it was made perhaps indicates that he valued it especially highly. The text on the back, written on November 8th 1915, dates from his last period of leave from the Front, and addresses the following elegiac and consolatory words to the by then widowed Elisabeth Macke: "I found this card in my desk here — it comes from that time of peace when we used to send each other such colorful greetings — I want you to have it now."[84]

Another such "colorful greeting" with similarly located horses was sent on May 21st 1913 to Kandinsky (fig. 124). In both images one finds the same simplicity and clarity in the composition, the same integration of intensely colored animals within a landscape setting. And in both cases Marc achieves a sense of monumentality despite the very small scale.

The postcard with *Two Horses against a Blue Mountain* (fig. 125), sent by Maria to Lily Klee, probably in the second half of May 1913, has text on the back referring to a possible meeting in Munich with the celebrated Russian dancer Sacharoff — repeatedly painted at this time by Alexei Jawlensky. This image again shows two animals, in all probability in Marc's "Blue Country" of Sindelsdorf and its environs. The horses appear to be withdrawn into themselves in a trance-like fashion, much as they are often to be found in the series of postcards sent to Else Lasker-Schüler.

Less than half a year later, on October 15th 1913, Marc himself wrote to Paul Klee to elucidate the scene shown on another postcard (fig. 126), employing a sort of spoonerism:

"A house, a horse, a bow of rain,

it must be thus so the rhyme is plain."

He then goes on to introduce the few principal motifs with great facility and vitality: the stance of the temperamental horse, the turn of its neck, and the vigorous beating of its tail — in short, varia-

tions on a pose much favored by Marc in earlier work. The diagonal alignment of the animal leads into the curve of the broad rainbow that arches protectively over the tall, narrow house.

The delicately painterly postcard showing *Three Horses in a Landscape with Houses* (fig. 127) was sent by Maria Marc to Paul Klee on November 8th 1913 as a note of thanks. It is clear that Marc's procedure in arriving at this image differed from his usual approach in work on other postcards. He began by painting in large planes of color, then outlining the figures of the animals over these so that the background coloring in part showed through. Some of each horse's body was then filled in so as to assume a degree of three-dimensionality. The resulting image testifies to Marc's readiness to experiment, be it from the point of view of color, form, or technique.

This was also the case with the postcard sent by Maria Marc to Lily Klee on March 22nd 1914, *Yellow Lion, Blue Foxes, and Blue Horse* (fig. 128). This image is in fact representative of the dramatic type of composition found in the painting *Animal Destinies* (fig. 177) and in related preparatory sketches.[85] The foxes' heads emerging out of the pale, indeterminate background seem to embody pure movement, and are accompanied by pointed beams of yellow light, but the massive figure of the lion acts as a counter to this force. Also present, poised between the beasts of prey, is the long-necked horse seen in the right foreground.

1913: SKETCHBOOK SHEETS

The watercolor *Two Horses* (fig. 129) comes from sketchbook XXX. The blue-green animal with its stiffly outstretched front legs looks as if suddenly frozen in mid-movement, while the pinkish brown horse standing by its side holds its head in a painfully contorted position to direct its gaze upward (the direction is picked up in the tree trunk of the same color). This juxtaposition of attention directed

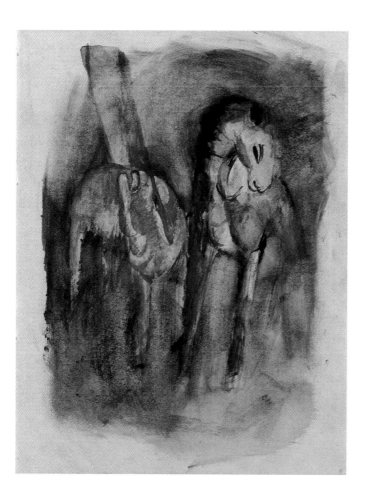

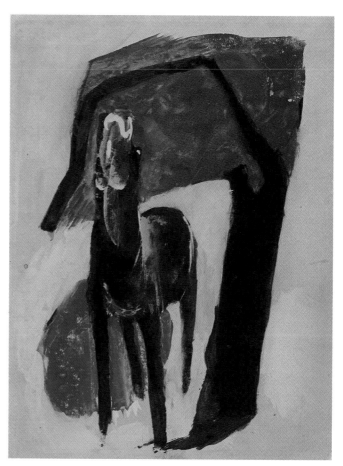

129
Two Horses, 1913
Sprengel Museum, Hanover
CAT. 89

130
Wailing Horse, 1913
Stiftung Domnick, Nürtingen
CAT. 90

131
Horses and Oxen, 1913
Private collection
CAT. 91

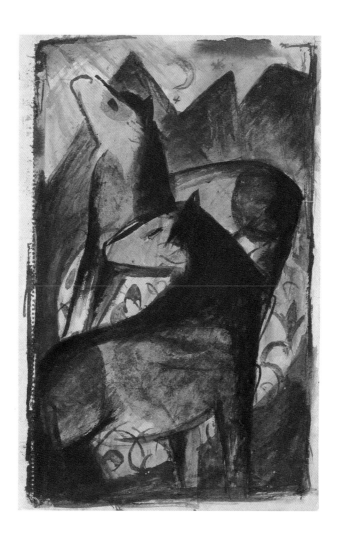

132
Two Blue Horses, 1913
Solomon R. Guggenheim
Museum, New York
CAT. 93

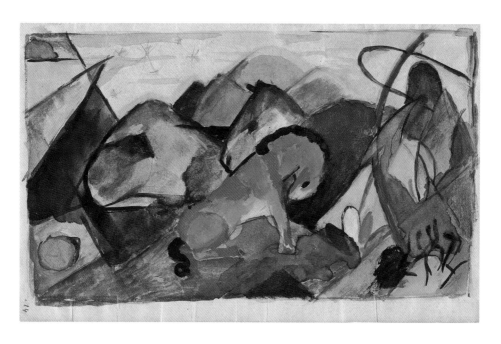

133
Mare and Foal Resting, 1913
Private collection, New York
CAT. 94

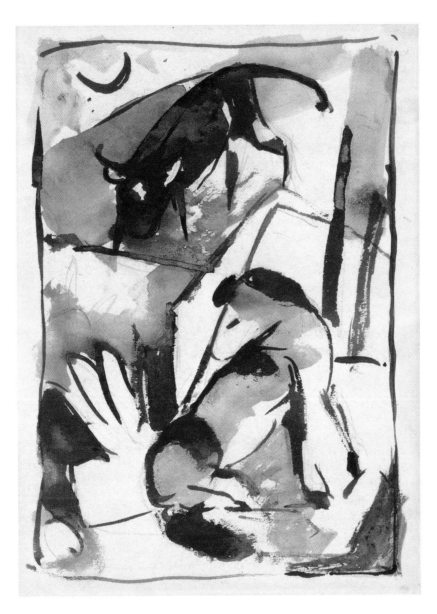

134
Horse and Ox at Night, 1913
Private collection, New York
CAT. 95

up and down assumes a more ominous significance as a result of the threatening nocturnal setting. Akin to the self-sacrificing deer in *Animal Destinies* (fig. 177) and alongside the terrified horses functioning as a subsidiary motif in that picture, the horse appears here for the first time as a suffering creature. Marc continued to be preoccupied with this notion. In the same sketchbook he treats the motif in a less compromising form in the *Wailing Horse* (fig. 130), where the animal is shown with its neck fully stretched. The tree to the right with its single bare and angular branch, probably intended as a symbol of want and pain, simultaneously serves as a framing device.

A third sheet *Horses and Oxen* (fig. 131) was also removed from sketchbook XXX. Divided by a vortex of radiating lines and circles, the composition falls into distinct foreground and background sections, occupied respectively by horses and by deer. This is something of an exception in Marc's oeuvre in as far as he does not usually show an interest in grouping animals according to species and families. With the almost mirror-image horses posed at either side of a cypress tree (fig. 1), Marc produces a variation on the motif used on a postcard to Else Lasker-Schüler in January 1913.[86] This vignette could easily serve as a design for a monument to Marc.

A sheet from sketchbook XXXI shows a "tower" consisting of two boldly simplified horses (fig. 132), looming figures whose vigilance is underscored by the background presence of the dark peaks of three mountains. Proximity to Marc's most celebrated composition (fig. 111) is signaled through the presence of a crescent moon and stars. The use of wash here is similar to that found in a previously unpublished sheet from a private collection (fig. 134), except that the blues and greens and the central oval area filled with ornamental plant motifs establish a more strident tone.

According to Lankheit, the watercolor *Mare and Foal Resting* (fig. 133) possibly also once formed part of sketchbook XXXI; and this too shows the sweeping curved lines found in the

drawing *Horses and Oxen*. The larger figure, the mother, is seen reclining in the hilly landscape. We recognize the foal in front of her from a postcard sent to Elisabeth Macke in February 1913 (fig. 118). Here, however, in place of a few figures seen against a pale ground, we find a creature fully integrated into its own prismatically segmented landscape.

The *Horse and Ox at Night* (fig. 134) is a free variation in black and gray tones on the "most splendid" postcard with *The Lemon-colored Horse and Fire Ox of Prince Yussuf* sent to Else Lasker-Schüler in March 1913 (fig. 116), and is spontaneous and assured in the sketchy rendering of the animals. This previously unpublished item (a chance find during preparations for our exhibition) shows, as do some other instances, that Marc made two versions of compositions that especially appealed to him, be this as a record for himself or as a sample of his work to show or give to friends (see also the case of the postcard for Alfred Kubin, fig. 120).

The *Small Red Horse* (fig. 135), now in a private collection, first came to light at a sale at Ketterer in Hamburg in December 1999. In all probability also originating as a page in a sketchbook, this is confirmed as an item found in Marc's estate in a statement by Maria Marc that appears on the back. It is one of the many engaging images that Marc produced for special occasions during 1913, and is notable for the related positions of the head and body, and the abstract forms that envelop these.

The "Erster Deutscher Herbstsalon" [First German fall Salon], held in Berlin in 1913 was instigated and organized by Herwarth Walden and selected and hung by Walden, Marc, and Macke. Among further contributions, Marc designed a poster announcing this event (fig. 136). The small horse seems to shy away on looking up at the announcement of the exhibition. Taking the pair of stylized conifers as a gauge, one would have to assume both the horse and the lettering to be huge. The presence of a broad rainbow and a large star introduce a celestial dimension, balancing playfulness with solemnity. There is a particularly effec-

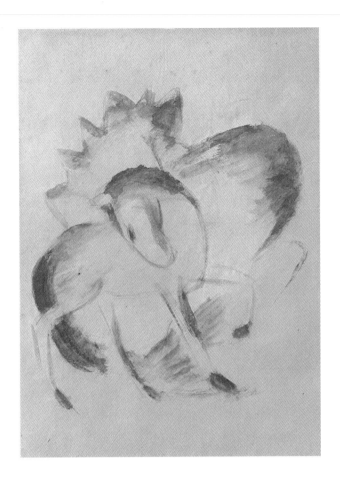

135
Small Red Horse, 1913
Private collection
CAT. 96

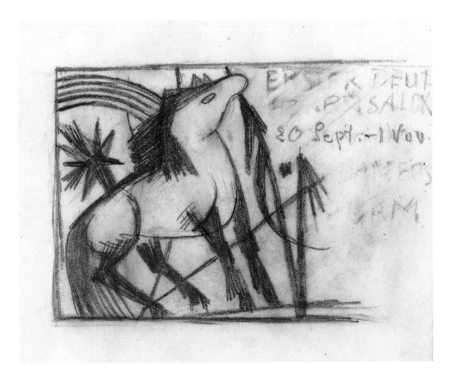

136
Small Horse, 1913
Private collection
CAT. 97

tive contrast between the emphatic character of the features seen on the left and the half-erased, almost hovering sequence of letters on the right. In the "Erster Deutscher Herbstsalon", the most comprehensive international survey of progressivist

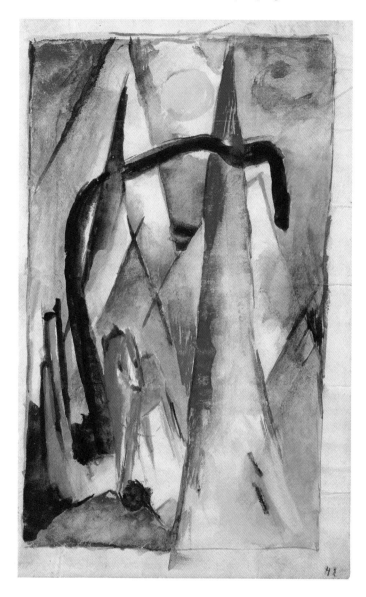

trends in contemporary art to be held in Germany in the years immediately preceding the First World War, Marc showed major works such as the *Tower of Blue Horses*, the *First Animals*, and *Animal Destinies*.

With the *Horse in a Landscape with Pointed Forms* (fig. 137) we come to the end of the series of

small-scale works made in 1913, most of which (except for the postcards) appear to have derived from sketchbooks. This vertical composition with the verso inscribed "Reserved for Dr. Domnick" was not acquired by the Staatsgalerie (as intended by the art dealer Stangl), but several decades later it can at least be shown in our exhibition. With regard to the mountain forms, this delicate composition may represent an echo of the trip in the South Tyrol that Marc made in spring 1913, the inspiration also for the Tyrol paintings he subsequently produced (fig. 157). But, in contrast to what one finds there, the animal seen here, boldly exploring the ravine between the soaring, stylized peaks, is not associated with transience. The indeterminate dark ribbon form recalls the branch that arches over the *Wailing Horse* (fig. 130).

1913: WORKS IN GOUACHE AND RELATED TECHNIQUES

We turn now to Marc's medium-sized works on paper or cardboard in watercolor, gouache, tempera, and in combinations of these and other media. These images occupied an increasingly important position within the sequence of postcards, sketches, and full-scale paintings produced in 1913. Mediating between small-scale works and paintings in oil on canvas also in terms of the time required for their execution, this category includes splendidly imaginative and sensitive creations by Marc at the peak of his prematurely abbreviated career. While consistent in their narrative and compositional intensity, they reveal Marc's readiness to employ a wide range of styles. This accounts for their diversity of character and the impossibility of establishing a precise chronology.

In the *Landscape with Black Horses* from the collection of the Ulm Museum (fig. 138), the animals are dwarfed by a setting that combines enormous reed-like plant forms and forceful abstract

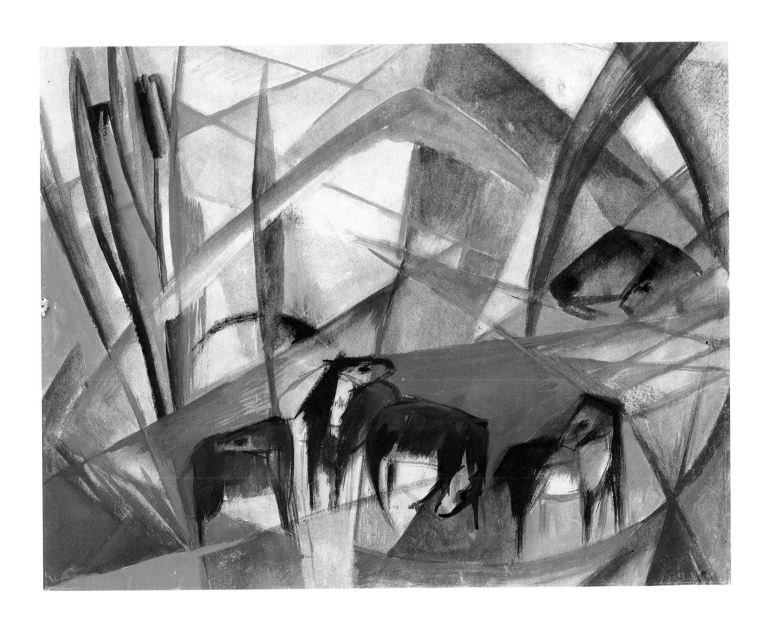

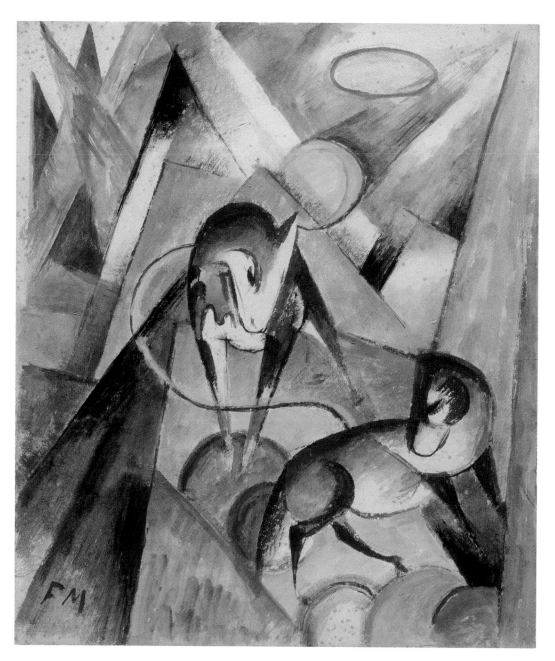

139
Landscape with Two Horses, 1913
Private collection
CAT. 100

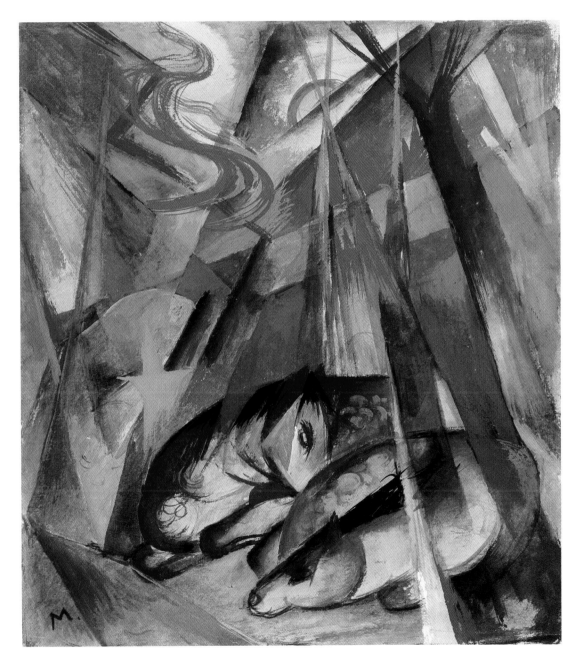

140
Sleeping Animals, 1913
Private collection
CAT. 101

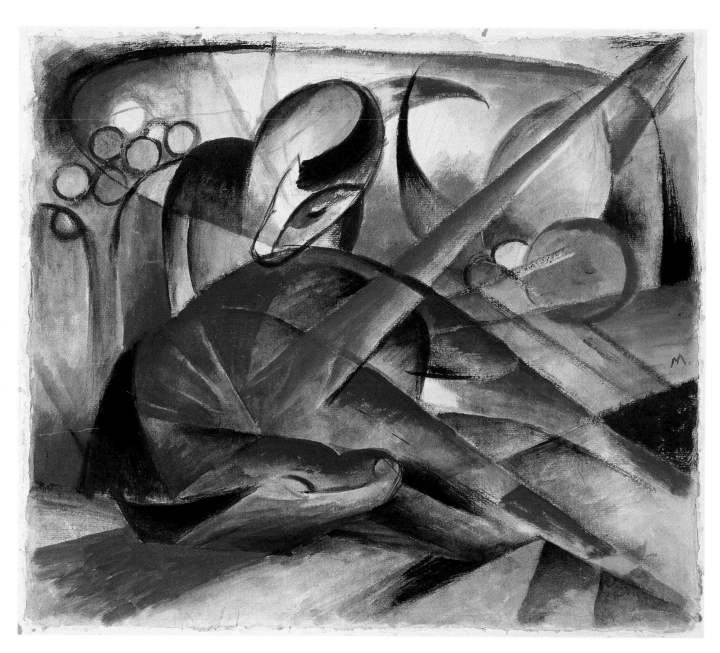

141
Dreaming Horse, 1913
Solomon R. Guggenheim Museum, New York
CAT. 102

beams and wedges. The predominantly green and blue verticals are sliced by diagonals in a blazing red. The resulting lattice makes almost no allusion to recognizable landscape elements. And yet the viewer is still prompted to see this improbable setting as by no means inimical to life, growth, and warmth, and thus as an environment in which the horses are at home.

The *Landscape with Two Horses* (fig. 139), once in the collection of Alfred Kubin, may owe its now subdued coloring to being over-exposed to light. An accumulation of prismatic forms suggests a setting of mountains in which the horses move about with the ease of chamois. They appear, moreover, to be linked together, as if by an umbilical cord. A crescent moon, symbol of the cyclical course of change in nature, appears within this rarefied, angular world, with a halo-like oval form above it. Here, Marc expresses himself in no longer easily decipherable forms and abstract signs.

In the *Sleeping Animals* (fig. 140) the landscape glows in strong, sometimes radiant colors. The pair of horses reclining on the ground appear to be dreaming, and are undisturbed by the dynamic, sometimes arrow-like embodiments of pure energy that stream through and around them. In the faceting of the landscape background, we can sense Marc's intensive engagement by this date with both Futurism and Orphism. He does not, however, borrow from either of these directly, but achieves an amalgam of impulses derived from each. As in the case of *Animal Destinies* (fig. 177), he constructs his image as a force field, as a space electrified by energy.

The *Dreaming Horse* from the collection of the Solomon R. Guggenheim Museum in New York (fig. 141) shows one animal reclining on the ground, fully absorbed in sleep, with a companion who is standing but has the same self-absorbed expression and who looks down on to the first. The larger figure, with its curved body forms tapering off into long legs that merge with the setting, establishes the rhythm of the composition: here, too, we find swooping curved forms sliced by diagonal

rays. This compositional device is at its most insistent in the case of the green diagonal running from the upper right (which, given the title of this picture, we may probably interpret as symbolically aimed at the center of the horses' body, at his heart). It is as if only the animal's central being is of significance here. Anatomical details such as Marc had studied and mastered years earlier would merely distract attention. Abstraction made the essence accessible.

The blue coloring of the sleeping horse is radiant, dominating, spiritual; a subdued green, with a little crimson, provides a chromatic balance. The white of the paper is frequently incorporated as an element within the composition or used to lighten particular colors. Dreams, sleep, and their brother death merge here to form a symbol of the peace evinced by the animal calmly embedded within the force fields of the landscape. Marc imbues the scene with such an aura of intimacy that, as in the case of images of human sleepers, discretion seems to forbid closer examination. A more thorough exploration of the dreams and sleep of Marc's animals might, nonetheless, prove very enlightening.

The subject of *Saint Julien l'hospitalier* (fig. 142) is discussed in the catalog essay by Karin von Maur (pp. 195ff.). In Marc's picture the knight who rages among the animals of the forest out of an insatiable lust for slaughter appears as a Blue Rider among tree trunks that recall those seen in the painting *Animal Destinies* (fig. 177), also titled by Marc "The Trees Showed their Rings, the Beasts their Veins" (both images inspired by the same text by Gustave Flaubert). Julien's pathological aggression is evoked through the red passage that appears below his mount, doubtless intended to allude to the blood-soaked forest floor. In the foreground animals cower in fright. But it is also possible that Marc intended this to be an image of Julien as already enlightened and chastened. And in the conscious simplicity of the composition Marc may have had in mind the conventional depiction of saints in votive images. In the almanac *Der Blaue Reiter* Marc and Kandinsky had

page 157
143
*Mythical Beasts
(Horse and Dog), 1913*
Staatsgalerie, Stuttgart
CAT. 104

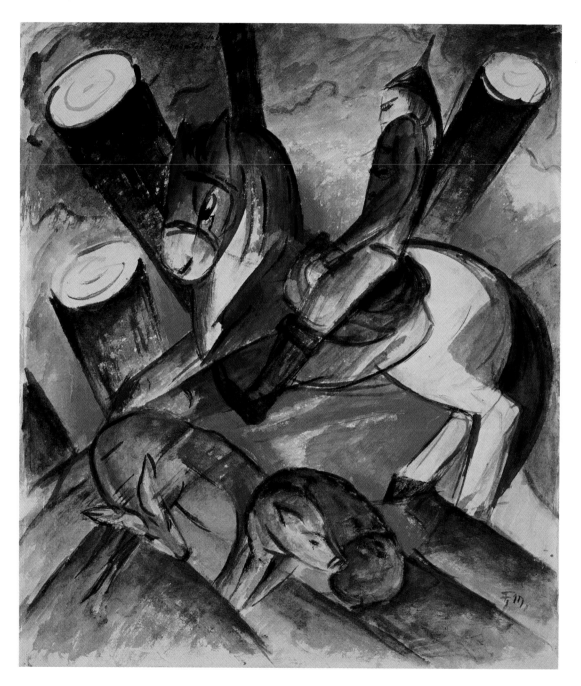

142
Saint Julien l'hospitalier, 1913
Solomon R. Guggenheim Museum, New York
CAT. 103

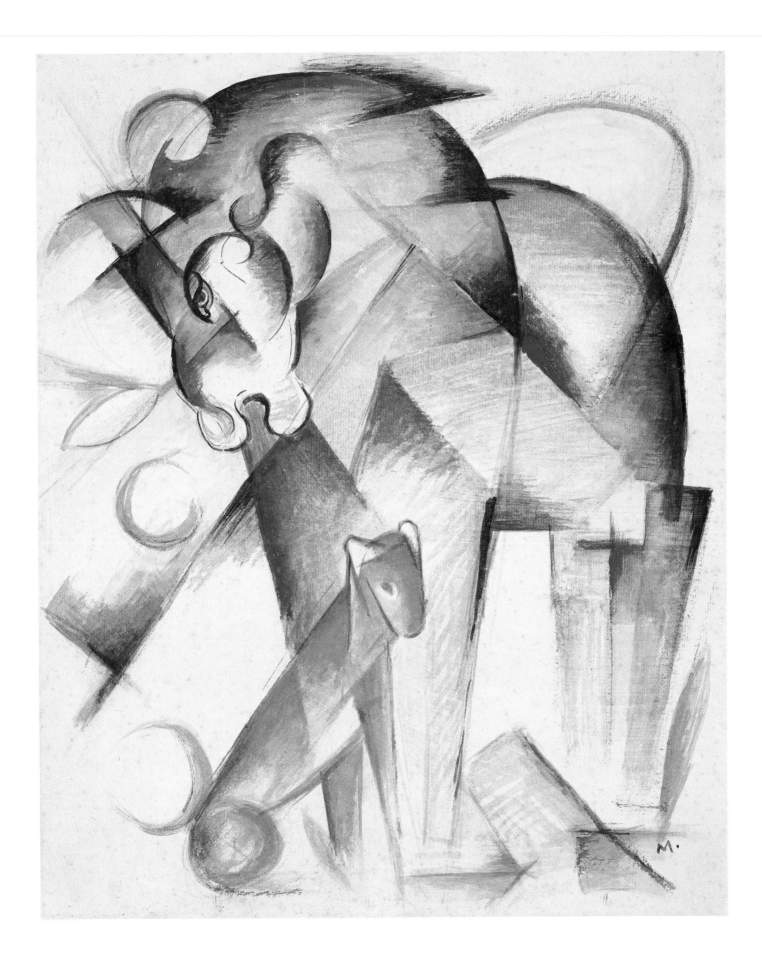

incorporated such items as examples of folk art, of an art that was simple but also, on account of its truthfulness, compelling. In doing so, they had effectively acknowledged them as a model for their own work.

volume, we have an impression of weightlessness. The principal motif is the curved form of the head and neck of the horse, which swell up directly out of the conical legs. Especially striking is the heroic and ornamental rendering of the face with its beau-

144
Two Horses, 1913
Private collection
CAT. 105

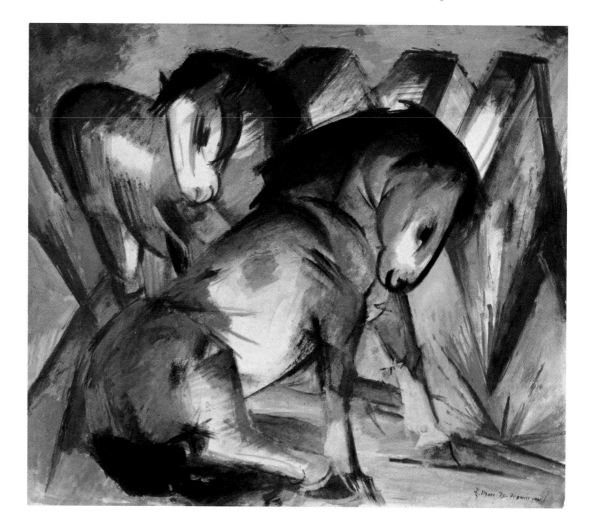

145
The Creation of the Horses, 1913
Hannema-de Stuers Foundation, Heino/Wijhe
CAT. 106

In contrast to Marc's approach in most of his gouaches and in the related works of 1912/13, in the *Mythical Beasts (Horse and Dog)*, from the collection of the Staatsgalerie, Stuttgart (fig. 143), he allowed the creamy tone of the paper a crucial role within the composition. This is suggestive of an indeterminate space extending around the animals, but it simultaneously signifies the luminosity of their bodies. The result has a diaphanous quality, with the animals and their setting so interwoven that, in spite of concrete indications of form and

tifully drawn eye, here a means of increasing our sense of the horse as a fantastical, and in that sense alien, creature. Alongside this gigantic animal, the dog appears distinctly slight. This work may also be understood in the context of Marc's scenes of the Creation, in which we encounter a similar juxtaposition of huge principal figures and smaller subsidiary animals.

We were especially pleased to be able to include in our exhibition the little-known tempera painting *Two Horses* (fig. 144). This splendid sheet

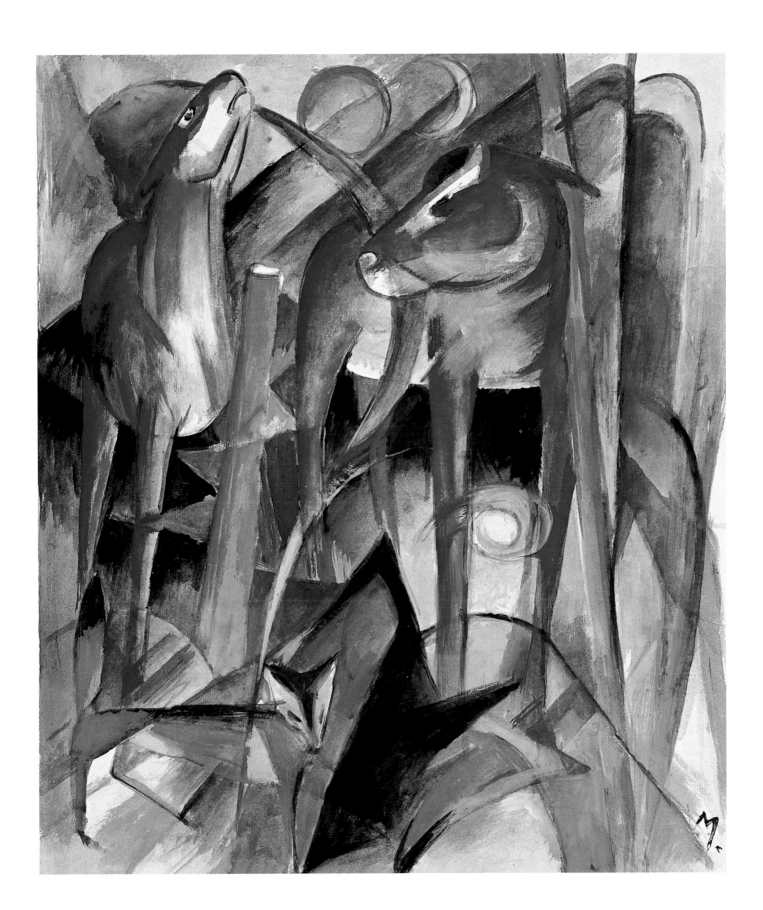

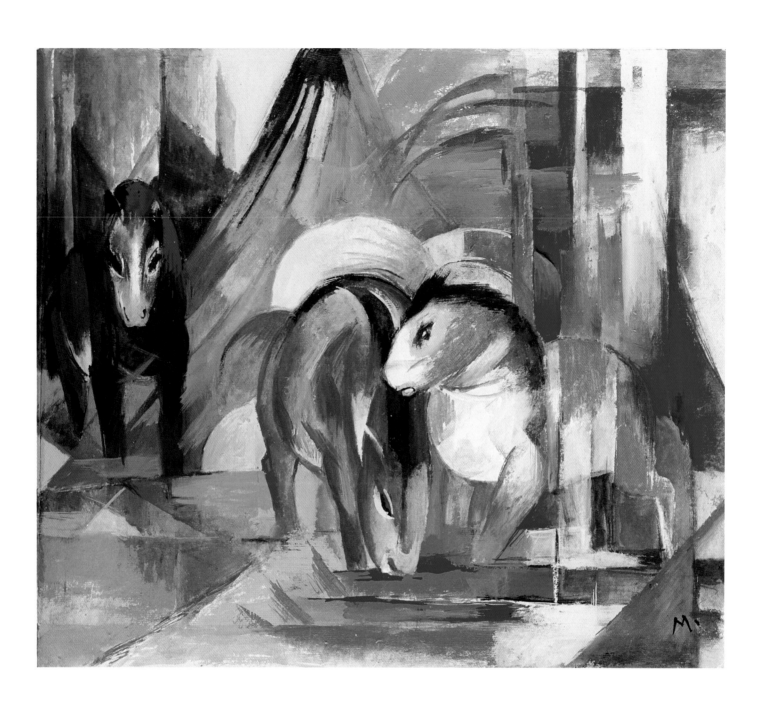

shows a seated animal in the foreground, somewhat resembling the horses seen both in a postcard sent to August and Elisabeth Macke (fig. 118) and in the *Mare and Foal Resting* (fig. 133); in the background we find a standing horse with a characteristic backward turn of the head. Both animals convey an air of contemplation. To left and right, dazzling reds, greens, and yellows seem to explode while the background is filled with a sequence of three angular blue forms similar to those found at the left of the painting of 1912 *Horses and an Eagle* (fig. 106).

In March 1913 Marc and Kandinsky evolved a plan to produce an illustrated Bible, intending to collaborate on this project with Paul Klee, Erich Heckel, Oskar Kokoschka, and Alfred Kubin. Kandinsky was to treat the Apocalypse and Marc to deal with Genesis. Sadly, the advent of war was to put a stop to these ambitious plans. Nonetheless, a number of important compositions by Marc may be seen as fragments testifying to its promised scope.

One of these was *The Creation of the Horses* (fig. 145), more imprecisely known as "Mythical Beasts", of which Marc wrote a year later that it had emerged "from my thoughts about an illustration for Genesis, a sheet showing the Creation of the Horses; the snorting and deep breaths of the first animals!"[87] The two horses stand on stalk-like legs in the midst of a landscape of extraordinary fecundity. Red tree trunks, vigorously curving leaf forms and the abbreviated shapes of branches merge into the rhythm of a ridge of green hills. Together with the enormous horses and the small fox, they convey the sense of a pulsating vitality that draws its energy from the red sun and the yellow crescent moon, symbols of the cycle of growth and decay in nature.

It is understandable that Lankheit, in his 1970 *catalogue raisonné*, should give this highly expressive sheet the title "Three Mythical Beasts". From around this time such creatures are frequently to be found in Marc's work. In these beings he was able to unite a number of different animals and was free to eschew anatomical detail, to merge species,

to imbue his figures with extraordinary powers, and to bestow on them a certain monumentality. This quality is also derived from the lines of force that flow through the compositions, and which are themselves derived from Marc's joy in the work of the Futurists. But even when Marc appears to be interested in making palpable the vigor of his creatures, he ultimately retains a certain distance from Futurist dynamism. In one of the two Futurist painters' manifestos of 1910 we read: "A galloping horse does not have four but twenty legs and its movements are triangular."[88] Marc was more concerned with the soul of an animal and felt that this was best expressed when it was at rest.

If we compare the *Three Horses at a Watering-place* from the Kunsthalle, Karlsruhe (fig. 146) with Marc's treatment of the same subject in 1910 (fig. 61) we immediately become aware of the remarkable transformation in Marc's art that in effect charts his path toward abstraction. Moreover, in the picture from Karlsruhe in spite of all the distortion of natural forms, Marc already evokes the impression of a forest clearing merely through the positioning of his horses. In *Mythical Beast II (Horse)* in the Ahlers Collection (fig. 147) he is able, with much the same technique, to suggest a dense thicket, the haunt of a somewhat deer-like horse. The richness of color here stands for the fullness of life and of beauty, and the astonishingly large crescent moon for the cyclical rhythm of life.

Radiating colored beams and the rainbow cutting across them determine the character of the small composition with a blue horse in the collection of the Museum of Modern Art in New York (fig. 148). Out of the pillar-like verticals, the rising diagonals, and the circular forms surrounding the central area, there emerges a simultaneously two- and three-dimensional network of closed and intersecting segments that resembles a temple. This structure is "consecrated" through the double rainbow as a sign of hope. The concentration of forces at the center is contained on the left by the counterweight of the sail-like green form and bordered on the right by the passage of deep blue out of which

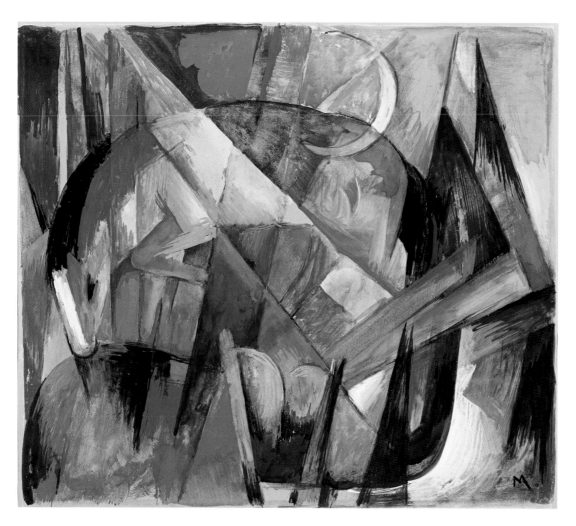

147
Mythical Beast II (Horse),
1913
Ahlers Collection
CAT. 108

148
Blue Horse with a Rainbow, 1913
The Museum of Modern Art, New York
CAT. 109

the semi-transparent horse's body emerges. In the segmented spectrum of colors and planes the figure of the animal, though positioned to one side, assumes a central role on account of its pale tone and the turn of its head and above all because the curve of the larger rainbow coincides with that of its body.

This small picture with the seemingly insubstantial horse in the "sacred" color blue shows the poetic vision of a landscape that appears to consist of light effects and the flow of energy. As early as 1910 the Futurists were writing: "Who can still believe that bodies are not transparent now that our sharpened and extended sensitivities allow us to divine the dark revelations of mediumistic phenomena? Why should we go on creating without taking account of our visual capacities, which aim at achieving something of what x-rays can?"[89]

Everything, accordingly, tends to the diaphanous, to pure color, to abstraction. In some respects like the *Dreaming Horse* (fig. 141), the animal associated with the rainbow no longer resembles an earthly being. It appears, rather, as a representative of the realm of the spirit, indeed almost as the patron saint of the spiritual order for which Marc wished to lay a path with his art.

The *Composition with Animals* from the Franz Marc Museum in Kochel am See (fig. 149) is probably later in date, and is perhaps a work of 1914, although deriving from a drawing in the already frequently mentioned sketchbook XXXI. This in effect concludes the series of works in gouache and related media. Designated an unfinished work by Schardt in 1936, this perhaps offers an explanation for its pale, transparent character. We find here three very generalized figures of horses and above these an ox, all incorporated within a loose planar grid, an arrangement strongly suggestive of Marc's interest in the work of the French artist Robert Delaunay. The animals almost merge with their setting. Here Marc stands on the threshold of non-objective, pure painting.

1913—14: MARC'S PRINTS: "THINKING IN WOOD"

On July 6th 1914, shortly before the war brought an almost complete end to his artistic activity, Marc wrote to Kubin concerning his illustrations for Genesis (fig. 154): "I'm making the whole thing as

woodcuts; the entire working process is thus so much slower — not the cutting itself, but the *thinking in wood* — that's the difficult thing."[90]

This "thinking in wood", Marc's occasional excursions into printmaking, can be seen very clearly in certain examples. In *Horse and Hedgehog* (fig. 150), which is divided both horizontally and by a dynamic diagonal, one finds three distinct segments, each dominated by a single animal. The large horse turns to look back with an extraordinary expression of loving curiosity towards the small hedgehog. Below, facing in the other direction, is a grasshopper,[91] located between plants and stones. In the context of this dream world, we may imagine this as simultaneously small and large: it is the inner, not the outer dimension of each animal that is of significance here. Marc is interested in the unhierarchical symbiosis, the dialog between the creature and the world of plants. Nature appears as

150
Horse and Hedgehog, 1913
Stangl Collection, on loan to Franz Marc Museum, Kochel am See
CAT. 111

page 164
149
Composition with Animals, 1913/14
Franz Marc Museum, Kochel am See
CAT. 110

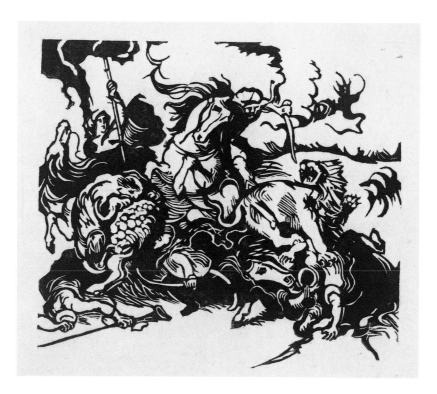

151
Lion Hunt, after Delacroix, 1913
Staatliche Graphische Sammlung, Munich
CAT. 112

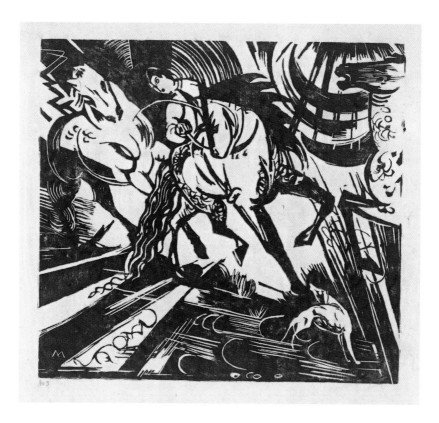

152
Riding Scene, after Ridinger, 1913
Staatliche Graphische Sammlung, Munich
CAT. 113

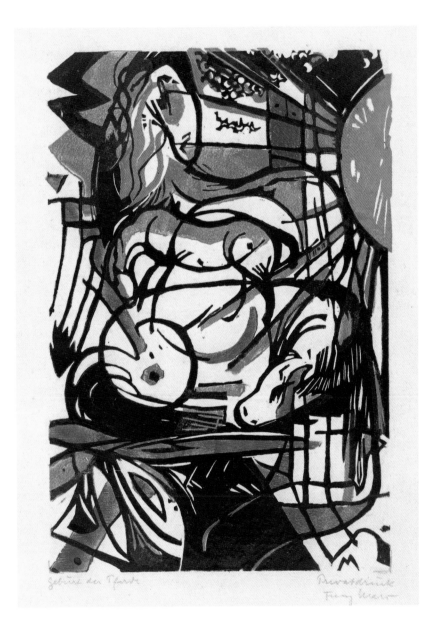

153
Birth of the Horse, 1913
Staatliche Graphische Sammlung, Munich
CAT. 114

a sort of paradisaical idyll, a place in which we are shown that animals live in peaceful coexistence, and by implication as suitable exemplars for humanity.

The dramatic *Lion Hunt, after Delacroix* (fig. 151) and the vigorously rhythmic *Riding Scene, after Ridinger* (fig. 152), are discussed in the catalog essay by Andreas Schalhorn (pp. 239ff.). It is revealing that Marc, with his very intimate knowledge of art history, should select precisely these 18th- and 19th-century artists — both masters in the rendering of horses — as his models.

In connection with the painted composition *The Creation of the Horses* (fig. 145) we have already spoken of the plan to produce a large illustrated edition of the Bible and have noted Marc's decision to use woodcuts for his own contribution. We may now consider several prints that appear to be related to this only partially realized project.

Among Marc's especially poetic and paradisaical visions of the world of horses was the four-color woodcut of 1913, *Birth of the Horse* (fig. 153). It shows the animal family in the rays of a huge sun, here a powerful symbol of the source and growth of every sort of life. With head turned inward, the mare reclines above entwined plants, approximating an oval form that symbolizes new life as well as rest. Above, also reclining but aligned in the opposite direction with head held high and face toward the sun, we find the stallion. Overlapping the figures of both and sheltered between them, is the grazing foal. This image of the life and warmth of communal creaturely existence hardly requires its title to be understood as a visualization of the myth of Creation. Drawing on traditional patterns for the representation of human and "holy" families, Marc is able to devise an image that assimilates the world of animals to that of humanity, but also ennobles them, even renders them "sacred".[92]

In the sheet of 1914 *Genesis II* (fig. 154) Marc employs a greater degree of abstraction than is to be found in the *Birth of the Horse*. In this notion of coming into being, the creatures' shapes are condensed out of curves and a dramatic battle between brighter and darker areas. Here we find a variety of embryonic forms: to the right is a horse-like creature with one of its legs already more fully developed, to the upper left the white lines of the profile of a horse emerge against a dark background. In a few purely abstract paintings made by Marc in the last pre-war months one finds a similar suggestion of fluidity coalescing into form. In the spring of 1915 Marc was to return to thoughts about the Creation in his *Sketchbook from the Front*, recording his ideas with the most modest means but with enormous visionary power.

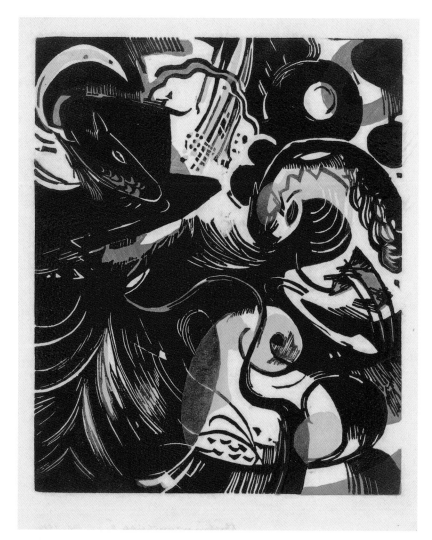

154
Genesis II, 1914
Staatliche Graphische Sammlung, Munich
CAT. 115

1913/14: THE POOR COUNTRY OF TYROL AND "PICTURES OF ALL SORTS"

On May 22nd 1913 Marc wrote to the Mackes from Sindelsdorf that he had been painting "pictures of all sorts", among them those now known as *The Tower of Blue Horses* (fig. 111), *The First Animals* (fig. 155), *The Poor Country of Tyrol* (fig. 157), and *Animal Destinies* (fig. 177). By way of introduction to the work of 1913, and in connection with our particular concern with horses, we have already considered the picture from this group most central to it, *The Tower of Blue Horses* (fig. 111). We shall now address the remaining paintings of 1913, ending with *Stables* (fig. 161), and followed by the *Playing Forms* painted in Ried in 1914 (fig. 162).

Among Marc's works on the theme of the Creation were the painting *The First Animals* (fig. 155), completed in May 1913, but already destroyed in a fire in 1917,[93] and a gouache painted in preparation for this work, now untraced though presumed to be in an American private collection.[94] In both cases, the upper half of the composition is dominated by a parental pair of horses in dynamic movement and, seemingly far beneath them, almost resembling toys, trot two young horses. As the foals are barely recognizable as such we have the impression that the "parents" may be mythical, primeval beats of enormous size in which the notion of the "horse", still not very clearly defined, is for the first time realized on a grand scale.

The situation is much clearer in the case of the *Blue Foals* (fig. 156), where the ornamental pose of the animals fills the vertical canvas. In contrast with what one finds in the earlier images of young horses, where Marc appears to have been interested in the youthful vitality and playful character of the animals (figs. 41, 42, 51, 53), he now achieves a more idealized type of image. The foals, momentarily halting their movement with outstretched forelegs, effectively constitute a composition of their own. The rearing horse seen in the background anticipates the physical power that they will in future be able to display.

At the end of his trip to Meran [now Merano, Italy] in the spring of 1913, Marc painted *The Poor Country of Tyrol* (fig. 157), a picture equal in size to the *Tower of Blue Horses*. In this dramatic land-

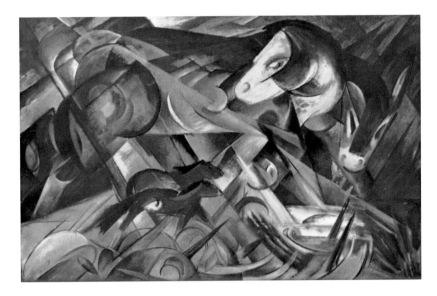

155
The First Animals, 1913
Destroyed in a fire

scape, as splendid in its coloring as in its forms, precipitous mountain slopes, isolated houses, well-fortified towers, and a centrally located red graveyard establish a far from lyrical mood. To the right there stands a border marker with the double eagle of Austria-Hungary; in front of it we find two seemingly frail black horses, and above it a vulture-like eagle against a gleaming sky with a rainbow. At the lower left Marc has inscribed the picture's ambiguous title.

Marc may perhaps have been alluding to the frequently woeful past of the Tyrol and in particular to the struggle for liberation (from Bavaria) waged in this region almost exactly a hundred years earlier. The suggestion of some commentators that Marc's picture may have been prompted by the tense political situation in what were to prove the last years of peace in Europe has not been supported by documentary evidence. It is, however, clear that the horses are a symbol of the misery that plagued the region and that left its traces in a number of other motifs featured in

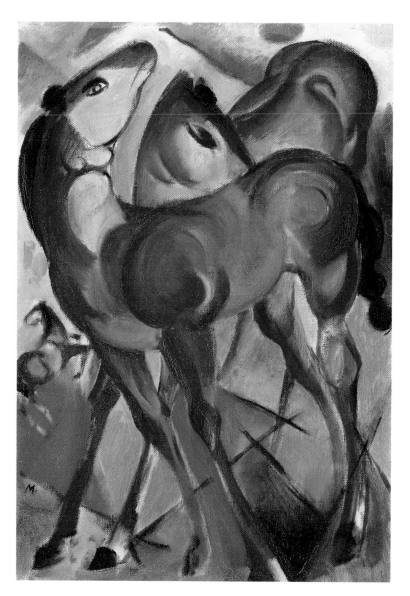

156
Blue Foals, 1913
Kunsthalle, Emden (Stiftung Nannen)
CAT. 116

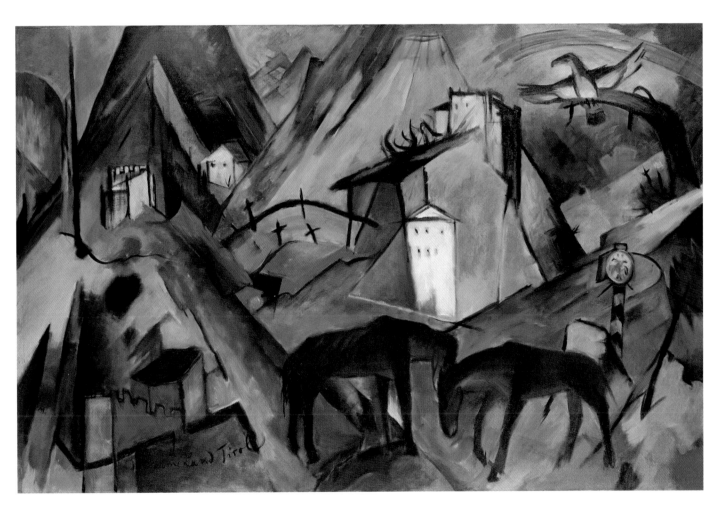

157

The Poor Country of Tyrol, 1913

Solomon R. Guggenheim Museum, New York

CAT. 117

Marc's composition. This painting has also been seen as a vision of the Apocalypse, with the eagle as a bird of prey awaiting the imminent death of the horses.[95] Others have seen the eagle as an allusion to the imperial coat-of-arms, here symbolically spreading its wings to soar toward a better future under the sign of hope embodied in the rainbow.

If one may be allowed momentarily to ignore such speculations (at least in as far as none are supported by concrete evidence), we can only assert, in the context of our principal theme, that this composition was unusual for Marc in showing a large, heroic landscape in which animals were not the protagonists but were present merely as a form of staffage to emphasize its emotional content. In spite of the plethora of melancholic motifs, the powerful mood of Marc's picture is derived above all from strong colors, which in many respects recall the work of Kandinsky.

Also somewhat puzzling are Marc's two versions of *Three Horses*: the earlier of these is in the Ahlers Collection (fig. 158) and the other, presumably close in date, is also in private hands (fig. 159). In both compositions we find two horses, one red and shown reclining, the other yellow and standing, and both looking with some curiosity to the left. Beyond and somewhat above these is a black horse, also standing but apparently asleep, with an exhausted appearance that recalls the horses seen in the picture of the Tyrol. An impression of the weakness of this animal is strengthened through the fact that the lines of its back and neck almost touch the upper edge of the picture, thus making it appear impossible for the creature to raise its head. Beyond, we see a body of water surrounded by hills: this perhaps suggests that the composition as a whole was intended as an idealized landscape with horses in a setting resembling Kochel am See.

The apparently extensive stylization of the animal bodies in the picture in the Ahlers Collection (fig. 158), which has the overall appearance of a full-scale composition sketch, is substantially transformed in the second version (fig. 159). Here the body shapes are simplified, more strongly contoured in a Cubist manner, the red reclining horse is almost fully visible, and the landscape background has undergone an angular stylization. As a whole, the composition is much clearer, while nonetheless resisting interpretation. It remains to be proven that the horses in both pictures were intended to symbolize the stages of life (as, for example, Andreas Hüneke has suggested). The motif of the old horse, which recalls Marc's early interest in working animals (figs. 19, 25), otherwise appears in 1913 only in *The Poor Country of Tyrol* (fig. 157) and in a picture that is currently untraced, *The Long Yellow Horse* (fig. 187).[96] This last shows a type of animal probably derived from a short story by Tolstoy and from a small wooden horse that Marc owned and that is now in the Franz Marc Museum in Kochel.[97]

As already indicated, Marc played a vital role in the selection and organization of the "Erster Deutscher Herbstsalon" held in Berlin in 1913, and showed important works of his own there. At this time he was particularly impressed by the latest paintings by Robert Delaunay, his *Formes circulaires* and his window pictures, and by Delaunay's ideas on simultaneous color contrasts. But he was also intrigued by the work of the Futurists (see pp. 209 ff.). On September 30th 1913 he summarized his thoughts on the impact of the show in a letter to Kandinsky: "For me, the result is astonishing: a significant preponderance (also as regards quality) of abstract forms that speak to us only as forms, almost without any figurative associations and beyond representational concerns (I know full well, of course, that this distinction doesn't really exist — all forms are also memories of something). As far as my own work is concerned, I realize now in what a confused manner I used to go about painting my pictures; I would work from two more or less totally separate starting points and would carry on painting until these appeared to merge — sadly only 'appeared'. Perhaps it's impossible to achieve a perfect connection, with nothing left over, but there are artists who get nearer to this goal and who see

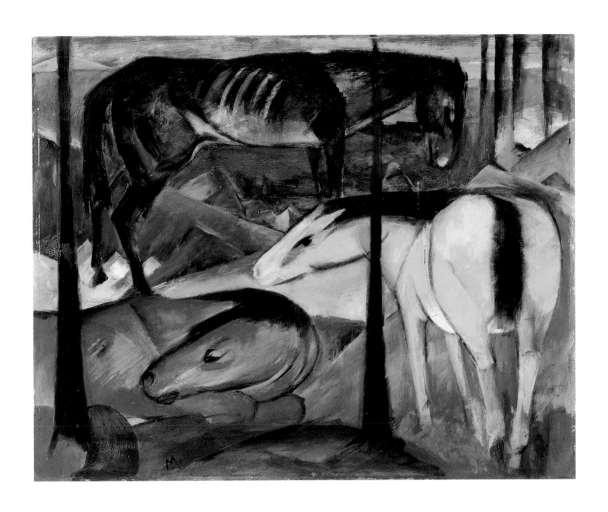

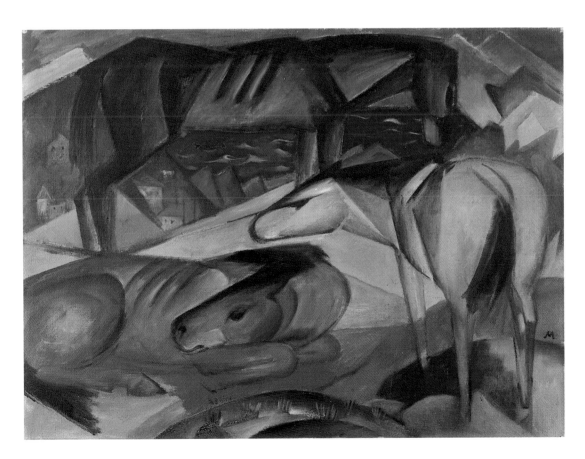

the goal more clearly. Among them I'd unhesitatingly count Delaunay."[98]

A talented self-analyst, predisposed to self-criticism, always ready to start over, Marc now broke with his own established patterns for the representation of horses, and set off for new territory. This phase of fruitful unease is reflected in *Stables* (fig.

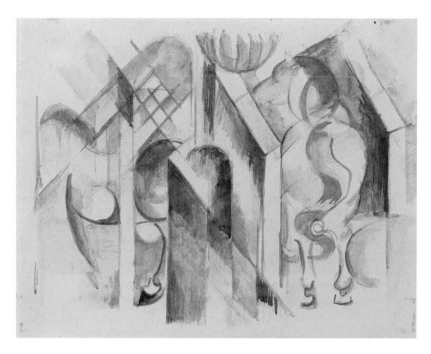

161), a painting with a dynamic two-dimensionality that clearly reveals Marc's preoccupation with Delaunay's approach to composition. A drawing from sketchbook XXX (fig. 160) shows a single motif from the subsequent picture, a still more or less naturalistically rendered horse between two partitions lifting its head a little to reach a hayrack. The left half of the sheet, on the contrary, offers a complete liberation from the figurative in anticipation of the general tendency of the painting.

Here, in contrast to what we find in pictures painted not very much earlier, the figures of the animals largely forfeit their presence as distinct bodily masses. The traditional dualism of body and space is abandoned. The horses and their setting merge into each other, creating a seemingly abstract tapestry of vibrant and strikingly joyful colors and forms. We find, however, that we are

still able to make out five horses. To the right there are two viewed from the back, and separated by a partition, with the hayrack suspended above them toward the center of the picture. In the left background there are two animals aligned parallel with each other and the picture plane that serve to lead the eye into the composition. It is apparent, however, that the white of their coats is less likely to be a record of their appearance than a feature determined by the formal requirements of the composition. Between these two pairs of animals, and occupying the center left of the foreground, is a horse with a glowing red coat, its head seen in profile and turned back at a sharp angle. The overall character of the picture is, however, more strongly determined by the coexistence and opposition of segmented disks, curving forms, and the vertical and diagonal stripes that both penetrate and intersect them. The result is a tightly constructed lattice of color and form that has the luminosity of the stained-glass windows of a Gothic cathedral. The forceful diagonals running from upper left lead the eye to the white horse at the center, to a condensed area of almost fully abstract forms. To the right this energy is countered by the calm pair of rear-view figures, with their almost identical pose and movement. The sideward turn of their heads returns our attention to the center of the composition, and finds an echo in the head of the red horse to the left. Marc has here created a kaleidoscopic pictorial cosmos out of the back and forth of animal communication in the stable.

Playing Forms (fig. 162), in the collection of the Folkwang Museum, Essen, shows Marc's further development of ideas derived from his continuing engagement with the work of Delaunay, in particular with pictures such as *Windows Overlooking the City (Fenêtres sur la ville)* of 1912, which is now also in the Folkwang Museum (fig. 180). Painted in the spring of 1914 in Ried, where Marc by this time had his own house, it shows that he was already embarked on his own artistic path toward purely abstract forms, toward pure painting. In this respect, the picture has no significance in the con-

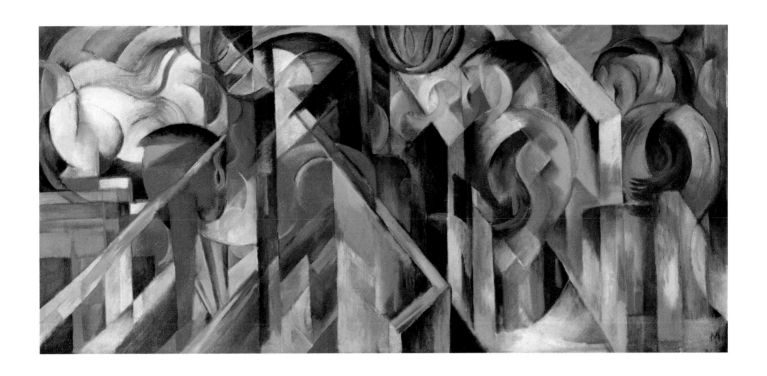

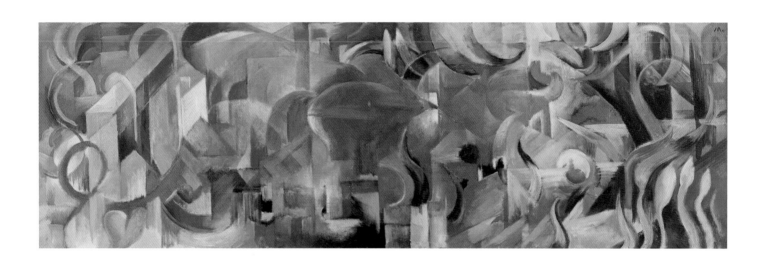

text of our survey of Marc's preoccupation with the horse as a subject. It is, nonetheless, clear that its proximity to *Stables* (fig. 161) is such — be it in terms of overall proportions or of color rhythms — that one can well imagine how *Playing Forms* could have emerged out of a series of studies resembling the earlier picture. This is not, however, to say that the entities resembling the partitions found in *Stables* or the recurrence of similar types of sweeping curves are to be interpreted as echoes of the subject treated in the earlier picture. By 1914, with Marc well on the way to abstraction, animals (even, with a few exceptions, horses) had almost entirely disappeared from his compositions. In *Stables* we can see the early stages of this development; and it is only through a rather forced reading of *Playing Forms* that any trace of them can be detected. Nonetheless, a letter written by Marc on May 16th 1915 touches on this very point and should give us pause: "There are very few abstract pictures without an object: this is *always* in there somewhere, quite clear and unmistakable, it's just that it doesn't always have to be outwardly obvious."[99] And in number 54 of his *100 Aphorisms* of early 1915 Marc wrote: "The age-old belief in color will take on an ecstatic fervor and spirituality as we overcome the sensual, the material, just as once the belief in God was intensified through the rejection of the images of idols. Color will be freed from matter and will lead the life that is immanent to it, functioning exactly as we wish it to."[100]

An ecstatic fervor, spirituality, and the life of color freed from matter are the defining characteristics of *Playing Forms*.

WAR: VISIONS AND REALITY

The following section of this essay is a digression in as far as it has little to do with horses. It does, however, have much to do with Marc's development, and it may thus contribute to an understanding of his personality and his art.

In January 1912, in a somewhat apocalyptic tone, Marc had begun as follows the text of a prospectus inviting subscriptions to the almanac *Der Blaue Reiter*: "Art today is on a path that our fathers could hardly have imagined; on standing for the first time in front of new works one feels as if in a dream and seems to hear the onrush of the approaching Four Horsemen of the Apocalypse; there is a sense of artistic excitement across the whole of Europe."[101] This excitement was to increase, and it was to be much more clearly apparent to Marc in February 1914 when he wrote his preface to the planned, but never published, second volume of the almanac:

"Yet again and indeed *repeatedly* we here make the attempt to persuade the desiring individual to turn his or her gaze away from the fine and good appearance, the inherited possession of past ages, and direct it to the gruesome, roaring essence [...]

The world is so full that we are suffocating. On every stone someone has staked a claim to show off his own cleverness. Every word has been leased out and invested with meaning. What can one do to attain salvation other than give up everything and flee? Other than draw a line between yesterday and today?

It is in this action that there lies the great mission of our age; the only one for which it is worth living and dying [...]

So we set off for new terrain and experience the great shock: that no one has been here before us, that everything is as yet unsaid, untouched, and unexplored. The world lies before us in its purity; our footsteps tremble. If we dare to go on, we shall have to cut the umbilical cord that binds us to the motherly past.

The world is giving birth to a new age; there is now only one question: has the time come to free ourselves from the old world? Are we ready for the *vita nuova*?"[102]

The spirit of hope for a new life, a *vita nuova*, such as the Italian poet Dante had described as a poetic utopia 600 years earlier, in an age similarly ripe for change, explains a great deal of Marc's atti-

162
Playing Forms, 1914
Museum Folkwang, Essen
CAT. 122

tude towards the war which Germany instigated six months later and which would develop into the First World War.

To those of advanced ideas, the Germany of Emperor Wilhelm II as it had developed by around 1914, imbued with the spirit of positivism and materialism, had long seemed in dire need not merely of reform but of dissolution. While it is hard to understand in retrospect, such people — intellectuals, idealists, and artists of every tendency — approved even war as a means to this end. Like countless members of his generation, and like many other artists, Marc readily enlisted in the army in August 1914. He placed his hopes in a thorough transformation of society, though what he had in mind was not so much a glorious German victory as the emergence of a new, enlightened Europe that, after the expected swift defeat of his beloved France, would take its starting point in the culture of that nation. Even Marc, with a short-sightedness that now makes us shudder, was at first intoxicated at the advent of war. On September 12th 1914 he wrote to Maria: "[...] I sense so strongly the spirit that hovers behind the fighting, behind every bullet, that the realistic, material aspect of things disappears entirely. Battles, wounds, troop movements all seem so mystical, unreal, as if they signified something quite other than what their names suggest."[103]

Until the summer of 1914 no one knew the meaning of murderous trench warfare, of World War. Initially, few expected the conflict to be prolonged, envisaging little more than a light military engagement. Marc saw in everything a necessary catharsis, believing that every individual was in some sense responsible for the war and that a sort of purgatory was essential for the future of Europe (he titled a text he published in December 1914 "In the Purgatory of War").[104] Once again, one is reminded of Dante, whose *Divina Commedia* recounts the passage from Hell, through Purgatory, to Paradise.

Maria Marc, however, could not share her husband's approval for the war as a necessary stage in the evolution of humanity. She was outraged at the geo-political realities that underlay the ostensible "causes" of the conflict. Much of the correspondence between Franz and Maria at this time allows us to conclude that there was a considerable difference of opinion between them on this matter. In a great many of his letters from the Front Marc bares his soul. Those written to Maria, but on occasion also those sent to his mother, to the widowed Elisabeth Macke, and to a few other friends constitute a touching document of Franz Marc's development as a man and of his identity as an artist. Thanks to their linguistic quality, they have also long been regarded as a component part of German literature.

In the midst of the turbulence of the war, in a fever of excitement, and with heightened sensibilities, Marc sought a meaning in all the destruction. In calmer moments, of which there were many for him in his post as a mounted messenger frequently left to his own devices, he found the time for deep introspection, reflecting on his life and on many fundamental questions of art, philosophy, literature, and religion. His intellectual horizons, already wide, in fact rapidly broadened at this time. This progress is most clearly to be seen in the sometimes visionary texts of his *100 Aphorisms*, written in the winter of 1914—15 in an even more than usually confessional style.

It would be a mistake to treat the Marc of the war years as all of a piece with the artist's pre-war self; and it is essential to bear in mind the extremity of Marc's existential situation during the war. If we attempt to understand Marc as he was at this period in order to discuss and assess his wartime writings, we have to bear in mind the psychic transformation that he experienced, and the crucial distinction between his pre-war and wartime point of view, as signaled in the 57th of his *100 Aphorisms*:

"By the way: These ideas did not come about in the studios of the Modernists of which one hears so much, but in the saddle, accompanied by the roar of cannon fire. It was precisely this, and only this deafening reality that tore my excited thoughts out of their habitual track of dear old sensual experi-

ence [to cast them] into quite another realm, into a higher, more spiritual possibility than this impossible present."[105]

This transformation of Marc's thinking under "the roar of cannon fire" is also evident in some lines written to Elisabeth Macke on January 29th 1915: "It's the same with me: I won't come back entirely the same man. The war has [...] thoroughly shaken up my whole way of thinking."[106]

In Marc's case, however, this experience of being "shaken up", this partial confusion (as it now appears to us), along with the daily horrors of a war that brought other artists (Max Beckmann, Ernst Ludwig Kirchner, George Grosz) close to physical and mental collapse, provoked a feeling of living on three distinct levels of consciousness, as he reported to Maria on May 25th 1915 (see p. 208).

While on active military duty, Marc never gave up hope of being able to return to his house at Ried; but it was also the case that his repeated encounters with death on the battlefield brought about a gradual ebbing of his fear of his own extinction. Indeed, death appeared to Marc as the starting point of true, spiritual life, and on occasion one can detect in his statements something resembling a disguised death wish. One example would be a letter written to Maria on March 28th 1915, which was Palm Sunday: "Animals, it goes without saying, also belong in this eternal cycle of types. The age-old doctrine of reincarnation or Nietzsche's concept of an eternal return have now assumed an entirely new significance for me that I had never grasped before. This is by no means an idle notion, for it reaches deep into the mystery of artistic creation; and perhaps it is the explanation of this mystery. The true forms of art are probably nothing other than this somnambulistic vision of the typical, the vision of more compelling (and thus *more correct*) interrelationships. What is correct was always correct, it has always been there." Later, in the same letter, as if Marc's sense of his own relation to the cosmos had attained a new dimension, he wrote: "The night sky, which I've been watching an awful lot this winter, has become for me a sort

of guiding thread, the logarithmic table of this idea: The relatonships between the individual stars and those between the constellations are like [the letters and spaces on] a bar of type; for those who can read [the sky], it is an open book of life, of 'possible situations'."[107]

As was almost inevitable, the length and the brutality of the war in due course forced even Marc into disenchantment. While his thoughts roved around ever broader themes, he adapted well to military routine, fulfilled his duties, was decorated with the Iron Cross and, in mid-October 1915, promoted to the rank of lieutenant. A few days before this event he wrote to Elisabeth Macke: "[...] my thoughts were nowhere, inconstant, unproductive, full of hatred for this war; and I'll tell you what makes my situation particularly bizarre: I'm becoming better and better at being a soldier! Often I feel I don't even recognize myself; we men are an odd lot. Sadly, the war makes us ever more manly; I now find that I can barely any longer imagine you women; and the fact that there are children and the life of children!"[108]

This cursory glance at the transformation wrought in Marc by his experience of war takes us to his statements of the spring of 1915, which offer many insights into his career in its entirety, but which (as we have argued) must also be understood as deriving their very strength of expression from his situation.

Marc had engaged deeply with Tolstoy's volume *What is Art?* and, in his self-critical tendency, had arrived at the insight that he reported as follows:

"The Blue Rider too has sinned a great deal; I'm full of regret for all our scribbling and our unthought-out exhibiting; but I nonetheless sense somewhere in modern art the pure line, the red thread of religious desire; we simply have to test ourselves a great deal more and exercise more *self-discipline* than in the past."[109]

Even if one is reluctant to accept Marc's evaluation in every respect, one might also take a frequently quoted letter, written on April 12th 1915 to Maria Marc, as an expression of the sensitivity he

felt at this time. One should not, however, take this letter out of context (as has usually been the case) as a key to a more general understanding of Marc and his artistic development:

"I've been thinking a lot about my own work. On the whole my instinct hasn't yet proved such a bad guide, even though the results have been flawed; I'm thinking, above all, of the instinct that led me from a sympathy for humanity to a feeling for the animals, the 'pure' beasts. The impious human beings that I found all around me (above all the men) didn't arouse my true feelings, whereas the untouched instinct for life of the animals called forth positive emotions in me. And it was from the animals that an instinct led me on to abstraction, something which excited me even more; to that second face of things that is so entirely Indian [i.e. other-worldly] and timeless and in which life resounds in total purity. I *very* soon learned to re-cognize humanity as 'ugly'; animals appeared to me more beautiful and purer; but even among them I discovered so much that was disturbing and so much that was ugly, that instinctively (out of an inner compulsion) the way I drew and painted them became increasingly schematic and abstract. Each year trees, flowers, the earth, everything revealed to me more ugly and disturbing sides, until suddenly, and only just now, I became fully aware of the ugliness of nature, of its *impurity*."[110]

Marc's words here should not all be taken at face value. Without doubt, his account of his overall development represented the process as he then saw it. One has, however, to bear in mind his increasing tendency toward self-criticism in these months of the war, in addition to his simultaneously increasing resentment of the "impure". (A psycho-logical "unmasking" of this nebulous, ubiquitous opponent of a "pure" art and lifestyle might well contribute a great deal to our understanding of Marc as an artist). We should be especially wary in endeavoring to assess Marc's statements on the element of the ugly and the disturbing in animals and in nature. Everything about Marc's behavior

contradicts these lines. He cared for army horses during the war with great feeling; he regularly requested the latest news of his beloved dogs, deer, and the other animals at home; he discovered places of natural beauty in many locations, even on the Front, and described them in a sensitive, often poetic, manner.

The word "ugly", which in his letter Marc at first uses within quote marks, is probably not to be understood in its conventional sense. In this instance we may also helpfully refer to a number of passages in Kandinsky's book *Über das Geistige in der Kunst*: "That thing is beautiful that has its source in an inner, spiritual necessity. That thing is beautiful that is inwardly beautiful." Ultimately, everything "outwardly ugly" could be beautiful: it was thus in art, so also in life.[111]

Earlier in the text Kandinsky speaks even more clearly on this point: "'Ugly', then, is only a conven-tional concept; as the outward result of a once effective inner necessity, it retains for some time an illusory afterlife. In these last years everything would have been termed ugly that had no relation to inner necessity."[112]

Is it not possible that Marc was employing the concept of ugliness in an equivalent manner? Could "ugly" not be understood as meaning "not beauti-ful", or "untrue", or not yet correct in the sense of Marc's latest ideas about art, about "pure", abstract painting? Were this the case, one would not be so inclined to judge Marc according to the somewhat exaggerated self-analysis to which he was moved in the bewilderment of war; and one would be far more inclined to judge him by his activities and endeavors during the last years of peace. With all his artistic striving and his sense of mission, he appears altogether different in that context.

To take just one example of how directly Marc reacted to his surroundings in wartime, we may consider his experience of an almost mystical dia-log with nature, which he reported to Maria Marc the following day, April 13th 1915:"[...] it is alto-gether thrilling to stand in such a rich old garden,

where spring looks at you with a million tiny eyes. I'm more in love than ever with flowers and leaves [...] we look at each other mutely and yet speak through our gestures: 'We already understand each other; the truth is somewhere else; both of us derive from it and will one day return to it.' With people one can hardly ever carry on in this way (perhaps [Paul] Klee is an exception), the egos always collide."[113]

Alongside the splendid "visions" among the *Aphorisms* (numbers 72, 73 and 74), which were pure visions of form and color, Marc gives voice to his particular love of nature — a complete contrast, that is to say, with what one finds in the letter of April 12th 1915 — in number 82: "I saw what the moorhen sees as it dives: the thousand rings that encircle each little life, the blue of the whispering sky swallowed by the lake, the enraptured moment of surfacing in another place. Know, my friends, what images are: the experience of surfacing in another place."[114]

One can only regret that such imaginative power in both word and image was granted no post-war period, no new level of creation. Perhaps Marc's work would have developed in the way that Max Beckmann's did, such a different sort of artist in the pre-war period but one who only really found himself in the experience of the horrors of the war and through the process of digesting these. But it is also possible that Marc would have returned to an "earthly simplicity", as Klee in his "night thoughts" of summer 1916 half feared (see p. 33).

Before we turn once again to Marc's horses, a few more lines from the letter to Maria Marc of April 12th 1915 cited earlier: "You mustn't conclude from what I've just said that now, returned to stability after my old mistakes, I *ponder* on the possibility of abstract form; on the contrary, I'm attempting to live in a very *intuitive* fashion; my outer concern with the world is very chaste and cool, very reserved and *observant*, so that my *interest* is not entangled in it and I currently lead a negative sort of life in order to give pure feeling room

to breathe and artistic development a chance. I put great trust in my instinct, in its productive capacities. I'll only be able to do something with this when I'm back at Ried, but then I'll really steam ahead; I often feel that I have something mysterious in my pocket, something that will bring me luck but that I mustn't look at; sometimes I lay my hand on it and feel it through the cloth."[115]

THE LAST HORSES

In Marc's letters from the Front one finds little more than occasional hints of the human suffering he encountered, of the real horrors of the war. It is possible that he felt unable to capture his experience in words, or that he did not wish to do so for fear of further worrying Maria. But much is revealed in his comments on horses.

On November 5th 1914 he speaks of the pitiful state of the horses after the battles in the Vosges.[116] On November 16th, in connection with his favorite dog, Russi, now weak with age, he observes: "I have horses here, of which I'm very fond, that I would have shot willingly and with a clear conscience, if I saw them suffering."[117] On February 11th 1915 he is overjoyed at the "16 horses, many of them very fine", that have been entrusted to him.[118] Just over a year later, on February 27th 1916, and only a few days before his death, he says in connection with the fighting around Verdun: "In essence we're always in pursuit. The poor horses!"[119]

Marc's sympathy for the miserable lot of his favorite animals in the war is especially evident in a letter sent from Mulhouse on December 17th 1914: "It's a regular soldier's life here [...] The only thing that gives me delight are the stables. How the poor horses enjoy themselves lying in the straw! It's a stable for hunters' horses, a splendid building. In the stables at Hagéville we could hardly get the saddles on the poor animals in their stalls because the beams got in the way, and nowhere was there any fresh straw; there was such

an appalling draft that, out of fear of catching a chill myself, I could never stay in there long. The [horses'] wounds healed badly because they always got reinfected in the dirty air and the dust. My heart would often bleed for the poor horses. And now — what a difference! Sadly, I wasn't there on the first day; I was told that after an hour almost all the horses *lay down* and rolled in the dry straw out of sheer pleasure!! The thought of the horses reconciles me to the tedium of life in the barracks."[120]

In an unconscious and almost prophetic parallel to his own fate, Marc wrote to Maria on December 6th 1915, three months before his death: "In these last days I also experienced the quite curious and upsetting death of a horse. The finest, fieriest, and also the bravest horse in the column, a wonderful, sturdy white horse, a real *Pegasus* of the legends, suddenly died from an infection of its appendix [...] during its last 2 hours it was in enormous pain and moaned and groaned like a human being. I felt at the time that it sighed like a man that was being shaken out of a lively dream. A few minutes later an awkward, ugly, decaying horse's body lay in front of me — Pegasus was nowhere to be seen — all that remained to us was the stinking mortal remains, and we had these buried. I thought of those eternally memorable words that have resounded down the ages: 'Let the dead bury their dead'."[121]

Else Lasker-Schüler, in her thoughts on Marc after his death, elevated to an almost Biblical dimen-sion the particular affection for horses that he expressed in so many ways: "When he was away at the war the Blue Rider always reminded me: 'It is not enough to be kind only to human beings, and what you do for the horses, who have to suffer so indescribably on the battlefield, you do also for me'" (see p. 193).

Marc had embarked on his artistic engagement with the world of horses with the studies from life that he made around 1905/06. Within only a few

years, and above all from 1910, he had already progressed from illustration to archetype. With his art he created an ideal realm for his horses to inhabit. However, the logic of his artistic evolution itself demanded its victims: ultimately the horse had to disappear. In Marc's increasingly abstract compositions the horse initially lost its naturalistic appearance, and subsequently its corporeal cohesion, in order finally to endure, in the pure forms of absolute painting, as nothing more than an echo. After his first few weeks of active military service it seemed to Marc barely conceivable that this war could be depicted "in painting camp fires, burning villages, the headlong dash of the cavalry, tumbling horses, and mounted patrols etc. This idea strikes me as really comic, even if I think of Delacroix who was almost the best at this sort of thing. Uccello was even better, and Egyptian friezes even better than him — but we must treat it in some way that's completely different, completely different!"[122]

This will to innovation is also apparent in the images in Marc's *Sketchbook from the Front* of spring 1915. With the exception of two pen-and-ink drawings (figs. 167, 168), this was the only artistic work that Marc was in a position to produce during the war years. Limited to the small scale of a pocket notebook (although he was of course already familiar with working on such a scale on account of the many painted postcards he had produced) and to the modest chromatic possibilities of the pencil (a particular restriction for such a master colorist), Marc nonetheless evolved an unprecedented wealth of images. In many cases these sketchbook drawings provide a visual equivalent to his recently completed *100 Aphorisms*. Frequently his thoughts on creation issued in splendid, abstract compositions. Despite their outwardly modest appearance, these drawings represent a highpoint in Marc's work as an artist.

Animals and plants are also to be found in the sketchbook drawings, but we shall here concentrate on scenes with horses. The *Peaceful Horse* (fig. 163) appears surrounded by a prismatic structure. Its body is paler in tone than its surroundings. Walk-

ing calmly as it grazes, the animal embodies harmony between a living being and its landscape setting. Should we perhaps interpret the juxtaposition of the dramatic criss-cross of diagonals and the sense of animal calm that they enclose as a reflection of the danger that war posed for horses? Does the title of this drawing allude to a quality specific to horses and thus to the fact that, in contrast to warring men, they suffer in war although they are themselves entirely innocent?

ferentiated in terms of pose, the construction of the group is more complex, and the setting is segmented in such a way that it becomes denser and darker toward the center. The horses appear to emerge out of the shadows; and again they convey a sense of majesty, as if they were the representatives of a higher state of being that can be sensed but not depicted. All four horses nonetheless reflect aspects of normal animal behavior: one figure stands with attention focused on the viewer along-

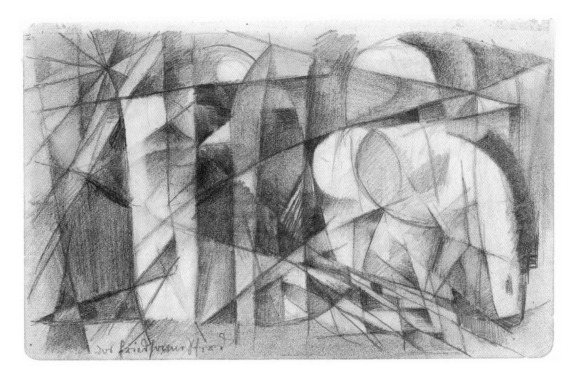

163
The Peaceful Horse, 1915
Staatliche Graphische
Sammlung, Munich
CAT. 123

In the last untitled horse drawing (fig. 164), a different, more open world appears. The few horses found here are small, while the mountains, the agave plants and the sun (toward which two animals raise their heads) are large. The sense of calm about the expansive, almost desert-like setting with further "peaceful" horses has the appearance of an image of the longing for an end to war: it is a vision of Paradise far removed from the daily belligerence of Marc's surroundings.

In the sheet titled *Fragment* (fig. 165) the vertical arrangement of the four animal figures recalls the subject of *The Tower of Blue Horses* (fig. 111). In the drawing, however, the horses are more strongly dif-

side another shown peacefully grazing; beyond, a third animal embodies concentration, with its head raised to one side; above this is a horse with its head in a contemplative sideways turn and an expression poised between observation and exploration, a stance often to be found in Marc's earlier images and perhaps at its finest in the melancholy *Blue Horse* of 1911 (fig. 72). The amount of work produced following that picture seems in retrospect so vast that it is easy to forget that this interval consisted of only four years. The title Marc gave to this well-balanced pictorial idea — *Fragment* — itself remains a puzzle. The dialog, the tension between name and content, prompts us, as is the

case with many other sheets from this sketchbook, to ponder more deeply on Marc's thinking at this time.

A second untitled sketchbook drawing within our group of four (fig. 166) shows three horses racing along with outstretched necks through a mountain landscape. This motif of dread and flight, already to be found in the painting *Animal Destinies* (fig. 177), is probably connected with contemporary events on the battlefield. (Although

more explicit denunciation of the war. After only a year at the Front Marc knew that this war could not be represented in any other way than with "the headlong dash of the cavalry, tumbling horses."

Marc invested all his feeling in two splendid, stirring pen-and-ink drawings that effectively combine protest and lamentation. Despite their small size (that of Marc's earlier painted postcards), these images achieve a monumental and symbolic character. The events that inspired them must in them-

164
Untitled, 1915
Staatliche Graphische Sammlung, Munich
CAT. 126

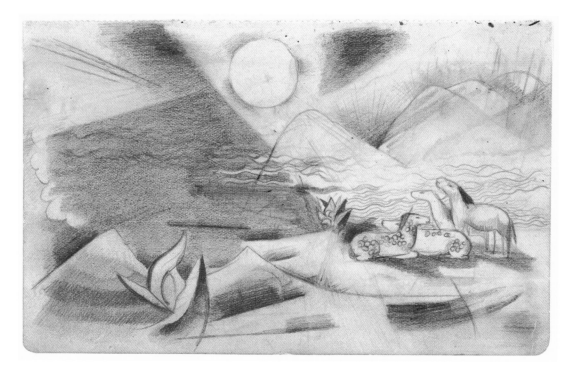

sheet 24 of the sketchbook bears a composition entitled *Conflict*, that image is in itself more ambiguous). This seems especially probable in the light of Marc's last works, the studies of horses produced around six months later, in the fall of 1915 (figs. 167, 168). In the sketchbook drawing Marc still applies to the theme of dread his new simplifying language of form. He is evidently more concerned with an artistic problem than with a true reflection of reality.
This reality, however, ultimately overpowered this advanced mode of expression. Marc's experiences were such that they virtually forced him to return to a traditional pictorial language in order to achieve a

selves have seemed to demand baroque drama, rousing rhetoric, or symbolic expression.

In September 1915 Marc made a *Marterl* in the Bavarian style (a small monument marking the site of an accident) for Hans Schilling-Zimssen (1869—1950), an officer and musician to whom Marc was very close, and who had been slightly wounded in action. "A humorous poem and a votive image from his hand", as Schilling-Zimssen recalled in 1917, "were intended to keep alive the memory of the event. The powerful rhythm that was conveyed in a hurtling group of riders could certainly have served for a colossal painting of the Four Horsemen of the Apocalypse."[123] This great subject

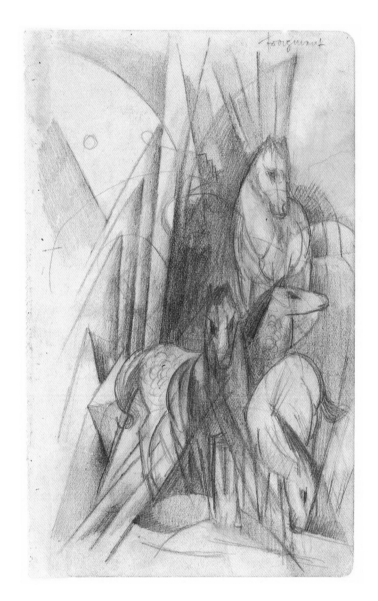

165

Fragment, 1915

Staatliche Graphische Sammlung, Munich

CAT. 125

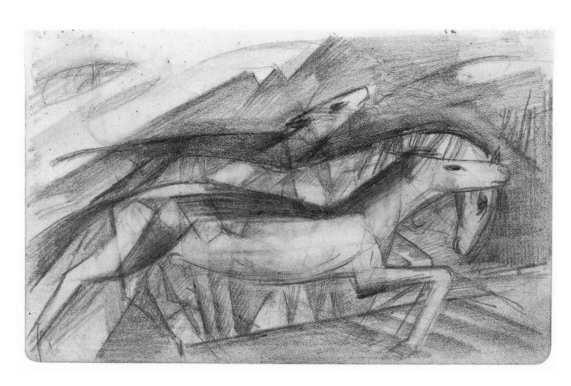

166
Untitled, 1915
Staatliche Graphische Sammlung, Munich
CAT. 124

had indeed already occurred to Marc at the time when the almanac *Der Blaue Reiter* was being announced.

The *Headlong Rush of Horses* (fig. 167), who sweep past the viewer like a dark star, at full tilt and terrifyingly close together, with all the signs of dread in their faces, could hardly have been drawn without some inner connection to Marc's ideas about this scene of the Apocalypse. How sad and how symptomatic that a man who in peace-time was so full of creative power should be forced to realize one of the great themes of Christian art on a monument erected more than half in jest.

The *Horses's Head* with its wildly staring eyes, flaring nostrils, ears laid back, and wide open mouth (fig. 168) expresses utter dread in its dramatic chiaroscuro and its oppressive close-up view. In the distant figures of other horses with riders and an animal that has fallen, the scene also has an apocalyptic dimension. This horse sees no way out of its situation. Its fine dark eye does not look straight ahead, but to the side as if seeking assistance. But the viewer, who receives this glance, has no consolation to offer as a response to this singular complaint against the war.

According to the evidence of these two drawings of horses, Marc's last works, it would seem that the war finally did open his eyes to reality, only to close them forever a few months later.

* * *

In the context of our survey of Marc's short but prolific career, some comments by August Macke seem to offer an especially apposite conclusion in the light of our concern with horses. In December 1910, a time when the two artists were in especially close contact, Macke wrote from Bonn: "At the moment I'm preoccupied with thoughts about erotic Japanese prints, Giotto, Michelangelo, but also about the horses that were painted in Sindelsdorf [...]

So, farewell. I'm happy that you're working. Give to your age images of animals that people will stand and look at for a long time. May the hoofbeats of your horses reverberate into the centuries to come."[124]

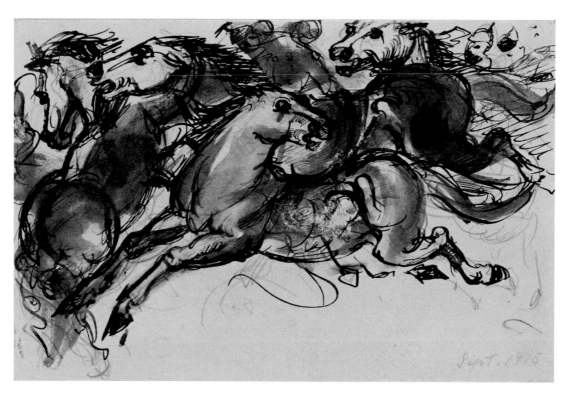

167
Headlong Rush of Horses, 1915
Staatliche Museen zu Berlin, Kupferstichkabinett
CAT. 127

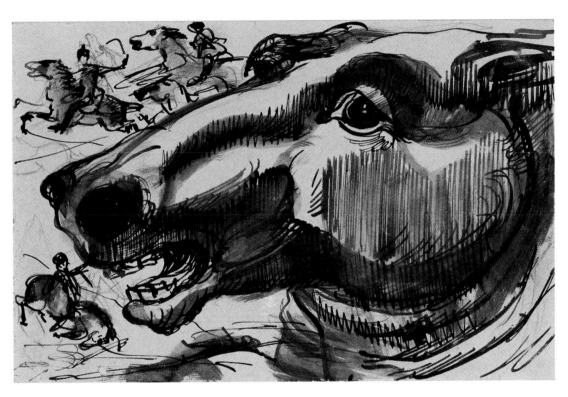

168
Horse's Head and Three Riders, 1915
Staatliche Museen zu Berlin, Kupferstichkabinett
CAT. 128

Notes

1 Meissner 1989, p. 54.
2 Macke 1964, p. 45.
3 Macke 1964, p. 73.
4 Lankheit 1983, p. 188.
5 Lankheit 1978, p. 143.
6 Macke 1964, p. 163; and see also Hüneke 1993, pp. 105ff.
7 Macke 1964, p. 184.
8 Marc 1941, p. 58.
9 Levine 1979, p. 58. On this point see also Langner 1980, pp. 69ff.
10 Schuster 1987, p. 88.
11 Lankheit 1978, p. 99.
12 Lankheit 1983, p. 53.
13 Meissner 1989, p. 139.
14 Lankheit 1978, p. 148.
15 Marc 1941, p. 77.
16 Lankheit 1976, p. 30.
17 Meissner 1989, p. 198.
18 Kandinsky 1911/1952, p. 132.
19 Schuster 1987, p. 122.
20 The drawing by Marc's father, made for the boy's tenth birthday, has an almost prophetic quality in both image and inscription. This is the first time that we find Franz Marc associated with horses; it was as a cavalry officer that he was to die near Verdun in 1916. The inscription reads: "Each year follows the one before as fast as this column of riders. Always sit up straight in the saddle until you're laid in your coffin! With fondest wishes from your father W. Marc."
21 Schardt 1936, p. 45.
22 Lankheit 1976, p. 28.
23 Meissner 1989, pp. 23 ff.
24 Nuremberg, Germanisches Nationalmuseum, Graphische Sammlung, inv. no. Hz 6359, sketchbook IV (1906), fol. 29a: graphite on paper 14.3 x 16.8 cm (image), 19.5 x 24.8 cm (page).
25 Meissner 1989, p. 26.
26 Meissner 1989, pp. 26 ff.
27 Schardt 1936, pp. 47 ff.
28 Meier 1986, pp. 230, 238, note 238; see also p. 244.
29 Nuremberg, Germanisches Nationalmuseum, Graphische Sammlung; inv. no. Hz 6361, sketchbook VI (1907/08), fol. 8: black chalk on paper, 17 x 13.5 cm (image), 20 x 13.5 cm (page).
30 Nuremberg, Germanisches Nationalmuseum, Graphische Sammlung, inv. no. Hz 6364, sketchbook IX (1908), fol. 25: graphite on paper, 10.6 x 14.5 cm (image), 10.6 x 17.6 cm (page).
31 Lankheit 1970: 73, canvas, cut into six pieces by Franz Marc; reassembled in around 1960. Dimensions in reassembled state: 105 x 206 cm; Rosenthal 1992, pp. 14 ff., color plate 5.
32 Lankheit 1970: 412, tempera, 58 x 78.5 cm; signed at the lower left: *Fz Marc*.
33 Meissner 1989, pp. 30 ff.
34 Meissner 1989, p. 30.
35 Langner 1980, pp. 50 ff., and Langner 1981, pp. 79 ff.
36 Macke 1964, pp. 24 ff.
37 Kandinsky 1911/1952, p. 117.
38 Kandinsky 1911/1952, pp. 119 ff.
39 Nuremberg, Germanisches Nationalmuseum, Graphische Sammlung, inv. no. Hz 6367, sketchbook XII (1909), fol. 9: black chalk on paper, the sky with white wash, 10.6 x 13.6 cm.
40 Lankheit 1970: 114, oil on canvas, 150 x 161 cm, damaged in a fire at the premises of a Berlin transportation company; narrow strips of canvas added above and below. Lankheit 1976, pp. 61ff., color pl. 7. See also Marc's comments on his "lively manner" with regard to the *Leaping Horses* in his letter of January 31st 1911 to Maria Franck, cited in Meissner 1989, p. 45.
41 Kandinsky 1911/1952, p. 123.
42 Lankheit 1970: 129, paper on cardboard, 59.7 x 80 cm; signed at the lower left: *F. Marc*. Formerly in the collection of the art historian Carl Georg Heise in Hamburg; destroyed during the Second World War. Heise's description of the colors is cited in Lankheit 1976, p. 70.
43 Meissner 1989, p. 34.
44 Meissner 1989, p. 34.
45 Langner 1981, pp. 91 ff., note 31.
46 Macke 1964, pp. 28 ff.
47 Macke 1964, p. 40.
48 Meissner 1989, p. 47.
49 Exh. cat. Munich 1999, p. 37.
50 Exh. cat. Munich 1980, p. 115.
51 Meissner 1989, p. 48.
52 Meissner 1989, p. 45. To begin with, Marc links the *élan* of a new composition with a concept of color that he had already sought to use, albeit unsuccessfully, in resuming work on what may well have been an earlier picture — in all probability a descendant of the first Lenggries motif. Writing to Macke on December 2nd 1910 (cited in Meissner 1989, p. 33), Marc observed: "I've of course resumed work, with a new canvas, on my large group of horses; its's very colorful, with the whole range (yellow, red, and violet bodies, and blue and green tails) against a white background, i.e. it's done in such a way that the white is more or less suggestive of a wall on which the whole thing is painted or is supposed to be." However, writing to Maria Franck on January 17th 1911 (Meissner 1989, p. 43), he complains: "The large picture with horses is still a problem child; I've now got it to look quite good, its tremendously colorful, but it's still going to be hard to complete it." It would seem that Marc then freed himself from this "problem child", in order to make a really new start — with his work on *The Red Horses*.
53 Levine 1979, p. 58.
54 Langner 1980, pp. 50 ff., in particular p. 56.
55 Meissner 1989, p. 54.
56 Meissner 1989, p. 55.

57 Meissner 1989, p. 46.

58 Lankheit 1970: 540, graphite on paper, 21.6. x 16.8 cm. From sketchbook XXI; sold at Christie's London on December 2nd 1980.

59 Kandinsky 1911/1952, pp. 68 ff.

60 Blade-like stalks are also to be found in the watercolor version of this composition (Lankheit 1970: 422), formerly in the collection of the Staatliche Galerie Moritzburg, Halle, but now untraced. Similar instances of diagonal stalks or tendrils traversing a composition are to be found in an unpublished *Study of a Horse* in the Germanisches Nationalmuseum, Nuremberg (inv. no. Hz 6367, sketchbook XXI, 1911, fol. 41), and in the painting *Nudes in the Open Air*, now in Düsseldorf, another work of 1911 (Lankheit 1970: 138).

61 Pese 1989, p. 119.

62 Schardt 1936, p. 100; see also p. 226.

63 Kandinsky 1911/1952, p. 94.

64 Lankheit 1978, p. 102.

65 Lankheit 1970: 189: canvas, 80 x 105 cm. Marc started work on this picture in October at Macke's house in Bonn, completing it in Sindelsdorf in November 1912.

66 Lankheit 1970: 210: oil on canvas, 200 x 130 cm. Marc was at work on this picture in Sindelsdorf in March 1913. He completed it in May. The painting was burnt in its lower section while stored at the premises of a Berlin transportation company in 1917. Formerly in the Nationalgalerie, Berlin; untraced since 1945. From the voluminous literature on this work, there follows a selection: Lankheit 1976, pp. 120 ff., fig. 53; Pese 1989, pp. 124ff., color pl. 1; exh. cat. Berlin 1998, p. 74, fig. 1.

67 Lankheit 1970: 728. Schuster 1987, no. 2, fig. 2. Pese 1989, p. 124, fig. 93.

68 On this point, see no. 33 of Marc's *100 Aphorisms*, written in 1914/15 while at the Front (Lankheit 1978, p. 195): "'In the Beginning was the Word'. Before the form there was always the idea. Before Gothic existed as a form, the glowing idea of it was always active as a truth, as sacred knowledge, as the hierarchy of saints that attains its highest formula and form in the profound notion of the Gothic cathedral."

69 Schuster 1987, p. 125.

70 Lankheit 1970: 837. Schuster 1987, p. 115, figs. 3—4. Hüneke 1998, pp. 47 ff.

71 Lankheit 1970: 727. Schuster 1987, no. 1, fig. 1; passage cited after p. 159.

72 Lankheit 1976, p. 118.

73 Macke 1964, p. 149.

74 Schuster 1987, p. 87.

75 Lankheit 1970: 748. Schuster 1987, no. 1, fig. 1.

76 Lankheit 1970: 739. Schuster 1987, no. 7, fig. 7.

77 Schuster 1987, no. 18, p. 122.

78 Lankheit 1970: 743. Schuster 1987, no. 9. fig. 9.

79 Schuster 1987, no. 19, fig. 19, and p. 122.

80 Schuster 1987, passim. See also Bauschinger 1999, pp. 58 ff., 72 ff.

81 Lankheit 1970: 794. Schuster 1987, no. 28, fig. 28.

82 Lankheit 1976, fig. 60; see also fig. 231.

83 Macke 1964, p. 162.

84 Macke 1964, p. 217.

85 Lankheit 1970: 209: oil on canvas, 196 x 266 cm; Basle, Kunstmuseum. Lankheit 1970: 619, mixed media, 16.4 x 26 cm; Munich, Bayerische Staatsgemäldesammlungen, gift of Sofie and Emanuel Fohn.

86 Lankheit 1970: 732. Schuster 1987, no. 4, fig. 4.

87 Lankheit 1976, p. 151.

88 Exh. cat. Berlin 1998, p. 176.

89 Baumgarth 1966, p. 182. For the original texts, see *Archivi del Futurismo*.

90 Meissner 1989, p. 97.

91 See the very similar drawing of 1906 (Lankheit 1970: 516).

92 See Langner's analysis of the *Deer in the Forest II* of 1914, in the collection of the Staatliche Kunsthalle, Karlsruhe; Langner 1981, p. 86 ff., fig. 1.

93 Lankheit 1970: 207; canvas, dimensions unrecorded; destroyed in 1917 in a fire at the premises of a Berlin transportation company.

94 Lankheit 1970: 464; gouache, 39 x 46.5 cm; formerly in the Solomon R. Guggenheim Museum, New York. Moeller 1989, no. 156, color pl. 156. Rosenthal 1992, no. 54, color plate 54.

95 See the work of the painter Ludwig Meidner from the last pre-war years, e.g. *Apocalyptic Landscape* of 1912/13 in the Staatsgalerie, Stuttgart.

96 Lankheit 1970: 201; oil on canvas, 60 x 80 cm; formerly in the Solomon R. Guggenheim Museum, New York; deaccessioned and sold, and currently untraced.

97 On connections with Tolstoy and with a small, wooden horse found in the artist's estate, and now at Kochel am See, see Hüneke 1993, pp. 111 ff., figs. 5—8. I am grateful to Klaus Zeeb for informing me that Marc's *Long Yellow Horse* is probably to be identified as a Przewalski, Mongolian in origin, on account of its head shape and yellow coat. Marc, as a keen visitor of zoos, may well have seen such a horse in Hellabrun.

98 Lankheit 1983, pp. 241 ff.

99 Meissner 1989, p. 147.

100 Lankheit 1978, pp. 200 ff.

101 Lankheit 1965, p. 316.

102 Lankheit 1965, p. 325.

103 Marc 1941, p. 8.

104 Lankheit 1978, pp. 158 ff. The probability that Marc's disturbing ideas were shared by others is revealed in particular by a letter from an American artist close to the circle around the almanac *Der Blaue Reiter*, the somewhat younger Albert Bloch, written to Marc on December 6th 1914: "Your idea that the people of Europe will render a common blood sacrifice through this war is sublimely beautiful. — This testifies to your recognition that this war is an inexorable *spiritual necessity*. I've always known that [...]." Cited in exh. cat. Munich 1997, p. 167.

105 Lankheit 1978, p. 201.
106 Macke 1964, p. 205.
107 Meissner 1989, p. 133.
108 Macke 1964, p. 216.
109 Lankheit 1978, p. 180.
110 Meissner 1989, pp. 140 ff.
111 Kandinsky 1911/1952, p. 136.
112 Kandinsky 1911/1952, p. 86.
113 Meissner 1989, p. 142.
114 Lankheit 1978, p. 209.
115 Meissner 1989, p. 141.

116 Macke 1964, p. 198.
117 Meissner 1989, p. 114.
118 Lankheit 1976, p. 148.
119 Meissner 1989, p. 198.
120 Meissner 1989, p. 121.
121 Meissner 1989, p. 179.
122 Meissner 1989, pp. 102 ff.
123 Published in the *Frankfurter Allgemeine Zeitung* in 1917; cited in Lankheit 1960, p. 72.
124 Macke 1964, p. 27.

Else Lasker-Schüler:
Obituary for Franz Marc, 1916

The Blue Rider is dead, a great figure out of the Bible, with the scent of Eden still clinging to him. He cast a blue shadow over the landscape. It was he who could still hear what the animals were saying; and he transfigured their mis-understood souls. When he was away at the war, the Blue Rider always reminded me: "It is not enough to be kind only to human beings, and what you do for the horses, who have to suffer so indescribably on the battlefield, you do also for me".

He is dead. Great angels bore his giant's body up to God, and God, with out-stretched hands, received his blue soul like a gleaming banner. I'm reminded of a passage in the Talmud [...] that tells of how God once stood among the people in front of the destroyed Temple and wept with them [...] The Blue Rider has arrived; but he was too young to die. I never saw a painter work as he did — so earnest and yet so gentle. He called his animals "lemon oxen" and "fire buffaloes" and a star always sparkled at his foreheard. And even the wildest animals would re-emerge as plants in his tropical hands. He magically transformed female tigers into anemones, and made leopards look like gillyflowers; when he painted a panther snatching a gazelle from a rock he called it an act of pure killing. He felt like one of the young patriarchs in the Bible, a magnificent Jacob, the Prince of Cana. He beat fiercely at the thicket around his shoulders; he regarded the reflection of his handsome face in the pool of a forest spring, and then he would wrap his miraculous heart in a hide, and carry it home across the meadows, as if it were a tired and sleepy little boy.

CITED IN LANKHEIT 1960, PP. 78—79

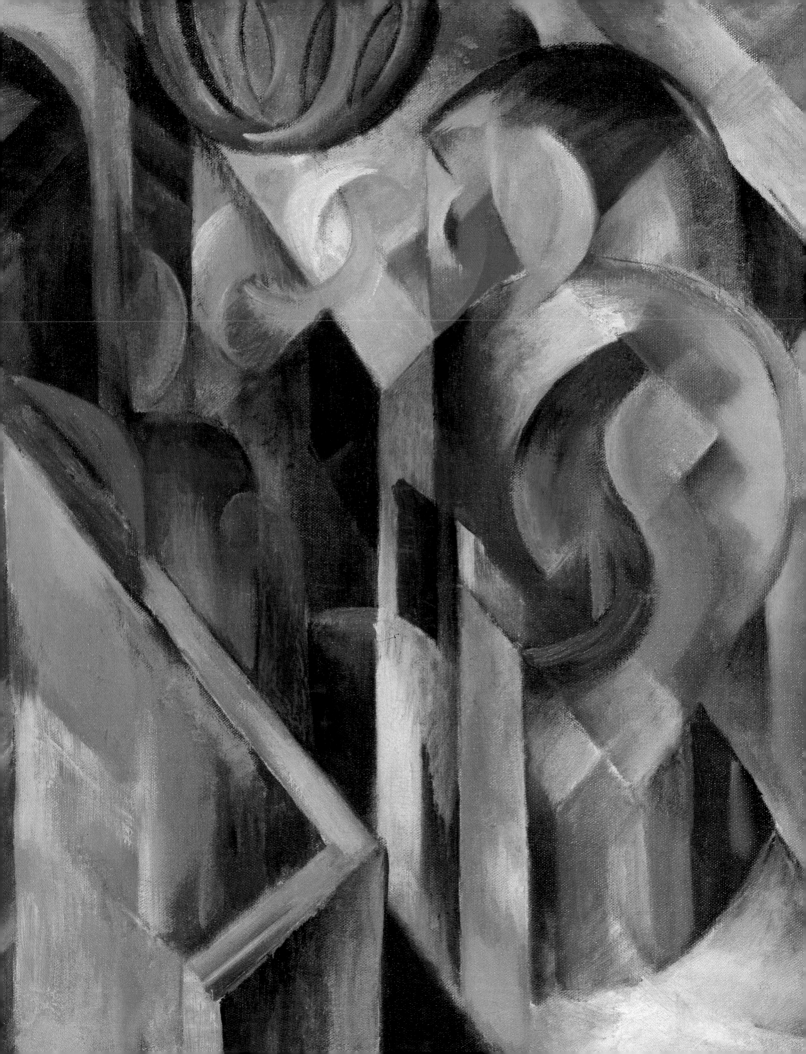

»...from looking at the world to looking through the world«

Franz Marc and Der Blaue Reiter
in the Struggle for Modernism

KARIN VON MAUR

The year 1910 was to prove a turning point in the life and work of Franz Marc, who was then 30 years old. To begin with, he definitively abandoned "deadening Munich" for the seclusion of the village of Sindelsdorf, near Kochel am See in the foothills of the Bavarian Alps, a move he was able to make thanks to the monthly stipend he now received from the collector Bernhard Koehler, Sr. Elisabeth Macke (Koehler's niece and the wife of Marc's best friend, the painter August Macke) was later to recall that around Sindelsdorf was "a very peculiar area, a lot of flat land with pasture and a wide sky, nearby some curiously lonely spots, with plentiful moorland that has something almost ominous about it. The village itself is small, but not compact, with paths that one can barely use when it rains".[1]

Secondly, Marc now devoted himself to painting animals, almost entirely neglecting other genres such as landscape, still life, or the nude. He explained his decision to do so in the same year, in his contribution to a volume compiled by the Munich publisher Reinhard Piper, *Das Tier in der Kunst* [Animals in Art], in terms of a desire to "heighten [his] feeling for the organic *rhythm* that

is to be sensed in everything". He was endeavoring, he said, "to empathize, in a pantheistic fashion, with the quiver and flow of the blood in all of nature"; and he aimed at an "*animalization* of art", a vitalization and animation, which he hoped would counter the trend toward the "avoidance of the animate". For this, he thought the animal picture the most appropriate vehicle.[2]

There is little doubt that, in his withdrawal from what he perceived as the decadence of urban culture, his flight to the country (by this date, a strategy already well-tried in artists' colonies such as Barbizon, Pont-Aven, Worpswede, or Neu-Dachau), and his turn to animal painting, Marc's convictions were significantly reinforced through a deep familiarity with the writings of the late 19th-century German philosopher Friedrich Nietzsche.[3] Crucial to these was a critique of the life-negating aspects and emphasis on rationality that characterized a culture pervaded by Christianity. In Nietzsche's view, the only remedy was to be found in an affirmation of the animal instincts and in self-determined creativity. It is clear that Marc shared Nietzsche's critical assessment of contemporary European culture. In a letter of 1899 to the

page 194
169
Stables, 1913
Detail from fig. 161

pastor Otto Schlier, he voiced his view that "we Europeans [...] have long since ruined our horses (= instincts) and it's unlikely that they'll fully recover". Yet he believed that a skilled and superior rider might bring his horse to show what it was capable of.[4] Evidently, the notion of the horse and rider as a metaphor of spiritual struggle was already meaningful to Marc by this date. As we shall see, it was to become central in the symbolism of the almanac *Der Blaue Reiter* (published in 1912), and not least in the title chosen for it.

In his contribution to Piper's book Marc in fact indicated the artists who, in his view, had paved the way, with their treatment of color and movement, for an "animalization of the feeling for art", even though they had not themselves concentrated on depicting animals. These included Delacroix, Cézanne, Van Gogh, Gauguin, and Signac.

 In his own work, Marc felt that he was getting ever closer to his goal in as far as he adopted and adapted certain elements in the work of this pioneer generation. His picture of 1909/10 *Cats on a Red Cloth*, with its surging brushstrokes worked into parallel ribbons of color, clearly reveals the influence of the painting of Van Gogh, whom Marc had described in 1907 in a letter to his companion, and future wife, Maria Franck, as the "dearest, truest, most touching painter that I know",[5] and whose work he had been able to study carefully at the one-man-show presented in Munich in December 1909 by the art dealer Franz Joseph Brakl.

In Marc's composition of 1910 *Leaping Horses* (fig. 54) the individual dabs of color are applied in a manner resembling mosaic and the picture plane is further emphasized through the undulating rhythms of the brushwork. In this quasi-pointillist phase, Marc in some respects comes close to the technique employed by Signac. In other respects the picture recalls Seurat's painting of 1890/91 *Le Cirque (The Circus)*, except that the

leaping movements of Marc's horses — carefully studied in many preparatory drawings — appear so dynamic that even Seurat's horse seems in comparison rather wooden.

Soon, however, Marc was inspired by the work of Gauguin, whom he had first discovered during his second trip to Paris, in 1907, and revisited on the occasion of the show held at Julius Thannhauser's Munich gallery in August 1910. He now made the transition to a summarizing treatment of forms and a reliance on large planes of boldly contrasting primary color, as seen in *Horse in the Landscape* (fig. 60).

 Here, for the first time, Marc replaced local color with what the scholar Klaus Lankheit was later to term "essential color"[6]: a subdued crimson for the horse's body, blue for the mane and the tail, and the complementary colors yellow, orange, and green for the landscape. This combination of a reduced but richly contrasting color scale with so simple a motif — the partial back-view of a horse seen against an undulating expanse of pasture — issues in a pictorial organism that appears to embody Marc's aim to empathize with nature "in a pantheistic fashion" through its interplay of rhythms and colored shapes.

MARC'S FRIENDSHIP WITH MACKE AND HIS INTEREST IN COLOR THEORY

Marc first met August Macke, who was based in Bonn and was seven years his junior, on January 6th 1910 in Munich. A lively exchange of ideas ensued, with Macke insistently drawing Marc's attention to the work of Cézanne and Matisse. Yet it was not until later in this year that Marc began seriously to engage with Cézanne. The publisher Reinhard Piper was planning to bring out a Cézanne monograph by Julius Meier-Graefe, and he commissioned Marc to make a drawing after a

particular painting of bathers (now in the Staats-galerie, Stuttgart) to illustrate the cover of this volume (fig. 170).

Marc wrestled with this task for a good while and made no less than "eighteen attempts to grasp Cézanne's picture. I went as far as making a complete analysis of its composition; but the main difficulty was that the image was intended only as a title page [sic.] for the reader simply to 'glance' at".7

It would appear that Marc drew on his experience of analyzing Cézanne when working on the composition of his own painting of 1911 *The Red Horses* (fig. 68), for here the group of four animals found in preceding versions was reduced to three. The vigorously posed bodies, arranged in a triangular formation, are rendered in a fiery red that corresponds to the primary contrasts of the landscape and is enhanced in its impact through the insistent blue of the rocks and bushes. The outlines of the necks and the inclination of the heads (down, up, and to the left) serve to indicate spatial interrelations, but they also assume an abstract, heraldically stylized autonomy as an arabesque of curved forms at the center of the composition. The series of pictures culminating in *The Red Horses* constituted an important step in Marc's progress toward an expression of his sense of the organic unity of nature, and the more so in that he was now employing purely pictorial means and could be said to have freed himself from

naturalism. Although Marc had derived these new devices from the study of natural appearances, he had intensified and condensed both form and color so as to arrive at an autonomous language of art.

Above all, *The Red Horses* was the fruit of Marc's studies of scientific color theories, from Chevreul to Bezoldt. He familiarized himself, for example, with the chromatic scale of spectral colors, and the theory of contrasts in color wheels, in every case checking the claims made with the help of a prism. Discussion of color theory also dominated Marc's correspondence with August Macke during the first year of their acquaintance. On December 12th 1910, however, Marc distanced himself from all scientific analyses and syntheses, declaring that these had begun to bore him like musical scales, and announcing that he had arrived at a color theory of his own:

"*Blue* is the *male* principle, austere and spiritual. *Yellow* is the *female* principle, gentle, serene, and sensual. *Red* is *matter*, brutal and heavy, and always the color that has to be fought and overcome by the other two!"8

Marc went on to explain how particular chromatic combinations could alter the way that the primary colors were perceived, and how every modification also necessitated the introduction of a related contrasting color. Thus, the "brutal" red of the three horses (that in the center has a more subdued, purplish tone) had to be countered by the "spiritual" blue of the bushes and rocks at the top left and lower right, in order "*to silence the voice of matter*", and at the same time anchored in the pacifying yellow of the pasture, with the help of the contrasting secondary colors green, orange, and violet (in the horses' manes and tails).

The analogy between colors and musical tones, lines, and melody also took up much space in this correspondence, although Marc, unlike his friend, was initially wary of "too insistent an application of the technical laws of music to painting".

170
Pen-and-ink drawing after Cézanne, Bathing nudes in front of a tent, 1883—1885 Cover of Julius Meier-Graefe's Cézanne monograph published in 1910

This did not, however, prevent Marc from enthusing, in a letter of January 14th 1911, about a "musical event", an evening of chamber music on New Year's Day, with quartets, piano pieces, and lieder by Arnold Schönberg, where he had discovered astonishing analogies with the painting of the expatriate Russian artist Wassily Kandinsky, whom he had met for the first time the day before: "Can you imagine music in which tonality (i.e. the adherence to a particular key) is completely suspended? While I was listening I kept thinking of Kandinsky's large composition, for nor does that admit any trace of a [particular] key [...] and also of Kandinsky's 'leaping marks'. This music lets every note that is sounded speak for itself [...] Schönberg maintains that concepts like consonance and dissonance are entirely illusory. A so-called dissonance is merely a consonance [of two elements] placed further apart [...]".

This insight gave Marc the idea that complementary colors need not appear next to each other, as they do in the prism, but could be "placed as far apart" as desired. "The partial dissonances that will arise as a result will be absorbed within the composition as a whole, where they will achieve an effect of consonance (harmony) in as far as they are complementary in their extent and their relative intensity." In the attempt to achieve an overall effect that was harmonious, what mattered was attaining the correct relationship, in terms of values, among the contrasts and the dissonances.[9]

KANDINSKY AND THE NEUE KÜNSTLERVEREINIGUNG MÜNCHEN

Over three months before the Schönberg concert, and his first meeting with Kandinsky, Marc had already become fascinated by the latter's paintings. One of the first of these to be seen by Marc

was also one of Kandinsky's first abstract compositions: *Improvisation 10*. This had been included in the second exhibition of work by members of the *Neue Künstlervereinigung München*, hereafter *NKVM* [New Munich Artists' Union] at Thannhauser's gallery, and it made such a strong impression on Marc that he immediately wrote a response to a deprecating newspaper review of this show. In this text he praised Kandinsky's "artistic insight" into the "logical implications of his colors" and the "liberated draftsmanship" found in his treatment of form.[10]

Marc sent this bold statement of support to Thannhauser, who in turn sent it on to the painter Adolf Erbslöh, then secretary of the *NKVM*. As Kandinsky was later to recall, Marc's intervention constituted the only voice raised in approval of the exhibition in the midst of a flood of insults and threats — and this in the reputed "art city", Munich.[11] The importance to the *NKVM* of this expression of sympathy is also evident in the fact that Erbslöh promptly wrote a letter to its author (as yet unknown to him), asking his permission to reprint his text in a leaflet, where it would appear opposite a reprint of a scathing review in the local press by M.K.Rohe. This leaflet was to be inserted in the exhibition catalog. Marc agreed to Erbslöh's proposal.

To the members of the *NKVM*, it was evident that such a strong supporter ought himself to become a member of the association; but its seemed appropriate first to find out about him and his own painting.

On December 31st 1910 the principal members of the *NKVM* assembled at the apartment in the Schwabing district of Munich shared by Kandinsky's compatriots Alexei Jawlensky and Marianne von Werefkin, and Marc was invited to join them. Already at this very first encounter, it was primarily Kandinsky who, in Marc's eyes, surpassed "everyone, even Jawlensky, in his personal charm", so that Marc was "altogether taken with this refined, deeply distinguished man".[12]

On February 3rd a delegation of *NKVM* members visited Marc in Sindelsdorf, and only two days later he received a telegram informing him that the vote taken at the association's general meeting was unanimously in favor of his membership and of offering him a place on the board. It was, however, at this point that Kandinsky had himself resigned from the board (he had in fact been its principal chairman) because it appeared that his views on "the program and activities of the Union [...] were no longer shared by the majority of members".[13]

In early February Marc walked from Sindelsdorf to the village of Murnau, where Kandinsky shared a house with his companion, the painter Gabriele Münter, for a second, longer meeting and a chance to see much more of Kandinsky's work. Still full of his excitement at this encounter, Marc wrote to Maria Franck on February 10th: "The hours I spent at his place are among the most memorable experiences of my life. He showed me a lot of his work, older things but also some of the most recent. The latter are all incredibly powerful; immediately I felt the great joy of his strong, pure, fiery colors, and then my brain got to work [...] There's a picture called 'Moscow', for example. Formally speaking, one can barely make out anything specific; but one immediately feels the quite terrifying quality that pervades this metropolis; one has the impression of seeing carriages roll over a bridge, of hearing the roar of the trains; then one becomes aware of some sort of conflagration, of luxury coexisting with misery; all this can be felt; and one is deeply agitated, veritably trembling, it is all so like a vision, so reminiscent of [the novels of] Dostoevsky, who is without any doubt a kindred spirit."[14]

The agitation that Marc felt on seeing the painting *Improvisation II — Moscow* is quite understandable. The picture was destroyed in 1945, but surviving photographs of this "simultaneous composition" with its cruciform partitioning suggest that it was an extremely exciting, turbulent, and evidently very colorful work, a truly kaleidoscopic rendering of Kandinsky's impressions of his most recent stay in Moscow. In December 1911 Marc was to include it, as number 26, in the first exhibition of work by artists associated with the almanac *Der Blaue Reiter*. There, it was to be purchased by the collector Bernhard Koehler, Sr., who preferred it to the more abstract *Improvisation 22*.[15]

It is striking and significant that Marc, in his first reaction to this picture, should notice in particular the threatening character of the city with its intrusive and unsettling diversity of impressions. This was in accordance with Marc's critical attitude toward the supposed "achievements" of civilization, a position that had already led him to leave Munich and move to the country.

To his delight, Marc found that he had now suddenly been released from his "brooding loneliness" and been absorbed into a "circle of artists and refined people that could hardly be improved upon."[16]

Marc now threw himself, with enormous enthusiasm and energy, into promoting the cause of the *NKVM*, even though this association was already beginning to unravel: a shared feeling of resentment toward Kandinsky was apparent by the time of the mid-February board meeting. A series of changes then came about very quickly. On August 10th 1911, writing to August Macke in Bonn, Marc observed that the association's next jury meeting, scheduled for the late fall, was likely to result in a "ghastly confrontation" and "a split, or the withdrawal of one party or the other". At the same time Marc assured Macke that: "We do not want to abandon the Union, but incompetent members will have to go"[17] (he names Kanoldt, Erbslöh, and Kogan). Marc urged Macke to become a member so as to obtain voting rights and the assurance of being better represented in *NKVM* exhibitions.

In April Marc had persuaded several of his artist friends to contribute to a text responding to the *Protest deutscher Künstler* [German Artists' Protest] launched by the conservative Worpswede painter Carl Vinnen as a reaction against what he and others perceived as the overrating of recent and contemporary French achievements by those organizing exhibitions or purchasing art in Germany. Vinnen's pamphlet, published in Jena by Eugen Diederichs, contained statements of approval by a number of renowned artists. In essence, it was an attack aimed at the progressives and Francophiles among curators and gallery directors (such as Hugo von Tschudi, who had recently been forced to exchange his directorship of the Berlin Nationalgalerie for a comparable post in Munich) and art critics (such as the influential Julius Meier-Graefe). Under the motto of the "Struggle for Art", Marc made the most of the opportunity to intervene in this emerging dispute. To begin with, he even advocated a direct juxtaposition of reproductions of pictures by French and German artists — Matisse/Erler; Renoir/Münzer; Cézanne/Trübner and Dill; Picasso/Stuck; Signac/Osswald; Gauguin/Hofmann, and so on — in order to promote a questioning of national stereotypes.[18] This idea was not taken up, although it was to be realized to a different end in the almanac.

Owing to Marc's initiative and to the intervention of both Kandinsky and Macke, a much more comprehensive text came into being: *Im Kampf um die Kunst: Die Antwort auf den "Protest deutscher Künstler"* [The Struggle for Art: A Response to the German Artists' Protest]. This was published in July 1911 by Reinhard Piper. It contained contributions of varying persuasiveness, some of them reprinted from national newspapers, by an even greater number of renowned artists than its rival (these included Liebermann, Slevogt, Corinth, Beckmann, Klimt, Rohlfs, and Hofer), by art critics and commentators (such as Worringer, Hausenstein, Harry Graf Kessler, and Henry van de Velde), and by museum directors and curators (among them, Gustav Pauli, Alfred Hagelstange, Karl Ernst Osthaus, Georg Swarzenski, and Alfred Lichtwark). Both in its content and on account of the reputations of its authors, the *Antwort* proved sufficiently convincing to take the wind out of the sails of Vinnen's *Protest*.

In May 1911 Marc presented around 25 works as one half of a two-man show at Thannhauser's gallery (the other half consisting of work by the French artist Pierre Girieud). Among these were two earlier versions of the composition eventually realized as *The Red Horses* (see fig. 68), *Blue Horse I* and its pendant *Blue Horse II* (figs. 72, 74), as well as *Deer in the Snow* and *Sheaves in the Snow*. After this exhibition, which subsequently traveled to Mannheim, Marc confessed to Macke that he wanted to "start over" with his approach to painting. Instead of beginning with "quite complex concepts of form and color", which then had to be progressively simplified and arranged, he now wanted to attempt a reversal of this process, to render his impression of a landscape using only a few colors and lines and then, by adding forms and colors, to arrive at the effect he desired.[19]

THE ALMANAC
DER BLAUE REITER
AND RELATED EXHIBITIONS

During the second half of 1911 Marc was primarily occupied with a plan (apparently first mentioned in a letter of June 19th that he had received from Kandinsky) to found an almanac:
"Well, now! I have a new plan," Kandinsky had announced. "Piper will have to deal with the publishing side and we two [...] will be the editors. A sort of (annual) almanac with reproductions and with articles only by artists. The book should convey something of the whole year and, serving both as a link to the past and a beam of light into the future, it should reflect life in its entirety [...] We'll

have an Egyptian figure next to a small Zeh [a drawing by the son of the Munich architect August Zeh], a work by a Chinese artist alongside one by [Henri] Rousseau, a popular print juxtaposed with a Picasso, and much, much more in this vein! Gradually, we'll get poets and musicians to contribute. The volume might be called '*Die Kette*' [The Chain], or something like that".[20]

A few weeks later Marc wrote to August Macke about the new plan: "We intend to found an 'almanac', which is to be the organ for all the genuinely new ideas of our time. Painting, music, theater, etc. It is to be published simultaneously in Paris, Munich, and Moscow, with a lot of illustrations. In Paris, Le Fauconnier and Girieud will help us to get contributors from France; as for musicians, we have Schönberg and a few from Moscow — and from there we also have [the artists David and Vladimir] Burlyuk. Much is to be explained by means of comparative illustrations; and so your old plan for a comparative art history will find a place here. We'll include old examples of painting on glass and French and Russian popular prints next to our own new things and those by others [...] We hope to get so much out of this project that will do us good, inspire us in our own work, and help us to clarify our ideas, that we have become completely absorbed in thinking about this almanac."[21]

In early October 1911, a series of editorial meetings took place at the Murnau "Russian House", participants including not only Kandinsky and Münter, but also Macke and Marc and their respective spouses, as well as Helmuth Macke (August's brother), and the painter Heinrich Campendonk. The almanac's proposed content and contributors were eagerly debated, as also the question of who was to supply which illustrations. Among those mentioned at this point were the Swiss artists Louis Moilliet and Cuno Amiet (and, curiously enough, it was only at this point that Kandinsky met the already Munich-based Swiss artist Paul Klee, to whom he was introduced by

Moilliet). From the very beginning there was interest in securing the collaboration of renowned foreign artists: there was talk of a certain "Matise" and "Delonné". Paintings by Gauguin and the late 16th-century master El Greco were to be included, as also illustrated broadsheets from Épinal, which Amiet was to provide.

On December 2nd 1911, during the jury meetings convened to select the third *NKVM* exhibition, a fundamental split between the members of the association occurred. There had been numerous quarrels over the preceding months, for example about resistance (in part, on financial grounds) to the participation of foreign artists, or concerning the unsatisfactory state of the Union's premises. Now, however, Kandinsky met with open disapproval on account of his *Composition V* (fig. 171), a work measuring two by three meters, the inclusion of which would have contravened a statute regarding maximum size that Kandinsky had himself proposed. Nonetheless, while the exclusion of this picture was clearly in line with the statutes, this also served to mask a general sense of bewilderment at its high degree of abstraction.

Kandinsky, Münter, Marc, and Kubin now resigned from the *NKVM*, to be followed by Le

171
Wassily Kandinsky
Composition V, 1911
Private collection

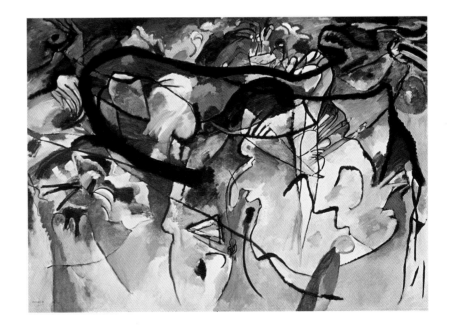

Fauconnier and the composer Thomas von Hartmann. Jawlensky and Werefkin (though approving of Kandinsky and his picture) stayed on out of solidarity with Erbslöh, the principal chairman. After this ill-tempered meeting, Kandinsky and Marc immediately embarked on the preparations for an exhibition of their own, which was in fact to be presented under the auspices of the projected almanac. Their first priority was to attract artists other than those already associated with the planned publication, especially artists from abroad.

In keeping with the desire to underline the spiritual connection between East and West, Marc and Kandinsky primarily sought artists from Russia (where Kandinsky's contacts were, of course, excellent) and from France (for example, Robert Delaunay). Contact with Delaunay was initially made through one of Kandinsky's former students, the painter Elisabeth Epstein, who had moved to Paris and who was a friend of Sonia Delaunay-Terk. Letters sent by Kandinsky also helped to induce Delaunay to send four paintings and a drawing to Munich for the exhibition, these being intended as representative of the series on which he had been working between 1909 and 1911. His submissions included a cubistic city scene of 1910, *La Ville No. 1 (The City No. 1)*, which was later to be acquired by Jawlensky, a second version of this subject enlivened with quasi-pointillist passages, and a very large picture of the Eiffel Tower, a work of 1911 that Bernhard Koehler, Sr. was to secure for his collection.[22] At the opening of the show, on December 18th (incidentally coinciding with that of the *NKVM* presentation, which occupied another space in Thannhauser's gallery) a total of 48 works by 13 artists had been amassed. In addition to the contributions from Kandinsky, Münter, Marc, Macke, Campendonk, and of course Delaunay, these included items by Albert Bloch, David and Vladimir Burlyuk, and Elisabeth Epstein. The composer Arnold Schönberg made his debut as a painter (with three pictures), evincing a talent that Kan-

dinsky had "discovered" in him. Two paintings by the recently deceased Henri Rousseau epitomized what Kandinsky termed "great Realism", in his view complementary opposite of "great Abstraction".

Significantly, the preface to the catalog (by Marc and Kandinsky) did not seek to align this presentation or its organizers with any particular position or point of view. Rather, it insisted that the exhibition be understood as an open forum for the latest developments in art in Germany, Russia, and France.

Only a few weeks later, on February 12th 1912, a second exhibition associated with the almanac (which had itself not yet appeared) opened at a bookshop used by the art dealer Hans Goltz. This was a more specialized presentation in as far as it was a show devoted to prints and drawings. It embraced more than 30 artists, and there were over 300 items, among them 17 drawings by Paul Klee, prints by artists of the *Brücke* [Bridge] group, now based in Berlin, and a series of Russian popular prints. The arrival of the almanac itself (in May 1912) therefore marked the third joint undertaking in the series.

Kandinsky was later, half in jest, to recount the process whereby the resonant title of the almanac was itself chosen: "We invented the name 'Der Blaue Reiter' at a table in the arbor at Sindelsdorf; we both loved blue — Marc horses and I riders. So the name seemed obvious. And, when we'd settled that, Mrs. Marc's fabulous coffee tasted even better."[23]

The name Kandinsky had originally proposed for the almanac — *Die Kette* [The Chain] — itself ostensibly hinted at a striving not only for friendly collaboration between painters and musicians, but also for the embrace of styles and genres from every era and nation, in order to affirm the notion of a cross-cultural equality between art and folk art, children's art, or the fetishes conventionally studied as ethnographic specimens. Modern repro-

duction technologies facilitated the comparative juxtaposition of works from widely divergent times and places. The aim here was to encourage an extension of "the existing limits of artistic expression". This goal was to be achieved through creating visual connections between works which could thus be shown to be "[...] internally related, even if externally they appear very different from each other".[24] The carefully calculated layout thus gave rise to an autonomous discourse between the images that ran parallel to, though sometimes independent of, the arguments to be found in the textual contributions: "Our attention", it was claimed in the preface, "is not directed toward works that conform to a certain accepted, orthodox external standard, but toward works that have inner life and a connection to the Great Change that is now occurring".[25]

"THE ERA OF THE GREAT SPIRITUAL"

The time of "Great Change" repeatedly invoked by Kandinsky was equivalent to what he also termed the "Era of the Great Spiritual", which he believed would be initiated by artists. The zeal pervading the texts that Kandinsky and Marc published in the almanac testifies to their deep sense of mission: they did indeed see themselves as the heralds of a time of redemption when humanity would be liberated from the base spirit of materialism. Considered from this point of view, the almanac was intended to serve as a focus for all the currents in painting and music that had succeeded in progressing from "looking at the world" to "looking through the world", and to an understanding of its "mystical and spiritual structure". According to Franz Marc, the artist's mission was now "to create *symbols* for their age that will in future take their place on the altars of a new spiritual religion, [symbols] in which there will remain no trace of the artist as maker."[26]

The religiously exalted notions of an era of change, of a "spiritual religion", which link the ideas expressed in the almanac with those formulated in the heyday of German Romanticism, are somewhat bewildering from the point of view of today; but from that of a century ago they are more easily comprehensible. By 1914 groundbreaking scientific advances such as the discovery of X-rays, the emergence of relativity theory, and the development of atomic physics, were already challenging the essentially Newtonian world view that had for so long been presumed stable. A passage from Kandinsky's *Rückblicke* [In Retrospect], first published in 1913, conveys something of the impact of theories postulating an atomistic universe as characterized by quantum theory on some of the artists of the time: "To my mind, the disintegration of the atom signified the disintegration of the entire world. Suddenly, the thickest walls were tumbling. Everything became uncertain, shaky, and yielding. I would not have been surprised if a stone had melted into thin air and become invisible before my very eyes [...]".[27]

From this point on, the visible world was no longer the only thing in which an artist could invest his faith and his trust: it had undergone a radical devaluation. The painter's essential objective now also embraced the invisible that lay beyond the visible. Kandinsky's turbulent abstract images of the last pre-war years may be seen to reflect the experience of this shift. While the Cubists started to open up three-dimensional space, rendering visible the framework that underlay the visible world, Kandinsky's way was to decompose it into colors and forms that made no attempt to represent the visible in a conventional way, and to allow these to function in terms of their own formal language — in Kandinsky's terminology as *Klänge* [tones, sounds]. Franz Marc, on the other hand, sought to look through the shell of the visible to see within it the invisible essence of form and color, cleansed of the impurity of external reality. His animals, assuming the

resonance of icons, are projected into an imaginary counterworld, in which they exist by themselves, in a primeval state close to that of the Creation. Marc's approach thus still differed greatly from that of his admired friend Kandinsky, in

172
Master Euthymios
Saint George, 1858
Engraved copperplate
Monastery of Simonopetra,
Mount Athos

whose painting all representational forms were gradually to give way to the dynamism of lines, colors, and symbolic forms. Marc's essential aim, at least around 1910—12, was to create the sense of his animals existing outside time and yet inextricably interwoven with the fabric of nature and the cosmos.

Marc's emphasis on the enduring, the definitive, as well as his search for the "mystical and spiritual structure" to be found beyond external appearances, may well have been indirectly inspired by his experiences in the spring of 1906, when he traveled with his elder brother, Paul, a Byzantinist, to Salonica [now Thessaloniki, Greece] and the monasteries on Mount Athos — an episode that

has largely been neglected by commentators. Although Marc's letters from this period mention no impressions of the art he encountered, it would be safe to assume that he was not left unmoved by his first direct experience of icon painting and illuminated manuscripts, which he and Paul Marc were allowed to study in connection with the latter's academic research. Monastic life on the peaks of the mountain, at an altitude of 2000 meters, with its long and physically demanding Orthodox church services, must in any case have fed his longing for monastic retreat, a feeling that was never entirely to leave him, the more so since, as the son of a devout Calvinist mother, he had originally intended to study theology.

It is in itself of some significance that Marc and his brother were at this time among the very few outsiders to have gained access to the legendary Athos manuscripts (even today, women are not allowed into the monastery). This is confirmed in a letter to Marie Schnür, dated April 6th 1906, in which Marc wrote: "As far as my brother's research aims are concerned, we have achieved more than we had ever hoped to and more than any scholar had predicted [...] We do not ourselves know what it is that has gained us the good will of the monks on Athos in contrast to the previous experience of European scholars. We've established the firmest of friendships, I can tell you! [...] The impressions we have are a curious mixture of the comic and the astonishing, of irony and profound emotion, of pleasure and of every possible kind of deprivation".[28]

Something of the formal concision, the luminosity and strength of contrast in the colors, the hieratic and statuesque quality of the figures, and the frequent occurrences of mounted saints — Saint George, for example (fig. 172) — must surely have remained with Marc, as a memory that would later feed both his emotional responses and his visual imagination.

The messianic view of the artist's role and the demand for a fundamental rebirth, as advocated

in the almanac, were in essence elements in a secularized version of Christianity. They emerged from a utopian belief that, through the "spiritual religion" of art, the world might attain wholeness. The extent to which Marc's way of thinking was imbued with this notion is suggested by the introductory and concluding passages of his preface to the second edition of the almanac, published in March 1914: "'Everything that comes into being can only be begun in this world'. This phrase of [Theodor] Däubler might be understood as the motto for all that we have created and all that we still aim to create. There will eventually be fulfillment [but] in a new world, in another life. On earth we can only point the way and set the tone". And: "How we admire the disciples of early Christianity for finding the capacity to attain inner peace in the tumult of those times. We pray constantly for such peace, and it is a quality for which we strive".[29]

THE SYMBOLISM OF HORSE AND RIDER IN THE WORK OF MARC AND KANDINSKY

As the sense of both general and political crisis in Europe deepened in the period 1912—14, the more fervent was the call for a spiritual renewal, with artists seeing themselves as leaders in the struggle to this end.

In this context, it would have been natural for the contemporaries of Marc and Kandinsky to see a militant element in the symbol and cover design of the almanac *Der Blaue Reiter*, which had been devised by the latter. As Beat Wyss has observed, among the almanac's illustrations there were numerous depictions of mounted crusaders and knights. Wyss has attributed their prevalence to Franz Marc.[30]

This would, however, appear to suggest a misunderstanding of the very different role of the horse

in the work of Marc and of Kandinsky. While the horse was still very much part of human civilization in the early 20th century, Marc for the most part depicted horses without riders (see the essay by Andreas Schalhorn, pp. 239ff., for some of the exceptions). Moreover, as illustrated in his cycle of paintings of 1911—12 featuring groups of three animals, and based on two studies in a sketchbook of 1911 (fig. 75) — *The Small Blue Horses* (fig. 77), *The Large Blue Horses* (fig. 78), and *The Small Yellow Horses* (fig. 79) — he tended to show these animals motionless, self-absorbed, and in a cosmically exalted landscape. In these pictures Marc created a paradigm for the notions he had formulated in 1910 of "organic rhythm" and the "quiver and flow of the blood in all of nature", here integrating these with his color symbolism of "intellectual" blue and "sensual" yellow as equivalents, respectively, for the male and the female principle. The significance of gender specification for Marc, and

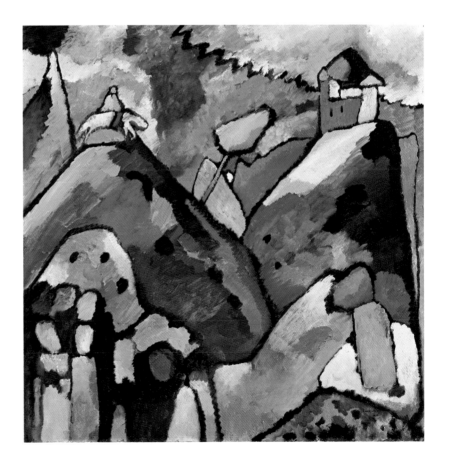

173
Wassily Kandinsky
Improvisation 9, 1910
Staatsgalerie, Stuttgart

not only in his choice of colors, is demonstrated in the canvas *The Small Yellow Horses* (fig. 79), where the animals are in fact painted over the figure of a reclining female nude of around 1908, the outline of her body merging with that of the horses' rumps.

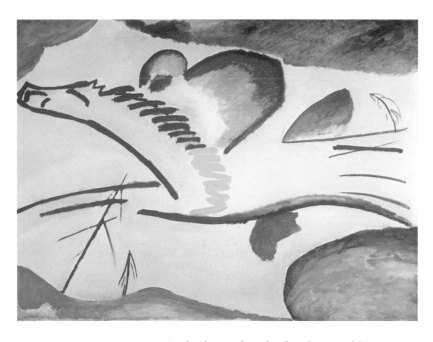

174
Wassily Kandinsky
Lyrical, 1911
Museum Boymans van
Beuningen, Rotterdam

Kandinsky, on the other hand, evinced from an early date a distinct attraction to images of riders and mounted knights. Moreover, as revealed by a glance at his work of the 1900s and early 1910s, the tempo of such images tended to increase, progressing from a measured walking pace to a frenzied gallop. This development is exemplified in a series of folkloristic scenes from Old Russia: from *In the Forest, Sunday* (both 1904), or *Riding Couple* (1906/07), through the three riders on white horses seen in *The Blue Mountain* (1908/09) or the riders on the peaks in *Composition II, Improvisation 9* (fig. 173), and *Improvisation 12* (both 1910), to the riders racing downhill in *Romantic Landscape* (1911) and the headlong rush evoked in the painting *Lyrical* (1911; fig. 174). A color woodcut version of this last picture was bound into the almanac. It was, then, the Russian artist who especially favored the motif of the rider, a preference

also apparent in Kandinsky's representations of Saint George and the Horseman of the Apocalypse among the paintings on glass he made in 1911.[31]

In the case of Marc, the very lack of aggression or belligerence is even more evident in the later work, where animals are often presented as innocent victims, as in the composition of 1913, *Animal Destinies* (fig. 177). And, as a whole, Marc's oeuvre does not really appear to support the reading proposed by Beat Wyss, which sees in it an "explosive ferment of intellectual fascism" clearly reflecting the "emphasis on the principle of the Will" found in the writings of Schopenhauer and Nietzsche.[32] A better source of evidence for such an intepretation, and one to which Wyss also refers, are those wartime writings in which Marc forcefully invoked the role he believed Germans were destined to play in "the prelude to the spiritual dominance of the good, new European".[33]

The sheer number of depictions of knights and riders to be found in the almanac (and these derive from a vast range of epochs and cultures) would above all appear to symbolize the editors' and contributors' understanding of their own work as part of a thrilling struggle for a new art. In the last pre-war decade the artistic avant-garde found itself confronted by enormous hostility. This was expressed on every possible occasion, and sometimes even physically. For avant-garde artists, however, the notion of struggle related not only to an enduring battle with the more aggressive elements within a bewildered public. It was also a concept they would readily apply to the intellectual and creative process implicit in their own work — in essence, the strenuous experience of wrestling with forms and colors to achieve a new pictorial language suited to a new view of the world. During the first months of the First World War, many artists felt that they were now physically living out a situation that they had anticipated and imaginatively experienced day after day in their studios. This was true of the

German Marc, the Frenchman Fernand Léger, and
the Italian Futurists who as early as 1909 had pro-
claimed war to be "the world's sole hygiene".[34]
Through this struggle they hoped to achieve a
"purgation" and "renewal" of consciousness, which
would prepare humanity for the radical quality
of their art. More than a few believed the war to
be a continuation of their own artistic struggle,
which would do away with inhibiting traditions
and liberate the spirit.

It is in this context that one should approach
Marc's statements about German spiritual leader-
ship. Marc was not concerned with national rival-
ries or antagonisms — the artists associated with
the almanac Der Blaue Reiter were, after all, pio-
neers of cultural internationalism. The important
thing was the shared struggle against a materialis-
tic view of the world. It was this for which Marc
and his friends gave the starting signal.

MYSTICISM AND AGGRESSIVE ACTIVISM

In other respects, Marc's position appears
strangely contradictory. On the one hand, we find
the pantheistic empathy recalled by both Kandin-
sky and Klee (see pp. 31, 33). In the words of
Johannes Langner, Marc wanted to "understand
nature on its own terms and thus return to being
at one with it".[35]

In this sense, Marc felt that the human being
and the animal were like monads in an organic
whole "between nature and the Kingdom of
Heaven". His views on life and death were charac-
terized by a mysticism that embraced an evident
readiness for self-sacrifice: "I do not at all acknowl-
edge death as destruction", he wrote to Maria Marc
in 1915. "Maybe you remember how I used to talk
about death: it is the definitive redemption [...]
the destruction of the form so that the soul may
be liberated".[36] When he received from Maria the

news of the death of his favorite deer, he endeav-
ored to console her with the following words:
"When I think of such a short little life, the life of
such an animal, I can't help but feel that it was
only a dream — in this case a deer's dream, but it
might just as well have been a man's dream — but
the dreaming creature is itself immanent, inde-
structible".[37]

And, not long before his own death, on March
4th 1916, a letter to his mother contains the stoical
statement: "This life that separates birth and death
is an exceptional state of being, a state in which
there is much to be feared and suffered — the
only real, constant, philosophical consolation lies
in our awareness that this exceptional state is
temporary and that the always restless [...] utterly
inadequate consciousness of the self, will even-
tually fall back into the wonderful peace that pre-
vailed before birth".[38]

On the other hand, it was precisely Marc's stoical
contempt for death and his belief in eternal
rebirth that fostered his provocative remarks
about the necessity of the war as a form of purga-
tory that would issue in the new "high type" of
European.

It is apparent that Marc, with his self-sacrific-
ing idealism and his utopian notion of an immi-
nent "Great Change" and re-evaluation of values,
had yielded so willingly to a death-defying eupho-
ria about what lay beyond as to lose sight of the
actual day-to-day reality and the horrors of the
war. Faced with his wife's open opposition and
clear disapproval, Marc did sometimes entertain
doubts; but on the whole he became increasingly
preoccupied with his vision of the new European
rising like a phoenix from the ashes. In his essay
"Das geheime Europa" [The Secret Europe], pub-
lished in the December 1914 issue of the soldiers'
magazine Das Forum, Marc writes: "[...] even with
the serious, bloody side of the day, we cannot in
the end forget the better part of the action, the
end: [for this also means] the beginning, the prel-
ude to the spiritual dominance of the new, good

European, this struggle to come that will claim even more victims and deaths than the bloody war".[39]

Nonetheless, toward his artist friend Kandinsky, who (as a Russian, and hence an enemy alien) was forced to leave Germany, Marc adopted a more moderate tone: "I have the sad feeling that this war will rage between us like a great flood, separating us [...] In such a time everyone, whether he likes it or not, is dragged back into his own nation. I struggle against this with all my might; the idea of the good European is closer to my heart than a sense of my identity as a German. I don't know how you feel now. I feel that I'm *really living* in this war. I even see in it a salutary, albeit terrible means toward our end. It will not set humanity back; it will bring about the necessary purgation of Europe, 'preparing' it'".[40]

The statements from *Das Forum* were, then, worded much more aggressively than Marc's private utterances of this period, even though Marc nonetheless held fast to his "beliefs". From a letter to his wife dated May 25th 1915, in which he confessed to a faltering hold on reality and the sense of becoming a multiple personality, it is evident that he was retreating ever more into an imaginary world and was on occasion even aware of doing so: "You're right, and hence also the great split in my personality at the moment, which is the result of my unusual life and its unusual events. I'm really living three lives simultaneously: first, the life of a soldier, which for me has the unreality of a dream, in which I'm constantly ambushed by the strangest associations of ideas and memories: for example, imagining that I were a soldier serving in one of Caesar's legions [...] The second life already has a lot more to do with real 'experience', thoughts about Europe, Tolstoy, August [Macke, who had been killed in action], the books that I'm reading, newspapers, and thoughts about the already legendary 'Front of the Giant Armies', the aerial battles (which we can now

watch every day), my letters — in all of this there is a certain element of reality that I take a look at now and again [...]

And then there is the *third* life: the unconscious growth and progress toward a goal, the budding of art and the creative spirit [...] *Everything* else becomes insignificant and irrelevant when I brood over this inner life [...] The true spirit does not need a body for its life — a body may perhaps be its external condition (its incarnation), but the spirit is only partially dependent on the body, and it may even leave it temporarily, and above all in its most important, most essential hours".[41]

Marc's inclination toward transcendence, which attained an almost hallucinatory quality during his time at the Front, is in marked contrast to his pragmatic intelligence and the determined and forceful commitment that were manifest in an enormous range of undertakings in support of artists and the new art: his key role in the organization of group exhibitions such as the shows associated with the almanac *Der Blaue Reiter* and, above all, the "Erster Deutscher Herbstsalon" [First German Fall Salon] presented in 1913 at the progressivist Berlin gallery of Herwarth Walden named after Walden's own magazine *Der Sturm* [The Storm]; the publication of numerous eloquent and persuasive articles, such as "Die konstruktiven Ideen der neuen Malerei" [The Notion of Construction in the New Painting], published in the Berlin periodical *Pan* in 1912; the initiation of contacts with numerous artist colleagues (both in Germany and abroad) or with the Expressionist poet Else Lasker-Schüler in Berlin (a friendship immortalized in Marc's long series of intensely poetic painted postcards, figs. 9, 110, 114, 115, 116, 117).[42]

THE ITALIAN FUTURISTS AND ROBERT DELAUNAY

Marc was exceptionally productive during the last pre-war years, and it was at this time that he achieved the most spectacular breakthrough in his painting. He was especially stimulated by a sense of competition with like-minded artists, in particular the Italian Futurists, whose work was exhibited at Walden's Berlin gallery in April 1912. Six months later Marc, Macke, and Walden hung a smaller version of the show at the Gereonsclub in Cologne, and Marc wrote a review culminating in the sentence: "Carrà, Boccioni, and Severini will prove to be a landmark in the history of modern painting. We shall certainly have reason to envy Italy her sons and will show their works in our galleries."[43]

On October 23rd 1912 Marc wrote to Kandinsky: "[It will] interest you to learn that I saw the work of the Futurists in Cologne and I am [...] filled with enormous enthusiasm for most of the pictures; I hope you will not be angry [...] they are dazzling painters; Impressionists, admittedly [...] they have a very strong hold on visible reality; the titles of their paintings are like Japanese poems; yet there is no trace of the literary; austere and severe; even their infamous 'sweetness' is severe, almost savage. 'When I open the window, the noise from the street enters the room': imagine painting something like that and not messing it up!"[44] Marc did have reservations about the "weak" Luigi Russolo, but he also told Paul Klee that he was "quite surprised at how *good* they were, superb pictures; the stupid howls of protest are really unfathomable [...]."[45]

The Futurists sought to establish a system for encapsulating the simultaneity of a variety of sensual perceptions, using fragmented images and interpenetrating lines of force, an approach that was to have an influence on Marc, as may be seen from his subsequent work. Like Kandinsky, both Boccioni and Carrà favored the motif of the rider as a symbol of progress and as a model of speed.

In 1912 Boccioni painted *Elasticity*, which was shown at the "Erster Deutscher Herbstsalon" in Berlin (fig. 175), and in 1913 Carrà produced his *Red Rider* employing similar Futurist devices (fig. 176).

Of even more significance for Marc's development was his trip to Paris with Maria and Macke in the fall of 1912 and his meeting there with Robert Delaunay, to whose work he had already paid much attention when he was preparing the almanac. Now Delaunay showed the three German visitors his newest "window pictures" (fig. 180), in which he had finally achieved an "absolute painting" that greatly impressed Marc. It was to Delaunay's work of this period that the Parisian poet Guillaume Apollinaire gave the term "Orphism". Writing to Kandinsky on October 5th, Marc reported: "Delaunay interested me greatly, he's utterly French, but

175
Umberto Boccioni
Elasticity, 1912
Pinacoteca di Brera, Milan
(Jucker Collection)

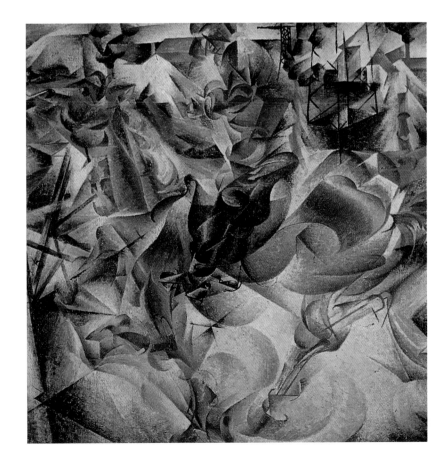

open and smart [...] he is on the way to producing really constructive pictures, without any element of representation whatsoever. You could call them purely tonal fugues."[46]

In December Marc embarked on a correspondence with Delaunay: their letters contain important statements, but they also reveal some crucial

176
Carlo Carrà
The Red Rider, 1913
Pinacoteca di Brera,
Milan (Jucker Collection)

areas of disagreement. Delaunay sent Marc his essay on light (it was later to be translated into German by Paul Klee and published in *Der Sturm*), in which he had summarized a number of his theories. Evidently these did not greatly interest Marc, who responded: "I love your pictures but I don't think that your philosophical and historical principles are sound and necessary for your own development as an artist or that of others [...] and they are hardly relevant to me".[47] Delaunay replied indicating that he had been very distressed by Marc's comments; it was clear that Marc had understood nothing of his thoughts about being an artist. He, Delaunay, was French, after all, and needed clarity, since in art he was "the scourge of disorder". He went on: "You tell me that you love my pictures. My pictures are the result of my efforts as an artist, [my struggle] to achieve '*pureté*' [...] All these things are very

closely connected, so how can one understand or love a part of this synthesis without the corresponding other part".[48]

A little later, in a letter of January 1913, Delaunay reprimanded the young German artists whose work he had seen (among them Marc) for their fanatical preoccupation with mysticism. This, he felt, prevented them from thinking clearly. "In my view, one doesn't need mysticism for art, for progress in art". Toward the end of the letter, reaffirming the content of his essay, Delaunay writes: "I'm striving for a universal art. My art will not be constrained [...] classified [...] I've shattered everything / and I love the kind of art / that possesses movement / rhythm / the germ of life / light".[49]

Marc's reply, on March 11th, was almost defiant: "My art is the only thing for which I find neither words nor explanations [...] Initially I brooded a lot on what I was doing [...] In the time since then I've freed myself. I reflect neither in front of my work nor in front of that of others. I paint the way I live: instinctively. I become conscious of my development only when a piece is done".[50]

The artists were, then, worlds apart, however genuine their mutual respect and esteem.

This, however, did not keep Marc from adopting key elements of Delaunay's rhythmic simultaneity of color contrasts and integrating these into his "mystical" view of the world. Already by the end of 1912, and increasingly during the following year (also, evidently, in response to the work of the Futurists), he broke away from the essentially closed forms of his animal motifs and embarked on a path toward prismatic interaction. A tendency toward faceted and broken forms is already detectable in pictures such as *Horses and an Eagle* (fig. 106) or *Red Horse and Blue Horse*, a work in tempera of 1912 (fig. 94), but also in the now untraced painting *The Tower of Blue Horses* (fig. 111), which Marc completed at Sindelsdorf between March and May 1913. While he had previously sent a watercolor postcard version to the

poet Else Lasker-Schüler (fig. 110), the full-scale work achieved much more than a cosmically exalted vision of the glassy transparency seen in the postcard image with its moon and star motifs. In the "steely" heroism of its echelon of horses' heads it already signals an uncompromising readiness to prepare for the coming "spiritual struggle".[51]

"MATTER AND SPACE ARE LOSING THEIR BOUNDARIES"

The prismatic dynamism and interlocking forms increasingly prominent in Marc's work culminated in the composition *The Trees Showed their Rings, the Beasts their Veins*, now known as *Animal Destinies* (fig. 177). Together with *The Tower of Blue Horses* (fig. 111) and five other pictures,

this made up Marc's contribution to the "Erster Deutscher Herbstsalon". At this exhibition — with 350 works, the most comprehensive international survey of progressivist trends in contemporary art to be held in Germany in the last pre-war years — it became evident that Marc and the German avant-garde in general had recently been working in a style that was in many respects comparable to that of some of their contemporaries abroad. These included several French artists, notably Delaunay (the best represented among them at the Berlin show, with 20 pictures), the Italian Futurists, and the Russian Rayonists, especially Natalia Goncharova in a picture such as *Yellow and Green Forest* (fig. 178). The "prismatic" style of Lyonel Feininger's work, as exemplified in *Gelmeroda I* (fig. 179), appeared both intellectually and stylistically close to Marc's recent production. Feininger himself noted this proximity, commenting after his visit to the "Herbstsalon":

177
Animal Destinies, 1913
Kunstmuseum, Basle

"Today, Marc's painting gave me something direct, immediate, there is truly a magnificent daring and an immense power in his pictures. His tower of blue horses has an unearthly beauty, both in form and color! It's really splendid".[52]

Although the "Herbstsalon" met with a very hostile public response and almost resulted in

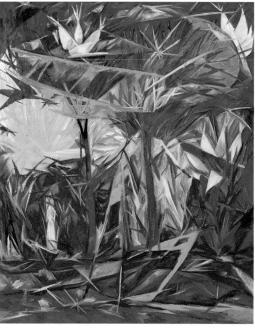

financial disaster for Walden (only averted by the generous financial support offered by Bernhard Koehler, Sr.), it has undeniable art historical significance as the last great gathering of the European avant-garde before the advent of a war that was to claim the lives of several key figures in this community, among them Boccioni, Macke, and Marc.

Marc himself summarized his impressions of the "Herbstsalon" in a letter to Kandinsky, who had complained about the hanging of his own contribution: "My guiding principle in selecting and hanging the pictures was in any case this: to show what immense spiritual deepening and intense artistic activity there is at the moment [...] I believe that any human being who loves his time and looks for spirituality in it can only walk through such an exhibition with his heart pounding with excite-

ment, and will keep on finding good surprises [...] I in any case felt ashamed that, painting away up at my dear Sindelsdorf, I had no idea that so much of the spiritual was at work and, above all, that the artists' goals were so diverse, with innumerable different perspectives of which I knew nothing".[53]

When, in 1915, Marc came across a postcard of *Animal Destinies* (fig. 177), a picture presented for the first time at the "Herbstsalon", he saw in it a chilling apocalyptic premonition of the war. This composition had, however, derived from his reading of Gustave Flaubert's novella of 1877, *La Légende de St. Julien l'hospitalier*. A picture in watercolor and gouache painted in the spring of 1913 is inscribed with the title of Flaubert's story (fig. 142); it is also one of Marc's rare depictions of horse and rider. It shows a knight dressed in blue with a pointed helmet mounted on a blue horse, against a glowing red background flanked by diagonally projecting tree trunks and two fearfully cowering animals. The verso of the sheet features an early composition sketch for *Animal Destinies*, which in turn alludes to the central scene in Flaubert's text: Julien has yielded to the passion for hunting that has become exaggerated into a wild fury of destruction and this, in due course, provokes revenge on the part of the animals. A black deer, already fatally wounded, predicts that the frenzied hunter will eventually kill his own parents. After Julien fulfills this prophecy through a misunderstanding, he becomes aware of the deep evil of his ways and undergoes a long period of penance as a ferryman assisting travelers across a raging river. In the end he is granted mercy after taking in a leper.

Animal Destinies evokes the animals' rebellion against the cruel hunter and the prophecy of the deer. Yet Flaubert's narrative was only a starting point for Marc, whose picture integrates the revenge of the animals into an apocalyptic vision of doom. As Frederick S. Levine has sought to show, Marc's elaboration may owe much to the ideas to be found

in Nietzsche's *Geburt der Tragödie aus dem Geiste der Musik* [The Birth of Tragedy from the Spirit of Music] (1872), and in Richard Wagner's musical drama *Götterdämmerung* [Twilight of the Gods] (first performed in 1876), and also to the symbolic image of the ash tree at the hub of the world in the Old Norse sagas, the *Edda*.[54] However, quite apart from the cultural and mythical context of notions of destined sacrifice and purifying doom, *Animal Destinies* is of particular interest in demonstrating how closely Marc's thinking about art resonated with the new scientific view of the world emerging in the early 20th century: "We are now able to see through matter, and the day is not far off when we will be able to penetrate its oscillating mass as if it were air [...] No mystic ever came close to [...] the perfect abstraction of modern thought, its ability to look right through everything".[55]

At the same time the rearing deer (or perhaps hind) in *Animal Destinies* does possess a symbolic significance in the context of Marc's oeuvre as a whole in that it marks the tendency for his animals now no longer to be represented as individual entities embedded in a natural setting, but to be rendered as strongly faceted and sometimes seemingly disintegrating forms. In the horizontal composition of 1913 *Stables* (fig. 161) the fragmentary repetition of equine shapes may still be iconographically motivated, but the image has largely been transformed into a sequence of abstract entities, its strikingly long format recalling Delaunay's *Windows Overlooking the City (Fenêtres sur la Ville)* (fig. 180) of the previous year.

Just as Marc had characterized Delaunay's windows as "tonal fugues", Paul Klee, in an entry in his journal later wrote: "Delaunay sought to shift the accent in art to the temporal — after the model of a pictorial fugue — through the use of an emphatically long format".[56]

Marc, however, did not stop at this stage, but went so far as to atomize the figurative motif to the very limit of recognizability. His picture *Playing*

Forms (fig. 162) is the logical continuation of the development initiated in *Stables* the previous year, the horse motifs here appearing even more volatile and relegated to the extreme right of the composition, while the rest vibrates with loose sequences of indeterminate, shifting forms and lively spirals. This painting belongs to a group of

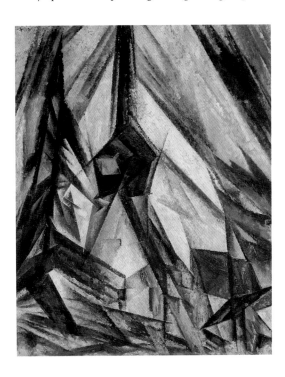

179
Lyonel Feininger
Gelmeroda I, 1913
Private collection

abstractions created between April and August 1914, with titles: *Playing Forms* (fig. 162), *Serene Forms, Battling Forms* (fig. 181), *Broken Forms*. That could be seen to chart the escalating sense of crisis just before the outbreak of war.

Marc's breakthrough to "absolute" painting was also driven by a strengthening of his interest in analogies between the visual and the musical, to which he was prompted by the concerts given at Paul Klee's house in Munich. Two painted postcards sent in December 1913 to Klee's wife, Lily (a piano teacher who was then giving lessons to Maria Marc), also testify to this fact. They are abstract watercolor studies and one of them, to judge by its title, *Sonatina for Violin and Piano*, appears to be an attempt to translate the musical into the painterly. August Macke, who still corre-

sponded regularly with Marc, had painted an abstract *Hommage à Bach* in 1912, and in 1913 he produced a group of abstractions called *Colored Forms*, which had also emerged from the attempt to achieve pictorial equivalents of musical impressions.[57]

And even Marc's last visit to Paul Klee, in November 1915, offers evidence of his belief in the possibility and value of visual and aural synesthesia: "We played Bach and, while he [Marc] was listening, [Jawlensky's] *Variations* were lying on the floor in front of him. This was very typical of him: looking at pictures while he listened to

in which plants, trees, animals, and the landscape seem to be caught up in a single, swirling act of Creation. They are accompanied by notes that attempt to put what Marc termed his "visions" into words, and that use language of an expressive power recalling the writings of Else Lasker-Schüler: "I was surrounded by strange forms and I drew what I saw: hard, unsavory shapes, black, steely blue, and green, crashing into each other so that my heart cried out in pain [...] Then I saw another picture: many small leaping forms that merged into the whirring and swooping lines of the images of sounds [...]"[60]

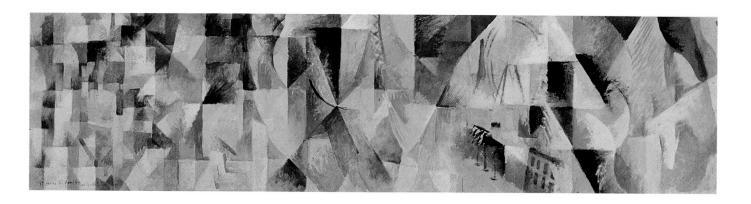

180
Robert Delaunay
Windows Overlooking the
City (Fenêtres sur la ville),
1912
Museum Folkwang, Essen

music. Earlier he often used to draw in his sketchbook while listening to music".[58]

With the increasing dissolution of the animals, or rather their transformation into abstract forms and colors courting or fighting each other, Marc reintroduced his creatures into the unending cycle of Creation. A literal instance of this metamorphosis is to be found in the reworking of his picture *The Large Yellow Horses* (fig. 80), destroyed in 1945, which first seems to have been conceived as a closed group like *The Large Blue Horses* (fig. 78), but was then transformed into a vortex of prismatic color wheel rhythms, probably in response to the pictures seen in the Delaunay room at the "Herbstsalon".[59]

The growing intensity of Marc's imagination at this time is evident in his sketches from the Front,

The deep-rooted metamorphosis to be found in Marc's paintings in what were to be the last years of his life is also evidence of the transformation of his view of the world. Both the natural world as a whole and the creatures in it seemed to have lost their magic for him, and he suddenly started to see them as "impure", even "ugly and unsavory, a bitter prison for the spirit".[61] And with the advent of a "dynamization of visual perception",[62] Marc's pictures also began to embrace dividing, hostile forces, as seen in *Battling Forms* (fig. 181) and especially in his *Sketchbook from the Front* (figs. 163—166).

Objects and animals, seemed to suffer from a "constraint and lack of freedom", to be bound to their bodies by gravity. "It is not correct to say that a chair stands; it is held; otherwise it would fly away and merge with the spirit". Or: "I had this vision: I was walking around among things and

those I saw were suddenly transformed, revealing their unsavoriness and escaping from their false existence".[63]

Marc's "visions" of the centrifugal force of matter and the dissolution of the material world coincided with the introduction of the camouflage stategies adopted in response to the new threat of attack from the air. Such strategies now began to play an important part in armed conflict. The veiling and obfuscating of borders and the outlines of objects resulted, as Roland Mönig has observed, in an "esthetics of disappearance".[64] Oskar Schlemmer was among the artists drafted to join reconnaissance units that were required to interpret and evaluate aerial photographs. The experience gained from such work, especially a familiarity with the new optics of the bird's eye view, had a demonstrable influence on their subsequent work, as on their view of the world.[65] This was also the case with Paul Klee, who was posted to the Bavarian Flying School at Gersthofen. Thus, in July 1917, Klee notes in his journal: "'All that is mutable is merely a simile'. What we see is a suggestion, a possibility, a makeshift. The real truth lies beneath and is at first invisible".[66]

As Marc recognized, his wartime "visions" sprang from the "new knowledge that was transforming the old legend of the world into a new formula of the world, the old way of looking at the world into a process of looking through the world".[67] The new European of the 20th century had attained a new level of knowledge: exact science, for which the law of gravity was only a concession to the limitations of human understanding. Marc, moreover, in one of his aphorisms, encapsulated a perception that, in the light of today's "virtual worlds", has the air of a prophecy: "matter and space are losing their boundaries for us [...] Everything is figured anew for our eyes".[68]

Thus, in the short period between 1908 and 1914, Franz Marc progressed at a dazzlingly rapid pace from the naturalism of his first horse studies to the Orphic abstractions of his last years. Within the broader context of the Expressionist upheaval of the last pre-war decade, Marc created a world of images that was unique, even while it effectively united the intellectual heritage of German Romanticism with the scientific approach to the world that was to dominate the 20th century. The increasing dynamism to be found in his pictorial language corresponds to an alteration in the metaphorical dimension of his animal motifs as these increasingly shed bodily solidity to reappear as the embodiment of elemental forces.

181
Battling Forms, 1914
Bayerische Staatsgemälde-
sammlungen, Munich

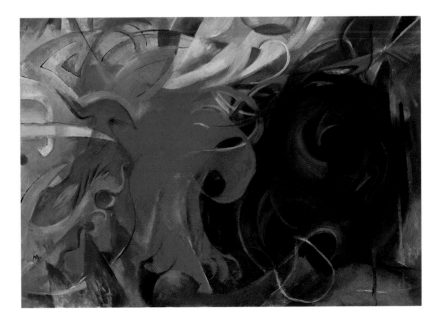

Notes

1 Erdmann-Macke 1962, pp. 162 ff.

2 Version of Marc's text edited by Reinhard Piper, published in Piper 1910, p. 190. For the original version of Marc's contribution, contained in his letter of April 20th 1910 to Piper, where he employs the notion of the "animalization of the feeling for art" (omitted in the printed text), see Meissner 1989, p. 30. On the term "avoidance of the animate", see the notes made by Marc in 1911/12, cited in Marc 1920, vol. i, p. 122.

3 See Strachwitz 1997, in particular pp. 32 ff.

4 Letter of December 30th 1899 to the pastor Otto Schlier, cited in Strachwitz 1997, document 9, p. 17.

5 Letter of July 24th 1907 to Maria Franck, cited in Meissner 1989, p. 26.

6 See Lankheit 1950, p. 20.

7 Letter of September 22nd 1910 to Reinhard Piper, cited in Lankheit 1976, p. 52. For Marc's drawing, see Meier-Graefe 1910 (image on the cover).

8 Letter of December 12th 1910 to August Macke, cited in Meissner 1989, p. 36.

9 Letter of December 12th 1910 to August Macke, cited in Meissner 1989, pp. 40—41.

10 On the *NKVM* exhibition mounted by Thannhauser in 1910, see Meissner 1989, pp. 219 ff.

11 Cited in Lankheit 1960, p. 46.

12 Letter of January 1st 1911 to Maria Franck, cited in Meissner 1989, p. 39.

13 Letter of January 10th 1911, from Kandinsky to Jawlensky, cited by Hoberg, in exh. cat. Munich 1999, p. 39.

14 Letter of February 10th 1911, to Maria Franck, cited in Meissner 1989, p. 47.

15 See Silvia Verena Schmidt-Bauer, "Werke der NKVM und des Blauen Reiter in der Sammlung Bernhard Koehler", in exh. cat. Munich 1999, p. 311. For Kandinsky's destroyed painting of 1911 *Impression II — Moscow*, see Roethel/Benjamin 1982, no. 373, illustration on p. 353.

16 Letter of February 5th 1911 to Maria Franck, cited in Meissner 1989, p. 45.

17 Letter of August 10th 1911, to August Macke, cited in Meissner 1989, pp. 56—57.

18 Letter of April 12th 1911 to August Macke, cited in Meissner 1989, pp. 54—55. See Carl Vinnen 1911, and *Im Kampf um die Kunst* 1911.

19 Letter of April 12th 1911 to August Macke, cited in Meissner 1989, p. 55.

20 Letter of June 19th 1911 from Kandinsky to Marc, cited in Lankheit 1983, p. 40.

21 Letter of August 9th 1911 to August Macke, cited in Meissner 1989, p. 58.

22 See Schmidt-Bauer (as in note 15, above), pp. 308 ff., illustration on p. 312.

23 Wassily Kandinsky, "Der Blaue Reiter (Rückblick 1930)", in Kandinsky 1955, p. 137.

24 Editors' preface, typescript dated October 1911, in the estate of August Macke, in Lankheit 1965, p. 313.

25 Editors' preface (as in note 24, above), p. 313. On this text, see Thürlemann 1986, pp. 210—222.

26 Franz Marc, "Die 'Wilden' Deutschlands", in Lankheit 1965, p. 31.

27 Kandinsky 1913/1977, p. 15.

28 Letter of April 6th 1910 to Marie Schnür, cited in Meissner 1989, pp. 22—23.

29 Lankheit 1965, p. 322.

30 See Wyss 1966, pp. 181 ff.

31 On the motif of the horse and rider, see the thorough essay by Marlene Baum, "Das Ross-Reiter-Motiv als Ausdruck des Geistigen im 'Blauen Reiter'", in *Das Münster*, l/1 (1997), pp. 48—55.

32 Wyss 1966, p. 191.

33 Franz Marc, "Das geheime Europa", in *Das Forum* i/12 (March 1915), cited in Lankheit 1978, p. 166.

34 A phrase used in F.T. Marinetti's founding manifesto of Futurism, dated February 11th 1909, first published in French in *Le Figaro* on February 20th 1909. See *Archivi del Futurismo*.

35 Langner 1981, p. 80.

36 Letter of June 25th 1915 to Maria Marc, cited in Meissner 1989, p. 151.

37 Letter of December 6th 1915 to Maria Marc, cited in Meissner 1989, p. 179.

38 Letter of February 17th 1916 to his mother, cited in Meissner 1989, pp. 195—196.

39 Franz Marc, "Das geheime Europa" (as in note 33, above), cited in Lankheit 1978, p. 166.

40 Letter of October 24th 1914 to Kandinsky, cited in Lankheit 1983, p. 263.

41 Letter of May 25th 1915 to Maria Maric, cited in Meissner 1989, pp. 148—149.

42 See Schuster 1987; also Marquardt/Rölleke 1998.

43 Franz Marc, "Die Futuristen", cited in Lankheit 1978, p. 136.

44 Letter of October 23rd 1912 to Kandinsky, cited in Meissner 1989, p. 80.

45 Letter of October 11th 1912 to Paul Klee, cited in Meissner 1989, p. 79.

46 Letter of October 5th 1912 to Kandinsky, cited in Meissner 1989, p. 78.

47 Letter of December 1912 to Robert Delaunay, cited in Vriesen/Imdahl 1967, p. 57.

48 Letter from Robert Delaunay to Franz Marc, cited in Vriesen/Imdahl 1967, p. 57.

49 Letter of January 1913 from Robert Delaunay to Franz Marc, cited in Hüneke 1986, pp. 265—266.

50 Letter of March 11th 1913 to Robert Delaunay, cited in Meissner 1989, p. 83.

51 On this point see the comments in Johannes Langner 1980, p. 62.

52 Letter of October 5th 1913, from Feininger to Alfred Kubin, cited in Hess 1959, pp. 67—68.

53 Letter of September 30th 1913 to Kandinsky, cited in Meissner 1989, p. 92.

54 See Levine 1979, pp. 77—103.

55 Aphorisms 47 and 48, cited in Meissner 1989, p. 290.

56 Journal for July 17th 1917 (entry no. 1081), in Klee 1988, p. 442.

57 See exh. cat. Stuttgart 1985, p. 74 with illustration.

58 Journal for November 1915 (entry no. 964), in Klee 1988, p. 374.

59 The notation "begun in 1912, repainted in 1914", cited in Lankheit 1970: 237, appears questionable with regard to the claimed date of completion in as far as a letter of April 23rd 1913 from Koehler to Marc (of which I was kindly informed by Dr. Verena Schmidt-Bauer) refers to a picture designated as "Yellow Horse (large)" as acquired or selected for acquisition in the accounting period 1912—13. Schardt, writing in the 1930s, assumed that Marc had worked on the picture until 1914. As the painting was apparently not included in the "Erster Deutscher Herbstsalon" in the fall of 1913, it would seem that Marc offered it separately to his patron Koehler. From the stylistic point of view, however, it does appear probable that Marc had already completed his repainting before the end of 1913: this is suggested, for example, by a comparison of the brush-work in this picture with that found in three works painted in that year: *Mandrill*, *Stables*, and *Deer* (Lankheit 1970: 218, 221, and 223, respectively). It is also of significance here that Koehler already owned Marc's picture *The Small Yellow Horses* and is therefore hardly likely to have wanted a similar but merely larger composition (i.e. the first version, dated 1912 in Marc's hand) if this had not been transformed in the spirit of Robert Delaunay's Orphist interpenetrations of color and form. As the painting itself was destroyed during the war, and secure documentation relating to it has yet to emerge, complete certainty regarding the date of completion remains unattainable.

60 Aphorisms 72—74, cited in Meissner 1989, pp. 206—207.

61 Aphorism 95, cited in Meissner 1989, p. 301.

62 See Franz 1993/94, p. 23.

63 Aphorism 97, cited in Meissner 1989, p. 302,

64 See Mönig 1993, p. 234; also Virilio 1986.

65 See Maur 1979, pp. 73 ff. On Klee, see Werckmeister 1981, pp. 9–83. On the transformation of the perception of time and place as a result of the advent of aviation, see Asendorf 1997.

66 Journal for July 17th 1917 (entry no. 1081), in Klee 1988, p. 440.

67 Aphorism 35, cited in Meissner 1989, p. 286.

68 Aphorism 47, cited in Meissner 1989, p. 290.

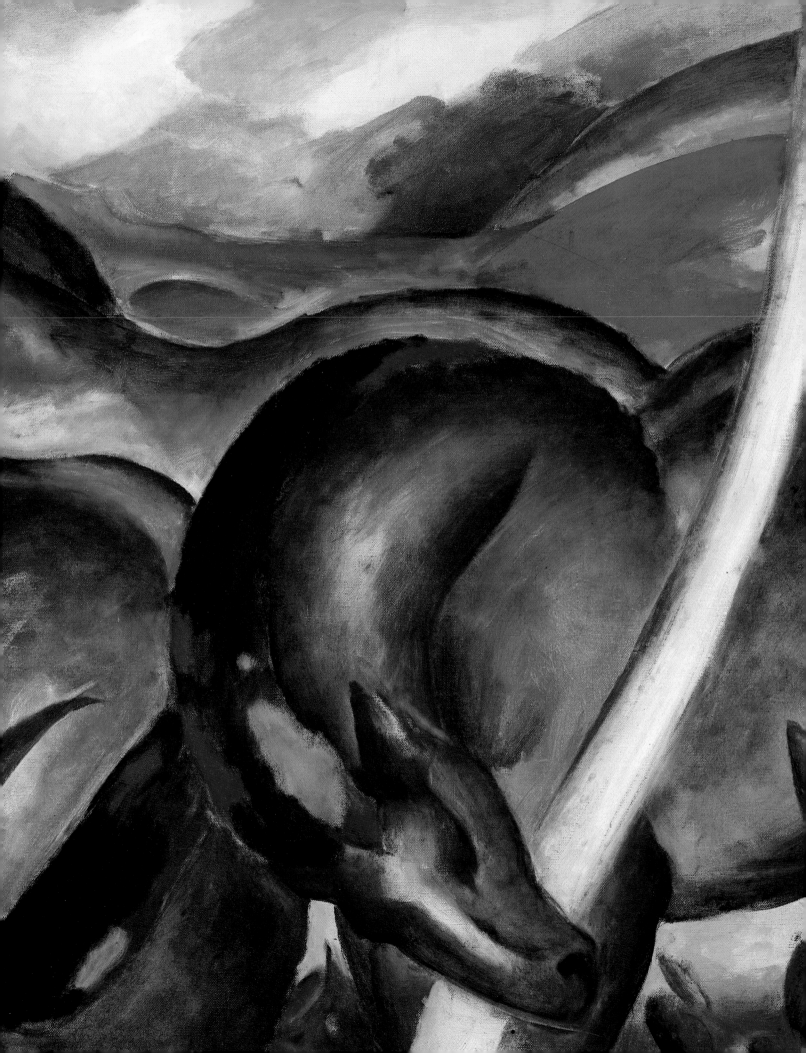

In the Garden of the Animals:

Environment and Landscape in the Work of Franz Marc

ANDREAS K. VETTER

"The horse is alert, with all its senses, to the plain surging up before it. Almost tripping over as it ascends, it seems to be flinging itself on the back of one mare after another. But, somehow, every single one evades it, and it is for this reason that, in its soul, the horse is always raging. Its irrepressible urge to go on, to move forward, has long been converted into a spiraling motion that repeatedly interrupts its own scenting of a promising new track. The horse experiences space almost as if the landscape were itself another living body. It must be able to spot the danger of yellow beneath its feet, to avoid it so as to come to no harm. And that is why its soul is without doubt blue. Blue, so as to rear up as distinctly as possible against those sunlit paths. And, as it flees, it seems to the horse that the landscape brushes against it."[1]

Writing in a characteristically expressionist style in 1916, Theodor Däubler was able to pinpoint with exceptional clarity the dualism that is fundamental to the work of Franz Marc: the fact that the singular rendering of animals that is his principal claim to fame is in effect inseparable from his treatment of their natural environment. Considering Marc's attention to landscape allows us to

see his work in a new light, not least with regard to the question of his artistic development. Marc's approach to depicting the natural environment of the animals that captured his attention was in every respect distinct from that prevailing among landscape painters during the 19th century, or that informing the work of animal painters associated with Munich during his own lifetime, such as Heinrich von Zügel. It would seem that, in evolving his own notion of landscape, Marc very soon stopped regarding it as an autonomous segment of scenery that might still constitute a meaningful image even if its figural or animal staffage were removed (fig. 183). He thought, rather, in terms of the totality of the setting and its occupants, so that individual aspects of a landscape — pasture, trees, mountains — might serve as a sort of "sounding board"[2] for the living creatures dwelling on and among them. It is this aspect of Marc's work that is conveyed in such a striking fashion in Däubler's vivid words. Several years later the same quality (in its broader implications) was to be hailed by Alfred Döblin as a testimony to the spirit infusing the early decades of the 20th century: "Is it possible that, concealed within us, there's an animal, a whole herd of animals? No, 'we' simply are the

page 128
182
*The Large Blue Horses,
1911*
Detail from fig. 78

herd of animals, the breathing of plants, the soul of slowly transforming minerals."[3]

This "natural harmony with the surrounding landscape,"[4] which determines the relationship of any of Marc's horses with the environment in

183
Hans von Marées
Horses in a Forest, 1861
Sammlung Georg Schäfer,
Euerbach

which it is shown, was not intended to contribute to a naturalistic or psychologizing rendering of the animal personality; it reflects Marc's concern, rather, with what is universally valid, with that which is typical of the situation as a whole.[5] Marc's aims in this context had much in common with that striving for the reconciliation of unadulterated nature, human existence, and cultural history that characterized German Romanticism.[6] His approach differed, however, in as far as he was committed to a steady, continuous process of detection, definition, and assertion; and in his early work (from before 1909), with its still naturalistic tendency, there is no hint of Romantic longing or the transformation of the observed. Marc was aware to an extreme degree of the fundamental difference between man and beast, and of the equally fundamental distinction between

culture and nature. As a result, his work is entirely free of any element of either sentimental or intellectual kitsch. For all its idiosyncrasy and its insistent thematic focus, it rarely seems other than plausible, indeed positively reasonable.

There is no doubt that the precursors of Marc's approach to the rendering of animals in landscape were the exponents of late 19th-century naturalism, who had aimed at capturing sometimes even the most banal aspects of the coexistence of animals and their natural habitat. The need for greater accuracy and sensitivity in the visual record of the latter encouraged a refocusing of the attention paid to landscape. Herds of sheep were now invariably to be found enveloped in a haze of dust; cows lingered sluggishly at muddy watering-places; and exhausted cavalry horses snorted with foaming nostrils as they crossed treeless plains. At the same time, naturalist painters tended to invest less energy in observing than in idealizing the observed; and, to that extent, they could be said to have worked in a tendentious manner, devising atmospheric compositions that conveyed an impression of the harmonious coexistence of man, domesticated animals, and the natural environment. Nonetheless, the familiarity with the subject required even to this end resulted in an unprecedented degree of psychological empathy. It was this partial engagement with the spiritual that enabled some exponents of traditional painting (ostensibly committed to reproducing the observed) to make the leap into an early manifestation of what might be called "Modernism". Confirming the new dimension now perceived in the natural world, this simultaneously opened up exciting new possibilities for the artist. His response to the now crucial psychological content of landscape gave him the power not only to render its appearance in a much freer and much more idiosyncratic manner,[7] but also to invest this with qualities that would indirectly prompt emotions in the spectator for which the objectively visible aspects of the image offered no basis.

It would appear that at the end of the 19th century the era of realist observation gave way to a phase of "projection" or "imaginative gazing."[8] Applied to the landscape as an artist's subject, this new attitude issued in images that were autonomous in their content. Although pictures by Moritz von Schwind (fig. 203), Franz von Stuck, or Fritz Erler (fig. 184) offer an image of the visible world that largely corresponds to reality and shows life in a manner that is physically credible, the landscape in such works is also functioning on another level, principally through a process of symbolic intensification. This ensured that an "imaginative" element[9] now coexisted alongside the merely visible aspect; and it was the former that enabled the spectator to respond to the picture on a new, emotional level. In the case of Fritz Erler (1868—1940), it is the presence and distribution of the horses that determines the way the landscape is constructed, and emphasizes the sensual dimension of its topography.

The young Franz Marc would, then, certainly have been aware not only of both the variety and the achievements of the art of the 19th century, but also of the new possibilities that artists were beginning to explore. The period in which he was an art student (1900—1903) corresponds art historically to the overlap of late Impressionism and early Modernism, and he would thus have been frequently confronted with the provocative coexistence of the perfect workmanship of the art accepted by the establishment and the intellectual excitement of revolutionary views on artistic method. Marc, however, had the personal advantage of being warmly open to new ideas. Tentatively entering into contact with the avant-garde, by 1909/10 he was emerging as an autonomous champion of the innovative spirit in German art that was already manifest in the Expressionism of the artists of the *Brücke* [Bridge] group and the Modernism of Munich, and had recently found a new focus in the *Neue Künstlervereinigung München*, hereafter *NKVM* [New Munich Artists' Union], which he joined in 1911.

As one might expect, the difference between landscapes painted by Marc at either end of this period of rapid evolution — a work from his student years (fig. 185) and one produced nearly a decade later (fig. 186) — could hardly be greater

184
Fritz Erler
Horses by a Stream,
undated
Lenbachhaus, Munich

from the point of view of style. Yet, even during this time, Marc's basic assumptions about depicting the natural world did not alter to such a degree that he came to believe in a fundamental distinction between nature and the image derived from it.[10] Comments that in this respect appear ambiguous — "Nature", he wrote in 1912, "glows with life in our pictures [...] In its essence, art was,

is, and will always be the boldest possible departure from nature" —[11] are only seemingly so. In essence, Marc's ambition was to approach ever closer to the reality of nature, using the means accessible to art, and thereby to accomplish a harmonious reconciliation between the two.

Of the work produced after 1909, *The Stony Path* (fig. 186) is the only large painting of pure landscape, and it formed part of Marc's contribution to the first exhibition organized by the editors of the almanac *Der Blaue Reiter* [The Blue Rider]. While the principal motif would appear to derive from a specific model in nature — one of the curving mountain paths in the Heimgarten Massif that Marc would himself have used from time to time —[12] it may also have been intended, with its stylized S-curve climbing toward the sun, as an allusion to the moralizing images of the "stony path" toward Christian salvation such as hung in many houses in Germany in the late 19th century. At the same time, with its emphasis on form as a means of conveying "atmosphere", it exhibits clear connections with both Symbolism and *Jugendstil*.

Writing of Franz Marc years after his death, Carl Georg Heise formulated one defining characteristic of his work as "careful observation of nature [but with] the details not gleaned from [mere] looking".[13] In doing so he hit upon a fundamental element in Marc's artistic development:

his striving to harness the concentrated power of expression to be found in the natural world — in complete contrast to what he came to recognize as the late Impressionist superficiality of many older contemporaries. Marc was fascinated by the intensity with which Van Gogh observed nature. He was deeply impressed by the exhibition of Van Gogh's work at the gallery of the art dealer Brakl in Munich in the winter of 1909. Around a year later he commented: "With what expressive force he compels us to share his vision of the beauty of the natural world. And how pitiful that I still think, in my heart of hearts, that I might be able to imitate nature [....]."[14] Equating this misguided ambition with attention focused merely on the "façade of things",[15] Marc had now, he recognized, to distance himself from the conventional observation of landscape and to focus, rather, on the inner, spiritual qualitites that he found to be manifest in and through the natural world. It appears that the encounter with the work of Van Gogh had indeed shown him the way forward: it was the "simplest things" that now primarily attracted the young painter's interest, "for it is only there that one can find the symbols, the deep feeling, and the mystery that are in nature."[16]

In considering the treatment of landscape in the context of Marc's pictures with horses, it is also important to take into account the thematic definition of landscape as a manifestation of the natural, which may on one occasion occur as a mere background and on another take the form of a closely observed abode. While in either case it would still be appropriate to speak of landscape in terms of the environment of the animals to be found there in any given case, of landscape as a "biotopia", the concept of landscape in itself has always been capable of embracing an enormous range of meanings, be it in its historical, art historical, or merely casual usage.[17] Within Marc's oeuvre, landscape is sometimes present simply as a larger detail from nature, almost as an extended version of the immediate background of the

185
Cottages on the Dachau Moor, 1902
Bayerische Staatsgemälde-sammlungen, Munich

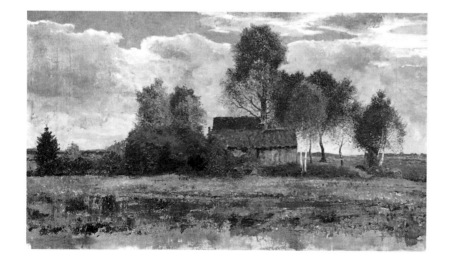

depicted horses. On other occasions it may serve to define and emphasize the character of the connection between nature and man. There is, then, no such thing as the landscape in and of itself; one way or another, it is always more specifically defined and oriented as a manifestation of nature, be this as a result of conscious topographical limitation, on account of the intervention of man (the varieties of "cultivated landscape"), or through the spectator's focus on one particular spot on the surface of the earth — that "curious intellectual process that first brought landscape into being [as an esthetic phenomenon]."[18]

Marc's lively interest in the principles of avant-garde art theory had a significant impact on his way of thinking about the natural environment and how it ought to be pictorially represented. As the development of Modernism after 1900 brought about a substantial weakening of both impact and authority in the pictorial representation of the natural,[19] it was in Marc's interest to retain those aspects that seemed to possess real value and to convey these as such in his work. The spectacular transformations of modernist landscape, the "landscape through which one hurries",[20] the metropolis and its cult of speed, appear to have held no interest for him, despite his later formal proximity to the work of Robert Delaunay and the Italian Futurists. Nor is Marc particularly concerned with a formally updated return to the ideal of a "well-ordered nature" that was the essence of the classical landscape.[21]

TOPOGRAPHY

What, then, of the potentially very variable manifestations of the natural world in Franz Marc's work? We should first consider the early, naturalistically treated images of animals, and not merely in order to reflect the chronological development of the oeuvre. The question as to whether those early landscapes in which animals are to be

found were treated with an eye to topographical exactitude is all the more exciting in that only a few works of this period have survived. It is in any case certain that Marc was not concerned with the specific location of each image, even though, until 1911, he often drew or painted out of doors.[22] In the work Marc produced before 1909 one finds, in effect, the distinguishing features of a particular sort of terrain or region; but this is as far from being a record of a particular setting, in the strict sense, as is one of Marc's images of horses from allowing us to identify a particular animal or even simply its type.

186
The Stony Path, 1911/12
San Francisco Museum of Modern Art

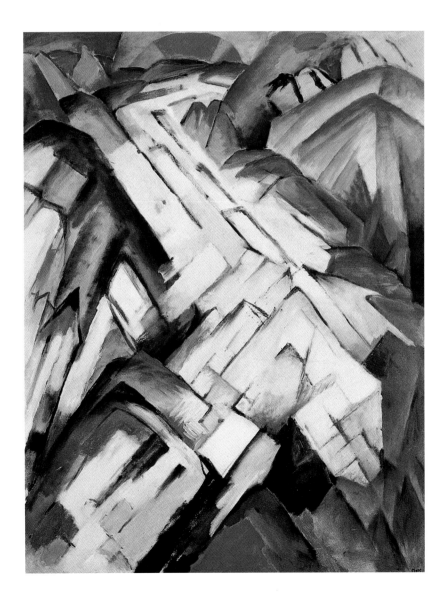

One should also bear in mind the nature of Marc's recorded statements regarding the country around Lenggries and its atmosphere: "The land up behind our house is simply magical; some parts of the paths lie a bit deeper than the meadows, so

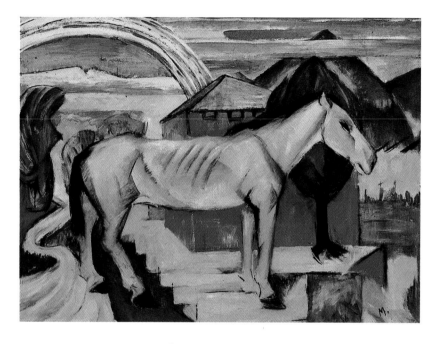

187
*The Long Yellow Horse,
1913*
Untraced

that one really walks and stands between the flowers. Yesterday it was overcast and there was a singular silvery glimmer in the air; the meadows had an indescribable color — the tree trunks were a pinkish violet. This is how one might paint a fairy-tale kingdom — steeping it in these colors."[23] Around Sindelsdorf, in the words of a friend, was "a very peculiar area, a lot of flat land with pasture and a wide sky, nearby some curiously lonely spots, with plentiful moorland that has something almost ominous about it [...] When you step on to the balcony you look down on to the paddock and the pasture. And all around the house, all day long, you can hear the clip-clop of hooves and other animal noises — neighing, braying, and mooing, he [Marc] lived surrounded by his models [...]."[24] And once more Marc himself: "Today I was again in the pasture (behind the wood at Oberriedern), and the glossy horses were enchantingly beautiful there, standing on a carpet of meadow saffron under the autumnal sky."[25] Such responses

offer us an approximate idea of the prevailing perception of this rural environment. In the words of Maria Franck, Marc's future wife, one can detect the sort of girlish, romantic delight in the sheer prettiness of the colors that also informs much of the art of *Jugendstil* — in Marc's immediate artistic environment, especially the paintings of Gabriele Münter (fig. 195).

In spite of this evidence of attention to detail, the landscape as it appears in Marc's pictures of horses remains generalized, with only a few exceptions. At the most, it summarizes the aspects of the appearance of the foothills of the Bavarian Alps and the first range of peaks, the area most familiar to Marc lying south of Lake Starnberg — with the villages of Lenggries, Sindelsdorf, Ried, Kochel am See, and Murnau — and, further to the south, the Alpine ridge made up of the Herzogsstand, the Jochberg, and the Rabenkopf. The gently rolling meadows, softly rounded hills, meager Alpine pasture, and zig-zag outline of the mountain peaks, all of which are to be found in the geographical repertoire of Marc's landscapes until 1914, come from this region (though similar features were also encountered during a trip to the South Tyrol in 1913).

Although born and raised in Munich, Marc was very familiar with this particular stretch of country. This was partly the result of his experiences as a child. His father, Wilhelm Marc, was a landscape painter who paid great attention to precisely that rural region in which his son was to live during most of what was to prove an all too brief career. Secondly, as an art student in the early 1900s, following in a tradition long-established at the Academy in Munich and the current practice of various Munich artists' groups, Marc went to paint *en plein air* in the surrounding country, notably in the moorland around the village of Dachau, which had attracted increasing numbers of artists from the 1860s, and especially from the 1890s. Here, he rapidly mastered the knack of rendering the appearance and the atmosphere of his chosen motifs, as can be seen in his earliest surviving works (fig. 185). His

approach at this time appears to have alternated between one that was essentially romantic or naturalistic and a colorism that was akin to that of the German Impressionists. As Marc started to focus his attention on animals, however, his rendering of landscape necessarily relinquished a generalizing comprehensiveness in favor of a narrower view determined by its starting point in the usual location of the depicted horses: the pasture or the paddock. Predictably enough, Marc chose the attractive hilly landscape of the "Blue Country"[26] around Kochel am See as the model for the broader terrain within which he would situate his subjects.

It is only rarely, however, that in Franz Marc's work one comes as near to the rendering of a specific location as in the series of pictures of 1908—09 associated with Lenggries (figs. 33—36), although Helmut Macke's account confusingly relocates these scenes to Sindelsdorf.[27] Marc had discovered a "little valley resembling an arena" and was reportedly charmed by the way the horses seemed to fit themselves into this landscape formation. In an oil sketch now known only from a photograph (fig. 35), the landscape fills the entire composition, while the painting *Large Landscape I* (fig. 36), with its much greater compositional tension, includes only the first group of bushes, thus conveying a much stronger sense of the horses engaging in an intense intuitive dialog with their habitat. It is not at all difficult for the spectator to place him- or herself imaginatively in this setting and its atmosphere, in which all the necessary information is provided. Yet there are already signs of the "homogenized" treatment of landscape motifs that Marc was increasingly to favor. Very soon he altogether abandoned the conventional, naturalistic description of landscape in favor of that reductionistic rendering of the appearance of natural forms which established the elements of a consciously artificial "terrain", both specific to his work and thematically related to his animals. By 1910, one year later, the celebrated *Horse in the Landscape* (fig. 60), ends this series,

the pasture being rendered primarily in terms of quasi-abstract color planes.

A further stylistic feature of Marc's increasing distance from the descriptive representation of landscape was his eager schematization of individual landscape features. Marc's canon, which was eventually to evolve into an idealized image of the natural environment of his horses, is also notable for embracing the principal components of that attractive region to which a significant portion of the progressive art community of Bavaria had retired since 1908: its picturesque villages, grasslands, hills, lakes, and mountains.

Nonetheless, in spite of the numerous village motifs to be found in the work of Marc's circle of friends based at Murnau, the frequent trips he himself made up to the hut on the alpine pasture above Kochel am See, and his joy in his own country residences, Marc as an artist evidently found little to attract him in architectural motifs. This is understandable in view of the emphatic absence from Marc's images of man or any aspect of the man-made world. Buildings very rarely occur in his pictures of horses, although the indispensable presence of stables always offered this possibility; and Marc did indeed embrace this motif as an interior setting (figs. 160, 161). Marc's horses appear in principle removed from the context of farm or village, with two strikingly different exceptions. While *The Long Yellow Horse* (fig. 187) stands in front of a red, cubic building clearly identified as a stable by its row of small windows

188
Three Horses in Front of Three Fir Trees, 1911
Private collection

189
Animals at a Watering-place, 1913
Destroyed

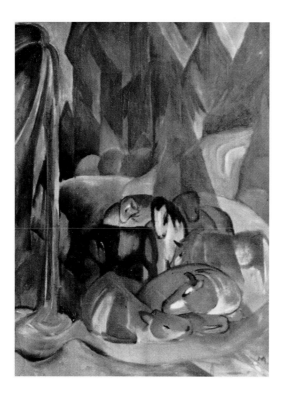

set just below the sloping roof, the three blue-roofed buildings seen in the background of the exquisite group of the *Two Horses* (fig. 144) appear to answer primarily formal and compositional requirements.

Also typical of Marc's work is the presence of water, initially incorporated as a natural component of a paddock, and of the Bavarian lake region in general: it occurs, for example, in the *Three Horses in Front of Three Fir Trees* (fig. 188), or in the form of a reed-fringed lake in *The Long Yellow Horse* (fig. 187). From 1911/12, however, when a "cosmic" dimension is detectable in Marc's rendering of the natural world, water clearly assumed a much greater importance, as a fundamental element of the Creation (it had already featured prominently in the early work *Orpheus with the Animals* (fig. 191). A spring might then become a source of the elixir of life and a symbol of Paradise, around which there could be assembled *The First Animals* (fig. 155) or a group of brightly colored horses (fig. 146).

Through the combination of these elements there emerged a veritable new landscape with a

topography of its own. This, however, was never merely a form of background for the principal motif; rather, it merged with the animals to create a harmonious whole. Without doubt, one of the most striking instances of Marc's response to nature was to be found in the now untraced *Large Landscape with Horses and a Donkey* (fig. 81), of which a contemporary description of the coloring has survived: "Somber blue mountain peaks and the green of a silhouetted forest surge up toward the center. Red enters with the figure of a horse that seeks to merge entirely with its setting. To the left of this red current there is a blue donkey, its own shape and coloring taken up in the green of the plant forms. To the right there is a whitish-blue horse, which, together with the yellow and yellowish-green stones, balances and contains this splendidly flowing landscape."[28] This fascinating picture, completed in March 1912, locates its protagonists in hilly terrain that merges into the lower slopes of distant mountain peaks. With this and the spiky agave plants, the scene has an almost South American air.

The landscape setting of the picture *Three Horses II* (fig. 159) encompasses a broad terrain. Behind the pasture the land drops down, then climbs again; a village appears on the slope. Lower hills surround the lake, merging in the distance into the mountains, which ascend almost to the upper picture edge. In contrast to these powerfully expressive images, in which the depicted animals play a major part, in *The Poor Country of Tyrol* (fig. 157) Marc effectively produced a landscape painting in which the horses serve merely as *repoussoir* figures. But they too, with their air of utter defeat, further intensify the gloom that is more intensely conveyed in the image of the graveyard crosses.[29] This negative quality, with which Marc burdens the landscape was doubtless grounded in the history of the South Tyrol and, being aware of this, Marc probably responded accordingly during his visit to the region. His essentially psychologizing approach here is, however, also suggestive of interesting parallels with

the ideas that his friend Kandinsky was developing at this time. Kandinsky's *Composition V* (fig. 171) — painted in 1911 and then shown at the first exhibition organized by the editors of the almanac *Der Blaue Reiter* — is comparable, even in its essential abstraction, with Marc's South Tyrol landscape both in the range and the distribution of its coloring and in the structural function of its black lines. It is also possible that Kandinsky's picture, and the approach to painting that it embodied, provided an intellectual impulse for Marc. According to Kandinsky, in his volume *Über das Geistige in der Kunst* [On the Spiritual in Art], a "composition" was a type of picture that conveyed a representation "of expressions forming especially slowly within me,"[30] and this would seem to correspond to the process whereby Marc digested and elaborated the visual and emotional experience of his journey. Having long mastered the artistic rendering of this sort of Alpine landscape, he felt increasingly compelled to refrain from naturalistic representation.[31]

Of particular importance in Marc's pictures with horses was the construction of a terrain specifically related to these protagonists. Marc could in fact be said to have thought in terms of the "landscape for a horse" as a category in its own right. This necessarily issued in considerable variety in his treatment of the natural environment. As the animals Marc depicted — and this was above all the case with horses — tended to dominate the compositions in which they occurred, there were three principal options in the treatment of the landscape setting: the landscape might retreat into insignificance; structurally (or otherwise directly) complement the figural motif; or provide a formally attuned background. Among the surviving works of 1910 there are paintings for which there are landscape studies indicating a concern for this third category.[32] In many pictures the horizon is so high that the motif appears wedged somewhat arbitrarily into a setting that seems to extend equally in every direction. But it is also possible for a sort of "zoom" effect to focus

attention on the horse (fig. 60). After 1911, however, except in the case of the works on paper (where Marc often refrains from demarcating a boundary for the image as a whole), one finds ever less concern with a picture space defined in realistic terms. Marc ceases to be preoccupied with conveying a sense of transition between earth and

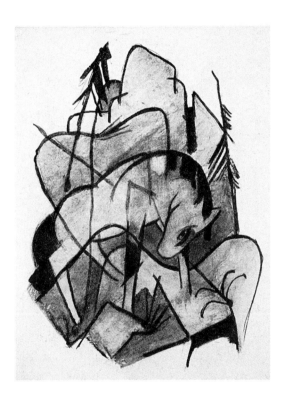

190
Horse, 1913
Estate of Maria Marc

sky, just as he is no longer interested in defining the exact nature of the foreground. In some compositions the animals are cropped by the lower picture edge, thus denying the viewer a chance to develop a feeling for the terrain and its optical distance from the subject(s). In other cases, animals may be freely distributed within the picture space and hence distanced from specific topographical features.

While the landscape as rendered by Marc thus effectively eschews many of the characteristics that would define it as such, it by no means relinquishes its power of suggestion. It retains this in its interaction with the animals serving in any given case as the main motif, and in particular

with their style and degree of abstraction. An especially clear example is to be found in an image evidently influenced by the work of Van Gogh,[33] *Leaping Horses* (fig. 54).[34] Here, the interplay of the rounded body shapes of the young horses, the kinetically curved lines created by their leaping motion, and the attractively undulating

191
Orpheus with the Animals,
1907/08
Lenbachhaus, Munich

forms of the terrain itself constitute an environment defined by the harmonious coexistence of a "landscape" (as rendered by the artist) and the animals in that landscape. Secondary landscape features such as the small, leafless trees signaling the advent of spring, relate in formal terms both to the young animals and to the undulations of their pasture. The harmony between landscape and horse is also very effectively conveyed through the recurrence of identical types of brushwork and in particular through color. In the bellies and throats of the horses one finds the same green tones as in the shaded sides of the hills; and the brown of the bodies is reflected in the treatment of the soil and in the branches.

In 1911 Marc began to subordinate the more naturalistic components of his compositions to the demands of the invention of motifs, and from now on he evinced a much greater freedom in his treatment of the picture space: the outcome was to be seen in a print, *Two Horses*, published in the almanac *Der Blaue Reiter* (see preparatory sketches, figs. 85—88). Here the animals appear to act almost

independently of the structure of an inhabitable terrain. This in itself is rendered in graphic abbreviations and anti-naturalistic deformations. In the case of the painted postcard *Two Blue Horses in Front of a Red Rock* (fig. 124) the setting is very effectively summarized in a way that one may presume to have derived from Marc's encounter in Paris with devices found in Japanese art. One of the graphically clearest compositions is the small ink drawing of 1913, *Horse* (fig. 190), where Marc's restraint in the use of line itself generates a sense of formal reconciliation between the animal and its environment, and is thus able to bestow the same degree of definition on every component in the scene. The birch trees in the small section of forest through which *The Frightened Horse* is seen galloping in a small tempera composition of the same year (fig. 193) are rendered in a manner that is entirely suggestive of the animal's own perception of this setting: the curve of the study trunks seems to echo the dynamix arcs of the horse's rapid motion.

It is clear, then, that Marc often introduced direct analogies between the representation of a setting and the horse(s) within it. One is thus prompted to assume that he took care to depict other species in similarly appropriate types of landscape: thus, for example, a tenderly treated, intimate setting for deer, or one with lush, intensely colorful vegetation for a tiger. In Marc's early work, in keeping with his still relatively naturalistic style of representation, he sought to establish a setting oriented to existing conditions. This approach did not fundamentally alter when he adopted a geometrically more abstract pictorial language. This change did, however, result in an ever greater formal merging of the elements within an environment, with the result that the distinction between certain landscape features was no longer relevant. With the advent of the prismatic images of 1914, Marc even ceased to differentiate the environment from its inhabitants. Instead, employing an optically structured division of the picture plane (which was in turn influ-

enced by the relative form and "mass" of each aspect of the motif), he created several homogenous spheres, each of which served as a setting for an animal.

PARADISE

The ultimate model for the Garden of the Animals is Paradise. While the presence of man there may be tolerated, the significance of Paradise for humanity lies in its loss and the consequent hope that it may one day be regained. The mythology of Antiquity united the notion of Arcadia (later refined by Christianity) with tales of divine beings, who — as in the case of Orpheus — also engaged with animals. In 1907/08 Franz Marc provided a design for a tapestry of this subject (fig. 191).[35] In the latest (fourteenth) edition of the Brockhaus encyclopedia, he would have been able to read about Orpheus, son of the Muses in the Golden Age: "Through the power of his song and the playing of his lyre, he was able to tame the wildest beasts and to make the stones and trees move."[36] For Marc, with his own emerging approach to the construction of landscape, this may well have seemed a by no means negligible talent.

In Marc's design Orpheus leads the troop of creatures, which includes birds, deer, and lions (a mixing of the species that was to be characteristic of the later work), through a gently sweeping forest-fringed meadow. A fish (its classical style possibly derived from a baroque print) lifts its head out of the small river in the background almost as if to complete the catalog of species.

While German painters of a *Jugendstil* tendency often located Arcadian or Elysian scenes in a birchgrove or a forest clearing with high, soft grass imbued with the mood of spring,[37] the *paradis réel* painted by Paul Gauguin in the 1890s offered a luxuriantly flourishing, aromatically humid exoticism. A surprisingly large number of the compo-

nents of Gauguin's pictures, for example those seen in *The White Horse* (fig. 192), exhibited in Paris in 1906 and reproduced in the periodical *Kunst und Künstler* in 1910,[38] are to be found in Marc's own work. But, as revealed in several poetic lines from a sketchbook of 1912/13, his unpainted imaginings were also sometimes surprisingly close to the elements of such a composition:

192
Paul Gauguin
The White Horse, 1898
Musée d'Orsay, Paris

"A pinkish rain fell on green meadows.
The air was like green glass.
The girl looked into the water;
the water was as clear as crystal [...]."[39]
One almost has the impression that Marc has imaginatively transposed himself into this scene on the banks of a small stream in Tahiti.

With their seemingly carefree symbiosis of unadulterated animal and plant worlds, their aboriginal inhabitants, and their own nature gods, Gauguin's South Sea idylls had a tendency to merge, in the imagination of enthusiasts (such as Marc and his artist colleagues and contemporaries), with the Arcadia of antiquity. This was in fact also to be true of Marc's landscapes with animals. Here, however, the human figure looks as if artificially placed in nature and loses cultural dominance, while it is the animals who represent the element of the emotional and the sensual. This explains the curiously restrained presence of human figures in the pictures of 1912 that almost seem as if they may have constituted a series: *The Waterfall*,[40] *The Dream* (fig. 103), and *The Shepherds* (fig. 104). These figures effectively relinquish their personality and their history, and become merely morphological components of the landscape. In a lecture of 1913 Hermann Nohl acknowledged this peculiarity in asserting, that in *The Dream* one should not seek to ascertain "the spatial interconnections" because there were "other relationships [to be grasped]."[41]

In *The Dream* (fig. 103) the setting does indeed appear to divide into two around the human figure: to the right and in the background a balmy "realm of landscape" where two blue horses watch over her, and to the left the angular forms of a "human world", with path and house, and the presence of an aggressive lion.[42] In *The Shepherds*, on the contrary (fig. 104), no such distinction is to be found; and, for the viewer, the two simple resting figures become a focus for empathy and, as such, a means of appreciating the composition in broader terms. Here Marc appears to oppose the *homo*

faber of Modernism by reminding man of his original sphere of being. Transposed into the corresponding landscape setting, man is also altered in his outer appearance, assuming a form suggestive of the archaic, the primitive.

The true Paradise,[43] however, finds its closest approximation in those pictures by Marc which show only animals, above all the now destroyed works *Resting Animals* (fig. 108) and *The First Animals* (fig. 155) painted, respectively, in 1912 and 1913. Here we find a world of luxuriant, sprawling plants and clear streams and pools, inhabited by creatures living in harmony with each other. The horses seem to reign over this community as its affectionate guardians. Even the relatively abstract images of works such as *The Watering-place on the Rubinberg* (fig. 115) or the drawings in the last sketchbook (fig. 165) sometimes convey the impression of Marc's genuine concern for his animals, his desire to provide them with their own environment, a geometrizied Garden of Eden.

THE ART LANDSCAPE

During the course of Marc's career he developed at least two variants of what we shall here term the "art landscape", both of these contributing a setting that only *his* animals could inhabit. To begin with, toward the end of 1909, the young painter discovered new approaches to pictorial construction that were as exciting as they were confusing when he came into contact with the work of the artists of the *NKVM*. In the exhibitions presented by this group[44] were to be found, among other works of great interest, the splendidly colorful and formally surprising Murnau landscapes painted by the artists who were soon to become Marc's friends: Wassily Kandinsky, Gabriele Münter (fig. 195), Alexei Jawlensky, and Marianne von Werefkin. The response of these artists, as also of Franz Marc and Maria Franck, to the landscape of the foothills of the Bavarian Alps — above all their deeply felt and

almost jubilantly expressed delight in the intensity of its colors — is apparent in Marc's letters.

Marc's visual experience was further broadened when he first encountered the novel, cubistically organized landscapes painted by Georges Braque (1882—1963; fig. 194) and by two Munich painters who worked in a manner similar to that of Braque at this time: Alexander Kanoldt (1881—1939) and Adolf Erbslöh (1881—1947). Pictures by all three were exhibited by the *NKVM*. The *NKVM* shows, along with subsequent Munich exhibitions and visits to Paris in 1907 and 1912, introduced Marc, by way of familiarity with the oeuvre of Van Gogh, and Cézanne, and the ongoing experiments of Robert Delaunay, to a range of work that both sparked and further encouraged the rapid evolution in his understanding of art.

As a result of Marc's increasing indifference toward the observation of landscape, his concern with depiction gave way to the search for new approaches informed by a concsious "distance from nature"[45] and, accordingly, an awareness of the artifice inherent in the landscape painter's activity. He embarked on a process of formal simplification and reduction, which he described in 1911 as the desire to take his starting point in a sketch after nature made "with three colors and a few lines," in order to produce, through the addition of further forms and colors as seemed appropriate, the true landscape, the "art landscape."[46] What now emerged in Marc's work was a new environment, one no longer in any sense resembling a biosphere and curiously resisting all recognition as such: a very good example would be the painting on glass *Two Horses in a Landscape* (fig. 93). Marc would have perhaps responded to the doubts raised by his new approach in saying that no one should really be surprised, given that his horses might themselves be blue, yellow, or green.

One of the fundamental characteristics of this "art landscape" was its elemental construction. From the esthetics of *Jugendstil*[47] Marc derived the tactic of schematization. This allowed artists to work with great economy, conveying a good deal

through the careful combination and juxtaposition of very few elements. Just as the animal, in particular the horse, became a symbol for Marc, and one that he could use as his central subject without further commentary, so he was also able to convey its landscape setting through radically simplified motifs, often rendered in distinctly colored segments with dark outlines. We may date Marc's first step in this direction to his concentration on particular aspects of the landscapes found in the large pictures painted between 1907 and 1909: identified as component parts of the landscape, these might then be represented simply as a sheaf of grain or a bush.[48]

It is almost as if Marc's schematized landscape were made up of a series of abbreviated forms devised for a particular environment. In this context, several of his pictures recall the work of the Old Masters of the 14th through 16th centuries, the art historical period of the "invention" of landscape. In the distinctly *Jugendstil* watercolor that Marc painted around 1906 as the illustration to a poem (fig. 18), the individual component parts of the scene may even be understood as representing basic elements in the structure of the world, the green sphere standing for the earth, three trees for the landscape, the comet for the cosmic dimension, and so on. Much the same

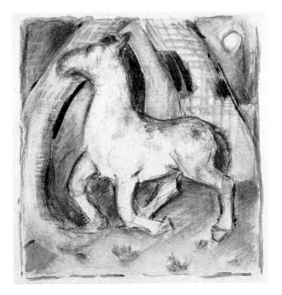

193
The Frightened Horse, 1913
Estate of Maria Marc

could be said of *The Frightened Horse* (fig. 193). Here, Marc distributes small tufts of grass across the smooth, sloping forest floor, as if his imagination had just been sparked by Medieval panel paintings seen at the Pinakothek in Munich. In

194
Georges Braque
Landscape near L'Estaque,
1908
Kunstmuseum, Basle

much of Marc's work the agave, with its green blade-like leaves, seems to serve as a symbol for the plant world in general. It is possible that the prominent position of these plants in Marc's compositions derived from Braque, whose *Landscape near L'Estaque* (fig. 194) he saw at the second exhibition of the *NKVM* in fall 1910, or perhaps from the work of Paul Gauguin (fig. 192). The agave plant occupies a prominent position in the many compositions where landscape is treated somewhat cursorily or is devoid of other specific types of vegetation, for example in *Blue Horse I* of 1911 (fig. 72)[49] or, four years later, in an enchanting sketchbook drawing of horses in a mountain landscape (fig. 164). It is evident that this plant is not of Bavarian origin and, in this respect, it adds to the alien character of such compositions: this is also notable in the case of the *Large Landscape with Horses and a Donkey* (fig. 81).

A positively dogmatic demonstration of this "elemental" compositional method is to be found in the small watercolor *Leaping Horse with Plant Forms* (fig. 98), in which Marc combines a brown horse with geometrically abstracted plants. The fact that all the components in this composition are treated in much the same way draws attention to Marc's procedure in many other landscape compositions. This is very obviously a feature of the sheet *Three Horses in front of Three Fir Trees* (fig. 188). Here, the simplified form of the composition — with its three very simply positioned horses, three equally balanced trees, the deftly inserted disk of the shallow pool, and the softly modeled undulations of the terrain beyond — recalls the decorative vignettes of *Jugendstil*.

The principle of the geometrical reduction of form is most clearly demonstrated in the case of triangular entities. In Marc's simplified rendering of the Bavarian landscape, the mountain appears as a fundamental building block, as is evident in the case of the painting on glass *Landscape with Animals and a Rainbow* (fig. 83), the painted postcard with *The Watering-place on the Rubinberg* (fig. 115), or that showing Marc's house in the village of Ried (fig. 11). One might even say that, given the intellectual sympathy between Marc and Kandinsky by this time, Kandinsky's principle of the "ascending triangle", presented in *Über das Geistige in der Kunst*, had here become manifest in the landscape.[50] As an artist close to the ideas and principles of Theosophy, Kandinsky drew on its notion of a hieratic arrangement of "cosmic reality", in which all of life — man, beast, and plant — existed on a lower plane below that of an "astral" level. Above these, according to Theosophists, there existed a "mental" level in addition to further "spiritual" realms.[51] Marc made use of a very direct method — one might almost call it naive — of introducing a spiritual and cosmic dimension into his compositions, through repeatedly including in them the moon, the sun, rainbows, or stars.[52] Apart from their clearly symbolic function as markers for the day and the night, the sky, the cosmos, a fairy-

tale realm, the element of magic, and so on, these also appear to serve as a center of energy within each of the images where they are to be found.

A further and more important aspect of the "art landscape" was its emancipation from naturalism in terms of color. Like his subsequent circle of friends at Murnau (fig. 195), Marc, as a still young artist trained in the use of a tonal palette, worked until 1910 in a manner also responding to Munich *Jugendstil*, with its emphasis on color planes, and was simultaneously coming to terms with his knowledge of recent and contemporary developments in France: the *valeur*-determined painting of Manet, the Fauvist liberation initiated by Matisse, the colorism of Delaunay based on simultaneous contrasts. Thereafter, his prismatically organized color scheme underwent few further changes. Marc carried on a theoretical discourse on this matter with his friends August Macke and above all Wassily Kandinsky, focusing in particular on the question of complementary colors and their atmospheric and thematic eloquence, a matter of obvious relevance to a work such as *Blue Horse I* (fig. 72). The fact that Marc depicted his animals in such artificial colors itself necessitated a corresponding anti-naturalistic rendering of the landscape associated with them — Kandinsky spoke of an "unnatural setting" oriented only to "inner, spiritual necessity".[53] Marc appears to have recognized that this sort of emphasis on his subjects would be incompatible with a conventional rendering of space in the treatment of their landscape setting.[54]

In January 1911 Marc wrote in a letter to Maria Franck: "There's something about this that seems curious to me: however wonderful I find the landscape to be and however ceaselessly I enjoy it, this doesn't entice me to paint it, i.e. to make a 'landscape' out of it; it simply has too much white and blue in it. If one goes out for a walk, one 'comes across' white or the palest blue, and this strikes my feeling for the use of color as positively absurd and laughable. Do you understand what I mean? Toward evening it all becomes much more colorful, instead of blue and white

195
Gabriele Münter
Autumn Landscape
(Yellow Trees), 1909
Private collection

there appear pink and complementary green tones, and violet, too, as the colorful evening draws on." A few days earlier he had written to August Macke: "At the moment, for example, I'm painting the trunks and branches in a forest. Well, instead of painting the trees in complementary tones indicative of their lit, neutral, and shaded sides, and thus showing their relation to the ground and the background, I'm painting one in pure blue, the next ones in pure yellow, green, red, violet, etc. (colors that I find in nature, but that are here mixed up and placed right next to each other). In the same way, I'm separating the tones of the terrain and the foliage into demarcated passages of pure color, and then distributing these across the entire picture relying on my artistic instinct (but without paying particular attention to the juxtaposition of complementary colors).[55]

What is especially remarkable here is the construction of a completely new form of nature unique to the world of Marc's pictures and assuming the image of a landscape made out of unnatural colors and forms. The essential harmony prevailing within this new whole is achieved through a process that Marc's contemporaries soon identified as a meaningful fusion: "stone, plant and animal are thus bound into a higher unity."[56] This is especially evident in *The Shepherds* of 1912 (fig. 104), where the depicted human figures assume the stony angularity of their surroundings, or in the *Leaping Horse* (fig. 99), where the same spots recur throughout the composition. In response to

the insight, characteristic of the age, that it was not at all possible to achieve a perfect representation of the object such as the naturalists and the photographers had sought, artists committed themselves to penetrating beyond this illusory reality to the truths and the powers that lay within,[57] a process in which Marc, too, engaged, through what he characterized as tracing the "organic rhythm [...] in everything"[58] (see the essay by Christian von Holst, pp. 62–63).

The notion of "empathizing" with one's subject had emerged from rational concepts of how a composition might be structured, painters striving to reflect the arrangement that they assumed to prevail in nature and the cosmos through the way they combined the elements of a picture. This approach led, in due course, to a tendency to render a diverse range of entities — animal, plant, rock, sky — with the same formal means, the same lines, colors, and three-dimensional entities (fig. 190). Assimilated and penetrated by this means, the individual elements assumed a common transparency, while the composition as a whole was more effectively infused with the spirit of an "overall rhythm".[59] For Marc this was one of the most important steps on the path toward the non-objectivity that, around 1914, started to emerge very clearly in his paintings (figs. 162, 181).

The extraordinary thing about Marc, however, is that his pictorial universe did not retreat into formal abstraction. He wanted to offer the viewer an inner logic, but he wanted his compositions to remain imaginatively "inhabitable". This was still the case even in 1915, when he claimed to feel the necessity of abstraction because he had become fully aware of the "ugliness of nature [...] its *impurity*".[60] In Marc's view, however, no perfect solution to this problem was to be found in mathematical abstraction, which Wilhelm Worringer had termed the "only conceivable expression of the liberation from everything that is arbitrary and chronologically contingent in the image of the world."[61] Alongside the prismatic structures and stereometric elements in Marc's work, therefore, we find that

he provides mediating zones that consist of dissolving colors or forms close to nature. Marc was also consciously resisting the danger he perceived as inherent to an over-strict application of the principles of Cubism: a thematic and atmospheric "emptiness". In his own work he aimed at an intensification of expression in both respects.

Marc did not evolve an "art landscape" capable of accommodating every motif in his work. Nonetheless, under the influence of the diverse theoretical and conceptual systems to which he had referred since his retreat from the observation of nature, he did create a long series of entirely self-referential landscape settings: in the case of the *Small Reclining Horses* of 1911, for example, plant, bush, and hill exist only in the form of linear constructions barely distinguished from each other. In the glass painting of the same year, *Landscape with Animals and a Rainbow* (fig. 83), abstract elements such as the square, the rectangle, and straight black lines, signal the coexistence of real and artificial worlds, or at least the optical imposition of the latter on the former. The painting of 1912, *Horses and an Eagle* (fig. 106), with its strikingly geometrical treatment of organic forms, shows a landscape divided into three segments, each occupied by one creature that, through its own coloring, has an influence on the coloring of the terrain to be found directly around it. Here it is as if nature had become an instrument that the painter might use to demonstrate his scheme of complementary colors.

In a series of works in tempera and watercolor painted in 1913 (figs. 138—149) Marc devised a fascinating realm that is peaceful yet also penetrated by cosmic energies. It is an environment in which opposites are subsumed: the sun and the moon shine simultaneously, or the moon appears in the sky above a bright, daylit world. And this is brought about not only by the harmony between the dominant tones of blue, green and red, but also through a fundamental merging of the animal bodies with the plant components and light effects found in the picture. The

Arcadia of *Three Horses at a Watering-place* (fig. 146) — a primeval world with a volcano and fertile plains of pasture and swamp — is one of Franz Marc's most wonderful creations. Comparable in its topography is the gorge found in *Animals at a Watering-place* (fig. 189). This landscape, untouched by man, is made up of steep, thickly wooded hills with a small river winding between them. The animals have assembled at a point where the river bends, and one can almost physically sense the tall, soft grass that grows at this spot, and the cool, fresh breeze stirred by the water cascading from a height of several meters.

The construction of an ostensibly natural, yet at the same time almost other-worldly abode for animals — as seen in *The Small Yellow Horses* (fig. 79), who cluster contentedly on a round-topped mountain higher than the neighboring peaks, or in the untitled drawing with horses in the mountains (fig. 164), who delight in the carefree harmony of their existence above the clouds — is the crowning glory of Marc's striving to imagine a natural environment. For here, this "endless nature"[62] of the imagination seems to become real.

Notes

1 Theodor Däubler, "Marc", in *Neue Rundschau* (1916), cited in Lankheit 1960, pp. 81—85.

2 This aspect of Marc's work had already been noted in Walter Bombe, "Franz Marc und der Expressionismus", in *Das Kunstblatt* iii (1917), pp. 72—79, cited in Lankheit 1960, pp. 103—112, this term occurring on p. 110.

3 Alfred Döblin, "Die Natur und ihre Seelen," in *Der Neue Merkur* vi (1922), pp. 5—14, this passage on p. 8.

4 August Macke, letter from Bonn to Bernhard Koehler, Jr. of October 21st 1912, cited in Macke 1987, pp. 292—293, this phrase on p. 293.

5 On this point, see Walter Bombe, "Franz Marc und der Expressionismus" (as in note 2, above), p. 109.

6 See Dietrich von Engelhardt, "Naturgeschichte und Geschichte der Kultur in der Naturforschung der Romantik", in exh. cat. Hanover 1994, pp. 53—59.

7 Warnke 1992, p. 172, speaking of the formal autonomy of the treatment of landscape, uses the term *Eigenform*.

8 The proximity to Medieval art in thrall to the imperatives of conventional religious imagery is only apparent, for the artist now thinks and acts entirely as an individual.

9 On the concept of the "imagination", see Marisa Volpi, "Imagination und Wirklichkeit in den Landschaften der Deutsch-Römer", in exh. cat. Munich 1987, pp. 120—132.

10 On this aspect of early Modernism, see O. Bätschmann on Hodler and Mondrian, in Bätschmann 1989, p. 196.

11 Franz Marc, "Die neue Malerei" (1912), cited in Meissner 1989, pp. 235—238, here pp. 237, 238.

12 According to Lankheit 1976, p. 115.

13 Carl George Heise, "Franz Marcs 'Springende Pferde'", in *Genius* i/2 (1919), pp. 218—220, cited in Lankheit 1976, p. 70.

14 Franz Marc, letter of Christmas 1910 to Will Wieger, cited in Lankheit 1976, p. 51.

15 Gottfried Boehm, "Das neue Bild der Natur. Nach dem Ende der Landschaftsmalerei", in Smuda 1986, pp. 87—110, this phrase on p. 91.

16 Franz Marc, letter of August 6th 1907 to Maria Franck, cited in Meissner 1989, p. 27.

17 On the terminological and historical dimension of the term "landscape", see Eberle 1980, pp. 15—32.

18 Georg Simmel, "Philosophie der Landschaft" (1913), reprinted in Simmel 1957, pp. 141—152, this passage on p. 141.

19 On this development, see Warnke 1992, p. 173.

20 A phrase used in Bätschmann 1989, p. 154.

21 An alternative view is offered by Michael Pauen, "Die Diskreditierung der Natur. Zur Entwicklung der Ästhetik der Abstraktion", in Zimmermann 1996, pp. 369—384.

22 On this point, see Franz Marc's letter of August 13th 1911 from Sindelsdorf to August Macke, in Macke 1964, pp. 68—69, in particular p. 69; also Helmut Macke (on the period from fall 1910 to spring 1911) cited in exh. cat. Munich 1980, p. 31.

23 Maria Marc, "Biographische Erinnerungen" (concerning 1908), cited in exh. cat. Munich 1995, p. 29.

24 Elisabeth Erdmann-Macke, in Erdmann-Macke 1962, pp. 162 ff.

25 Franz Marc, letter of September 18th 1909 to Maria Marc, cited in exh. cat. Munich 1995, p. 39.

26 As termed by Lankheit 1986, cited in Andreas Firmenich, "Landschaft, Natur, Kosmos, Geist. Zur Entwicklung der Landschaft bei Franz Marc", in exh. cat. Munich/Münster 1993—94, pp. 85—93, here p. 85.

27 Helmut Macke (as in note 22, above), cited in exh. cat. Munich 1908, p. 31.

28 Alois Schardt, cited in Lankheit 1976, pp. 81—82.

29 In the study for this picture (Lankheit 1970: 644) star-like crosses are incorporated even more insistently into the landscape.

30 Kandinsky 1911/1952, p. 142.

31 See also Friedländer 1947, p. 175.

32 See, for example, *Landscape* (Lankheit 1970: 573) in relation to *Horse in a Landscape* (Lankheit 1970: 572), or *Exotic Landscape* and *Undulating Hilly Landscape with Three Fir Trees* (sketchbook XXI, fols. 5, 6) in relation to *Red Horse in a Colored Landscape* (Lankheit 1970: 885).

33 On this point see p. 20. In all probability, Marc also drew inspiration in terms of form from the series of Van Gogh *Olive Groves* painted in June 1889 and from the variations on the *Cornfield with Mower* of around 1889.

34 Eugen von Kahler, an artist associated with the almanac *Der Blaue Reiter*, was influenced by this motif and produced a very similar work in tempera (on this see Cobarg 1995, pp. 83—84); but such examples with a direct connection to Marc are only rarely to be found among the work of his well-known contemporaries.

35 There is also a sketchbook sheet of 1906 (fig. 24) in which Orpheus is seen seated under a large tree that frames a view of the landscape, while the animals, among them a group of horses, stream towards him.

36 Brockhaus 1903, vol. xii, p. 656.

37 Decades earlier Arnold Böcklin had, of course, painted mythological subjects; but his pictures were quite distinct in their boisterous and forthright sensuality.

38 *Kunst und Künstler* viii (1910), pp. 86—101; on this point in general, see also exh. cat. Paris 1989, pp. 408—409.

39 Notes in sketchbook XXVII (1912/13), cited in Meissner 1989, p. 254.

40 Lankheit 1970: 171; Rosenthal 1992, color pl. 38.

41 Hermann Nohl, manuscript of a lecture given in February 1913, cited in Lankheit 1960, pp. 16—22, this phrase on p. 20.

42 For an iconographic interpretation of this composition in the context of the mythology of antiquity and the Christian religious background of the figure, see Mönig 1996, pp. 72—73.

43 In 1912 Macke and Marc painted a mural *Paradise* (Lankheit 1970: 188) in Macke's house in Bonn. In addition, Marc engaged in many projects relating to the theme of the "Creation", as testified by his plan for an illustrated Bible, or the titles of many pictures. On the religious aspect of Marc's work, see Carla Schulz-Hoffman, "Franz Marc und die Romantik. Zur Bedeutung romantischer Denkvorstellungen in seinen Schriften", in exh. cat. Munich 1980, pp. 95—114.

44 For extensive commentary on this point, see exh. cat. Munich 1999. The exhibited works included: Kandinsky's study for *Landscape (Dünaberg)* of 1910 at the second exhibition, and Vladimir Bekhteyev's *Diana Hunting* of 1911, at the third exhibition, in 1911. Also of relevance in this context was Macke's *Red Indians on Horseback* of 1911, shown at the first exhibition of artists associated with the almanac *Der Blaue Reiter*.

45 The term used of Van Gogh, Gauguin, and Cézanne by Werner Hofmann, in Hofmann 1987, p. 204.

46 Franz Marc, letter of April 12th 1911 from Sindelsdorf to August Macke, cited in Macke 1964 pp. 52—53, here p. 53. Klaus Lankheit claims that it was in 1905 that Marc recognized a "super-objective power of expression in the line"; see Lankheit 1976, p. 34.

47 Marc's first wife Marie Schnür was close to the Munich *Jugendstil* association *Die Scholle* [Native Soil], to which painters such as Püttner and Putz also belonged.

48 See *Sheaf of Grain* (Lankheit 1970: 61); and *Bush in the Sun* (Lankheit 1970: 62).

49 The landscape studies for this composition also testify to the significance of this plant for Marc: *Large Green Agave Plant* (Lankheit 1970: 157), *Landscape with Agave Plant* (Lankheit 1970: 158), or *Exotic Landscape* (sketchbook XXI, fol. 5).

50 Kandinsky 1911/1952, p. 50. The result is a sort of "spiritual landscape". In contrast, Böcklin, Franz von Stuck, and their followers are described as "seekers after the spirit within the outer form."

51 On this point, see Stefanie Foley, "Was war der Neue Mensch?", in exh. cat. Bielefeld 1992, pp. 30—38, in particular p. 31.

52 The image of the crescent moon and the stars also constituted, from 1912, a link with the work of the Expressionist poet Else Lasker-Schüler (see essay by Christian von Holst, pp. 127–136). In the case of Marc, these motifs then evolved into "a cosmic signet to designate the Creation"; see Lankheit 1976, p. 121.

53 Kandinsky 1911/1952, p. 78.

54 See Franz Marc, letter of February 2nd 1911 to Maria Franck, cited in Meissner 1989, p. 45.

55 Franz Marc, letter of January 17th 1911 to Maria Franck, cited in exh. cat. Munich 1980, pp. 29—30, this passage on p. 30; Franz Marc, letter of January 14th 1911 from Sindelsdorf to August Macke, cited in Meissner 1989, pp. 39—43, this passage on p. 41.

56 Lothar Schreyer, "Franz Marc und der Expressionismus", in *Deutsches Volkstum* (April 1926), pp. 277—282, cited in Lankheit 1960, pp. 115—122, here p. 117. On the notion of "fusion", see Kandinsky's letter of August 20th 1911, cited in Lankheit 1983, p. 53, and the manuscript of Kandinsky's text of 1935, "Our Friendship", cited in Lankheit 1960, pp. 43—51, in particular p. 47.

57 See Franz Marc, letter from Sindelsdorf of February 20th 1911 to Maria Franck, cited in Meissner 1989, p. 53.

58 See Franz Marc, letter from Sindelsdorf of April 20th 1910 to Reinhard Piper, cited in Meissner 1989, pp. 30—31, here p. 30, previously published in Piper 1910, p. 190. On the idea of "organic rhythm", see Christoph Wagner, "Franz Marc und die Musik. Prismatische Farbigkeit und organischer Rhythmus", in exh. cat. Kochel am See 1998, pp. 67—94, in particular pp. 82—87.

59 Marc also explicitly refers to the work of Cézanne here: see Franz Marc, "Die neue Malerei", in *Pan* xvi (March 7th 1912), cited in Lankheit 1978, pp. 101—104, in particular p. 102.

60 Franz Marc, letter of April 12th 1915 to Maria Marc, cited in Meissner 1989, pp. 140—141, here p. 141.

61 Worringer 1981, p. 81. Marc made a point of referring to this book in Franz Marc, "Die konstruktiven Ideen der neuen Malerei", in *Pan* xviii (March 21st 1911), cited in Lankheit 1978, pp. 105—108, in particular p. 107.

62 Franz Marc, letter from Sindelsdorf of February 20th 1911 to Maria Franck, cited in Meissner 1989, p. 53.

Theodor Däubler:
Essay on Franz Marc, 1916

He will remain among us. He has left us his animals: we will love them and we will not forget the man who created them. Here, among people, animals in their simplicity represent the explicit element in character. Each animal embodies it own cosmic rhythm. In every case the nature of the beast depends on the stars. When a particular species becomes extinct something extraordinary happens up in the heavens: a new sign is added to the zodiac when terror flames forth as a star. Only man can evade being fatally undone by the stars, the stars that once raised him to an upright position, for man is free. Franz Marc knew this.

Every single thing embodies its own stellar rhythm. The animal carries its own rhythm around with it. Every animal harbors within itself the germ of a soul. But who knows where this will manifest itself? In something that is beyond the animal? In its sign of the zodiac? Here, among us, the animal is not yet its own fulfillment but, rather, its own tragic beginning. Most animals are beautiful, but not happy. It may well be that they assumed an earthly existence out of terror at their inescapable future among the stars [...]

It was as if the horse were the beast that appeared on Marc's coat-of-arms, his secret mascot. He was able to see into its soul. The horse is alert, with all its senses, to the plain surging up before it. Almost tripping over as it ascends, it seems to be flinging itself on the back of one mare after another. But, somehow, every single one evades it, and it is for this reason that, in its soul, the horse is always raging. Its irrepressible urge to go on, to move forward, has long been converted into a spiraling motion that repeatedly interrupts its own scenting of a promising new track. The horse experiences space almost as if the landscape were itself another living body. It must be able to spot the danger of yellow beneath its feet, to avoid it so as to come to no harm. And that is why its soul is without doubt blue. Blue, so as to rear up as distinctly as possible against those sunlit paths. And, as it flees, it seems to the horse that the landscape brushes against it. In its transparency its blueness thus becomes striped with yellow; and, in its contentment, the horse will gallop up and down, returning again and again to its own traces. Dust billows up in its wake, and it seems to the horse that it is swimming, then flying [...]

He who is a match for the horse has a soaring, blue spirit. The world circling around him has the white of clouds and the gray of dust. When he rests, he contemplates its colors and, to his eye, they are the epitome of color, absolute brightness. When the rider flies, his blue glints with silver. Anyone who can ride finds ecstasy in this blue.

Marc was a poet of color. He dared to play with color, like a fearless child.

CITED IN LANKHEIT 1960, PP. 82, 84 ff.

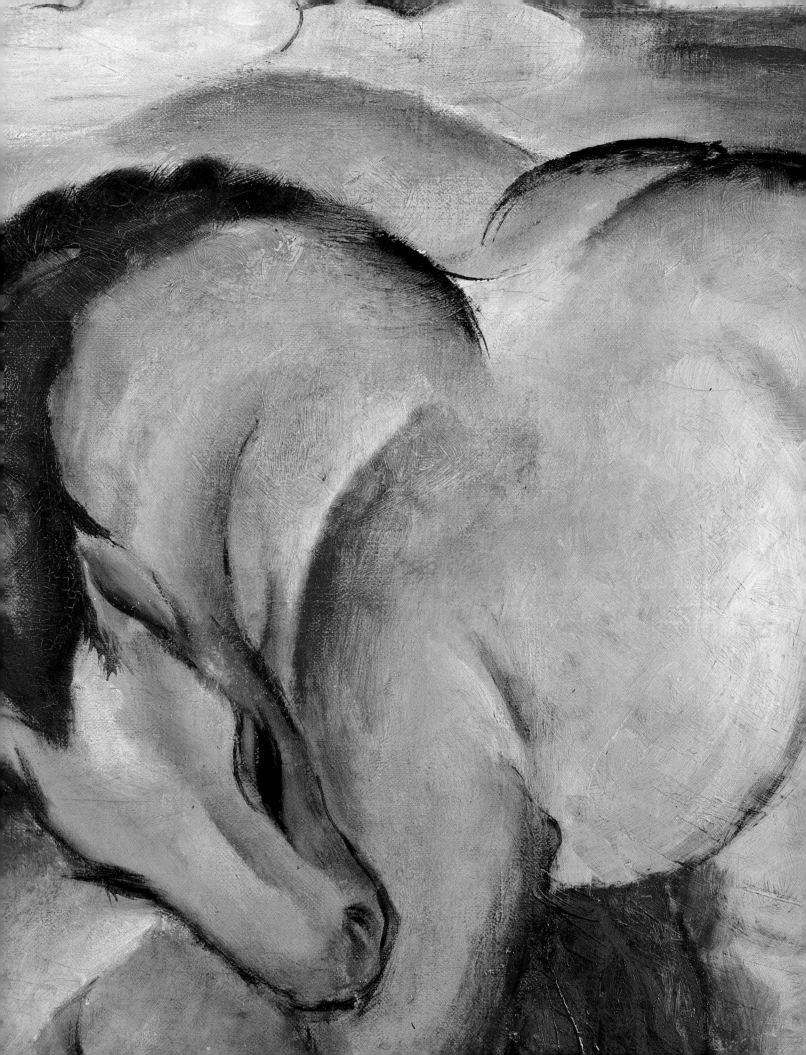

A Horse without *a Rider?*

Franz Marc, Reinhard Piper, and
the Horse in Art

ANDREAS SCHALHORN

While Franz Marc's attempts at encapsulating the essence and the distinctive aura of horses were enormously varied, with very few exceptions — their rarity adding, however, to their interest (fig. 142) — he concentrated on showing the horse *without* a rider. He depicted individual animals (e.g. fig. 72), pairs (fig. 94), groups (fig. 68), or horses seemingly engaged in a dialog with other creatures (fig. 106). On occasion, Marc's horse pictures also included human beings (fig. 104).

The novelty and singularity of Marc's stance as a painter of horses and other animals, which was inextricably bound up with his ambitions for a thematic and formal renewal of art, is especially evident if his achievement is examined in terms of its relation to earlier artistic representations of the horse. The very nature of some of his images (figs. 197, 151, 152) invites us to consider the earlier history of horse painting. Marc also made a significant contribution to the survey volume published in 1910, *Das Tier in der Kunst* [Animals in Art], by Reinhard Piper (1879—1953). Piper, who was later to act as publisher for the almanac *Der Blaue Reiter* [The Blue Rider], had originally

197
Cover (with Marc's drawing after Delacroix)
Reinhard Piper, Das Tier in der Kunst (Munich 1910)
Formerly in the Archiv R. Piper & Co. Verlag, Munich

page 238
196
The Small Yellow Horses,
1912
Detail from fig. 79

planned to bring out a volume with literary texts on animals (*Das Tier in der Dichtung*).[1] When this project fell through, he produced instead a historical overview of the representation of animals in art, starting from prehistory and the "primitive peoples". The book ends with a chapter on contemporary animal sculpture.[2]

For the first edition of Piper's book, Marc not only provided a design for the cover, adapting a watercolor by Eugène Delacroix (fig. 197); his work was also represented in the concluding section of the book in the form of black-and-white reproductions of his *Two Horses* in bronze (fig. 37—39).[3] Piper also incorporated a text that Marc had sent to him in April 1910 (the importance of which was soon recognized) advocating an "*animalization* of art" (see essay by Christian von Holst, pp. 62–63).[4]

Here Marc acts as a guide to his own work, but also to earlier painters' contributions to the understanding and use of color (in this matter almost exclusively citing French examples): "A path leads directly from Delacroix and Millet, via Degas and Cézanne, to Van Gogh and the Pointillists: and the youngest generation of French artists have joined in a wonderful race toward this goal. But, strangely enough, they avoid the most obvious subject for this art: the *image of the animal*."[5]

The next year, as co-editors of the almanac *Der Blaue Reiter*, Marc and the expatriate Russian artist Wassily Kandinsky included older material, such as the *Fighting Stallions* by Hans Baldung Grien (fig. 209),[6] among their selection of reproduced images. Finally, in 1913, in connection with his preoccupation with the woodcut, Marc made copies after 18th- and 19th-century images (figs. 151, 152).[7] In general, then, one can point to repeated concern on Marc's part with the earlier history of the horse in art.

Marc's awareness of art history is almost emblematically illustrated in an unpublished colored sketch made in 1911 (fig. 198).[8] In its foreground, just right of the center, stands a small

horse that is characteristic of Marc's work in its compact form and the luminosity of its bluish-violet tone. As a rear-view figure, it draws the eye into the picture space, which is occupied by two mounted horses and further human figures. To the right we can make out a full-grown brown horse. This too is presented in diagonal rear-view, but it carries a nude figure who is riding bareback. At least two further nudes, in all probability male, stand to the right of this horse. To the left of the composition there is a black horse, shown in right profile parallel to the picture plane with its head raised. Positioned near its front legs is a figure who seems to be holding the animal by its reins. Beyond and to the left of this horse, smaller background figures are seen against a dark blue sky. One, viewed from the rear, stands out on account of a schematically rendered red-and-white head covering suggestive of Arab costume. In fact, the entire left half of the composition has an Oriental character, such as might well prompt comparison with an oil sketch by Otto von Faber du Faur (fig. 204). The horse to the right, meanwhile, is reminiscent of the countless race-horses with jockeys painted by Edgar Degas;[9] and the naked rider is suggestive of a connection with motifs in the work of Paul Gauguin (fig. 192). In the context of such echoes, one could perhaps see Marc's little blue horse without a rider as a figure engaged in surveying the motifs to be found in the horse painting of earlier, albeit not all that distant eras.

To Franz Marc's way of thinking, or so it would seem (see the essay by Andreas K. Vetter), horses were assured of a place in the "Garden of the Animals" on account of their identity as creatures outside the control of man. As depicted in Marc's work, they appear to be distanced from human beings and the evidence of civilization. Yet the cultural connection between man and the horse (including the latter's marginalization, during the course of the 20th century, as an animal associated primarily with sport and leisure) was in reality quite different. A fable recounted in 1789 by Novalis [Georg Philipp Friedrich Freiherr von

Hardenberg] (1772—1801) makes clear the positive evaluation of the use humanity has made of the horse:

"A wolf said to a horse: 'So why do you remain so faithful to those human beings, who only torment you; why don't you make a bid for freedom?' 'But then who would protect me, in the wild, against you and your sort?' answered the philosophical horse. 'Who would care for me if I fell sick, where would I find such good and nourishing food, or a warm stable? You can have your chimera of freedom any day in exchange for everything that constitutes my slavery. And even the work I have to do: is it really such a misfortune?'"[10] The horse, the fable implies, appears to bind itself voluntarily to the human house and home. An existence in the wild, where it would ostensibly be free, would mean death.

A much more ambiguous impression of the horse in the service of man is conveyed by Jonathan Swift (1667—1745) in his novel *Gulliver's Travels*, published in 1726. Gulliver's fourth and last journey takes him to the land of the horses (or Houyhnhnms), where these animals are the only beings gifted with reason, while the creatures physically resembling human beings (the Yahoos) are its wildlife and exist in a state of unenlightened instinctiveness. The Yahoos were kept as servants by the Houyhnhnms. In the fourth chapter of this section of the novel, Gulliver tells his inquisitive host, the Master of the Horses, of the life of these animals in his own country, England: "I owned, that the *Houyhnhnms* among us, whom we called *Horses*, were the most generous and comely Animal we had; that they excelled in Strength and Swiftness; and when they belonged to Persons of Quality, employed in Travelling, Racing, and drawing Chariots, they were treated with much Kindness and Care, till they fell into Diseases, or became foundered in the Feet; but then they were sold, and used to all kind of Drudgery till they died; after which their skins were stripped and sold for what they were worth, and their Bodies

left to be devoured by Dogs and Birds of Prey. But the common Race of Horses had not so good Fortune, being kept by Farmers and Carriers, and other mean people, who put them to greater Labour, and fed them worse. I described as well

as I could, our Way of Riding; the Shape and Use of a Bridle, a Saddle, a Spur, and a Whip; of Harness and Wheels. I added, that we fastened Plates of a certain hard Substance called *Iron* at the Bottom of their Feet, to preserve their Hoofs from being broken by the Stony Ways on which we often travelled".[11]

The cultural-historical status of the horse as an animal used, and exploited, by man, was in many cases undermined as a result of the gradual introduction, during the 19th and early 20th centuries, of motorized vehicles to replace working animals. This was particularly so in the context of urban life. In 1895, when electric trams were introduced in Munich, the horses used to pull trams since 1876 were phased out.[12]

The suffering of horses mistreated by man was nonetheless a recurrent theme in the literature of the late 19th century. The evidence of Marc's familiarity with the work of Leo Tolstoy (1828—1910) embraced not only the latter's state-

198
Scene with Horses and Riders, 1911
Germanisches National-musuem, Nuremberg

ments on art,[13] but also his short story of 1861
(first published in Russia in 1886), *Kholstomer* [lit.
The Canvas Measure], first translated into German
in 1889. A drawing made in 1913 captures the
equally pitiable and dignified image of the horse
so called on account of its "long and sweeping
strides, the like of which was nowhere to be found
in all Russia."[14] This animal, an old piebald geld-
ing, recounts night after night for the other horses
on a country farm the story of its life, as extraordi-
nary as it was sorrowful, before finally being led
away to the knacker's yard to be slaughtered.

The bond between horse and man (and the
fate of the horse in this union) as sketched by Tol-
stoy, Swift, and Novalis, should be borne in mind
as we turn our attention to animal painting as an
autonomous category evolving out of genre paint-
ing. Animal painting in its own right emerged in
Holland in the 17th century. Particularly subtle
observers of the horse were painters such as
Paulus Potter (1625—54) and Karel Dujardin
(1622—78), whose images of animals frequently
showed no human figures at all. Nonetheless, as
revealed at least by a second glance at etchings by
and after these artists (figs. 199, 200), the horses
shown have in fact exchanged the dangers of
freedom (of which Novalis speaks) for the age-old
fetters of domestication: in the case of Dujardin
the horses are accompanied by a plow and, sig-
nificantly, are viewed as much from the rear (the
plowman's or coachman's position) as from the
side.[15] The grazing horse to the right has, more-
over, had its tail cropped. Paulus Potter greatly ele-
vates his pair of horses in the flat Dutch country-
side, so that both the piebald and the white horse
(in all likelihood a mare and a stallion) loom large
against the open sky.[16] As a result, they assume
positively monumental proportions. And yet,
framed by the belly and the legs of the neighing
beast, we find in the distance beyond a broad
stretch of water a substantial building with two
towers. This is also reminiscent of Marc's images
of horses in landscapes that often include build-
ings, usually simple farm huts, in their back-

grounds (figs. 79, 103, 127). Some traces of civi-
lization do then in fact appear in his works, as for
example, in those devoted to the theme of *Stables*
(figs. 160, 161).

The somewhat posed quality of the two ani-
mals seen in the print after Potter's *Neighing
Horse* (fig. 200) permits a more detailed rendering
of external appearance, particularly in the case
of the figure in the foreground. Potter often
adopted this approach in his compositions with
cows and sheep.[17] At the same time, Potter suc-
ceeds in suggesting a degree of communication
between his protagonists (the white horse is
shown looking at the piebald horse): this was later
to become one of Marc's favored compositional
devices (figs. 37—39, 56).

In *Das Tier in der Kunst* Reinhard Piper
offered an early 20th-century interpretation of
Potter's approach to depicting animals: "Hardly
anyone has identified so objectively with animals,
or so wanted to give voice to animals, and only to
animals. No one was so successful in shaking off
the tendency to anthropomorphism. There is no
trace in Potter's work of his personal response to
his subjects. We have to assume that he himself
had something of the impulsiveness, the sureness
of instinct, but also of the 'dull' passivity of his
animals."[18] In the picture illustrated here, however,
the arrangement of the horses, and in particular
their almost heroic elevation in the landscape,
betrays a certain tendency to "humanization".[19]
The point that Piper is making appears, in fact,
truer of Dujardin's *Horses and a Plow* (fig. 199),
where the animals turn their backs on the viewer,
and are totally absorbed in their own activities,
and not — as in the case of Potter's picture —
effectively put on display.

It is notable that, in commenting on Potter,
Piper speaks of an artist "identifying with" the
animal that is his subject, for this was in fact a
rephrasing of a notion that had become fashion-
able in German art theory and esthetics by 1910:
that of *Einfühlung* or empathy. By "identifying
with an animal", Piper doubtless implied the abil-

ity to empathize with it in both physical and psychic terms.[20] Marc too, in his textual contribution to Piper's volume, wrote of empathy: "I'm endeavoring to empathize, in a pantheistic fashion, with the quiver and flow of the blood in all of nature, in the trees, in the animals, in the air [...].[21] And in fact one of the aims of Piper's book had been to encourage empathy with the defining animality of animals. In his preface, written in May 1910, he stated: "I should like this little book to encourage its readers to look in a new way not only at animals in *works of art* but also at their subject, *animals themselves*. For art offers the best means of knowing and interpreting nature; it achieves a synthesis of what we find there, while science can only offer an analysis.

In our age of the metropolis, of the artificialization and mechanization of all aspects of life, getting back in touch with nature has almost become a route to rejuvenation. And it is through animals that nature speaks at its clearest and purest, and it is also here that it speaks very directly to us, to humanity. We should look at animals not only with the eyes of the artist but also with our own eyes. Artists should open our eyes to the beauty of animals, but then we must start using these eyes [...] This book might also serve as a complement to the *Natural Histories* of the animal kingdom, in as far as the illustrations in such volumes are often woefully inaccurate on account of their excess of painstaking *correctness*, and hence [...] their inability to grasp the *essential* impression, the *character of the animal*. It is above all here that artists have something important to contribute."[22]

Piper's evident regret at the process of "artificialization and mechanization" reveals that he shared the sentimental longing of many of his contemporaries for a return to the union of man and nature, a dream that required animals as mediators. The horse, as a domesticated animal, was seen as especially close to man, and to the extent that its connection with the wild could even be understood as an exception. According

to a text published in 1908: "In developed countries [...] few people have the opportunity to see wild mammals. The sight of grazing deer, horses, sheep, and goats offers only a hint of the enjoyment afforded by the observation of mammals in the wild."[23] From the point of view of the history of culture and civilization, the horse has indeed had a close connection with humanity; considered in other contexts, however, it is an alien presence, continuing to testify to the era of unadulterated nature that preceded civilization.[24] Was it perhaps for this reason that Marc, who from 1910 more or less lived "among horses" at Sindelsdorf, so favored this animal as a vehicle for his art?

It would be difficult to dispute Piper's criticism of the tendency toward a certain "painstaking *correctness*", as evinced by the etching made

after Potter (fig. 200). This approach was to find its apotheosis in the work of the 18th-century English artist George Stubbs (1724—1806). Fired by the spirit of the Enlightenment, Stubbs was to raise the pictorial representation of the horse to an entirely new level. The first in a long line of British "horse painters", he based his pictures on a series of extremely detailed studies of the skeleton and the musculature of the horse.[25] Such precision enabled him to emerge as a sought-after painter of horse "portraits". Unlike Potter, however, Stubbs depicted only thoroughbred horses from the best stud-farms. On the whole, he showed these in strict profile so that experts could examine and appreciate every detail of the coat, musculature, and pose of each animal.

A follower of Stubbs in what Piper calls "the objective tradition in animal painting"[26] was Albrecht Adam (1786—1862), who in fact founded a dynasty of painters. One painting by Adam, showing the artist with his palette in hand accompanied by his three sons in his Munich studio (fig. 201), combines several of the available means of incorporating horses, both with and

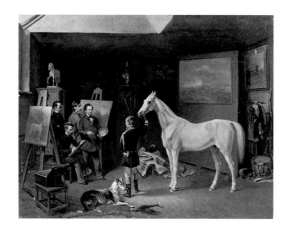

201
Albrecht Adam
In the Studio, 1854
Stadtmuseum, Munich

without riders, into a composition: behind the white Arab horse, whose bridle is held by a boy in a military-style uniform, a battle painting hangs on a partition.[27] At the extreme right of the picture is a small equestrian portrait of a rider, while in the left half of the scene the picture of a horse stands on an easel. On top of the stove in the left

background we find the small sculptural figure of a white horse. Most of these works would have been commissioned, but they did not win Adam the high status associated with academic history painting or commercial portraiture.[28]

This practice of painting animals in the studio — it was still current in the late 19th century in the classes taught by Heinrich Zügel (1850—1941) at the Academy of Art in Munich, where a cow was used —[29] was quite distinct from Marc's procedure. He observed and painted horses in the landscape of Upper Bavaria. His earlier efforts to master animal anatomy, which enabled him to earn a living, are quite different in character (figs. 5, 27). Toward the end of *Das Tier in der Kunst*, Piper writes almost apologetically of Marc and his bronze sculpture *Two Horses* (figs. 37—39): "As we shall soon see, his studies of animal anatomy for artists, the preparations for which have long occupied him, reveal that, in spite of this indifference toward narrow-minded 'correctness', he has fully mastered the rendering of animals from the scientific point of view."[30] In commenting later on the failure of his plans to publish Marc's studies of anatomy, Piper recalled: "In [Marc's] studio on Schellingstrasse he gave lectures on animal anatomy to a class of just under a dozen. During the class he would draw on a blackboard. I can still hear his dark warm voice. I proposed to him that we publish the lectures as a book. Nothing came of this, but we stayed in contact."[31] Marc, however, was no longer concerned to record a supposedly "natural" beauty (that had in fact been perfected by man through selective breeding) as a measure of anatomical and biological correctness — the principal interest of a painter such as Albrect Adam.[32]

Animal painters at work in Munich in the early 19th century adopted the compositional devices favored by Dujardin or Potter and further developed these. Moreover, at a time when landscape painting was itself slowly emerging as an autonomous genre and was no longer in thrall to obligatory idealization, animals were increasingly

incorporated in the record of rural Bavaria. The small painting of 1819 (fig. 202), *Landscape on the River Isar near Munich* by Wilhelm von Kobell (1766—1853), combines topographical exactitude with elements of genre painting. A groom with his dog and two farm horses and a foal are positioned at a ford in the center of the composition, and thus incorporated within a view of the sweeping landscape.[33] The groom, who is just a boy, is playing on a wooden flute, the dog is drinking, the horses are motionless and appear to have fallen asleep. In the figure of the flautist with the animals grouped closely around him, we may assume a latent allusion to the mythological subject of Orpheus (see fig. 191). There is also, however, an element of humor to be detected within this idyll: in the middle distance at the extreme left of the composition two young girls, aided by a dog, endeavor to coax an unwilling goat toward the river bank.

Kobell's trio of horses, complete with long cast shadows like all the figures in the picture, combines a young brown horse with a white horse and (as the groom's own mount) a black horse. While both Potter and Dujardin have their animals standing out above the horizon line, in Kobell's case the black horse serves to bestow visual prominence on the young flautist, whose torso towers above the silhouetted city and the distant Bavarian Alps shrouded in a blue haze. Through the inclusion of prominent Munich landmarks, in particular the easily recognizable Frauenkirche [Church of Our Lady], Kobell defines his landscape primarily as the environs of a city. The ostensible innocence of Kobell's flute-playing peasant lad makes it all too easy to forget that even by the end of the 19th century the equestrian monument or portrait still largely served the purpose of elevating, and thus glorifying, the ruler or military commander.[34]

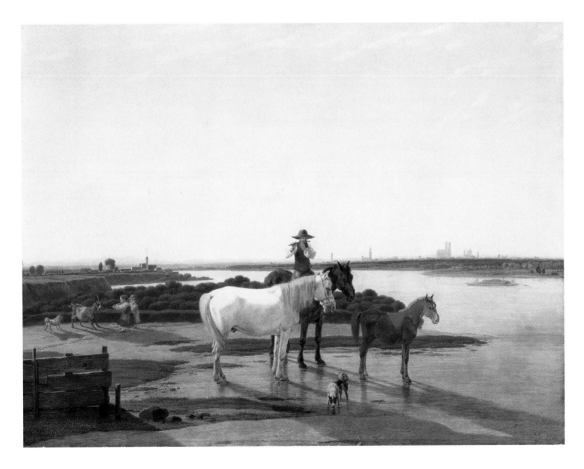

202
Wilhelm von Kobell
Landscape on the River Isar
near Munich, 1819
Bayerische Staatsgemälde-
sammlungen, Munich

Marc, too, on occasion, used the ford or watering-place as a setting for the horses he depicted; but, in doing so, he was often relocating these animals from the expanses they would have occupied in the wild to the seclusion of the forest (fig. 146). Marc in fact succeeded in concentrating and intensifying a sense of the state of harmony and peace that appears to prevail between man and beast in Kobell's picture, but he did so despite treating the horse almost exclusively as a part of its natural environment (fig. 148).

This conscious act of removing animals from an environment transformed or entirely created by man, be it rural or urban, was already implicit in a picture by Moritz von Schwind (1804—71), *Hermit Leading Horses to Water* (fig. 203).[35] Nonetheless, from the point of view of pictorial narrative, Schwind's attention is not exclusively focused on the animals. It is man, in the figure of the monk, who has achieved a retreat from civilization and now lives as a hermit. The horses that he leads to water, with their bridles and saddles removed, may be presumed to belong to the knight seen sleeping in a hollow in the rockface.[36] And it is only because the traveler himself is

recovering, through sleep, from the exertions of his journey, that the animals may also rest. Nor can they in any real sense themselves become "hermits". As John Berger has observed: "The treatment of animals in 19th-century Romantic painting was already an acknowledgement of their impending disappearance. These images are of animals *receding* into a wildness that existed only in the imagination."[37]

Like Potter and Kobell before him, Schwind juxtaposes white and black animals to encompass the horse as a species. In Marc's work the notion of a bipolar unity is often conveyed through the pairing of blue and red horses (figs. 93, 94). Independent of the significance here of Marc's own system of color symbolism (see the essays by Christian von Holst and Karin von Maur), it is possible that a passage contributed by Marc's friend August Macke to the almanac *Der Blaue Reiter* (published in May 1912) may throw light on this matter: "The relationship of the various forms to each other allows us to recognize each individual form. Blue only becomes visible in contrast to red, the large size of a tree in contrast to the smallness of a butterfly, the youth of a child in contrast to the age of an old man. It is clear to us that one plus two equals three; but we are unable to grasp that which is without form, without end, the meaning of zero. God eludes our comprehension."[38] It is worth mentioning in this context that, in spite of the "old fashioned" style of Schwind and Kobell, Marc valued their work for its spiritual quality.[39]

The notion of a return to the wild, the restoration of the horse to a natural environment on which human civilization had (apparently) had no impact, did not exclude the tendency of man to regard the horse as a symbol — in fact, the opposite was the case. It was precisely the removal of the human figure as a rider that led to psychological interpretations of the horse in relation to human concerns. Among the painters of 19th-century Romanticism, above all in France, the horse became a metaphor of unrestrained freedom and,

203
Moritz von Schwind
Hermit Leading Horses to
Water, c. 1850
Bayerische Staatsgemälde-
sammlungen, Munich
(Schack-Galerie)

by implication, also of the freedom of the artist. Reinhard Piper writes of the "intensification of the artist's feelings that issued in the intensified images of Romanticism""[40] For artists, the horse became "the bearer of *their* passions, of *their* stance toward the world."[41]

The fiery temper of the horse — its acknowledged sublimity did not exclude an irrepressible streak of the dangerously bestial — repeatedly became the subject for painters whose style was markedly colorist, and not least of a painter such as Théodore Géricault (1791—1824). Among the principal artistic successors of Géricault (who was himself to die in a riding accident) was the only slightly younger French Romantic painter Eugène Delacroix (1798—1863). In 1910 Franz Marc was to count these artists among the precursors of a type of painting that he saw as making possible an "*animalization* of art". Marc repeatedly engaged with their work. His design for the cover of Piper's *Das Tier in der Kunst* was a drawn adaptation of Delacroix's watercolor of 1825—28, *A Horse Shying at Lightning*,[42] in pen and brush with white ink on black paper (fig. 197). Marc worked from a black-and-white reproduction of the watercolor found in a sumptuous catalog of the Cheramy Collection published in 1908 by Julius Meier-Graefe and Erich Klossowski.

Piper wrote of the significance of Delacroix's horse as follows: "As in the case of Rubens, so, too, in that of this master of French Romanticism, the re-awakener of *color* in European painting, horses, lions, and tigers were vessels that he filled with his passion. His white horse frightened by a storm [...] might perhaps arouse misgivings among experts. Yet no one would deny the impact of this turbulent scene. It is truly an unleashing of the elements. And Delacroix has not travestied the animality of the beast: he has, rather, allowed it to achieve the most magnificent, the most triumphant expression. The distinctive organism of the animal is by no means compromised by the introduction of elements alien to it; rather [Delacroix] has allowed all of its brute force and all

of its splendor, otherwise dispersed or quiescent, to flare up like an explosion."[43]

In speaking here of the "animality of the beast",[44] Piper approaches Marc's own concept of *animalization*, but for Marc this was not a quality limited to animals. It extended, rather, to all of the natural world in as far as its "animation" might be conveyed in art. In the case of Delacroix the horse was not only exposed to the forces of nature; it also seemed to embody these. Marlene Baum has noted the role of the horse in Nordic mythology, where it is associated with storms, and indeed with lightning, because "its excentric movements mirror the jagged shape of a lightning bolt."[45] While animal bodies of such expressive outline as found in Delacroix's horse ultimately proved incompatible with Marc's approach (where empathy with nature existed alongside a system of color symbolism and a continuing process of abstraction), the two artists are nonetheless united in their common search for a means of translating the elemental power of nature into forms that might be conveyed in a painting.

In many other works by Delacroix, however, and in particular those pictures of an almost intimate character, the horse is reconciled with man as its inseparable counterpart. In the work of a German artist trained in the colorist tradition associated with Delacroix we again find the horse presented almost as if in dialog with man. In *Bedouins* (fig. 204), an oil sketch from the estate of one of the few German Orientalists, Otto von Faber du Faur (1828—1901), a native of Ludwigsburg, a dark brown horse seen in profile is placed parallel to the picture plane confronting the group of figures indicated in the title.[46] The men in white robes and a bare-chested negro servant direct their attention to the animal, and one of the group appears to hold it by the reins; yet the presentation of the horse's legs would prompt us to suppose that it seeks to resist being deprived of its freedom of movement. While the horse is the true protagonist of this

picture, even without a rider, the fact that it is already saddled reveals that it in fact serves as a mount. It preserves, then, only a faint echo of the elemental freedom, or the isolation, of Delacroix's horse frightened by lightning. Of particular importance, however, is the explicit relo-

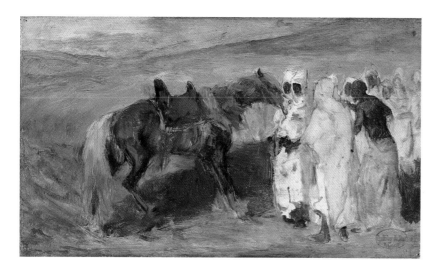

204
Otto von Faber du Faur
Bedouins, c. 1883
Staatsgalerie, Stuttgart

cation of the horse to the Orient — a world alien to the European viewer but simultaneously associated with origins.

The image of the riderless animal already equipped with a saddle recalls Gustave Courbet's *Bolting Horse* of 1861, now in the Neue Pinakothek in Munich.[47] This composition originally showed a very straight-backed *piqueur*, equipped with a French horn, mounted on the horse. Courbet, however, altered this arrangement: the rider disappeared and, with him, the suggestion of a hunting subject. The horse tearing through the forest at a ferocious pace has shaken itself free of its rider and by this means has gained in elemental power. It now moves of its own accord, even though it may give the impression of an animal observed in the process of enforced flight. The "eradication" of man undertaken by Courbet in his own work found in Marc's *Small Yellow Horses* (fig. 79) a rather more practically motivated modification: here Marc was reusing an old canvas and he painted his three animals over a composition with a reclining female nude. Evidence of this

process of replacing the human figure with the horse as the subject of a picture is also to be found in the case of the *Small Horse in Cool Pink* (fig. 119). Here the colored body of the horse is fragmentarily developed over a pre-existing drawing of a female figure (see the essay by Christian von Holst, p. 136).

Toward the end of the 19th century, and particularly in the following decades (those coinciding with Marc's brief career), the notion of the horse *with* a rider as an inseparable unit persisted above all in the context of religious and mythological subjects. The art produced in Munich around 1900 was profoundly influenced by this and other aspects of the work of the *Deutsch-Römer* [German Romans], artists such as Arnold Böcklin or Adolf von Hildebrand, by Symbolists such as Franz von Stuck, and especially by the scenes with horses and riders painted by the Idealist Hans von Marées.

Evident reference to the work of Marées (1837—87) in the case of one of Marc's Munich contemporaries is to be found in the large picture *The Amazons' Repose* (fig. 205), painted in 1913 by Albert Weisgerber (1878—1915).[48] In this multi-figural composition, in some respects recalling a baroque history painting, the combative unity of horse and woman that epitomizes the equestrian Amazons is exchanged for a scene of rest on the banks of a lake.[49] The naked female figures are seen bathing or sleeping in the sun. Alongside a nude of rather more androgynous character in the right foreground, a horse, shown in foreshortened rearview, surveys the lively scene. Here, woman and horse achieve a sibling communion. In the middle distance further Amazons arrive on horseback. The belligerent character associated with these mythological figures — rendered in compositions such as *The Battle of the Amazons* by Rubens in the Alte Pinakothek in Munich — is here largely eliminated by Weisgerber.

On occasion, one finds in Marc's work groups of horses accompanied, rather than mounted, by human figures, as in the case of two drawings of 1911 (figs. 69, 70). It is in these examples that the influence of Marées on Marc is most evident. Yet Marc was not in fact to pursue the idea of a timeless unity of animal and man imbued with an idealized reminiscence of classical antiquity. In this respect he differed from another contemporary, the briefly Munich-based Russian painter Vladimir Bekhteyev (Wladimir von Bechtejeff; 1878—1971), who is known to have painted not only a picture with mounted Amazons (1909)[50] but also a composition showing *Diana Hunting* (fig. 206).[51] Of artists in the circles in which Marc moved, Bekhteyev (whom Marc came to know as a fellow member of the *Neue Künstler Vereinigung München* [New Munich Artists' Union], and Eugen von Kahler were those who most frequently took horses as their subject.[52]

Influenced by his familiarity with French art, and in particular Cubism, Bekhteyev's picture shows the goddess of hunting and of the forest with her retinue, all of them on horseback. They are accompanied, as they hurtle between the trees, by three dogs. In some respects, the mounted figures — riding bareback and without reins — resemble Amazons, who (like centaurs) offer an especially emphatic image of the symbiosis of the animal and the human.[53] In Piper's book *Das Tier in der Kunst*, the celebrated *Amazons* made in 1895 by the sculptor Louis Tuaillon were placed at the conclusion of the chapter on the equestrian monument, as the last of a series of images, which also included the *Bamberg Rider* (c. 1230—40) and Andreas Schlüter's *Great Elector* (1696).[54]

In the case of his *Horse Tamer* (fig. 207),[55] Bekhteyev again combines a progressivist style with a figure from the mythology of classical antiquity, in this case Castor, one of the two Dioscuri.[56] The horse-tamer is shown engaged in almost balletic bodily interplay with the rearing horse. In Franz Marc's works, on the contrary, one never finds such emphatically mythical refer-

ences, even though, in a letter of 1915 to Maria Marc, he was to refer to one horse as a "Pegasus" (see essay by Christian von Holst, p. 183). Repeatedly, however, Marc signals a cosmic dimension to his images, as in the case of a preliminary version of *The Tower of Blue Horses* (fig. 110), in which the animals are emblazoned with star symbols. (On this point see also a sheet from a sketchbook now in Nuremberg, fig. 112).

Marc had already firmly committed himself to painting horses and other animals when, on two occasions in 1913 (working in woodcut, a technique he had first tried a year earlier), he turned to pre-existing images of horses and riders. His 18th- and 19th-century models could hardly have been more diverse. In one case he selected a motif from among the 22 engravings illustrating the *Neue Reit-Kunst* [New Art of Riding] (fig. 208), a volume compiled by Johannes Elias Ridinger (1698—1767);[57] in the other he turned, as he had in 1910, to an extremely frenzied image by Eugène Delacroix, in this case the *Lion Hunt* (fig. 151), originally a large work now preserved only in fragmentary form. A smaller, carefully executed oil study, now in Stockholm, may also have served

205
Albert Weisgerber
The Amazons' Repose,
c. 1913
Staatsgalerie, Stuttgart

206
Vladimir Bekhteyev
Diana Hunting, 1912
Staatsgalerie, Stuttgart

207
Vladimir Bekhteyev
The Horse Tamer, 1909
Lenbachhaus, Munich

as a model.[58] In both cases Marc eschewed the use of several colors, as found in his woodcut *Birth of the Horse* (fig. 153), and used black ink only.

In Marc's work of this time one can, indeed, speak of the arrival of a literal "mounted column" of riders, for example the image, in watercolor and gouache, inspired by a short story by Gustave Flaubert, *Saint Julien l'hospitalier* (fig. 142).[59] The anthropomorphizing of the animal, latent in Marc's repeated efforts to achieve an abstract empathy with horses and other beasts under the motto of an *animalization* of art, now frequently gave way to a revival of the notion of the union of steed and rider. This is to be found in the last drawings he made at the Front, in 1915 (figs. 167, 168), as in one of his last pre-war images, a watercolor showing his house in the village of Ried (fig. 11). And he had introduced himself in December 1912 in a postcard to Else Lasker-Schüler (fig. 9) as the "Blue Rider" who stands beside his blue mount and effectively merges with it.

Marc's woodcut after Ridinger (fig. 152) places the dramatically rendered horse and rider in a setting that in no way recalls that of a riding school. Even the original horseman's long riding crop has been transformed: here it resembles part of a vigorous linear pattern both reflecting and extending the circular forms found in the sky. In addition, the rider on the left half of Marc's sheet is accompanied by a horse without a saddle and reins that partially reiterates the positioning of the legs and body of the mounted horse. We only see the head and raised front leg of a third horse, at the extreme right of the sheet; it is unclear whether or not this is mounted.

The ground and the sky consist of busily alternating passages of light and shade organized into stripes and circles, imbuing the scene with a nervous excitement of which there is nothing in Ridinger's image. While the dog at the lower right turning to look back at his master (perhaps suggestive of a hunting scene), does not appear in the sheet that Marc took as his main model, dogs are to be found elsewhere in the Ridinger volume.[60]

The sheer turbulence of this composition focuses all attention on the rider, who in Ridinger's image is merely a background figure. Again in contrast to Marc's model, horse and rider seem to merge, largely as a result of the extreme vigor of their presentation. However, although Ridinger was an expert on *dressage* (the method of training horses to perform, on command, in a very precise and elaborate manner), Marc himself was not concerned with the artificial symbiosis of horse and rider at which this sort of training aimed.[61]

In Marc's woodcut *Lion Hunt, after Delacroix* (fig. 151), the bond between man and horse in battle forms a natural but no less dynamic unity. It is possible that the lightning bolt seen at the upper left is derived from the Delacroix watercolor that Marc reworked in 1910 (fig. 197). The lightning (a counterweight to the sun at the upper right) also signals the starting point of a diagonal running from upper left to lower right, which serves as the principal axis of the composition.

Without doubt, Marc's recognition of an affinity between the nature of the horse and the spiritual quality of his own art had by this time drawn his attention to a great many older images. These would have included the work of Hans Baldung Grien, whose *Fighting Stallions* of 1534 (fig. 209)[62] was among the reproductions included in the almanac *Der Blaue Reiter*. The image reproduced in the almanac came from the collection amassed by the publisher Reinhard Piper while researching and preparing his volume *Das Tier in der Kunst*, although in that publication Piper eventually illustrated another woodcut by Baldung Grien, in which the instincts of the horse was more drastically visualized.[63] Together with the sheet reproduced in the almanac and a third woodcut, this image belonged to the series *Wild Horses in the Forest*.[64]

In his book Piper sought to interpret the woodcut he illustrated. In his view, Baldung Grien's image was above all striking for its "large

208
Johann Balthasar Probst,
after Johann Elias Ridinger
Trotting (detail), from
Neue Reit-Kunst, 1722
Württembergische Landes-
bibliothek, Stuttgart

forms pulsating with life and its sense of the fantastical, as in a ballad. In this realm there is nothing for humanity. Nature — which remains ever alien to man, and mocks his smartness — speaks with a strongly passionate voice through these rampaging and rearing animals, which seem to emerge from and then withdraw back into the

experience, and how they see. In his *Ästhetik der Tierwelt* [Esthetics of the Animal Kingdom], published in 1908, Karl Möbius takes as his starting point the esthetic theory expounded by the Munich professor of philosophy Theodor Lipps (1851—1914): "What is the nature of our empathy with those animals whose beauty so fascinates us? Our empathy with a magnificent lion; with a hot-tempered horse; with the eagle that we see hovering above us [...]?

In responding to [such] animals esthetically, we transfer [into them] our own feelings of rest and movement, our sensations of the pressure of firmer and softer materials, of textures that are smooth or rough, of wet and dry, of warm and cold, of brightness, darkness and colorfulness; but we imagine these feelings and the emotions and spiritual states arising from them as both altered and weaker in the animals, according to their own [physical and psychic] organization. [...] Through empathizing so variously with the countless forms of animal life our enjoyment of nature is wonderfully enriched."[66]

209
Hans Baldung Grien
Fighting Stallions, 1534
Metropolitan Museum of
Art, New York

thick forest."[65] Although Piper focuses here on pure animality as the expression of the irrational, even demonic, dimension of nature embodied in these horses, his response to this woodcut must have been close, at least in part, to the thinking and feeling of Franz Marc. At the same time, it has to be admitted, Marc could hardly have found the surging passion exuded by Baldung Grien's horses compatible with the posited purity of animals that he took as the starting point for a new, pure art. Creatures such as those seen in his *Sleeping Animals* (fig. 140) necessarily came closer to this ideal.

The character of Reinhard Piper's account of Baldung Grien's image offers a hint at why the title of this essay includes a question mark: "A Horse *without* a Rider?" Those who observe animals — whether in nature or in a work of art — always project on to these subjects a particular pre-established notion of how they feel, how they

On September 9th 1913 Franz Marc sent to Paul Walden, the son of the poet Else Lasker-Schüler, then living in the Hellerau district of Dresden, a postcard painted with a scene taken from the life of the American (or Native) Indians, known outside America at this time as Red Indians (fig. 210).[67] Although perhaps not especially suitable for a boy who was already 14, this was a motif clearly appropriate for a child. The postcard image shows three horses (pale brown, very dark gray, and blue in coloring) in a hilly landscape. No human figures are visible, and it is debatable whether the triangular forms at the upper right are to be interpreted as wigwams. (Elsewhere Marc uses precisely such forms as schematic representations of haystacks or mountains, figs. 46, 144). One thing, however, is clear: these animals are intended for riding, and this despite the fact that they are shown without saddles and bridles — this, after all, is also the case in Bekhteyev's *Diana Hunting* (fig. 206) and Weisgerber's *The Amazons' Repose* (fig. 205). In

1911 August Macke painted two American Indi-
ans on horseback, and he too showed the horses
without saddles and bridles.[68]

In Germany around 1900 the American
Indian was an extremely well-loved figure in pop-
ular literature. 1912 brought the death, at the age
of 70, in Radebeul, of Karl May, author of the tales
of Winnetou (a Native American) and his white
friend Old Shatterhand.[69] In May's many adven-
ture stories, set not only in the Wild West but also
in the wilds of Kurdistan, the plot almost always
turns on the horse as the hero's true and valiant
companion. A particular attraction for German
readers of Karl May (and there is a parallel here
with those who liked the paintings of an Oriental-
ist such as Faber du Faur, fig. 204) lay in the fact
that the adventures recounted took place in a
world quite unlike their own, a world untouched
by industrialization. In such a world the horse
assumed the role of the *natural* means of locomo-
tion; and it was not a machine, but — like man
himself — a living creature.

In 1913 Franz Kafka produced a text consist-
ing of only one sentence. As indicated by its title,
it concerned the *The Wish to Become a Red Indian*:

"If one were only a Red Indian, instantly alert, and
on a racing horse, leaning against the wind, kept
on quivering jerkily over the quivering ground,
until one shed one's spurs, for there needed no
spurs, threw away the reins, for there needed no
reins, and hardly saw that the land before one was
smoothly shorn heath when horse's neck and
horse's head would be already gone."[70] This para-
ble clearly reveals that the desire to be a American
Indian, closely bound up with the notion of riding,
had turned out to be literally untenable. The dream
of the natural union between man and horse as a
metaphor of freedom vanished into thin air.

Marc, however, was able in his art to formu-
late this dream in ever new ways and to capture it
in images. Even when he painted horses without
riders, they were still horses that belonged to the
"Blue Rider" (fig. 9). They stand as an impressive
testimony to Marc's striving for an *animalization*
of art, understood as the representation of nature
imbued with spirituality. Marc's project coincides
with the vision and the ambition implied in a
statement by August Macke in the almanac *Der
Blaue Reiter*: "To look at plants and animals is to
sense their mystery."[71]

210
Red Indians' Horses, 1913
Bayerische Staatsgemälde-
sammlungen, Munich

Notes

1 Piper 1947, pp. 428 ff.

2 Two illustrations show sculptures by Antoine-Louis Bayre (1796—1875); four illustrations show bronze sculptures by August Gaul (1869—1921). Piper 1910, figs. 120—125.

3 Piper 1910, p. 189, figs. 126 ff.

4 Piper 1910, p. 190.

5 Piper 1910, p. 190. The italics in the quotation are Piper's.

6 On the reproductions included in the almanac *Der Blaue Reiter*, see Thürlemann 1986, pp. 210 ff.; and Wyss 1996, pp. 133 ff.

7 Even in the 1860s Edgar Degas, for example, was making copies after older images of horses as part of his training. See exh. cat. Washington 1998, pp. 16 ff., cats. 1—5 and figs. 1, 2, 7—10, 20 for the copies (mostly in drawn form) after the Parthenon frieze, Anthony van Dyck, Paolo Uccello, Benozzo Gozzoli, Théodore Géricault, and Eugène Delacroix.

8 Nuremberg, Germanisches Nationalmuseum, inv. no. Hz 6377, sketchbook XXII, fol. 7 (1911): 13.2 x 20.3 cm (page, used horizontally), 12.8 x 18.6 cm (image).

9 See exh. cat. Washington 1998, e.g. nos. 27, 56, 80.

10 Novalis 1995, p. 94.

11 Swift 1986, p. 243; on this point, see Baum 1991, pp. 233 ff.

12 Exh. cat. Munich 1988, p. 241.

13 Marc discusses Tolstoy's publication of 1895, *What is Art?* in a letter to Maria Marc of April 18th 1915, cited in Meissner 1989, pp. 143 ff.

14 Tolstoy 1933, p. 405. On Marc's drawing (Lankheit 1970: 632): graphite on paper, 13 x 20 cm, from sketchbook XXXI, signed at the lower left: "Der Leinwandmesser (Tolstoi)" [The Canvas Measure (Tolstoi)], Franz Marc Museum, Kochel am See, see Hüneke 1993, pp. 110 ff., fig. 5.

15 *Two Horses and a Plow*, etching on paper, 15.7 x 18.7 cm (sheet), 15.2 x 18.2 cm (plate); inv. no. A 11203. Illustrated Bartsch 1978, no. 25—I (179).

16 *Neighing Horse* (copy), etching, 15.6 x 22.9 cm (sheet), 15.5 x 22.8 cm (plate); inv. no. A 00/7045 (KK). See Illustrated Bartsch 1978, no. 10—II (49).

17 See Piper 1910, fig. 80, for the etching *Cow and Sheep*.

18 Piper 1910, p. 119.

19 On the inevitably anthropomorphic manner in which artists have seen and represented animals, see Artinger 1995, pp. 35 ff.

20 For an overview of the concept of *Einfühlung*, see Düchting 1991, pp. 60, 62. On *Einfühlung* and Expressionist poetry and in the work of Franz Marc, see Cosentino 1977, pp. 109 ff.

21 Piper 1910, p. 190.

22 Piper 1910, p. 6.

23 Möbius 1908, p. 13.

24 On the particular psychic and physical relation between human beings and horses, see Baum 1991, pp. 88 ff.

25 See exh. cat., Frankfurt 1999, no. 39 ff. Eadweard Muybridge was the first, in 1887, to achieve a photographic record of the exact sequence of the movements made by the horse when walking, trotting, galloping, etc.; see Schumacher 1994, p. 180.

26 Piper 1910, p. 150.

27 On the evolution of horse painting out of battle painting, see Artinger 1995, pp. 17 ff.

28 On the low status of animal painting in the 18th and 19th centuries, see Artinger 1995, pp. 31 ff.

29 See Bauer 1998, p. 33, fig. 24 (photograph dated 1896). It was only in 1891 that a class in animal painting was established at the Academy of Art in Munich, with Zügel as professor from 1895; see Artinger 1995, p. 18.

30 Piper 1910, pp. 190 ff.

31 Piper 1947, p. 430. On Reinhard Piper and the almanac *Der Blaue Reiter*, see Meier 1986, pp. 227 ff.

32 The horse seen in the studio of Albrecht Adam (fig. 201) was an Arab stallion, a gift from the Egyptian Viceroy to Duke Maximilian of Leuchtenberg; see exh. cat. Munich 1981, p. 203, no. 158.

33 Wichmann 1970, p. 419, no. 1219.

34 On the history of the equestrian monument, see exh. cat. Bremen 1991, pp. 8 ff. An example of the *embourgeoisement* of the equestrian monument as a motif during the 19th century is to be found in Franz Krüger's small painting showing *Prince Wilhelm Riding, Accompanied by the Artist* (1836). This picture is reproduced in Piper 1910, fig. 106.

35 Oil on oak panel, 46.7 x 38.5 cm; see Ruhmer 1969, pp. 351 ff., inv. no. 11578. Count Schack remarked of this picture: "A hermit leads to water the horses of a rider who has spent the night in his cave. Here the wild rocky landscape is of great painterly beauty."

36 On this picture, see Heilmann 1988, p. 43: "The setting, enclosed by a precipitous rockface, transforms the depicted event into an allegory of animal nobility: the hermit, who leads the horses to drink from a clear mountain stream and stands between them, deep in thought, seems to endow these beautiful beasts with a soul."

37 Berger 1980, p. 15.

38 August Macke, "Die Masken", in Kandinsky/Marc 1912, p. 22.

39 "[...] our Germans easily look old-fashioned, but the spiritual quality of these masters is compelling even alongside the most modern French [artists]. True art is always good." In: Franz Marc, "Deutsche und französische Kunst" (1911), cited in Meissner 1989, p. 223.

40 Piper 1910, p. 150.

41 Piper 1910, p. 150.

42 Schumacher 1994, fig. on p. 200: 23.5 x 32 cm, Budapest, Szépművészeti Múzeum. On Marc's design for the cover (24 x 16 cm, Lankheit 1970: 838), see exh. cat. Berne 1986, no. 93.

43 Piper 1910, p. 150.

44 On the engraving of the *Large Horse* (1505) by Albrecht Dürer, see Piper 1910, p. 87: "The scrap of spirit that he has squeezed into this huge body, is certainly not enough to enliven it. One has the feeling that the old nag has been standing on the same spot for hours. The sullen passivity of this animal is superbly brought out here."

45 Baum 1991, p. 47; here too on the mythological significance of the horse associated with thunderstorms.

46 This work may well be a *bozzetto* for the painting *Horses Returning Home;* see Engels-München 1902, illustration on p. 68. Faber du Faur travelled to Tangier in 1883. This former cavalry officer, a student of Piloty from 1870 to 1873, later mainly painted Orientalist subjects.

47 Eschenburg 1984, pp. 75 ff., inv. no. 8651, with illus.

48 Ludwig 1989, p. 76, fig. 22. In 1913 Weisgerber was president of the *Neue Münchner Sezession* [New Munich Secession].

49 On the subject of the Amazons, see Baum 1991, pp. 66 ff., 72; see also Grant/Hazel 1992, p. 40. On the Amazons in art around 1900, see Ludwig 1989, pp. 74 ff.

50 Exh. cat. Munich 1999, illustration on p. 25 (Bayerische Staatsgemäldesammlungen, Munich).

51 Exh. cat. Munich 1999, fig. 116, no. 183 (oil on canvas, 89 x 108 cm).

52 For an example of the horse and rider in the work of Kahler, see the colored drawing *Rider (At the Circus),* c 1910/11, in exh. cat. Munich 1999, fig. 109, no. 174.

53 On centaurs, see Baum 1991, pp. 69 ff., 128 ff.: "Images of centaurs offer a way [...] of treating the relationship between man and beast as a paradisaical state. The archaic identity of Ego and Id or of intellect and feeling is of great expressive power precisely because a separation of the two components here seems impossible. Many depictions of riders, in which man and beast appear to be in a state of inner harmony, testify to this."

54 Schumacher 1994, illustration on p. 240 (Staatliche Museen zu Berlin); see Piper 1910, p. 105, fig. 68.

55 Exh. cat. Munich 1999, fig. 135, no. 209 (oil on canvas, 110 x 94 cm; private collection, on long-term loan to the Gabriele Münter und Johannes Eicher-Stiftung, Munich).

56 On the Dioscuri in general, see Grant/Hazel 1992, pp. 236 ff.

57 Ridinger 1722, sheet 3, "Das Trottieren/Le Trot." 23.3 x 35.6 cm (plate).

58 See Daguerre de Hureaux 1993, fig. on p. 204, top: *Chasse au lion*, 1855, 56.5 x 73.5 cm (Stockholm, Nationalmuseum), and Daguerre de Hureaux 1993, fig. on p. 204, bottom: *Chasse au lion (fragment)*, 1855, 175 x 359 cm (Musée des Beaux-Arts, Bordeaux).

59 On the motif of the Christian rider — for example, Saint George — and its heightened spiritual significance for Marc around the time of the work of the

almanac *Der Blaue Reiter*, see Schuster 1993—94, pp. 183 ff., figs. 29—33.

60 See the dogs that appear on sheets 5, 18, and 22 in Ridinger 1722.

61 Wrangel 1927, vol. 1, p. 782: "[...] among the most artful are the types of gait taught in the Upper School [...] such as the *pirasse* and the *passage* [which have] evolved from the natural types of forward movement [walk, trot, gallop], and are their highest development. [Then there is the] so-called artificial leaping, as in the *capriole* [...] and the *ballotade*."

62 Woodcut, 23 x 34.4 cm, New York, Metropolitan Museum of Art; Harris Brisbane Dick Fund, 1933; see Kandinsky/Marc 1912, after p. 44; exh. cat. Berne 1986, no. 129.

63 Piper 1910, p. 93, fig. 60.

64 Exh. cat. Washington 1981, pp. 264 ff., nos. 83—85. See also Baum 1991, pp. 112 ff., figs. 31—33.

65 Piper 1910, p. 92. On the aroused stallion rejected by the mare, it is claimed: "The behavior of the animal in the foreground, though trivial in itself, is here imbued with an air of grotesque demonic possession".

66 Möbius 1908, p. 10. Theodor Lipps's concept of esthetic empathy was derived from the philosophy of art evolved by Friedrich Theodor von Vischer (1807—87), who taught in Stuttgart from 1866 to 1877; see Möbius 1908, pp. 9 ff. In 1908 Wilhelm Worringer also made use of this concept: in his doctoral dissertation, published by Reinhard Piper two years later as *Abstraktion und Einfühlung*, he engages critically with esthetic empathy as a principle of artistic creation. Worringer reiterates the essence of Lipps's theory: ("Esthetic pleasure is objectified pleasure in oneself"): "To enjoy something esthetically means to enjoy my own response embodied in an object that is sensually distinct from me, to empathize with it". (Worringer 1910, p. 17).

67 Schuster 1987, p. 155, no. 21: Pen and brush with ink, watercolor, and gouache on card, 14.2 x 8.9 cm, inscribed at the lower right: Indianerpferde [Red Indians' Horses]; Bayerische Staatsgemäldesammlungen, Munich, Gift of Sofie and Emanuel Fohn. Lankheit 1970: 783.

68 Exh. cat. Munich 1999, fig. 186, no. 273: *Red Indians on Horses*, oil on wood, 44 x 60 cm; Munich, Städtische Galerie im Lenbachhaus, Munich.

69 The four volumes of *Winnetou* stories were published between 1893 and 1910. *Old Shatterhand* appeared in three volumes between 1894 and 1896.

70 Franz Kafka, "Wunsch, Indianer zu werden", first published in 1908, reprinted in Franz Kafka, *Betrachtung* (Leipzig 1913); cited here in the English translation by Willa and Edwin Muir in Kafka 1983, p. 390.

71 August Macke, "Die Masken", in Kandinsky/Marc 1912, p. 22.

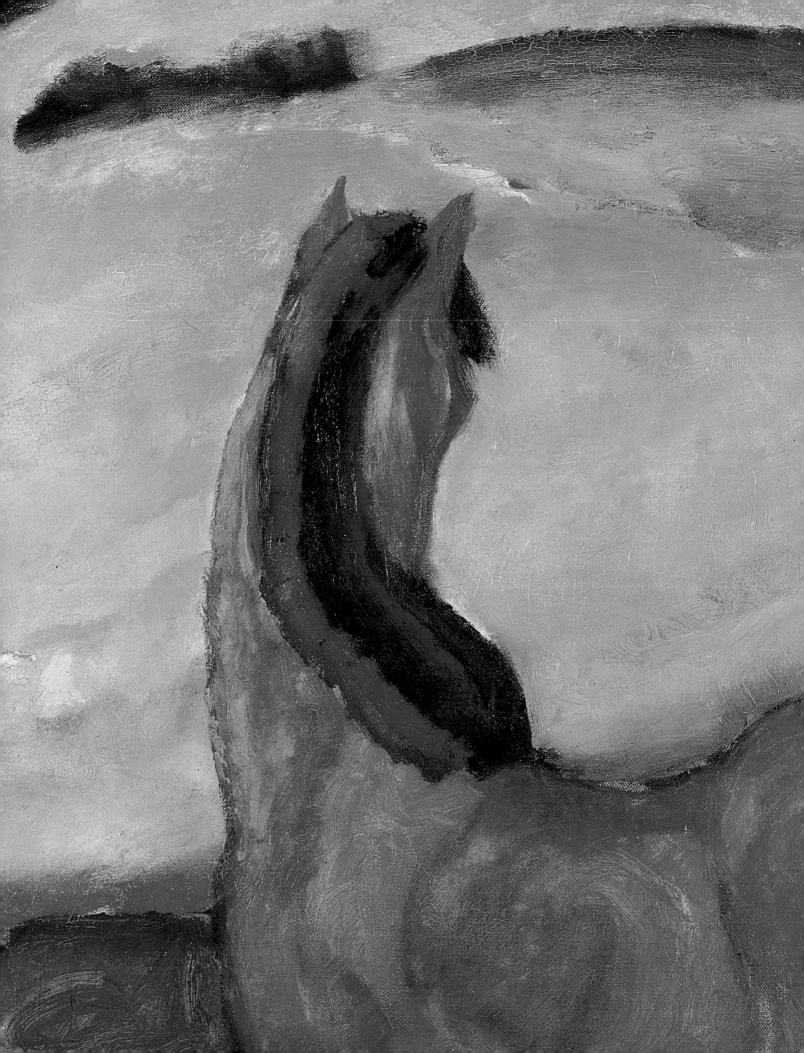

The Horse as a Living Creature

Franz Marc's Horses in the Eyes of a Behavioral Scientist

KLAUS ZEEB

Among Franz Marc's notes from 1911—12 we find these fascinating comments: "For artists, is there a more mysterious notion than that of how the landscape appears through the eyes of an animal? How does a horse, or an eagle, or a deer, or a dog see the world? How miserably soulless is our convention of placing animals in the landscape as *we* perceive it, rather than seeking to penetrate the soul of the animal so as to glean something of its own world of images [...]

What has a deer got to do with the image of the world as we see it? Is there any logical or even artistic reason at all for painting the deer as it appears to our retina or in a cubistic form because we feel the world to be so? Who is to say that the deer feels the world to be Cubist; its sense of the world is a *deer's* sense, the landscape must, then, be as the *deer* would perceive it [...].[1]

The aim of this essay is to consider Franz Marc's rendering of horses from the point of view of the behavioral scientist, in other words to think about how a horse *sees* the world, and moreover how it *experiences* the world. For experience is much more than a mere reaction to what is registered by

the retina. Experience has to be understood and described as a process taking place within the consciousness of the individual creature. Occurrences in the immediate environment are digested (that is to say, experienced) by the individual on the psychic level and, where necessary, met with the appropriate behavioral response.

Nowadays, many people might be inclined to question the assumption that animals have a consciousness. On this point, Volker Arzt, a journalist reporting on scientific developments, has commented as follows: "[...] There are now so many new approaches to research into the intellectual and psychic capacities of animals that we have attempted to summarize these in the form of a continuous conceptual thread even though this remains in need of reinforcing in some places [...].[2]

In the comments that follow I shall attempt to convey what a behavioral scientist might be able to glean from Marc's pictures with regard to the behavior and experience of the horses found there. There are in fact interesting parallels to be drawn between the situation of the behavioral scientist and the artist, for both find themselves confronted with rather similar difficulties. According to the

page 256
211
Horse in the Landscape,
1910
Detail from fig. 60

art historian Mark Rosenthal, "[Marc] wanted to penetrate appearance and depict an inner reality which in nature was epitomized by a rhythmic organization of phenomena [...] By 1913 a more complete fusion of animal with landscape is achieved. The sense of an inchoate environment demonstrates both Marc's feeling for the world as a whole and his developing urge to represent Creation [...].[3]

These remarks prompt the behavioral scientist to introduce the concept of evolution. For the principle of evolution is the preservation of balance in nature, a principle that we may also assume to have informed the process of art as understood by Marc. In this context, however, it would perhaps be better to employ the concept of "harmony". We are not here concerned with the debate between Creationists and Evolutionists.

THE HORSE FROM THE POINT OF VIEW OF BIOLOGY

Returning to Marc's question — "How does a horse [...] see the world?" — it is necessary to begin by considering the anatomical and physiological preconditions for this "seeing". As already indicated, it will be useful in this context to survey briefly the evolution of the horse or, rather, of the species to which it belongs.

Specialists on this matter agree that the horse only gradually evolved into an inhabitant of the savannah and the steppe. The eohippus, in existence around 70 million years ago, was the size of a fox, but by around 5000 years ago it had developed into an animal with a height of between 1.40 and 1.50 meters. It was at around this time that man ceased to regard the horse as merely yet another source of food, and recognized that it might be put to good use as a mount and to pull heavy loads on account of its speed and its strength. The currently prevailing theory is that

the domestication of the horse began in two distinct regions: in the steppes of the southern Ukraine, and in what is today Kazahkstan.

The evolution of any given species signifies, among other things, a process of adapting to an environment with regard to a number of factors: its value as a source of food and water, the prevailing weather conditions, and the number and nature of rivals for the resources available. It involves both physical changes and the development of behavioral strategies, in both cases in the interests of survival. By around 5000 years ago the five-toed feet of the eohippus had evolved into single-hoofed toes. Supported on these, the horse was capable of especially sustained walking — migrating over vast distances in the search for food and water — and equally of swift flight from predators, in particular wolves. This last was only possible because the development of the organs of breathing and circulation had been such that these were able to provide the muscles with sufficient oxygen during periods of great exertion.

The horse is, then, equipped with very good qualifications for powerful, sustained, and rapid movements. For these to function well, they must be trained accordingly. Training in fact gets underway when foals are still very young, in the form of repeated games involving leaping and fighting (figs. 226, 227). Only a few days after they are born, foals begin to band together for the purposes of play. This also, of course, assists the process of socialization.

The most important factor in enemy avoidance is the availability of early-warning systems: sense organs that enable an animal to see, hear, or smell potential danger from some distance. The horse is much better equipped than human beings in all three respects. Nonetheless, such early-warning systems are not in themselves enough to guarantee the safety of the individual animal. This requires special strategies. In the case of horses, family groupings give rise to larger social group-

ings. When a herd of horses is resting at least one will stand guard, usually the mother of the youngest foal. Foals, being most at risk from enemies, rest at the center of the group.

Life within a social group must be well-organized if those lower in rank are not to be worse off than those higher in rank. Horses are exceptionally well-equipped for the control of social interaction, with possibilities for expression located throughout the body, albeit primarily in the head and the tail. There are three categories of expressive behavior: one ensures mutual avoidance (to spare lower-ranked animals), another facilitates contact, and a third signals readiness for, or acceptance of, social interaction, for example for the purposes of mutual grooming or for mating.[4] We shall presently return to these points in more detail in connection with Marc's images.

Almost nothing is known of the capacity of horses to hear and to smell, except that it is evident that this is far superior to that of human beings, as demonstrated by the ability to scent water sources at a distance of several kilometers. We possess much more information with regard to vision. In contrast to human eyes, those of horses have horizontally aligned oval pupils. This offers the advantage of a wide angle of vision and a sharp perception of vertical structures, but the disadvantage that horizontal structures are perceived unclearly. It is for this reason that horses tend to shake their heads up and down when unsettled by a particular object; this enables them to establish a clearer visual image of their surroundings. As a result of the positioning of a horse's eyes to either side of its head and its horizontal and oval pupils, it enjoys almost panoramic vision, whether standing or grazing. It is, however, unable to see its own hindquarters.

Within the horse's field of vision, the images registered by both eyes may be mentally combined to produce three-dimensional objects: this would be

the case with all that falls within an angle of approximately 65 degrees. Whatever lies outside this angle will be visible to only one eye and will thus appear two-dimensional. Nonetheless, even the smallest movements are detectable in this region — a particular advantage in the effort to avoid enemies. These optical conditions also explain why horses may suddenly shy: a moving object

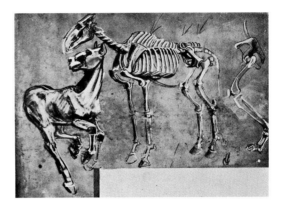

212
Anatomical Studies of Horses, 1907/08
Destroyed

cannot be clearly identified and the response of the horse is swiftly to put itself at a safe distance, from which it can assess the danger by sight, hearing, or smell and decide how to respond.

A final remark concerning the anatomy of the horse, and one that may be illustrated with an explanatory drawing made in 1907/08 by Marc (fig. 212). Especially clearly visible in the study of the horse skeleton is the difference in height between the spinal processes found toward the front and toward the rear of the vertebral column. These form a bridge between the fore- and hindquarters. In the study, Marc has added arrows pointing at the back of the horse and a line indicating the curve of the belly. These were perhaps intended to draw attention to the fact that horses are able to stand without using any muscle power, because the interplay of the skeleton and the tendons of the back and the belly makes for a self-supporting structure.

The ability to stand without expending energy is also of considerable significance for

feeding. Horses devote as much as 16 hours a day to the search for food, and ripping out grass with the front teeth is in itself strenuous. In this respect it is a great advantage that energy need not be wasted on standing.

In terms of the biology of the horse, one would answer as follows Marc's question as to how a horse sees — and experiences — the world: It sees the world, that is to say its immediate envi-

large number of animals capable of taking turns to stand guard. For the horse, the herd means security. Finally, the world is experienced in large part as a potential source of food. As mentioned earlier, in natural conditions a horse may spend up to two-thirds of any twenty-four-hour period engaged in feeding and, where necessary, in the search for food.

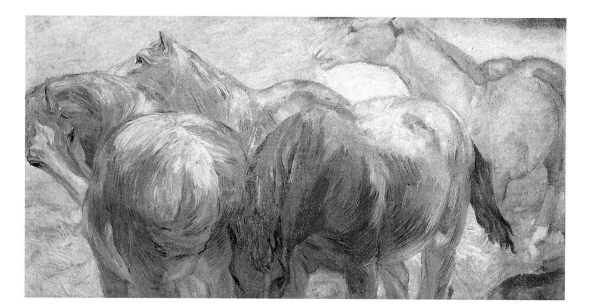

ronment, extending almost in every direction around itself without having to turn its head. This virtually complete panoramic view only provides a sharp image in the area (around a fifth of the total) that lies at the center of the horse's gaze. Of objects and occurrences in the remaining four-fifths, to the sides and the rear, the horse is nonetheless able to perceive movements, even the slightest movements. Before it was domesticated, the horse living in the wild would, for example, have been alert to the presence of a prowling wolf. Nowadays, it would be the small splinter of glass on the ground glinting suddenly in the sunlight that might make a horse shy and tear away if its rider is inattentive. The horse, then, may be said to experience the world as an animal that must always be on guard and must always be prepared to flee. Life in a herd offers the advantage of a

THE POINT OF VIEW OF THE BEHAVIORAL SCIENTIST

Behavioral scientists and art historians employ quite different methods in describing the objects and circumstances that concern them. In the present context, our consideration of Marc's images of horses will not, therefore, be approached chronologically but, rather, according to the functional cycle of behavior illustrated in each case.

What, then, is a functional cycle? The behavior of living creatures ultimately serves to promote the preservation of the individual and the propagation of the species. In the interests of self-preservation, the individual must engage with its environment through the application of various sorts of behavior. Specific types of behavior adopted in response to specific stimuli origi-

nating in the environment also each function in a specific way that contributes toward the preservation of the individual. For example: the grass growing on the pasture has a particular appearance (optical stimulus) and a particular smell (olfactory stimulus). These stimuli and the feeling of hunger arising in the central nervous system in response to them prompts the horse to start eating. For the horse as an organism, the function of feeding is to foster self-preservation through the intake of nutrients. This series of interconnections is termed a functional cycle. Behaviorial scientists categorize the behavioral patterns of animals in terms of numerous functional cycles — those, for example, encompassing behavior relating to nutrition, excretion, resting, and comfort.[5] However, in describing the behavior of living creatures, it is never possible to think entirely in terms of categories that are absolutely separate. Functional cycles also to some extent overlap. This is especially the case with those relating in some way to social behavior; and, because a horse does virtually everything while functioning as an integral part of a group, some sort of social behavior is almost always to be observed.

THE BEHAVIOR OF HORSES IN PAIRS AND IN GROUPS

The behavior of horses in pairs and in groups embraces several functional cycles that are distinctive of this animal: grazing, calm standing, and social engagement. All of these are exemplarily depicted in Marc's painting of 1908 *Large Picture of Horses at Lenggries I* (fig. 213). This shows four animals. The first of these, in the left foreground, turns back to attend to its coat; the second horse, behind the first, has raised its head; the third has its head bent toward the ground; and the horse at the right is throwing its head back. How would the behavioral scientist interpret this scene?

The horse in the left foreground is preoccupied in cleaning itself. The animal behind it, as seen by its raised head and the positioning of ears, eyes, and nostrils, has its attention focused on the distance. Behavioral scientists term this the "attentive posture" (see also fig. 225). This horse is standing guard, making sure that no potential danger is overlooked. We must presume that the second horse in the foreground is engaged in grazing. The one on the right is either being aggressively rejected by the others or is making an aggressive attempt to approach the group: this is signaled by the tightened nostrils, the

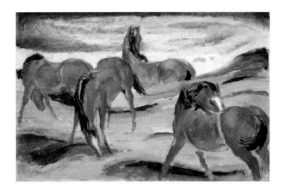

214
Grazing Horses III, 1910
Private collection

mouth with its corners pulled back, the fearful, wide-open eyes, and the drawn-back ears. In sum, one can say that this painting captures a characteristic moment in the day of a herd of horses. On further inspection, one also notes the tension in the bodies of the two animals in the background in contrast to the relaxed attitude of the foreground pair.

A peculiarity of Marc's rendering of horses is the pose used here for the animal on the left, also seen, for example, in a picture of 1910, *Grazing Horses III* (fig. 214), and in the left-hand figure in a sketch of 1908 (fig. 215). Here, however, Marc departs to some degree from the exact rendering of what he would have observed.

HOW HORSES INTERACT

In the sketch of 1908 (fig. 215), which we may consider as preparatory for the *Large Picture of*

Horses at Lenggries (fig. 213), the raised head of the horse at the right indicates that this animal is being threatened by the horse in the center background. It is throwing its head up and producing the equine equivalent of a pout: it turns its upper lip inside out and pushes it forward and down so that it resembles a snout.

I would interpret the situation depicted in *Two Standing Horses with a Bush* (fig. 217) as follows: the proudly upright horse on the right is threatening the other as is indicated by its pricked ears. The second animal is seen turning away, a gesture that may here be understood as a form of counterthreat.

The *Large Landscape I* of 1909 (fig. 216) shows a group of horses integrated into a particular setting. The behavior of these animals corresponds to that found in the earlier sketch (fig. 215). As animals originating on the steppe, horses feel the need for an uninterrupted view of the land around them and as much breeze as possible. Both are evidently available to the *Horses on a Hilltop*

recorded by Marc in 1906 (fig. 218). As Marc has very accurately observed, horses in such a situation may be found standing relatively far apart.

For a behavioral scientist, the full title of the picture of 1911 *The Red Horses (Grazing Horses IV)* (fig. 219) is unconvincing in as far as much more movement is depicted than would in reality occur while grazing is taking place. The horse on the left appears to have just galloped up to the group and yet immediately turns away from the horse to the right in a somewhat threatening manner. This horse has pulled its ears back and threatens the new arrival with its lowered head and the expression of its right eye. The horse in the background appears to be aroused by this ill-tempered exchange, but throws its head back and directs its gaze into the distance. It is possible that Marc may have wanted to convey the belligerence prevading the scene — for which a more fitting title would be "Fighting Horses" — through his striking use of red for the bodies of the animals.

215
Group of Horses, 1908
Private collection

216
Large Landscape I, 1909
Private collection

217
Two Standing Horses with a Bush, 1908
Germanisches National-museum, Nuremberg

218
Horses on a Hilltop, 1906
Private collection, on loan to the Franz Marc Museum, Kochel am See

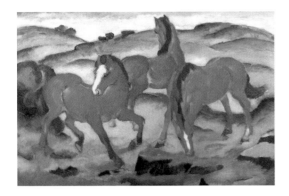

219
The Red Horses, 1911
Private collection,
anonymous loan to the
Busch-Reisinger Museum,
Cambridge, Mass. 21. 1991

220
Horses Running on Pasture,
1910
Germanisches National-
museum, Nuremberg

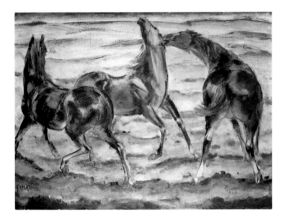

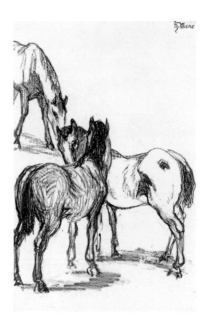

221
Fighting Horses, 1910
Destroyed; formerly in the
Heise Collection, Hamburg

222
Three Horses, 1908
Staatliche Graphische
Sammlung, Munich

Fighting is more explicitly the subject of a picture from the previous year (fig. 221). Here the horse on the right with tightly pulled back ears seeks to bite the centrally positioned animal in the neck. The latter also displays ears threateningly pricked. The horse on the left seems to be engaged in circling the fighting pair, its own pricked ears testifying to its agitation.

In the drawing of 1910 *Horses Running on Pasture* (fig. 220) we find an example of social interaction and, apparently, confrontation between two horses who are seen in rapid motion (the position of their tails is clearly indicative of this state). The heads of the horses in the foreground are turned

slightly toward each other — incidentally also illustrating the large angle of vision available to a horse. We may perhaps conclude that the only sketchily indicated horse in the background is also moving at a rapid pace. Its left ear, in addition, indicates a state of great alertness.

A scene dating from 1908, by contrast, exudes an air of peace (fig. 222). The two horses in the foreground are engaged in "social grooming", that is to say they are nibbling at each others' coat, an activity only to be observed among animals that are very familiar with each other, and which also serves to further cement such bonds. The position of the ears of these horses, is, however, not cor-

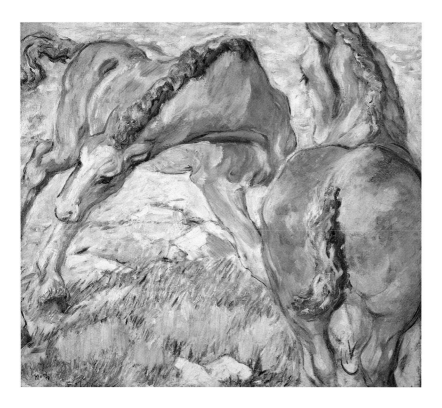

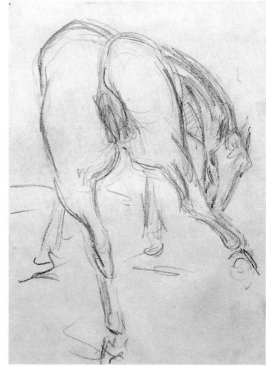

223
Mare with Foal, 1909
Private collection

224
Study of a Horse, c. 1910
Private collection
Cat. 18 verso

rectly rendered: during sessions of "social groom-ing", the ears are almost continously turned to the side, that is to say placed in a neutral position. The apparently relaxed horse seen in the background devotes itself to grazing.

The horse found in a later drawing (fig. 224) is attending to its own coat, specifically to the skin of its right leg. Both social and solitary forms of grooming belong to the functional cycle of behav-ior relating to comfort.

YOUNG HORSES

Marc's images of horses also provide plentiful evi-dence of behavior relating to the propagation of the species. The painting of 1909 *Mare and Foal* (fig. 223) appears to show a young horse that is perhaps already a yearling: it struggles to reach its back leg with its head in order to groom itself using its lips and teeth. The vehemence of its as

yet imperfectly controlled movements is under-lined by its arched tail. The mare, meanwhile, watches the efforts of her offspring with an expression of maternal interest and care.

In a study of 1910 (fig. 225) Marc has very accurately, but at the same time very artfully, cap-tured a characteristic expression of the alert curiosity of a young horse. It is shown with raised head, ears directed forward, widened nostrils, and eyes alertly open as it advances; its body is tensed and ready to gallop away immediately, should the need arise. It is hard to imagine how the "attentive posture" of a young and inquisitive horse might better have been conveyed.

As observed earlier, vigorous movement (run-ning and leaping) is of particular importance for the development of the skeleton, the tendons, and the ligaments of the horse as an animal that spends the greater part of its time, standing, walk-ing, or running. As we have also noted, foals are to be found practicing such movement in the form of games when they are only a few days old. In

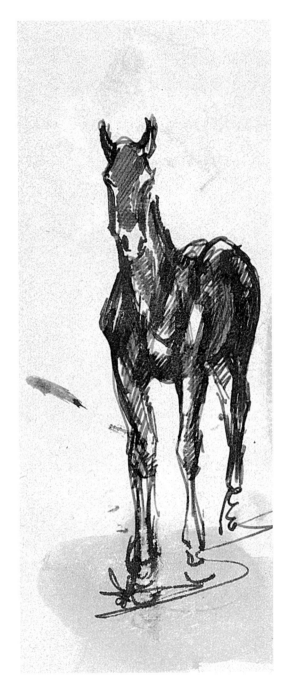

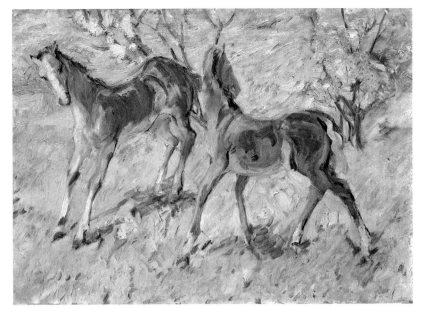

225
Study of a Foal, 1910
Detail of fig. 52

226
Foals at Pasture, 1909
Private collection

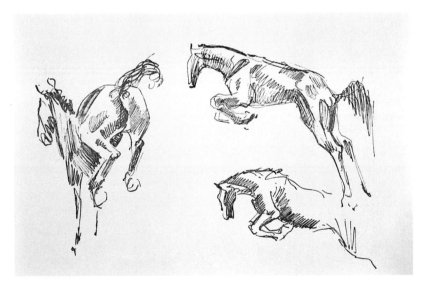

the painting of 1909 *Foals at Pasture* (fig. 226) Marc depicts two foals at play. The animal on the left, seemingly just completing a leap, turns its head toward the other as if inviting it to play. It is, however, not clear why the foal on the right is shown turning its head away (perhaps this is a case of artistic licence?).

The *Studies of Leaping Horses* of 1910 (fig. 227) testify to Marc's close observation of animal movement: at the upper right we find a horse in the first phase of the leaping motion, at the lower right the position adopted during the central phase (the "flight"), and at the left a horse landing on its front legs.

227
Studies of Leaping Horses
Untraced

228
Horse in the Landscape,
1910
Private collection

229
Head of a Horse, 1907
Untraced

STUDIES OF EXPRESSION

A drawing of 1910 (fig. 228) offers another example of horse and landscape in harmony. For the behavioral scientist, this image is notable on account of the markedly upright pose. This might be interpreted as a feature of the pleasurable stretching and shaking in which the animal engages after rising from the ground. This activity is also suggested by the undulating tail and the corresponding movements that continue through the animal's body.

In conclusion, we shall consider two studies of horses' heads. One of these, a drawing of 1907 (fig. 229), shows a horse absorbed in chewing with its head turned to the side (a pose Marc repeatedly recorded). The other, a more finished drawing made in 1906 (fig. 230), features a horse wearing a bridle. Its face, with loose folds of skin at the nostrils and the lips, conveys the weary resignation of a much-abused creature. This is an elderly animal that may well have had a hard and perhaps trau-

matic life; and its pricked ears still signal an attitude of defiance.

It is possible that some readers may not agree with some of these remarks, or indeed find them to be unsatisfactory. Some may feel that too little account has been taken of the fact that these images are, first and foremost, works of art; others may find some of the scientific analyses too far-fetched. This divergence of views is inevitable, given the nature of the task the author was asked to take on: to interpret the work of an artist using the methods of a behaviorial scientist. Franz Marc asked "How does a horse [...] see the world?" The behavioral scientist bases his own conclusions on what he can himself see in Marc's images.

Notes

1 Meissner 1989, pp. 232—234, this passage on p. 233.
2 Arzt/Birmelin 1993, p. 9. On this point, see also B. Tschanz et al., "Befindlichkeiten von Tieren — ein Ansatz ihrer wissenschaftlichen Beurteilung", in *Tierärztliche Umschau* lii (1997).
3 Rosenthal 1992, pp. 29—30.
4, 5 Zeeb 1998.

230

Horse's Head, 1906

Franz Marc Museum, Kochel am See

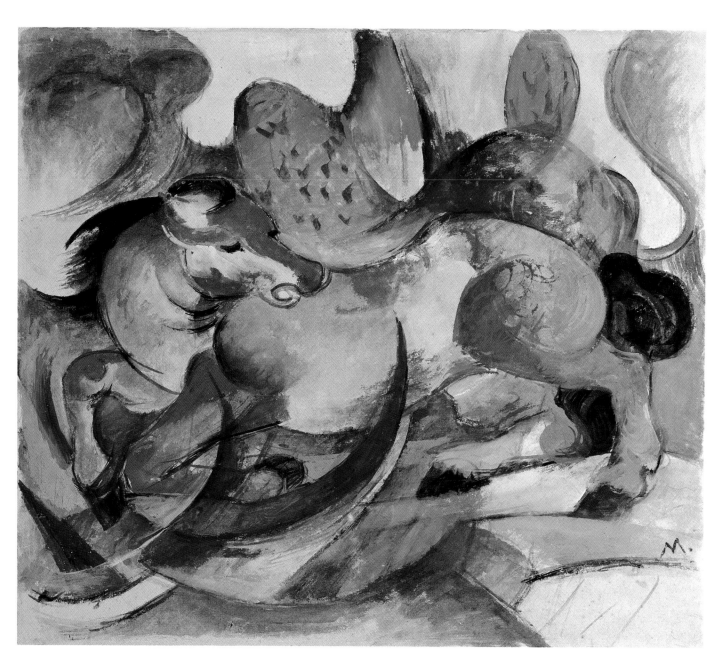

231
Leaping Horse, 1913
Private collection
Cat. 103a

Catalog

ANDREAS SCHALHORN

Arrangement: items are listed and numbered in approximate chronological order; where the exact year of production is uncertain, this is indicated with c. (= circa, about) or with a diagonal slash.

Titles and dimensions: in each case the original (or traditional) German title follows its English translation as used in this volume. Fig. = number of illustration in this volume. Dimensions are cited with height preceding width.

Bibliographical references (Bibl.): in most cases the abbreviated bibliographical references cited in each entry (referring to the bibliography provided in this volume) include only the most significant publications of the last twenty years, with an emphasis on the catalogs of exhibitions devoted to Franz Marc and to the almanac *Der Blaue Reiter*. Most of these publications provide information on earlier literature in addition to thorough studies of individual works.

Abbreviations: r. = right; l. = left; t. = top; b. = bottom; sig. = signed (by Marc, including additional comments); inscr. = inscribed (by another hand); fol. = page number of a sketchbook; cat. = catalog number; p. = page number; pl. = plate number; fig. = illustration number (in cited volume).

The exhibition at the Busch-Reisinger Museum consisted of cat. nos. 38, 46, 47, 48, 117, and 121.

1 Figs. 19,230
Horse's Head, 1906
Pferdekopf
Charcoal on cardboard, 79.5 x 58.5 cm
Franz Marc Museum, Kochel am See
Bibl.: Lankheit 1970: 275

2 Fig. 20
Three Studies of a Horse's Head, 1906
Drei Studien eines Pferdekopfes
Graphite on paper, 19.2 x 12.5 cm
Estate of Franz Marc, on loan to Franz Marc Museum, Kochel am See
Bibl.: Lankheit 1970: 529; exh. cat. Munich 1980, cat. 59; Hüneke 1990, fig. 8

3 Fig. 21
Head of a Dead Horse, 1907/08
Kopf eines toten Pferdes
Graphite on paper, 14.8 x 22.6 cm
Private collection, on loan to Franz Marc Museum, Kochel am See
Bibl.: Lankheit 1970: 532; exh. cat. Munich 1980, cat. 74

4 Fig. 22
Horses, c. 1905
Pferde
Graphite on paper, 13.4 x 20.3 cm
Sig. b.l.: 13a; sig. b.r.: 25.
From sketchbook I
Collection of Etta and Otto Stangl, on loan to Franz Marc Museum, Kochel am See
Bibl.: exh. cat. Munich 1993, cat. 42

5 Figs. 23, 218
Horses on a Hilltop (Facing into the Breeze), 1906
Pferde auf Bergeshöhe (gegen die Luft stehend)
Red chalk, pen and ink, and white gouache on paper, 12.5 x 19.2 cm
Private collection, on loan to Franz Marc Museum, Kochel am See
Bibl.: Lankheit 1970: 530; exh. cat. Munich 1980, cat. 58

6 Fig. 25
Small Study of a Horse I, 1905
Kleine Pferdestudie I
Oil on canvas on cardboard, 27.5 x 31.5 cm
Sig. b.l.: Indersdorf; sig. t.r.: F.M.
Franz Marc Museum, Kochel am See
Bibl.: Lankheit 1970: 27

7 Fig. 26
Sketch of Horses II, 1906
Pferdeskizze II
Oil on canvas on cardboard, 25 x 39 cm
Franz Marc Museum, Kochel am See
Bibl.: Lankheit 1970: 42

8 Figs. 29, 222
Three Horses, 1908
Drei Pferde
Lithograph on paper, 14 x 9 cm
Sig. t.r.: Fz. Marc
Trial proof for a postcard
Staatliche Graphische Sammlung, Munich
Bibl.: Lankheit 1970: 818; exh. cat. Munich 1980, cat. 208

9 Fig. 30
Horses in the Sun, 1908
Pferde in der Sonne
Lithograph on paper, 35.5 x 28 cm
Sig. b.r.: Fz. Marc
Staatliche Graphische Sammlung, Munich
Bibl.: Lankheit 1970: 822; exh. cat. Munich 1980, cat. 210; exh. cat. Berlin 1998, cat. 32

10 Fig. 32
Horse in Front of a Large Bush, 1908
Pferd vor großem Busch
Oil on canvas, 150 x 65 cm (two fragments glued together)
Staatsgalerie, Stuttgart
Bibl.: Lankheit 1970: 72

11 Figs. 33, 215
Group of Horses, 1908
Pferdegruppe
Graphite on paper, 13.5 x 17 cm
From sketchbook X
Private collection
Bibl.: Lankheit 1970: 534; exh. cat. Munich 1980, cat. 8; Moeller 1989, cat. 31

12 Figs. 37—39
Two Horses, 1908/09
Zwei Pferde
Bronze, height 16.4 cm
One of four casts from the estate of Maria Marc
Staatliche Kunsthalle, Karlsruhe
Bibl.: Lankheit 1970: 906; exh. cat. Munich 1980, cat. 242; exh. cat. Berne 1986, cat. 66; exh. cat. Hanover 1989, p. 29, fig. 5; Pese 1989, pl. 43; exh. cat. Bremen 1991, illus. on p. 83; exh. cat. Dortmund 1996, p. 181; exh. cat. Bremen 2000, cat. no. 16

13 Fig. 40
Study of a Horse, 1908/09
Studie eines Pferdes
Oil on canvasboard, 40 x 26 cm
Private collection
Bibl.: exh. cat. Munich 1980, cat. 17

14 Figs. 41, 226
Foals at Pasture (Frolicking Foals), 1909
Fohlen auf der Weide (Springende Fohlen)
Oil on canvas, 50.5 x 70.5 cm
Sig. b.r.: Marc
Private collection
Bibl.: Lankheit 1970: 80; Lankheit 1976, p. 49, pl. 5

15 Figs. 42, 223
Mare with a Foal (Horses in the Morning Sun), 1909
Mutterpferd und Fohlen (Pferde in der Morgensonne)
Oil on canvas, 75 x 85 cm
Sig. b.l.: Marc 09
Private collection
Bibl.: Lankheit 1970: 81; exh. cat. Dortmund 1996, p. 179

16 Fig. 43
Small Picture of Horses, 1909
Kleines Pferdebild
Oil on canvas, 16 x 25 cm
Sig. t.l.: FzM:
Collection of Etta and Otto Stangl, on loan to Franz Marc Museum, Kochel am See
Bibl.: Lankheit 1970: 92; exh. cat. Munich 1980, cat. 18; Pese 1989, pl. 42; Partsch 1990, fig. on p. 16; exh. cat. Munich 1993, cat. 39

17 Figs. 36, 217
Large Landscape I (Landscape with Red Horses), 1909
Große Landschaft I (Landschaft mit roten Pferden)
Oil on canvas, 110.5 x 211.5 cm
Private collection
Bibl.: Lankheit 1970: 93; exh. cat. Munich/Münster 1993—94, p. 89, fig. 11

18 Fig. 44
Study of a Horse, c. 1910
Pferdestudie
(second study of a horse on the verso)
Graphite on paper, 21 x 16 cm
Private collection
Bibl.: exh. cat. Berlin 1998, cat. 38

19 Fig. 45
Two Horses, 1910
Zwei Pferde
Graphite, with white heightening on paper, 28.5 x 42.5 cm
Staatliche Galerie Moritzburg, Halle
Bibl.: Lankheit 1970: 409; Moeller 1989, cat. 43; exh. cat. Hanover 1989, cat. IV

20 Fig. 46
Horses at Pasture, 1910
Pferde auf der Weide (Pferde in Landschaft)
Gouache on paper, 62 x 82 cm
Musée d'Art moderne et d'Art contemporain de la Ville de Liège
Bibl.: Lankheit 1970: 414; exh. cat. Berne 1986, cat. 72

21 Fig. 47
Horses at a Watering-place, 1910
Pferde in der Schwemme
Mixed media on paper, 10.2 x 15.5 cm
Possibly from sketchbook XX
Private collection, Switzerland
Bibl.: Lankheit 1970: 416

22 Fig. 48
Two Horses at a Watering-place, 1910
Zwei Pferde in der Schwemme
Tempera, with gold heightening on paper, 34.5 x 46 cm
Sig. t.r.: Fz Marc
Private collection
Bibl.: Lankheit 1970: 415; Moeller 1989, cat. 44

23 Fig. 49
Red Horse in a Colored Landscape, 1910
Rotes Pferd in farbiger Landschaft
Tempera on paper, 17 x 21.5 cm
From sketchbook XXI
Private collection
Bibl.: Lankheit 1970: 575

24 Fig. 51
Four Foals at Pasture, 1910
Vier Fohlen auf der Weide
Pen and ink, with watercolor on paper, 10.1 x 15.5 cm
From sketchbook XVIII, fol. 14
Germanisches Nationalmuseum, Nuremberg
Bibl.: none

25 Fig. 52
Studies of Foals, 1910
Fohlenstudien
Pen and brush and ink, with red and white wash on paper, 15.5 x 20.3 cm
From sketchbook XVIII, fols. 19 a and 20
Germanisches Nationalmuseum, Nuremberg
Bibl.: none

26 Fig. 53
Leaping Horses, 1910
Springende Pferde
Pen and ink on paper, 8.8. x 10.7 cm (image), 11 x 15.4 cm (sheet)
From sketchbook XVIII
Private collection
Bibl.: Lankheit 1970: 563; Moeller 1989, cat. 59

27 Figs. 55, 219
Horses Running on Pasture, 1910
Laufende Pferde auf der Weide
Graphite on paper, 10 x 15.4 cm
From sketchbook XVIII, fol. 2
Germanisches Nationalmuseum, Nuremberg
Bibl.: Lankheit 1970: 539

28 Fig. 56

Two Horses, 1910
Zwei Pferde

Graphite and tempera on paper, 13.4 x 21.2 cm
Sig. t.r.: Sindelsdorf I(V?) 1910; sig. b.l.: 1910/4
From sketchbook XV
Collection of Etta and Otto Stangl, on loan to
Franz Marc Museum, Kochel am See
Bibl.: Lankheit 1970: 538; exh. cat. Munich 1993,
cat. 48; exh. cat. Berlin 1998, cat. 40

29 Fig. 57

Grazing Horses I, 1910
Weidende Pferde I

Oil on lined canvas, 63.5 x 93.5 cm
Städtische Galerie im Lenbachhaus, Munich
Bibl.: Lankheit 1970: 126; exh. cat. Munich 1980,
cat. 24; Partsch 1990, illus. on p. 25; Rosenthal
1992, pl. 13

30 Fig. 58

Grazing Horses II, 1910
Weidende Pferde II

Oil on canvas, 34 x 92.5 cm (fragment of a larger
composition)
Staatsgalerie, Stuttgart
Bibl.: Lankheit 1970: 127

31 Figs. 59, 214

Grazing Horses III, 1910
Weidende Pferde III

Oil on canvas, 62 x 92.5 cm
Private collection
Bibl.: Lankheit 1970: 128

32 Figs. 60, 211

Horse in the Landscape, 1910
Pferde in Landschaft

Oil on canvas, 85 x 112 cm
Museum Folkwang, Essen
Bibl.: Lankheit 1970: 130; exh. cat. Munich 1980,
p. 59, fig. 23; Pese 1989, pl. 57; Partsch 1990, fig.
on p. 30; exh. cat. Munich/Münster 1993—94,
p. 90, fig. 14

33 Fig. 61

Three Drinking Horses, 1910
Drei trinkende Pferde

Watercolor and gouache on paper, 14 x 17 cm
From sketchbook XXIII
Solomon R. Guggenheim Museum, New York
Bibl.: Lankheit 1970: 594; Moeller 1989, cat. 53

34 Fig. 62

Horses at Pasture, 1910/11
Pferde auf der Weide

Pen and ink, with wash on paper,
11.1 x 17.9 cm
From sketchbook XXIII
Private collection
Bibl.: Lankheit 1970: 588; exh. cat. Munich 1980,
cat. 103; Moeller 1989, cat. 63; Hüneke 1990,
fig. 21

35 Fig. 63

Two Horses in a Mountain Landscape, 1910/11
Zwei Pferde in bergiger Landschaft

Graphite on paper, 21.7 x 16.9 cm
Staatliche Graphische Sammlung, Munich
Bibl.: exh. cat. Munich 1980, cat. 215; Moeller
1989, cat. 62

36 Fig. 64

Two Horses Fighting, 1910
Zwei streitende Pferde

Charcoal, pen and ink, with wash on paper,
48.6 x 63.8 cm
Private collection
Bibl.: Lankheit 1970: 411

37 Fig. 66

Horses at Pasture II, 1910
Pferde auf der Weide

Tempera on paper, 26.5 x 40 cm
Private collection
Bibl.: Lankheit 1970: 418; exh. cat. Munich 1980,
cat. 102

38 Figs. 14, 68, 219

The Red Horses (Grazing Horses IV), 1911
Die roten Pferde (Weidende Pferde IV)

Oil on canvas, 121 x 182.9 cm
Sig. b.r.: F. Marc
Private collection, anonymous loan to the Busch-
Reisinger Museum, Harvard University Art
Museums, Cambridge, Mass., 21.1991
Bibl.: Lankheit 1970: 131; exh. cat. Munich 1980,
p. 50, fig. 1; Pese 1989, pl. 60; Rosenthal 1992,
pl. 14

39 Fig. 69

Boys with Horses and a Dog, 1911
Knaben mit Pferden und Hund

Graphite on paper, 17 x 21.5 cm
From sketchbook XXI
Private collection, Zollikon
Bibl.: Lankheit 1970: 584; Moeller 1989, cat. 66;
exh. cat. Munich/Münster 1993—94, p. 24, fig. 3

40 Fig. 70

Boys with Horses and a Dog, 1911
Knaben mit Pferden und Hund

Black chalk on paper, 17 x 21.5 cm
From sketchbook XXI
Private collection
Bibl.: Lankheit 1970: 585; exh. cat. Munich 1980,
cat. 110; Moeller 1989, cat. 67

41 Fig. 71

Young Horse in a Mountain Landscape, 1910
Junges Pferd in Berglandschaft

Graphite on paper on cardboard,
17 x 10.2 cm
Sig. b.r.: 10; inscr. on the cardboard mount: Für
Otto u. Etta Stangl, Weihnachten 1950, herzlichst
Maria Marc [for Otto and Etta Stangl, Christmas
1950, Cordially, Maria Marc]
From sketchbook XXIV
Collection of Etta and Otto Stangl, on loan to
Staatliche Graphische Sammlung, Munich
Bibl.: Moeller 1989, cat. 75; Hüneke 1990, fig. 39;
exh. cat. Munich 1993, cat. 46; exh. cat. Berlin
1998, cat. 39

42 Fig. 72

Blue Horse I, 1911
Blaues Pferd I

Oil on canvas, 112.5 x 84.5 cm
Städtische Galerie im Lenbachhaus, Munich
Bibl.: Lankheit 1970: 136; exh. cat. Munich 1980,
cat. 27; Pese 1989, pl. 64; Partsch 1990, illus. on
p. 18; Rosenthal 1992, pl. 20

43 Fig. 73

Standing Horse viewed from the Rear, 1911
Stehendes Pferd von hinten

Graphite on paper, 15.8 x 10 cm
Private collection, Essen
Bibl.: Lankheit 1970: 646; Moeller 1989, cat. 74

44 Fig. 74

Blue Horse II, 1911
Blaues Pferd II

Oil on canvas, 113 x 86 cm
Kunstmuseum, Berne (Stiftung Othmar Huber)
Bibl.: Lankheit 1970: 137; exh. cat. Munich 1980,
p. 57, fig. 15; exh. cat. Berne 1986, cat. 82

45 Fig. 76

Studies of Horses with Circular Forms, 1911
Pferdestudien mit Kreisformen

Graphite on paper, 21.7 x 16.9 cm
Private collection
Bibl.: Lankheit 1976, illus. on p. 80

46 Fig. 77

The Small Blue Horses, 1911
Die kleinen blauen Pferde
Oil on canvas, 61 x 101 cm
Sig. b.l.: Marc
Staatsgalerie, Stuttgart
Bibl.: Lankheit 1970: 154; Maur/Inboden 1984,
p. 216; Pese 1989, p. 119, pl. 58; Partsch 1990,
p. 54; Maur 1999, cat. 88

47 Figs. 78, 182

The Large Blue Horses, 1911
Die großen blauen Pferde
Oil on canvas, 104.8 x 181 cm
Sig. on verso: Marc, Blaue Pferde
Walker Art Center, Minneapolis, Minn. (Gift of
T.B.Walker Foundation, Gilbert M. Walker Fund,
1942)
Bibl.: Lankheit 1970: 155; Pese 1989, pl. 68;
Rosenthal 1992, pl. 21; exh. cat. Munich 1999,
fig. 276

48 Figs. 79, 196

The Small Yellow Horses, 1912
Die kleinen gelben Pferde
Oil on canvas, 66 x 104.5 cm
Sig. b.l.: Marc
Staatsgalerie, Stuttgart
Bibl.: Lankheit 1970: 156; exh. cat. Munich 1980,
cat. 32; Maur/Inboden 1984, p. 217; exh.
cat. Berne 1986, no. 83; Pese 1989, pl. 69; Partsch
1990, fig. on pp. 34 ff.; exh. cat. Kochel 1992,
pl. 3; Rosenthal 1992, pl. 29; exh. cat. Berlin
1998, cat. 52; Maur 1999, no. 89

49 Fig. 82

Black Horse and White Horse in a Mountain
Landscape with a Rainbow, 1911
Schwarzes Pferd und weißes Pferd in Gebirgs-
landschaft mit Regenbogen
Charcoal, with watercolor and gouache on paper,
31.8 x 10.5 cm
From sketchbook XXI
Graphische Sammlung Albertina, Vienna
Bibl.: see Lankheit 1970: 874; Moeller 1989,
cat. 76; exh. cat. Berlin 1998, p. 161, fig. 24;
Hüneke 1990, fig. 38

50 Fig. 83

Landscape with Animals and a Rainbow, 1911
Landschaft mit Tieren und Regenbogen
Painting on glass, 108 x 45.7 cm
Private collection
Bibl.: Lankheit 1970: 874; exh. cat. Munich/Münster
1993—94, p. 96, fig. 1; exh. cat. Berlin 1998, p. 161,
fig. 23; Cat. Christie's London 1997, cat. 116

51 Fig. 84

Leaping Horse, 1911
Springendes Pferd
Brush and ink on paper, 17 x 21.7 cm
Sig. on verso in pencil: Springendes Pferd
with a boxed figure 4
From sketchbook XXI
Private collection
Bibl.: Lankheit 1970: 593

52 Fig. 85

Two Horses (Leaping Horses), 1911/12
Zwei Pferde (Springende Pferde)
Watercolor and gouache on paper, 11.5 x 15.5 cm
From sketchbook XXV
Private collection
Bibl.: Lankheit 1970: 597; exh. cat. Hanover
1989, illus. on p. 117

53 Fig. 86

Two Horses, 1911/12
Zwei Pferde
Gouache, over printed image on paper,
17.5 x 22 cm (sheet), 14.1 x 20.8 (image)
Sig. t.l.: Richtige Vorlage [correct model]
Franz Marc Museum, Kochel am See (Stiftung in
memoriam E. u. A. Winterstein)
Bibl.: Lankheit 1970: 419; Cat. Christie's London
1997, cat. 160

54 Fig. 87

Two Horses, 1911/12
Zwei Pferde
Tempera and gouache, over printed image on
paper, 14 x 20.9 cm
Sig. in pen and ink: b.r.: F Marc; to r. and b.
remarks in Marc's hand on the print and the colors
Private collection
Bibl.: Moeller 1989, no. 77; exh. cat. Berlin 1998,
no. 45

55 Fig. 88

Two Horses, 1911/12
Zwei Pferde
Mixed media on paper,
14.3 x 20.9 cm
Kunsthalle, Hamburg
Bibl.: Lankheit 1970: 420; exh. cat. Berne 1986,
cat. 115; Moeller 1989, cat. 78; Pese 1989, pl. 63

56 Fig. 89

Resting Horses, 1911/12
Ruhende Pferde
Woodcut printed in black, green, and blue inks
on paper, 16.7 x 22.5 cm
Staatliche Graphische Sammlung, Munich
Bibl.: Lankheit 1970: 825: exh. cat. Munich 1980,
cat. 216; exh. cat. Düsseldorf 1984, cat. 1;
exh.cat., Hanover 1989, cat. 19; exh. cat. Munich,
cat. 58; exh. cat. Berlin 1998, cat. 46

57 Fig. 90

Small Wild Horses, 1912
Wildpferdchen
Woodcut on paper, 6.2 x 8 cm
Sig. b.r.: M
Staatliche Graphische Sammlung, Munich
Bibl.: Lankheit 1970: 830; exh. cat. Munich 1980,
cat. 219; exh. cat. Düsseldorf 1984, woodcut
cat. 3; exh. cat. Hanover 1989, cat. 25; Hüneke
1990, fig. 54

58 Fig. 91

Drinking Horse, 1912
Trinkendes Pferd
Woodcut printed in brown ink on paper,
41.5 x 28.4 cm (sheet), 21.8 x 8.4 cm (image)
Sig. center l.: M; sig. (in graphite) b.l.: Trinkendes
Pferd; sig. b.r.: Privatdruck Franz Marc
Staatliche Graphische Sammlung, Munich
Bibl.: Lankheit 1970: 832; exh. cat. Munich 1980,
cat. 222; exh. cat. Düsseldorf 1984, woodcut
cat. 9; exh. cat. Hanover 1989, cat. 27; Hüneke
1990, fig. 50; exh. cat. Munich/Münster 1993—
94, cat. 134; exh. cat. Berlin 1998, cat. 60

59 Fig. 92

Small Leaping Horses, 1912
Springende Pferdchen
Woodcut on paper, 13.2 x 9 cm (image)
Sig. b.l.: M
Staatliche Graphische Sammlung, Munich
Bibl.: Lankheit 1970: 844; exh. cat. Munich 1980,
cat. 227; exh. cat. Düsseldorf 1984, cat. 4; exh.
cat. Hanover 1989, cat. 161; Hüneke 1990, fig. 48;
Partsch 1990, illus. on p. 37; exh.
cat. Munich/Münster 1993—94, cat. 144

60 Fig. 93
Two Horses in a Landscape, 1912
Zwei Pferde in Landschaft
Painting on glass, 22 x 24.4 cm
Private collection
Bibl.: Lankheit 1970: 876; exh. cat. Berne 1986,
cat. 86

61 Fig. 94
Red Horse and Blue Horse, 1912
Rotes Pferd und blaues Pferd
Tempera on paper, 26.3 x 34.3 cm
Sig. o.l.: Fz. Marc.
Städtische Galerie im Lenbachhaus, Munich
Bibl.: Lankheit 1970: 437; exh. cat. Munich 1980,
cat. 124; exh. cat. Düsseldorf 1984, cat. 21; exh.
cat. Berne 1986, cat. 87; Moeller 1989, cat. 92;
Partsch 1990, p. 2; Rosenthal 1992, pl. 28

62 Fig. 95
Horse and Donkey, 1912
Pferd und Esel
Tempera on paper, 37 x 29.5 cm
Sig. b.r.: Marc.
Private collection, courtesy of Galerie Art Focus,
Zürich
Bibl.: Lankheit 1970: 438; Moeller 1989, cat. 93;
exh. cat. Munich/Münster 1993—94, cat. 33

63 Fig. 97
Green Horse, 1912
Grünes Pferd
Tempera on paper, 22,5 x 35.4 cm
Sig. b.r.: Fz. Marc.
Private collection
Bibl.: Lankheit 1970: 440

64 Fig. 98
Leaping Horse with Plant Forms, 1912
Springendes Pferd mit pflanzlichen Formen
Graphite, brush and ink, with watercolor on
paper, 11.5 x 15.6 cm
From an unidentified sketchbook, fol. 19
Private collection
Bibl.: Moeller 1989, cat. 81; exh. cat. Munich/
Münster 1993—94, cat. 54

65 Fig. 99
Leaping Horse, 1912
Springendes Pferd
Oil on canvas, 87.5 x 112 cm
Sig. on verso: Fz. Marc/12
Collection of Etta and Otto Stangl, on loan to
Franz Marc Museum, Kochel am See
Bibl.: Lankheit 1970: 165; exh. cat. Kochel 1992,
p. 77, fig. 3; exh. cat. Munich 1993, cat. 40; exh.
cat. Berlin 1998, cat. 59

66 Fig. 100
Little Blue Horse, Picture for a Child, 1912
Blaues Pferdchen, Kinderbild
Oil on canvas, 57.5 x 73 cm
Sig. t.r.: Dem l. Walterchen Macke gewidmet
1912 [dedicated to dear little Walter Macke]
Saarland Museum, Saarbrücken (Stiftung Saar-
ländischer Kulturbesitz)
Bibl.: Lankheit 1970: 166: Partsch 1990, illus. on
p. 49

67 Fig. 101
Blue Foals, 1912
Blaue Fohlen
Oil on wood, 27.5 x 31 cm (image), 33 x 37 cm
(support)
Stedelijk Museum, Amsterdam
Bibl.: Lankheit 1970: 168

68 Fig. 102
Two Blue Foals, 1911
Zwei blaue Fohlen
Watercolor on paper, 43.7 x 39.7 cm
Private collection, Switzerland
Bibl.: Lankheit 1970: 432; Moeller 1989, cat. 73;
Hüneke 1990, fig. 34

69 Fig. 103
The Dream, 1912
Der Traum
Oil on canvas, 101 x 136 cm
Sig. b.r.: Marc
Museo Thyssen-Bornemisza, Madrid
Bibl.: Lankheit 1970: 172; exh. cat. Munich/Mün-
ster 1993—94, p. 173, fig. 12; Pese 1989, pl. 79;
exh. cat. Bremen 2000, cat. 23

70 Fig. 104
The Shepherds, 1912
Die Hirten
Oil on canvas, 100 x 135 cm
Sig. b.l.: Marc; sig. on verso: Fz. Marc, Sindelsdorf
Private collection, on loan to Franz Marc
Museum, Kochel am See
Bibl.: Lankheit 1970: 173: Rosenthal 1992, pl. 24;
exh. cat. Munich/Münster 1993—94, p. 193, fig. 3

71 Fig. 105
Two Horses, 1912/13
Zwei Pferde
Mixed media on paper,
13 x 16.5 cm
From sketchbook XXVIII
Private collection
Bibl.: Lankheit 1970: 619; exh. cat. Munich 1980,
cat. 123; exh. cat. Hanover 1989, p. 29, fig. 7; exh.
cat. Munich/Münster 1993—94, cat. 60

72 Fig. 106
Horses and an Eagle, 1912
Pferde und Adler
Oil on canvas, 100 x 135.5 cm
Sig. on verso: Fz. Marc Sindelsdorf M.M.
Sprengel Museum, Hanover
Bibl.: Lankheit 1970: 185: exh. cat. Munich 1980,
illus. on p. 80; exh. cat. Hanover 1989, cat. 13;
Pese 1989, pl. 83

73 Fig. 107
Mare with Foals, 1912
Stute mit Fohlen
Oil on canvas, 76 x 90 cm
Sig. t.r.: M
Private collection, Switzerland
Bibl.: Lankheit 1970: 191; Pese 1989, pl. 86; exh.
cat. Hamburg 1992, p. 20, fig. 1

74 Fig. 109
Sketch for the Tower of Blue Horses, 1912
Skizze zum Turm der blauen Pferde
Graphite on paper, 17 x 10.1 cm
Sig. l.r.: 30_2
From sketchbook XXVI
Private collection
Bibl.: Lankheit 1970: 611; exh. cat. Berlin 1989,
cat. 95

75 Fig. 112
Horse with Female Nude, 1912/13
Pferd mit weiblichem Akt
Graphite on paper, 17.1 x 10.2 cm
Sig. t.r.: 77; sig. b.r.: 19
From sketchbook XXVI, fol. 18
Germanisches Nationalmuseum, Nuremberg
Bibl.: Pese 1989, pl. 104

76 Fig. 114
The Mother of the Blue Horses II, 1913
Die Mutterstute der blauen Pferde II
Watercolor, gouache, and ink on card, 14 x 9 cm
Unmailed postcard
Sprengel Museum, Hanover
Bibl.: Lankheit 1970: 749: Moeller 1989, cat. 133;
exh. cat. Hanover 1989, cat. 15; exh. cat. Bremen
1991, p. 85; exh. cat. Bremen 2000, cat. 32

77 Fig. 117
Small Black Horse, 1913
Schwarzes Pferdchen
Ink and watercolor, with gilt paper on card,
varnished, 14.1 x 9.1 cm
Postcard to Else Lasker-Schüler, May 27th 1913
Staatliche Museen zu Berlin – Preußischer Kul-
turbesitz, Kupferstichkabinett
Bibl.: Lankheit 1970: 774; Schuster 1987, cat. 19;
Moeller 1989, cat. 131; Pese 1989, pl. 108; exh.
cat. Hanover 1989, cat. VII; Hüneke 1990, fig. 72;
exh. cat. Berlin 1991, cat. 134; Mönig 1996, fig. 15

78 Fig. 118
Red Horse with Black Figures, 1913
Rotes Pferd mit schwarzen Figuren
Graphite and watercolor on card, 9 x 14 cm
Postcard to Elisabeth Macke, February 6th 1913
Private collection
Bibl.: Lankheit 1970: 737: exh. cat. Berlin 1991,
cat. 123

79 Fig. 119
Small Horse in Cool Pink, 1913
Pferdchen in Kaltrosa
Watercolor on card, 9 x 14 cm
Postcard to Elisabeth and August Macke,
May 1913
Private collection
Bibl.: Lankheit 1970: 738; exh. cat. Munich 1980,
cat. 171; Moeller 1989, cat. 118

80 Fig. 120
Blackish Brown Horse and Yellow Ox, 1913
Schwarzbraunes Pferd und gelbes Rind
Watercolor, with gilt paper on card, 14 x 9 cm
Postcard to Alfred Kubin, March 24th 1913
Städtische Galerie im Lenbachhaus, Munich
Bibl.: Lankheit 1970: 750; exh. cat. Munich 1980,
cat. 177; Moeller 1989, cat. 116; Hüneke 1990,
fig. 75; exh. cat. Berlin 1991, cat. 127

81 Fig. 121
Red Horse and Blue Horse, 1913
Rotes und blaues Pferd
Graphite and watercolor on card, 14 x 9 cm
Postcard (inspired by a frescoed mural in the
church of St. Georg ob Schenna, South Tyrol) to
Wassily Kandinsky, April 5th 1913
Städtische Galerie im Lenbachhaus, Munich
Bibl.: Lankheit 1970: 752; exh. cat. Munich 1980,
cat. 165; Moeller 1989, cat. 120; exh. cat. Berlin
1991, cat. 128

82 Fig. 122
Red Horse and Blue Horse, 1913
Rotes und blaues Pferd
Graphite, pen and ink, with watercolor on card,
14 x 9.2 cm
Postcard to Lily Klee, April 19th 1913
Private collection, Switzerland
Bibl.: Lankheit 1970: 758; exh. cat. Munich 1980,
cat. 169; exh. cat. Düsseldorf 1984, cat. 30; exh,
cat, Berne 1986, cat. 243; Hüneke 1990, fig. 81;
exh. cat. Hamburg 1992, cat. 168, pl. 41; exh.
cat. Bremen 2000, cat. 34

83 Fig. 123
Green Horse and White Horse, 1913
Grünes und weißes Pferd
Tempera on card, 9 x 14 cm
Postcard to Elisabeth Macke, November 8th 1915
Private collection
Bibl.: Lankheit 1970: 769; exh. cat. Munich 1980,
cat. 187; Moeller 1989, cat. 147; Hüneke 1990,
fig. 73; exh. cat. Berlin 1991, cat. 121

84 Fig. 124
Two Blue Horses in Front of a Red Rock, 1913
Zwei blaue Pferde vor rotem Felsen
Tempera on card, varnished, 14 x 9 cm
Postcard to Wassily Kandinsky, May 21st 1913
Städtische Galerie im Lenbachhaus, Munich
Bibl.: Lankheit 1970: 771; exh. cat. Munich 1980,
cat. 176; Moeller 1989, cat. 121; Hüneke 1990,
fig. 82; exh. cat. Berlin 1991, cat. 133.

85 Fig. 125
Two Horses against a Blue Mountain, 1913
Zwei Pferde vor blauem Berg
Mixed media, with silver paper on card,
14 x 9.2 cm
Postcard to Lily Klee, undated
Private collection, Switzerland
Bibl.: Lankheit 1970: 773: exh. cat. Munich 1980,
cat. 175; exh. cat. Düsseldorf 1984, cat. 29; exh.
cat. Berne 1986, cat. 248; exh. cat. Hamburg
1992, cat. 171, pl. 40

86 Fig. 126
Blue Horse, Red Horse, and a Rainbow, 1913
Blaues Pferd, rotes Pferd und Regenbogen
Watercolor and ink on card, 14 x 9.1 cm
Sig. b. (in ink): Ein Haus, ein Pferd, ein Bogen-
regen, das muss so stehn des Reimes wegen [A
house, a horse, a bow of rain, it must be thus so
the rhyme is plain]
Postcard to Paul Klee, October 15th 1913
Ahlers Collection
Bibl.: exh. cat. Berlin 1991, cat. 137

87 Fig. 127
Three Horses in a Landscape with Houses, 1913
Drei Pferde in Landschaft mit Häusern
Mixed media on card, 9.2. x 14 cm
Postcard to Paul Klee, November 8th 1913
Private collection, Switzerland
Bibl.: Lankheit 1970: 787; exh. cat. Munich 1980,
cat. 183; exh. cat. Berne 1986, cat. 240; exh.
cat. Hamburg 1992, cat. 174; exh. cat. Bremen
2000, cat. 35

88 Fig. 128
Yellow Lion, Blue Foxes, and Blue Horse, 1914
Gelber Löwe, blaue Füchse, blaues Pferd
Mixed media on card, 9.2 x 14 cm
Postcard to Lily Klee, March 22nd 1914
Private collection, Switzerland
Bibl.: Lankheit 1970: 792; exh. cat. Munich 1980,
cat. 186; exh. cat. Düsseldorf 1984, cat. 39; exh.
cat. Berne 1986, cat. 242; exh. cat. Hamburg
1992, cat. 176

89 Fig. 129
Two Horses, 1913
Zwei Pferde
Watercolor on paper, 22 x 17 cm
From sketchbook XXX
Sprengel Museum, Hanover
Bibl.: Lankheit 1970: 648; Moeller 1989, cat. 85;
exh. cat. Hanover 1989, cat. 14; Hüneke 1990,
fig. 35

90 Fig. 130
Wailing Horse, 1913
Klagendes Pferd
Tempera on paper, 22 x 16.8 cm
Sig. b.l.: 3
From sketchbook XXX
Stiftung Domnick, Nürtingen
Bibl.: Lankheit 1970: 650; Domnick 1982, cat. 144

91 Fig. 131
Horses and Oxen, 1913
Pferde und Rinder
Graphite on paper, 21.9 x 16.2 cm
Sig. b.r.: 1.; inscr. on verso: Zwei Studien in Tempera [two studies in tempera]
From sketchbook XXX, fol. 1
Private collection
Bibl.: Munich/Münster 1993—94, cat. 76

92 Fig. 1
Two Small Blue Horses, 1913
Zwei blaue Pferdchen
Tempera on paper, 20 x 12.5 cm
From sketchbook XXXI
Private collection
Bibl.: see Lankheit 1970: 732; Moeller 1989, cat. 108

93 Fig. 132
Two Blue Horses, 1913
Zwei blaue Pferde
Watercolor and ink on paper, 20 x 13.3 cm
From sketchbook XXXI
Solomon R. Guggenhein Museum, New York
Bibl.: Lankheit 1970: 634; exh. cat. Munich 1980, cat. 121; Moeller 1989, cat. 100; Rosenthal 1992, pl. 47

94 Fig. 133
Mare and Foal Resting, 1913
Ruhende Stute und Fohlen
Watercolor on paper, 10.7 x 18.4 cm
Possibly from sketchbook XXXI
Private collection, New York
Bibl.: Lankheit 1970: 653

95 Fig. 134
Horse and Ox at Night, 1913
Pferd und Ochse bei Nacht
Brush and ink, with wash on paper, 14 x 10.9 cm
Private collection, New York
Bibl.: none

96 Fig. 135
Small Red Horse, 1913
Rotes Pferdchen
Graphite, with gouache and white gouache on paper, 11.5 x 9.7 cm
Inscr. on verso: Aus dem Nachlass Franz Marc bestätigt Maria Marc [Maria Marc confirms that this work derives from the estate of Franz Marc]
Private collection
Bibl.: none

97 Fig. 136
Small Horse, 1913
Pferdchen
Black chalk on paper, 12.1 x 15.2 cm
Sig. t.r.: ERSTER DEUT [...] HERBSTSALON [...] 20 Sept—1 Nov 1[...] STURM
Private collection, courtesy of Galerie Utermann, Dortmund
Bibl.: exh. cat. Düsseldorf 1984, cat. 23; Moeller 1989, cat. 161

98 Fig. 137
Horse in a Landscape with Pointed Forms, 1913
Pferd in Landschaft mit spitzen Formen
Watercolor and gouache on paper, 20.1 x 12.6 cm
Sig. b.r.: in pencil: 42; inscr. on verso t.r.: XXXI DO; inscr.: Für Dr. Domnick reserviert [Reserved for Dr. Domnick]
From sketchbook XXXI
Sprengel Museum, Hanover
Bibl.: Lankheit 1970: 637: Moeller 1989, cat. 134; exh. cat. Hanover 1989, cat. 16

99 Fig. 138
Landscape with Black Horses, 1913
Landschaft mit schwarzen Pferden
Gouache on paper, 35 x 45.3 cm
Museum, Ulm
Bibl.: Lankheit 1970: 477; Moeller 1989, cat. 160

100 Fig. 139
Landscape with Two Horses, 1913
Landschaft mit zwei Pferden
Gouache on paper, 45.8 x 39.6 cm
Sig. b.r.: FM
Private collection
Bibl.: exh. cat. Stuttgart 1973, cat. 152

101 Fig. 140
Sleeping Animals, 1913
Schlafende Tiere
Tempera on cardboard, 43.8 x 38.7 cm
Sig. b.l.: M
Private collection
Bibl.: Lankheit 1970 462; exh. cat. Munich 1980, cat. 126; Moeller 1989, cat. 127; exh. cat. Munich/Münster 1993—94, cat. 38; exh. cat. Murnau 1999, cat. 19

102 Fig. 141
Dreaming Horse, 1913
Träumendes Pferd
Pencil, ink, watercolor, and gouache on paper, 39.6 x 46.8 cm
Sig. at right edge: M.
Solomon R. Guggenheim Museum, New York
Bibl.: Lankheit 1970: 463; exh. cat. Murnau 1980, cat. 127; Moeller 1989, cat. 145; Hüneke 1990, fig. 76; Partsch 1990, illus. on p. 50; exh. cat. Munich/Münster 1993—94, cat. 39; Rosenthal 1992, pl. 45; Mönig 1996, fig. 4

103 Fig. 142
Saint Julien l'hospitalier, 1913
Der heilige Julian
Watercolor, gouache, and bronze powder on paper, 46 x 40.2 cm
Sig. b.l.: F.M.; sig u.l.: la Légende de St. Julien l'hospitalier
Solomon R. Guggenheim Museum, New York
Bibl.: Lankheit 1970: 465; exh. cat. Munich 1980, cat. 130; Moeller 1989, cat. 148; Rosenthal 1992, pl. 57

103a Fig. 231
Leaping Horse, 1913
Springendes Pferd
Watercolor on paper, 40 x 46 cm
Sig. b.r.: M
Private collection, courtesy Christie's
Bibl.: Lankheit 1970: 466 Hüneke 1990, fig. 61

104 Fig. 143
Mythical Beasts (Horse and Dog), 1913
Fabeltiere (Pferd und Hund)
Graphite and watercolor on paper, 44 x 36.3 cm
Sig. l.r.: M.
Staatsgalerie Stuttgart, Graphische Sammlung (Sammlung Borst)
Bibl.: Lankheit 1970: 471; exh. cat. Munich 1980, cat. 132; Moeller 1989, cat. 150; exh. cat. Munich/Münster 1993—94, cat. 42

105 Fig. 144

Two Horses, 1913
Zwei Pferde
Tempera on paper, 39.6 x 45.3 cm
Sig. b.r.: Fz. Marc Dr. Fromm gew.
[dedicated to Dr. Fromm]
Private collection, courtesy of the Galerie
Kornfeld, Berne
Bibl.: Lankheit 1970: 473

106 Fig. 145

The Creation of the Horses
(Three Mythical Beasts), 1913
Schöpfung der Pferde (Drei Fabeltiere)
Tempera on paper, 45.5 x 39.5 cm
Sig. b.r.: M.
Collection Hannema-de Stuers Foundation,
Heino/Wijhe, Netherlands
Bibl.: Lankheit 1970: 478; exh. cat. Düsseldorf
1984, cat. 28; Moeller 1989, cat. 155; exh. cat.,
Munich/Münster 1993—94, cat. 45

107 Fig. 146

Three Horses at a Watering-place, 1913/14
Drei Pferde an der Tränke
Tempera on paper, 39.7 x 45.5 cm
Sig. l.r.: M.
Staatliche Kunsthalle, Karlsruhe
Bibl.: Lankheit 1970: 479; Moeller 1989, cat. 169;
Pese 1989, pl. 84; exh. cat. Munich/Münster
1993—94, cat. 46; exh. cat. Berlin 1998, cat. 76

108 Fig. 147

Mythical Beast II (Horse), 1913
Fabeltier II (Pferd)
Tempera on cardbard, 26 x 30.5 cm
Sig. b.r.: M.
Ahlers Collection
Bibl.: Lankheit 1970 482; Moeller 1989, cat. 157;
Partsch 1990, illus. on p. 74; exh. cat. Berlin 1993,
cat. 11; exh. cat. Munich/Münster 1993—94,
cat. 49

109 Fig. 148

Blue Horse with a Rainbow, 1913
Blaues Pferd mit Regenbogen
Graphite, watercolor, and gouache on paper,
16.2 x 25.7 cm
The Museum of Modern Art, New York (John S.
Newberry Collection, 2. 64)
Bibl.: Lankheit 1970: 486; Moeller 1989, cat. 162;
exh. cat. Munich/Münster 1993—94, cat. 50

110 Fig. 149

Composition with Animals, 1913/14
Tierkomposition
Tempera on paper, 61 x 47.5 cm
Franz Marc Museum, Kochel am See
Bibl.: Lankheit 1970: 490: exh. cat. Munich/Mün-
ster 1993—94, cat. 51; exh. cat. Berlin 1998,
cat. 75

111 Fig. 150

Horse and Hedgehog, 1913
Pferd und Igel
Woodcut on blue, fibered paper, 15.8 x 21.8 cm
Inscr. on verso: Pferd und Igel Kat. 1913/2/
Privatdruck Franz Marc bestätigt Maria Marc
[Maria Marc confirms that this item was printed
by Franz Marc]
Collection of Etta and Otto Stangl, on loan to
Franz Marc Museum, Kochel am See
Bibl.: Lankheit 1970: 836; exh. cat. Düsseldorf
1984, woodcut cat. no. 12; exh. cat. Munich 1993;
cat. 61; exh. cat. Munich/Münster 1993—94,
cat. 136; exh. cat. Berlin 1998, cat. 71

112 Fig. 151

Lion Hunt, after Delacroix, 1913
Löwenjagd, nach Delacroix
Woodcut on paper, 25 x 27.2 cm
Sig. at center r.: M
Staatliche Graphische Sammlung, Munich
Bibl.: Lankheit 1970: 838: exh. cat. Munich 1980,
cat. 231; exh. cat. Düsseldorf 1984, cat. 14;
exh. cat. Hanover 1989, cat. 33; exh.
cat. Munich/Münster 1993—94, cat. 138

113 Fig. 152

Riding Scene, after Ridinger, 1913
Reitszene, nach Ridinger
Woodcut on paper, 27 x 29.3 cm
Sig. b.l.: M
Staatliche Graphische Sammlung, Munich
Bibl.: Lankheit 1970: 839; exh. cat. Munich 1980,
cat. 232; exh. cat. Düsseldorf 1984, cat. 15; exh.
cat. Hanover 1989, cat. 34; Pese 1989, pl. 91; exh.
cat. Munich/Münster 1993—94, cat. 139

114 Fig. 153

Birth of the Horse, 1913
Geburt der Pferde
Four-color woodcut on paper, 21.5 x 14.5 cm
Sig. b.r.: M
Staatliche Graphische Sammlung, Munich
Bibl.: Lankheit 1970: 840: exh. cat. Munich 1980,
cat. 233; exh. cat. Düsseldorf 1984, cat. 16; exh.
cat. Hanover 1989, cat. 35; Pese 1989, pl. 95;
Hüneke 1990, fig. 89; Rosenthal 1992, pl. 43; exh.
cat. Munich 1993, cat. 62; exh. cat. Munich/Mün-
ster 1993—94, cat. 140; Mönig 1996, fig. 26; exh.
cat. Berlin 1998, cat. 72; exh. cat. Bremen 2000,
cat. 44

115 Fig. 154

Genesis II, 1914
Schöpfungsgeschichte II
Three-color woodcut on paper, 23.7 x 20 cm
Sig. l.r.: M
Staatliche Graphische Sammlung, Munich
Bibl.: Lankheit 1970: 843; exh. cat. Munich 1980,
cat. 236; exh. cat. Düsseldorf 1984, cat. 19; exh.
cat. Hanover 1989, cat. 38; exh. cat. Munich
1993, cat. 63; exh. cat. Munich/Münster 1993—
94, cat. 143; exh. cat. Berlin 1998, cat. 79; exh.
cat. Bremen 2000, cat. 43

116 Fig. 156

Blue Foals, 1913
Blaue Fohlen
Oil on canvas, 53.5 x 37.5 cm
Sig. b.l.: M.
Kunsthalle, Emden
(Stiftung Henri and Eske Nannen)
Bibl.: Lankheit 1970: 199

117 Fig. 157

The Poor Country of Tyrol, 1913
Das arme Land Tirol
Oil on canvas, 131.1 x 200 cm
Sig. b. at center: M; sig. b.l.: das arme Land Tirol
Solomon R. Guggenheim Museum, New York
Bibl.: Lankheit 1970; 205; exh. cat. Munich 1980,
illus. on p. 81; Pese 1989, pl. 111; Partsch 1990,
illus. on p. 73; Rosenthal 1992, pl. 63; exh. cat.
Munich/Münster 1993—94, p. 107, fig. 3; Mönig
1996, fig. 23

118 Fig. 158
Three Horses I, 1913
Drei Pferde I
Oil on paper, 60 x 75 cm
Sig. b.l.: M
Ahlers Collection
Bibl.: Lankheit 1970: 200; exh. cat. Berlin 1993,
cat. 13; exh. cat. Munich/Münster 1993—94,
p. 112, fig. 9

119 Fig. 159
Three Horses II, 1913
Drei Pferde II
Oil on canvas, 59 x 80.5 cm
Sig. b.r.: M
Private collection, on loan to Staatliche Museen
zu Berlin – Preußischer Kulturbesitz, Neue
Nationalgalerie
Bibl.: Lankheit 1970: 215; exh. cat. Munich/
Münster 1993—94, p. 112, fig. 10

120 Fig. 160
Stables, 1913
Stallungen
Brush and ink on paper, 16.8 x 22 cm
From sketchbook XXX
Private collection
Bibl.: Lankheit 1970: 656; exh. cat. Munich 1980,
cat. 145; exh. cat. Düsseldorf 1984, cat. 44;
Moeller 1989, cat. 171; exh. cat. Munich/Münster
1993—94, cat. 77; exh. cat. Berlin 1998, cat. 74

121 Figs. 161, 169
Stables, 1913
Stallungen
Oil on canvas, 73.6 x 157.5 cm
Sig. b.r.: M.
Solomon R. Guggenheim Museum, New York
Bibl.: Lankheit 1970: 221; exh. cat. Munich 1980,
cat. 41; Pese 1989, pl. 5; Partsch 1990, illus. on
p. 56; Rosenthal 1992, pl. 61; exh. cat.
Munich/Münster 1993—94, cat. 9

122 Fig. 162
Playing Forms, 1914
Spielende Formen
Oil on canvas, 56.5 x 170 cm
Sig. t.r.: M.
Museum Folkwang, Essen
Bibl.: Lankheit 1970: 233; exh. cat. Munich/
Münster 1993—94, cat. 19; exh. cat. Berlin 1998,
p. 169, fig. 10; Partsch 1990, pp. 80 ff.

123 Fig. 163
The Peaceful Horse, 1915
Das friedsame Pferd
Graphite on paper, 9.8 x 16 cm
Sig. b.r.: Das friedsame Pferd
From the *Sketchbook from the Front*, fol. 14
Staatliche Graphische Sammlung, Munich
Bibl.: Lankheit 1970: 680; exh. cat. Munich 1980,
250/14; exh. cat. Munich/Münster 1993—94,
cat. 98

124 Fig. 166
Untitled, 1915
Ohne Titel
Graphite on paper, 9.8 x 16 cm
From the *Sketchbook from the Front*, fol. 27
Staatliche Graphische Sammlung, Munich
Bibl.: Lankheit 1970: 693; exh. cat. Munich 1980,
250/27; exh. cat. Munich/Münster 1993—94,
cat. 111

125 Fig. 165
Fragment, 1915
Fragment
Graphite on paper, 16 x 9.8 cm
Sig. t.r.: Fragment
From the *Sketchbook from the Front*, fol. 30
Staatliche Graphische Sammlung, Munich
Bibl.: Lankheit 1970: 696; exh. cat. Munich 1980,
250/30; Moeller 1989, cat. 188; Partsch 1990,
illus. on p. 93; exh. cat. Munich/Münster 1993—
94, cat. 114

126 Fig. 164
Untitled, 1915
Ohne Titel
Graphite on paper, 9.8 x 16 cm
From the *Sketchbook from the Front*, fol. 32
Staatliche Graphische Sammlung, Munich
Bibl.: Lankheit 1970: 698; exh. cat. Munich 1980,
250/32; exh. cat. Munich/Münster 1993—94,
cat. 116

127 Fig. 167
Headlong Rush of Horses, 1915
Jagende Pferde
Graphite, pen and brown ink, with wash on card,
9.8 x 16 cm
Sig. b.r.: Sept. 1915
Postcard, without address or postmark
Staatliche Museen zu Berlin – Preußischer
Kulturbesitz, Kupferstichkabinett
Bibl.: Lankheit 1970: 797; Moeller 1989, cat. 184;
exh. cat. Hanover 1989, cat. IX; exh. cat. Berlin
1991, cat. 143

128 Fig. 168
Horse's Head and Three Riders, 1915
Pferdekopf und drei Reiter
Graphite , pen and brown ink, with wash on
card, 9 x 14 cm
Postcard, without address or postmark
Staatliche Museen zu Berlin – Preußischer
Kulturbesitz, Kupferstichkabinett
Bibl.: Lankheit 1970: 796; Moeller 1989, cat. 185;
exh. cat. Hanover 1989, cat. X; exh. cat. Berlin
1991, cat. 142; exh. cat. Bremen 1991, illus. on
p. 36

Unnumbered late addition to exhibition
Two Horses in a Landscape, 1913
Zwei Pferde in Landschaft
Graphite and watercolor on paper, 12.6 x 20.2 cm
Sig. b.r.: St. Georgen.
Private collection
Bibl.: Cat. Villa Grisebach 2000, no. 79, fig. 21

Bibliography

ARCHIVI DEL FUTURISMO
Drudi Gambillo, Teresa Fiori, eds., *Archivi del Futurismo*
(2 vols., Rome 1958, 1962)

ARTINGER 1995
Kai Artinger, *Von der Tierbude zum Turm der blauen Pferde. Die künstlerische Wahrnehmung der wilden Tiere im Zeitalter der zoologischen Gärten*
(Berlin 1995)

ARZT/BIRMELIN 1993
Volker Arzt and I. Birmelin,
Haben Tiere ein Bewußtsein?
(Munich 1993)

ASENDORF 1997
Christoph Asendorf, *Super Constellation. Flugzeug und Raumrevolution. Die Wirkung der Luftfahrt auf Kunst und Kultur der Moderne*
(Vienna and New York 1997)

BÄTSCHMANN 1989
Oskar Bätschmann, *Entfernung der Natur. Landschaftsmalerei 1750—1920*
(Cologne 1989)

BAUER 1998
Helmut Bauer, *Schwabing. Kunst und Leben um 1900*
(Munich 1998)

BAUM 1991
Marlene Baum, *Das Pferd als Symbol. Zur kulturellen Bedeutung einer Symbiose*
(Frankfurt am Main 1991)

BAUMGARTH 1966
Christa Baumgarth, *Geschichte des Futurismus*
(Hamburg 1966)

BAUSCHINGER 1999
Sigrid Bauschinger, "The Berlin Moderns: Else Lasker-Schüler and Café Culture", in exh. cat., ed. Emily D. Bilski, *Berlin Metropolis. Jews and the New Culture 1890—1918*
The Jewish Museum, New York (Berkeley, Ca. 1999)

BERGER 1980
John Berger, "Why Look at Animals?" (1977) in John Berger, *About Looking*
(London 1980), pp. 1—26

BROCKHAUS 1903
Brockhaus' Konversations-Lexikon
(14th ed., Berlin 1903)

CAT. CHRISTIE'S LONDON 1997
Catalog of sale held on October 7th 1999
Christie's, London

CAT. VILLA GRISEBACH 2000
Catalog of sale held on May 26th 2000
Villa Grisebach, Berlin

COBARG 1995
Merete Cobarg, *"Eugen von Kahler (1882—1911). Leben und Werk"* (Ph.D. dissertation typescript, University of Karlsruhe 1995)

COSENTINO 1972
Christine Cosentino, *Tierbilder in der Lyrik des Expressionismus*
(Bonn 1972)

DAGUERRE DE HUREAUX 1993
Alain Daguerre de Hureaux, *Delacroix*
(2 vols., Paris 1993)

DOMNICK 1982
Ottomar and Greta Domnick, *Die Sammlung Domnick. Ihre Entstehung — ihre Aufgabe — ihre Zukunft*
(Stuttgart 1982)

DÜCHTING 1991
Hajo Düchting, *Franz Marc*
(Cologne 1991)

EBERLE 1980
Matthias Eberle, *Individuum und Landschaft. Zur Entstehung und Entwicklung der Landschaftsmalerei*
(Giessen 1980)

ENGELS-MÜNCHEN 1902
Eduard Engels-München, *Otto von Faber du Faur*
(Munich 1902)

ERDMANN-MACKE 1962
Elisabeth Erdmann-Macke, *Erinnerungen an August Macke*
(Stuttgart 1962)

ESCHENBURG 1984
Barbara Eschenburg, ed., *Kataloge der Bayerischen Staatsgemäldesammlungen/Neue Pinakothek München: Spätromantik und Realismus*
(Munich 1984)

EXH. CAT. BERLIN 1991
Expressionistische Grüße. Künstlerpostkarten der Brücke und des Blauen Reiter, ed. Magdalena M. Moeller, Brücke-Museum, Berlin
(Stuttgart 1991)

EXH. CAT. BERLIN 1993
Expressionistische Bilder. Sammlung Firmengruppe Ahlers, ed. Peter Lipke
(Bielefeld 1993)

EXH. CAT. BERLIN 1998
Der Blaue Reiter und seine Künstler, ed. Magalena M. Moeller, Brücke-Museum, Berlin, and Kunsthalle, Tübingen
(Munich 1998)

EXH. CAT. BERNE 1986
Der Blaue Reiter, ed. Hans Christoph von Tavel,
Kunstmuseum, Berne
(Berne 1986)

EXH. CAT. BIELEFELD 1992
O Mensch! Das Bildnis des Expressionismus,
Kunsthalle, Bielefeld
(Bielefeld 1992)

EXH. CAT. BREMEN 1991
Ross und Reiter in der Skulptur des XX. Jahrhun-
derts, ed. Martina Rudloff, Albrecht Seufert,
Gerhard Marcks-Stiftung, Bremen
(Bremen 1991)

EXH. CAT. BREMEN 2000
Der Blaue Reiter, ed. Christiane Hopfengart,
Kunsthalle, Bremen
(Cologne 2000)

EXH. CAT. DORTMUND 1996
Von der Brücke zum Blauen Reiter. Farbe, Form
und Ausdruck in der deutschen Kunst von 1905
bis 1914, ed. Tayfun Belgin, Museum am Ostwall,
Dortmund
(Heidelberg 1996)

EXH. CAT. DÜSSELDORF 1984
Franz Marc 1880—1916. Gemälde. Aquarelle.
Zeichnungen. Graphik, Wolfgang Wittrock Kunst-
handel, Düsseldorf
(Düsseldorf 1984)

EXH. CAT. FRANKFURT 1999
Mehr Licht. Europa um 1770. Die bildende Kunst
der Aufklärung, ed. Herbert Beck, Peter C. Bol,
Maraike Bückling, Städelsches Kunstinstitut, and
Liebieghaus, Frankfurt am Main
(Munich 1999)

EXH. CAT. HAMBURG 1992
Die Künstlerpostkarte. Von den Anfängen bis zur
Gegenwart, ed. Bärbel Hedinger, Altonaer
Museum, Hamburg, and other venues
(Munich 1992)

EXH. CAT. HANOVER 1989
Der Blaue Reiter. Kandinsky, Marc und ihre
Freunde, Sprengel Museum, Hanover
(Hanover 1989)

EXH. CAT. HANOVER 1994
Die Empfindung der Natur. Max Ernst, Paul Klee,
Wols und das surreale Universum, ed. Karin
Orchard, Jörg Zimmermann, Sprengel Museum,
Hanover
(Freiburg im Breisgau 1994)

EXH. CAT. KOCHEL AM SEE 1998
Franz Marc und der Blaue Reiter, Franz Marc
Museum, Kochel am See, and other venues
(Munich 1998)

EXH. CAT. MUNICH 1980
Franz Marc 1880—1916, ed. Rosel Gollek,
Städtische Galerie im Lenbachhaus, Munich
(Munich 1980)

EXH. CAT. MUNICH 1981
Albrecht Adam und seine Familie. Zur Geschichte
einer Münchner Künstlerdynastie im 19. und
20. Jahrhundert, ed. Ulrike von Hase-Schmundt,
Münchner Stadtmuseum
(Munich 1981)

EXH. CAT. MUNICH 1982
Der Blaue Reiter im Lenbachhaus München, ed.
Rosel Gollek, Städtische Galerie im Lenbachhaus,
Munich
(2nd ed. Munich 1982)

EXH. CAT. MUNICH 1987
"In uns selbst liegt Italien". Die Kunst der Deutsch-
Römer, ed. Christoph Heilmann, Haus der Kunst,
Munich
(Munich 1987)

EXH. CAT. MUNICH 1988
Die Prinzregentenzeit, ed. Norbert Götz and
Clementine Schack-Simitzis, Stadtmuseum,
Munich
(Munich 1988)

EXH. CAT. MUNICH 1993
Sammlung Etta und Otto Stangl. Von Klee bis Poli-
akoff, ed. Carla Schulz-Hoffmann, Bayerische
Staatsgemäldesammlungen/Staatsgalerie moder-
ner Kunst, Munich
(Ostfildern-Ruit 1993)

EXH. CAT. MUNICH/MÜNSTER 1993—94
Franz Marc. Kräfte der Natur. Werke 1912—1915,
ed. Erich Franz, Bayerische Staatsgemäldesamm-
lungen/Staatsgalerie moderner Kunst, Munich,
and Westfälisches Landesmuseum, Münster
(Ostfildern-Ruit 1993)

EXH. CAT. MUNICH 1995
Maria Marc 1876—1955, ed. Annegret Hoberg,
Städtische Galerie im Lenbachhaus, Munich
(Munich 1995)

EXH. CAT. MUNICH 1997
Albert Bloch. Ein amerikanischer Blauer Reiter,
ed. Annegret Hoberg, Henry Adams, Städtische
Galerie im Lenbachhaus, Munich
(Munich 1997)

EXH. CAT. MUNICH 1999
Der Blaue Reiter und das neue Bild. Von der
"Neuen Künstlervereinigung München" zum
"Blauen Reiter", ed. Annegret Hoberg, Helmut
Friedel, Städtische Galerie im Lenbachhaus,
Munich
(Munich 1999)

EXH. CAT. MURNAU 1999
Paul Klee und seine Weggefährten, ed. Brigitte
Salmen, Schloßmuseum des Marktes Murnau
(Murnau 1999)

EXH. CAT. PARIS 1989
Gauguin, eds. Richard Bettel et al., Galerie
nationale du Grand Palais, Paris, and other venues
(Paris 1989)

EXH. CAT. STUTTGART 1973
Neuere Kunst aus württembergischem Privatbe-
sitz, I: Klassische Moderne, ed. Karin von Maur,
Bernd Rau, Karin Hartmann, Staatsgalerie,
Stuttgart
(Stuttgart 1973)

EXH. CAT. STUTTGART 1985
Vom Klang der Bilder. Die Musik in der Kunst des
20. Jahrhunderts, ed. Karin von Maur, Staats-
galerie, Stuttgart
(Stuttgart 1985)

EXH. CAT. WASHINGTON 1989
Hans Baldung Grien. Prints and Drawings, ed.
James H. Marrow, Alan Shestack, National
Gallery of Art, Washington, D.C.
(Washington 1981)

EXH. CAT. WASHINGTON 1998
Degas at the Races, ed. Ann Sutherlands Boggs,
National Gallery of Art, Washington, D.C.
(Washington 1998)

FRANZ 1993/94
Erich Franz, "Franz Marc: Konstruktion der Verwandlung", in exh. cat. Munich/Münster 1993—94, pp. 14—30

FRIEDLÄNDER 1947
Max J. Friedländer, *Essays über die Landschaftsmalerei und andere Bildgattungen* (The Hague 1947)

GRANT/HAZEL 1992
Michael Grant and John Hazel *Lexikon der antiken Mythen und Gestalten* (8th ed. Munich 1992)

HEILMANN 1988
Christoph Heilmann, *Deutsche Malerei der Spätromantik. Ein Führer durch die Schack-Galerie München* (2nd ed. Munich 1988)

HESS 1959
Hans Hess, *Lyonel Feininger* (Stuttgart 1959)

HOFMANN 1987
Werner Hofmann, *Die Grundlagen der modernen Kunst* (3rd ed. Stuttgart 1987)

HÜNEKE 1986
Andreas Hüneke, *Der Blaue Reiter. Dokumente einer geistigen Bewegung* (Leipzig 1986)

HÜNEKE 1990
Andreas Hüneke, *Franz Marc, Zitronenpferd und Feuerochse: 100 Grafiken* (Leipzig 1990)

HÜNEKE 1993
Andreas Hüneke, "Das Jahr 1913: Lauter ganz verschiedene Bilder", in exh. cat. Munich/Münster 1993—94, pp. 105—116

HÜNEKE 1998
Andreas Hüneke, "Der Blaue Reiter und Berlin", in exh. cat. Berlin 1998, pp. 45—52

ILLUSTRATED BARTSCH 1978
Leonard J. Slatkes, ed. *The Illustrated Bartsch, I: Netherlandish Artists* (New York 1978)

IM KAMPF UM DIE KUNST 1911
Im Kampf um die Kunst. Die Antwort auf den "Protest deutscher Künstler". Mit Beiträgen deutscher Künstler, Galerieleiter, Sammler und Schriftsteller (Munich 1911)

KAFKA 1983
Nahum N. Glatzer, ed., *The Penguin Complete Short Stories of Franz Kafka* (Harmondsworth 1983)

KANDINSKY 1911/1952
Wassily Kandinsky, *Über das Geistige in der Kunst* (first published 1911; 10th ed. Berne 1952)

KANDINSKY 1955
ed. Max Bill, *Wassily Kandinsky: Essays über Kunst und Künstler* (Berne 1955)

KANDINSKY 1913/1977
Wassily Kandinsky, *Rückblicke* (first published 1913; 3rd ed. Berne 1977)

KANDINSKY/MARC 1912
ed. Wassily Kandinsky, Franz Marc, *Der Blaue Reiter* (Munich 1912)

KLEE 1988
ed. Wolfgang Kersten, *Paul Klee. Tagebücher 1898—1918* (Stuttgart 1988)

LANGNER 1980
Johannes Langner, "'Iphigenie als Hund'. Figurenbild im Tierbild bei Franz Marc", in exh. cat. Munich 1980, pp. 50—73

LANGNER 1981
Johannes Langner, "'Symbole auf die Altäre der kommenden geistigen Religion'. Zur Sakralisierung des Tierbildes bei Franz Marc", in *Jahrbuch der Staatlichen Kunstsammlungen Baden-Württemberg* XVIII (Munich 1981), pp. 79—98

LANKHEIT 1950
Klaus Lankheit, *Franz Marc* (Berlin 1950)

LANKHEIT 1960
Klaus Lankheit, *Franz Marc im Urteil seiner Zeit* (Cologne 1960)

LANKHEIT 1965
ed. Klaus Lankheit, *Der Blaue Reiter: Dokumentarische Neuausgabe* (Munich 1965)

LANKHEIT 1970
Klaus Lankheit, *Franz Marc. Katalog der Werke* (Cologne 1970)

LANKHEIT 1976
Klaus Lankheit, *Franz Marc. Sein Leben und seine Kunst* (Cologne 1976)

LANKHEIT 1978
ed. Klaus Lankheit, *Franz Marc. Schriften* (Cologne 1978)

LANKHEIT 1983
ed. Klaus Lankheit, *Wassily Kandinsky — Franz Marc. Briefwechsel* (Munich 1983)

LEVINE 1979
Frederick S. Levine, *The Apocalyptic Vision. The Art of Franz Marc as German Expressionist* (New York 1979)

LUDWIG 1989
Horst Ludwig, *Franz von Stuck und seine Schüler: Katalogbuch Villa Stuck München* (Munich 1989)

MACKE 1964
Wolfgang Macke, ed., *August Macke, Franz Marc: Briefwechsel* (Cologne 1964)

MACKE 1987
Werner Frese, Ernst-Gerhard Güse, eds., *August Macke: Briefe an Elisabeth und die Freunde* (Munich 1987)

MARC 1920
Maria Marc, ed., *Franz Marc: Briefe, Aufzeichnungen und Aphorismen* (Berlin 1920)

MARC 1941
Franz Marc: Briefe aus dem Feld (Berlin 1941)

MARQUARDT/RÖLLEKE 1998
Ulrike Marquardt, Heinz Rolleke, eds., *Else Lasker-Schüler — Franz Marc: Mein lieber, wundervoller blauer Reiter. Privater Briefwechsel* (Düsseldorf 1998)

MAUR 1979
Karin von Maur, *Oskar Schlemmer. Monographie und Œuvrekatalog*
(Munich 1979)

MAUR 1999
Karin von Maur, ed., exh. cat., *Picasso und die Moderne. Meisterwerke aus der Staatsgalerie Stuttgart und der Sammlung Steegmann*
(Ostfildern-Ruit 1999)

MAUR/INBODEN 1984
Karin von Maur, Gudrun Inboden, eds., *Staatsgalerie Stuttgart: Malerei und Plastik des 20. Jahrhunderts*
(2nd ed., Stuttgart 1984)

MEIER 1986
Andreas Meier, "Das Umfeld des Verlegers. Reinhard Piper und der 'Blaue Reiter'", in exh. cat. Berne 1986, pp. 227—239

MEIER-GRAEFE 1910
Julius Meier-Graefe, *Paul Cézanne*
(Munich 1910)

MEISSNER 1989
Günter Meissner, ed., *Franz Marc: Briefe, Schriften und Aufzeichnungen*
(2nd ed., Leipzig 1989)

MÖBIUS 1908
Karl Möbius, *Ästhetik der Tierwelt*
(Jena 1908)

MOELLER 1989
Magdalena M. Moeller, *Franz Marc. Zeichnungen und Aquarelle*
(Stuttgart 1989)

MÖNIG 1993
Roland Mönig, "'... mit pochendem Herzen am Anfang der Dinge ...'. Franz Marcs 'Skizzenbuch aus dem Felde'", in exh. cat. Munich/Münster 1993—94, pp. 233—241

MÖNIG 1996
Roland Mönig, *Franz Marc und Georg Trakl. Ein Beitrag zum Vergleich von Malerei und Dichtung des Expressionismus*
(Münster 1996)

NOVALIS 1995
Hans-Joachim Mähl, Richard Samuel, eds., *Novalis: Werke in einem Band*
(Munich 1995)

PARTSCH 1990
Susanna Partsch, *Franz Marc 1880—1916*
(Cologne 1990)

PESE 1989
Claus Pese, *Franz Marc. Leben und Werk*
(Stuttgart 1989)

PIPER 1910
Reinhard Piper, *Das Tier in der Kunst*
(Munich 1910)

PIPER 1947
Reinhard Piper, *Vormittag. Erinnerungen eines Verlegers*
(Munich 1947)

RIDINGER 1722
Johann Elias Ridinger, *Neue Reit-Kunst in Kupfer-Stichen inventiert und gezeichnet von Johann Elias Ridinger*
(Augsburg 1722)

ROETHEL/BENJAMIN 1982
Hans K. Roethel, Jean K. Benjamin, *Kandinsky, Werkverzeichnis der Ölgemälde, I: 1900 bis 1915*
(Munich 1982)

ROSENTHAL 1992
Mark Rosenthal, *Franz Marc*
(Munich 1989; 2nd ed., 1992)

RUHMER 1969
Eberhard Rühmer, ed., *Katalaoge der Bayerischen Staatsgemäldesammlungen, II: Schack-Galerie*
(text vol., Munich 1969)

SCHARDT 1936
Alois Schardt, *Franz Marc*
(Berlin 1936)

SCHUMACHER 1994
Birgit Schumacher, *Pferde. Meisterwerke des Pferde- und Reiterbildes*
(Stuttgart 1994)

SCHUSTER 1987
Peter-Klaus Schuster, ed., exh. cat., *Franz Marc. Else Lasker-Schüler. Der Blaue Reiter präsentiert Eurer Hoheit sein Blaues Pferd. Karten und Briefe*
(Munich 1987)

SCHUSTER 1993—94
Peter-Klaus Schuster, "Vom Tier zum Tod. Zur Ideologie des Geistigen bei Franz Marc", in exh. cat. Munich/Münster 1993—94, pp. 168—169

SIMMEL 1957
Georg Simmel, *Brücke und Tür. Essays des Philosophen zur Geschichte, Religion, Kunst und Gesellschaft*
(Stuttgart 1957)

SMUDA 1986
Manfred Smuda, ed., *Landschaft*
(Frankfurt am Main 1986)

STRACHWITZ 1997
Sigrid Gräfin von Strachwitz, *"Franz Marc und Friedrich Nietzsche. Zur Nietzsche-Rezeption in der Bildenden Kunst"*
(Ph.D. dissertation typescript, University of Bonn 1997)

SWIFT 1986
Jonathan Swift, *Gullivers Travels* (1726)
(first published 1726; Oxford and London 1986)

THÜRLEMANN 1986
Felix Thürlemann, "Famose Gegenklänge. Der Diskurs der Abbildungen im Almanach 'Der Blaue Reiter'", in exh. cat. Berne 1986, pp. 210—222

TOLSTOY 1933
Leo Tolstoy, trans. Louise Aylmer Maude, "Strider", in Leo Tolstoy, *Nine Stories*
(Oxford 1933), pp. 389—439

VINNEN 1911
Carl Vinnen, ed. and intr., *Ein Protest deutscher Künstler*
(Jena 1911)

VIRILIO 1986
Paul Virilio, *Ästhetik des Verschwindens*
(West Berlin 1986)

VRIESEN/IMDAHL 1967
Gustav Vriesen, Max Imdahl, *Robert Delaunay — Licht und Farbe*
(Cologne 1967)

WARNKE 1992
Martin Warnke, *Politische Landschaft. Zur Kunst-geschichte der Natur*
(Munich 1992)

WERCKMEISTER 1981
O. K. Werckmeister, "Klee im Ersten Weltkrieg", in *Versuche über Paul Klee*
(Frankfurt am Main 1981), pp. 9—83

WICHMANN 1970
Siegfried Wichmann, *Wilhelm von Kobell. Mono-graphie und kritisches Verzeichnis der Werke*
(Munich 1970)

WORRINGER 1910
Wilhelm Worringer, *Abstraktion und Einfühlung. Ein Beitrag zur Stilpsychologie*
(3rd ed. 1910; reprint, Munich 1948)

WRANGEL 1927
Gustav Graf Wrangel, *Das Buch vom Pferde*
(2 vols., 6th ed., Stuttgart 1927)

WYSS 1996
Beat Wyss, *Der Wille zur Kunst. Zur ästhetischen Mentalität der Moderne*
(Cologne 1996)

ZEEB 1998
Klaus Zeeb (with photographs by Dieter Schin-ner), *Die Natur des Pferdes. Beobachtungen eines Verhaltensforschers*
(Stuttgart 1998)

ZIMMERMANN 1996
Jörg Zimmermann, ed., *Ästhetik und Natur-erfahrung*
(Stuttgart 1996)

ILLUSTRATION CREDITS

Illustrational material was in most cases provided by the public or private collections cited for each item. The other material derives from the authors' archives or from the sources indicated in the following list (numerals refer to fig. nos. in this volume):

Archiv Klaus Lankheit, Munich: *3, 5, 6, 12, 13, 27, 35, 54, 65, 75, 80, 81, 108, 155, 170, 188, 189, 190, 195, 212, 227*

Gabriele Münter und Johannes Eichner-Stiftung, Munich: *7, 8, 15, 16*

Exh. cat. Munich 1980, p. 45: *10*

Pese 1989, fig. 4: *17*

Kulturhistorisches Bildarchiv Hansmann, Munich: *19, 21, 23, 25, 26, 86, 230*

Volker Naumann, Stuttgart: *32, 77, 79, 134*

Rosenthal 1992, pl. 5: *34;* pl. 26: *96;* pl. 40: *186;* pl. 58: *187*

Exh. cat. Berne 1986, cat. 86: *39*

Hauswedell & Nolte, Hamburg: *64*

Franziska Adriani, Stuttgart: *67, 76, 109, 130, 131, 139, 231*

Christie's, London: *83, 197*

Artothek, Peissenberg: *99, 177*

Belser Verlag, Stuttgart: *111*

Exh. cat. Hanover 1989, cat. 32: *113*

Haus der Kunst, Munich: *171*

Exh. cat. Paris 1989, p. 410: *192*

Exh. cat. Munich 1999, fig. 40: *193;* fig. 54: *194*

Exh. cat. Washington 1981, cat. 81: *209*

Moeller 1989, cat. 55: *229*

This publication is the English translation of
the catalog originally published in German to
accompany the exhibition "Franz Marc: Pferde"
at the Staatsgalerie Stuttgart from 27 May to
10 September 2000.
It is published in conjunction with the exhibi-
tion "Franz Marc: Horses" at the Busch-Reisinger
Museum, Harvard University Art Museums,
Cambridge, Mass., from 29 September 2000 to
18 March 2001.
The exhibition and catalog have been
made possible by the Friends of the Busch-
Reisinger Museum / Verein der Freunde
des Busch-Reisinger Museums an der Harvard
Universität, e. V.

Catalog edited by Christian von Holst, with
contributions from Karin von Maur, Andreas
Schalhorn, Andreas K. Vetter, and Klaus Zeeb

Translated from the German by
Elizabeth Clegg (Essays by Christian von Holst,
Andreas K. Vetter, Andreas Schalhorn; Biography;
Catalog; Picture Captions)
Claudia Spinner (Essays by Karin von Maur,
Klaus Zeeb)
Copy editing (English version)
Elizabeth Clegg

Design
SeidlCluss, Stuttgart

Production
Christine Müller

Typesetting
Claudia Schädel, Weyhing digital, Ostfildern-Ruit

Reproductions
C + S Repro, Filderstadt

Printed by
Dr. Cantz'sche Druckerei, Ostfildern Ruit

Published by
Hatje Cantz Verlag
Senefelderstraße 12
73760 Ostfildern-Ruit
Germany
tel. + 49 711 4 40 50
fax. + 49 711 4 40 52 20

In cooperation with
Busch-Reisinger Museum
Harvard University Art Museums
32 Quincy Street
Cambridge, MA 02138, USA
tel. + 1 617 495 9400
fax. + 1 617 495 9936
www.artmuseums.harvard.edu

Distribution in the US
D.A.P., Distributed Art Publishers, Inc.
155 Avenue of the Americas, Second Floor
New York, N.Y. 10013–1507
tel. + 1 212 627 1999
fax. + 1 212 627 9484

Printed in Germany

Cover illustration:
The Red Horses (detail), 1911, private collection,
anonymous loan to the Busch-Reisinger
Museum, Harvard University Art Museums,
Cambridge, Mass., 21.1991
Cat. 38

Frontispiece
Two Small Blue Horses, 1913, private collection
Cat. 92